READING

GREEK

ART

READING

GREEK

ART

Essays by Nikolaus Himmelmann

SELECTED BY HUGO MEYER

EDITED BY WILLIAM CHILDS

Princeton University Press

PRINCETON, NEW JERSEY

Copyright © 1998 by Princeton University Press

All Rights Reserved

Published by Princeton University Press, 41 William Street, Princeton, New Jersey 08540

In the United Kingdom: Princeton University Press, Chichester, West Sussex

http://pup.princeton.edu

LIBRARY OF CONGRESS CATALOGING-IN-PUBLICATION DATA

Himmelmann, Nikolaus, 1929–

 Reading Greek art / essays by Nikolaus Himmelmann ; selected by Hugo Meyer ;
edited by William Childs

 p. cm.

 Includes index.

 ISBN 0-691-05825-3 (alk. paper). — ISBN 0-691-05826-1 (pbk.)

 1. Art, Greek—Themes, motives. 2. Gods, Greek, in art.

 I. Meyer, Hugo. II. Childs, William A. P., 1942– III. Title.

N5630.H5 1998

709'.38—dc21 97-30969

 CIP

This book has been composed in Fairfield types with Rusticana display and Kadmos Greek

Princeton University Press books are printed on acid-free paper and meet the guidelines for
permanence and durability of the Committee on Production Guidelines for Book Longevity
of the Council on Library Resources

Printed in the United States of America

10 9 8 7 6 5 4 3 2 1

10 9 8 7 6 5 4 3 2 1 (pbk.)

Contents

List of Illustrations

British Museum [1948.10-51.1] (photo: courtesy of the Trustees of the British Museum)

27. Judgment of Paris, Attic red-figure amphora (detail). London, British Museum [E 289] (photo: courtesy of the Trustees of the British Museum)

28. Judgment of Paris, Attic white-ground pyxis. New York, Metropolitan Museum of Art, Rogers Fund, 1907 [07.286.36] (photo: courtesy of the museum, negative no. MM17672)

29. Judgment of Paris, Attic red-figure fragment. Athens, Agora Museum (photo: courtesy of the American School of Classical Studies at Athens, Agora Excavations)

30. Apollo and Muse, Attic white-ground kylix. Boston, Museum of Fine Arts, Henry Lillie Pierce Fund [00.356] (photo: courtesy of the museum)

31a–d. Muses with Archilochos, Attic white-ground pyxis. Boston, Museum of Fine Arts, Henry Lillie Pierce Fund [98.887] (photo: courtesy of the museum)

32. Judgment of Paris, ivory casket veneer from Kul Oba. St. Petersburg, Hermitage (photo: courtesy of the museum)

33. Judgment of Paris, ivory casket veneer from Kul Oba. St. Petersburg, Hermitage (photo: courtesy of the museum)

34. Judgment of Paris, Attic red-figure pyxis lid. Copenhagen, National Museum, Department of Near Eastern and Classical Antiquities [731] (photo: courtesy of the museum)

35a–d. Judgment of Paris, Attic red-figure pyxis. Athens, National Museum [14908] (photo: courtesy of the museum)

36. Artemis, Attic red-figure lekythos. Athens, National Museum [1272] (photo: courtesy of the museum)

37. Artemis, Attic red-figure pelike (detail). London, British Museum [E 432] (photo: courtesy of the Trustees of the British Museum)

38. Aphrodite, Attic white-ground kylix. Florence, Museo Archeologico [75409] (photo: Gabinetto Fotografico della Soprintendenza alla Antichità d'Etruria, Florence, negative no. 4503)

39. Aphrodite, Attic red-figure pelike. St. Petersburg, Hermitage [KAB 78r] (photo: courtesy of the museum)

40. Birth of Aphrodite, Attic red-figure lekythos, drawing. Berlin, Antikensammlung, Staatliche Museen, Preussischer Kulturbesitz [F 2688] (photo: after *JdI* 1 [1886] pl. 11.1)

41. Aphrodite, Attic red-figure hydria (detail). New York, Metropolitan Museum of Art, Fletcher Fund, 1926 [26.60.75] (photo: courtesy of the museum, negative no. 69211 B)

Preface

If it is necessary today to explain why the work of a foreign scholar is published in translation, then there are two unassailable reasons for the present book: first, the writings of Nikolaus Himmelmann arguably figure among the most original, coherent, and significant interpretations of ancient, particularly Greek, art since J. J. Winckelmann, the founder of the modern study of Greek art in the eighteenth century; and second, Professor Himmelmann's texts frequently approach poetry, which renders them extremely difficult to read in the original German.

Nikolaus Himmelmann, who studied in Marburg, Basel, and Munich, wrote his dissertation on the Ilissos grave stele from the Kerameikos in Athens (1956). He taught at the Universities of Marburg and Saarbrücken and, from 1966, at Bonn, where he became emeritus professor in 1994. He is the author of many books and articles on Greek and Roman art and the reception of ancient art in the postantique world. Many of his works have been translated into a variety of foreign languages but here for the first time into English.

The selection of Professor Himmelmann's works presented here was made by Hugo Meyer not only to represent his wide-ranging interests but also to demonstrate the coherence of his thought and vision. The book is divided into two parts. The first contains a series of studies of Greek art; the second part presents Professor Himmelmann's reflections on both the method of approach to works of ancient art and the role of antiquity in contemporary society.

Although the selected texts were never intended by the author to constitute collectively a history of Greek art, those in the first part of this book do precisely that, which explains the logic behind the order in which the essays are presented. Beginning with the eighth century B.C., Himmelmann tackles the major issues of artistic representation in vase-painting and sculpture down to the fourth century B.C. He does not present us with a simple historical account but challenges the reader to look carefully and to see precisely those elements of sculpture and painted scenes on vases that have for the most part been invisible to previous generations of scholars. From these formerly unseen details, Himmelmann builds up a view of Greek art which rests solidly

both on what is actually there and what the Greeks themselves said about art, or more accurately, what the Greeks said about manufactured objects. This reservation in calling the objects *art* is not perfunctory, because the word *art* today has so many different meanings that it can only be misleading in the study of early Greece. Yet the word has become so common in the discussion of manufactured objects, it is impossible or at least extremely awkward to avoid. Therefore, let *art* be understood broadly to designate objects in the production of which the appearance is intended to be appreciated in some manner independent of the actual function of the object.

The second part of this collection contains an article on the iconography of an Anatolian sarcophagus of the Roman Imperial period; a study of the eighteenth-century founder of the modern study of ancient art, J. J. Winckelmann; and selections from a book on the contemporary view of antiquity entitled *The Utopian Past*. The first two demonstrate lucidly how a work of ancient art can be approached and the pitfalls of assumptions that continue to obstruct the modern study of the past. In the final paper, the author describes reactions to the Classical past from Roman times to the present with a range and incisiveness that the editor has not found in far longer essays on the subject.

The editors wish to thank the various translators, whose work was not easy. Professor Himmelmann reviewed all the translations as well as producing himself "Some Characteristics of the Representation of Gods in Classical Art." William Childs has attempted to harmonize the language of the translations and to bring the footnotes into accord with American practice. However, references in the footnotes have been updated only to supplement very old or obscure publications for illustrations of the objects discussed. It should be noted that article titles are not cited when references are made only to an illustration or a limited observation in an otherwise nonpertinent discussion. Principal among the new references are the *Lexicon of Classical Mythology* (*LIMC*) and the various vase-lists of J. D. Beazley and the Beazley Archive, since these provide extensive modern bibliographies of the pertinent objects. Totally new references have been added in cases where the editor felt the contemporary American reader would profit from them. These vary tremendously in nature, but again mainly provide basic, recent bibliography and the location of illustrations of objects. However, it should be noted that no new references on the issues discussed by Himmelmann have been included, for which reason there is no general bibliography. The new notes give specific references for quotations from literature, ancient and modern, which were not deemed necessary in the original publications. Wherever possible, English translations are also cited for the works of Winckelmann, Goethe, and other modern authors. However, all the citations in the text were translated from Himmelmann's

German versions, though checked against the originals, with the exception of original English texts, which are given in their original wording. Dr. Tina Najbjerg helped extensively with the updating of references and the checking of citations. Students in a graduate seminar in the spring of 1995 read and criticized most of the translations in the first part of the book. Both Dr. Najbjerg and the seminar students are to be thanked for greatly improving this publication.

The production of the translations was greatly facilitated by a generous grant from the Leon Levy–Shelby White Foundation, for which the editors wish here to express their sincere appreciation.

Abbreviations

NOTE: The abbreviations used, for periodicals and reference works, are those recommended by the *American Journal of Archaeology* 95 (1991) 4–16, and, for primary-source titles, the list of abbreviations in *The Oxford Classical Dictionary*, 3rd ed., ed. S. Hornblower and A. Spawforth (Oxford and New York 1996), ix ff., along with the following:

Arias-Hirmer	P. E. Arias and M. Hirmer, *A History of Greek Vase Painting*, revised by B. B. Shefton (London 1962).
ASR	C. Robert, *Die antiken Sarkophag-Reliefs* II (Berlin 1890), III.1 (Berlin 1897), III.2 (Berlin 1904), III.3 (Berlin 1919).
Bemerkungen	Nikolaus Himmelmann, *Bemerkungen zur geometrischen Plastik* (Berlin 1964).
Boardman, *ARFVAP*	J. Boardman, *Attic Red Figure Vases: The Archaic Period* (London 1975).
BrBr	*Denkmäler griechischer und römischer Skulptur*, ed. H. von Brunn, F. Bruckmann, and P. Arndt (Munich 1888–).
Clairmont, *Parisurteil*	C. Clairmont, *Das Parisurteil in der antiken Kunst* (Zurich 1951).
"Diadoumenos"	Himmelmann, "Die 'Schrittstellung' des polykletischen Diadoumenos," *MarbWPr* (1967) 27–39.
Eigenart	Himmelmann, *Zur Eigenart des klassischen Götterbildes* (Munich 1959).

"Erzählung und Figur"

Himmelmann, "Erzählung und Figur in der archaischen Kunst," *AbhMainz* (1967) no. 2, 73–97.

FR

Griechische Vasenmalerei: Auswahl hervorragender Vasenbilder, ed. A. Furtwängler and K. Reichhold (Munich 1904–32).

Koch-Sichtermann, *Römische Sarkophage*

G. Koch and H. Sichtermann, *Römische Sarkophage* (Munich 1982).

LIMC

Lexicon Iconographicum Mythologiae Classicae (Zurich and Munich 1981–94), 7 volumes to date.

Lippold, *Griechische Plastik*

G. Lippold, *Die griechische Plastik*, in *Handbuch der Archäologie* V (Munich 1950).

Overbeck, *Schriftquellen*

J. Overbeck, *Die antiken Schriftquellen zur Geschichte der antiken Kunst bei den Griechen* (Leipzig 1868; reprint, Hildesheim-New York 1971).

Pfuhl, *MuZ*

E. Pfuhl, *Malerei und Zeichnung der Griechen* (Munich 1923).

Robert, *Bild und Lied*

C. Robert, *Bild und Lied: Archäologische Beiträge zur Geschichte des griechischen Heldensage* (Berlin 1881; reprint, New York 1975).

Robert, *Hermeneutik*

C. Robert, *Archäologische Hermeneutik: Anleitung zur Deutung klassischer Bildwerke* (Berlin 1919; reprint, New York 1975).

Schefold, *UKV*

K. Schefold, *Untersuchungen zu den Kertscher Vasen* (Berlin-Leipzig 1934).

Sichtermann-Koch, *Griechische Mythen*

H. Sichtermann and G. Koch, *Griechische Mythen auf römischen Sarkophagen* (Tübingen 1975).

Simon, *Opfernde Götter* E. Simon, *Opfernde Götter* (Berlin 1953).

WKlSchriften *J. J. Winckelmann: Kleine Schriften, Vorreden, Entwürfe*, ed. W. Rehm and H. Sichtermann (Berlin 1968).

"Zur knidischen Aphrodite" Himmelmann, "Zur knidischen Aphrodite I," *MarbWPr* (1957) 11–16.

READING
GREEK
ART

INTRODUCTION

T HE ESSAYS OF Nikolaus Himmelmann translated in this volume
were published between 1957 and 1976; they deal with both vase-
painting and sculpture. They do not fit neatly into any of the numerous
theoretical systems popular over the last decades. They are founded on the
great tradition of interpretative scholarship that began with Carl Robert in the
last century and are inspired by an intimate examination of the objects and
texts.[1] Yet the exposition is at times poetic rather than ruthlessly analytical.
The poetic, or, as Himmelmann would prefer to call it, the philosophical qual-
ity of the essays is of necessity closely connected with the nature of the in-
quiry. Himmelmann does not seek to elucidate evolution and chronology, nor
to attribute specific works to artists, nor to analyze specific styles. Perhaps the
best term to encompass the main body of essays in this book is one I believe
Erwin Panofsky coined: *iconology*.[2] Himmelmann reads sculpture and painted
scenes on vases as expressive in all their various aspects: the iconographical,
that is, what relates to all the representational elements; the compositional;
and the stylistic. To all this he adds a sensitive reading of contemporary texts.
The result is a new perspective on how Greek art functions, how we may ap-
proach any Greek object.

The history of Greek art has itself a long history, which begins in antiquity.
J. J. Pollitt has collected and commented on the relevant literary passages.[3]
Not surprisingly, an important component of the ancient commentary on art
was a simple chronology of artists linked to a progressive evolution of tech-
nique. This at least appears to be the basis of the earliest attempted history of
art we know, composed by Xenokrates of Athens, a sculptor himself, who
wrote in the early third century B.C. Although his work is not preserved,
enough has been gleaned from later writers to reconstruct his approach and

some of his observations.[4] Art for Xenokrates was representation of the perceived world in painting and sculpture, and art history was the account of technical progress from schematic forms to convincing imitations of perception made by individual artists. The Roman polymath Pliny the Elder provides much the same type of account in his *Natural History* (Books 33–37), in which, however, he introduces an interesting twist, for the history of representation is subdivided and presented under the rubrics of the materials used: stone, bronze, earths, etc.; in each case Pliny focuses on technical improvements introduced by individual artists.[5]

Implicit, however, in these first attempts to objectify the history of representation is a subjective element that complicates our very understanding of what a representation is: expression. When Aristotle in the *Poetics* (1450a) states that the fifth-century painter Polygnotos was accomplished in depicting the *ēthos*, or "character," of a person, this may at first appear to mean an objective, concrete enhancement of an image, but in what physical forms does character reside?[6] Equally disturbing is the statement by Pliny (*NH* 34.19.52) that after the year 292 (Olympiad 121) "art ceased . . . and began again in the 156th Olympiad (156–153 B.C.)." Here the word *art* can no longer encompass representation in general but must refer to certain forms of representation considered to be "good" as opposed to "not good," since we know that representations were produced in the period Pliny excludes.[7]

There is clearly a qualitative element to representation that eludes categorization simply in terms of the faithful depiction of a supposed objective perception, and this distinction was obvious to those who first attempted to comment on representations. Indeed, a corollary of the qualitative nature of representations was recognized very early on: knowledge of what was represented. This is the basis of the distinction Plato draws in the *Republic* (10.596ff.) between the cabinetmaker producing a couch and a painter producing an image of a couch. Since the painter or poet cannot have real knowledge of all they represent, the images they produce are a priori misleading.

The beginning of a modern systematic account of ancient art traditionally begins with J. J. Winckelmann in the eighteenth century.[8] The emphasis on Winckelmann is perhaps a bit misleading, though his work had greater impact than that of any of his contemporaries and is more accessible to the modern reader, because he based his observations on a close examination of the preserved monuments.[9] His commentaries on ancient art remain lucid and comprehensible to the modern reader, though the romantic, even mystical tenor must often seem alien.

Winckelmann knew very little about original Greek art, and it was the task of the nineteenth century to begin where the ancient commentators had left

off. It was necessary to collect, record, and organize the originals that were preserved, figuring out where the painted pottery had been manufactured, as well as dating it, and to identify statues, many of them Roman copies, from the descriptions preserved in ancient commentaries such as Pliny's *Natural History*. Indeed, it is hardly surprising that the great compilations of the nineteenth century followed the methods of Xenokrates and Pliny, because Pliny had served as a model for the modern world since the Renaissance in his presentation of the history of art.[10] This should not obscure the novelty of the modern approach: Winckelmann and his successors introduced a rigorous style of inquiry and recording still in use by scholars today, the basis for the organizing methods of public museums. The desire for more information led to systematic excavation of ancient sites, and this in turn became a matter of national prestige, while a "classical education" became the mark of a "gentleman."

The prodigious task of organizing the material remains of antiquity has tended to obscure nineteenth-century scholars' often brilliant insights into the significance of individual works. Indeed, recent interpretative scholarship has at times rather self-consciously set itself up as a new and revolutionary approach to antiquity and particularly to the study of the art and general material culture.[11] This self-assessment is perhaps most valid for analyzing how art is to be understood in general: What is the function of the image and what is its role in society?[12]

There must remain a tension in any inquiry between objects that are considered art and those that are merely elements of material culture. Today the word *art* carries a vast number of diverse connotations and is accordingly difficult to discuss. In his "Plastic Arts in Homeric Society," the title of the first essay in this volume, Himmelmann inquires whether the concept "art" had any meaning in the world of the Homeric epic. The frequent observation that the Greek language never had a word equivalent to the English *art* (or the German *Kunst*, for that matter) has never been very helpful, because *art* has no clear meaning in our own language.[13] It frequently denotes something different from *craft*, or the technical ability to make something. But in what way does art differ from craft? A simple but viable answer is that art refers to an object that is prized more not just because of the skill with which it is made, but because of its quality of expression conferred by the maker and valued by society. Himmelmann locates this artistic quality in the lifelikeness of images, whether in the explicitly divine production of the shield of Achilles (*Iliad* 18.478ff.) or in the more mundane brooch of Odysseus (*Od.* 19.226–31).[14] It is perhaps at first difficult to see in Geometric figures the vivid activities described in the epic passages (figs. 11–18), but the noticeable length and roundness of the legs signal, in contrast to the rigid rectilinearity of the torsos and arms, a distinct

quality of the human form that forces one to recall the epithet of the greatest hero of them all, Achilles: "fleet-footed."[15] The quality of lifelikeness is clearly not to be found in any attempt to depict a version of perceived reality, but in forms that convey absolutely the content, and the content is also absolute. Thus the human figure has the inherent power of motion and is set in scenes of generic character without being materially affected by contingent elements: battle, funeral ceremony, hunt.

In the second essay in this volume, "Narrative and Figure in Archaic Art," Himmelmann pursues the issue of how the increasingly complex images of the Archaic period are to be understood. The generic is replaced by the specific both in terms of subject and the constituent elements; we can frequently identify specific myths and their ancillary paraphernalia. But we shall be sorely disappointed if we imagine that accurate depiction of the perceived world, which Xenokrates and Pliny had led us to expect, has evolved very far. Although the human figure has gained a certain substance and seems a more coherent organism, the organization of images is often difficult to decipher. The fundamental and early study of this phenomenon is Erwin Panofsky's "Perspective as Symbolic Form," which originally appeared in 1927.[16] Panofsky demonstrated that ancient pictures of any period lack a coherent linear perspective and thus the ancient mind configured space in a different way from the modern. Consequently, to look for a progressively more accurate rendition of space in early Greek art must be vain. Later Bernhard Schweitzer gave more definition to the significance of the object in Greek art as opposed to the organization of objects in a spatial continuum: objects, including human figures, develop their own internal coherence and their rendition approaches the experience of perception, but the idea of a continuous spatial container for objects remains, as Panofsky had argued, lacking.[17] It is, however, Himmelmann's study translated here that finally began to fill in the details. The real image is not the convincing approximation of perception, but the fullest elaboration of the conceptual reality of the subject of the image. Himmelmann coins the felicitous term *hieroglyph* for the physical elements of an image; these hieroglyphs are distributed within a framework according to their meaning, not according to some perceived actuality. The presence of bearded Paris in scenes of the Judgment of Paris in the Archaic period are not meant to portray Paris as a mature man, but to characterize the predicament or situation in which Paris finds himself (fig. 26).[18] He must be a judge and display wisdom, an attribute of maturity. He is elaborately robed in these same scenes because he is a prince, though in the tale he is still but a simple shepherd on Mt. Ida. Finally, Paris is frequently depicted running away from the goddesses led by Hermes to indicate the terrible consequences of his judgment. Thus the figure

of Paris is composed of a set of hieroglyphs: the beard, the robe, the stance. Hieroglyphs carry the implicit meaning of a form, not the explicit. Thus beard is wisdom, not age; helmet is courage, not warrior.

The symbolic role of elements of Archaic representations appears to have been recognized by the Greeks themselves in the Classical period. Athenaeus (13.603e–604b) records that Ion of Chios told a story about color which describes a shift in the understanding of color terms in the Classical period. In the account of Ion, Sophokles cites passages from Phrynichos and Simonides with the term πορφύρεος (purple) used respectively for the cheeks of a boy and the mouth of a girl. Sophokles' interlocutor objects to the term as ugly. At issue is that color terms in early Greek have a range of meaning only loosely connected to hue; they can designate such widely divergent things as texture and character.[19] This experience of color as something quite separate from physical appearance of a thing is paralleled in other cultures.[20] By the Classical period the Archaic fluidity of concepts was no longer understood. E. H. Gombrich has described the early phases of artistic production as a process of matching experienced reality.[21] This seems to address only a small part of the real issue and ignores the function of the image as expressive of a content not explicit in the things represented. Consequently we may describe the development of early Greek art as a search for ever more convincing expressive formulae with implicit, absolute meaning that does not depend on a narrative context.

If forms and colors have implicit, absolute meaning and location is relative in a hierarchical system of meaning exclusive of the three-coordinate continuum we normally demand today, time is also not a regular, linear sequence of moments. Indeed, one must stop and ask whether the word *narrative* actually applies to Greek depictions of mythological events.[22] The "scene" of Odysseus and Kirke on the kylix of the Boston Polyphemos Painter is hardly a scene at all, since it has neither coherent space nor logical time (fig. 1). Perhaps the composition is the key to its understanding: the figures are disposed symmetrically around the kylix that Kirke holds out, a kylix of the same shape as the one on which the "scene" is painted. Kirke, nude, her whole body painted white, stirs the magic potion in the kylix she holds out to Odysseus's men on the right, who are already partly turned into animals. Odysseus rushes "into the scene" on the left with sword drawn, sandwiched between two of his transformed followers; Eurylochos dashes off on the extreme right side. All the elements of the story of *Odyssey* 10.226–337 are here, but they have neither spatial nor temporal logic commensurate with the textual account. The depiction of Kirke totally nude must give particular pause, since it is not mentioned in the *Odyssey*. It seems most logical to interpret her nakedness as a reference to her

attempt to seduce Odysseus. But the prominence of the nakedness in the use of white paint suggests further an interpretation of the subject matter that goes beyond any supposed textual source: Kirke is a dangerous harlot.[23] Instead of narrative, perhaps the "scene" would better be called a thematic presentation. This is certainly suggested if we look at the "scene" on the other side of the kylix: the blinding of Polyphemos.[24] The subject is again drinking with dire consequences. The story in each case illustrates the subject, but it is perhaps the latter that is the essential, and it is given a particular twist by the vase-painter that need not derive from a textual version of the story.[25]

Himmelmann argues that it would be wrong to speak of a basic event to which subsidiary, or in the traditional jargon, complementary elements are added.[26] Although this is probably correct in the sense of an artistic amalgamation, nonetheless a single mythic event is depicted, which constitutes the subject of the image, however complex the temporal and spatial elements—in this instance, the Kirke episode.[27] And yet there is a story to which all the parts contribute, and herein lies the apparent ambiguity of the Archaic images: a subject is depicted that we must assume is chosen because of a thematic content, yet it is composed of a lively interaction of apparently disparate elements that constitute a logical temporal progression.[28] Indeed, if we wish to understand how these scenes were experienced, we need only turn back to the Homeric descriptions of the shield of Achilles and the brooch of Odysseus. There is thus every reason to believe that the contemporary Greek spectator saw an eminently "real" scene, replete with motion and sound.

Greek pictures must be read; they depict the world as we experience it, but not in the manner we experience it. What we would call abstraction is blended with naturalism of detail: space and time are disposed in a hierarchy of relative meaning; objects are progressively depicted in more precise approximations of perception. Part of the answer to the ambiguity for the modern viewer of Archaic images is the very nature of the content. The subject matter is frequently drawn from myth. The divine and heroic myths of the Greeks functioned down through the Classical period and beyond as vehicles for religious beliefs and social values, the same as in other cultures. The profusion of mythic images on every type of object, painted pottery, armor, clothing, stone sculpture attached to temples and tombs, and wall-paintings in public buildings cannot blind us to their primary religious and social content.[29] In addition, the works under consideration have mainly been found either in sanctuaries or in tombs and must have a more obvious function than mere physical enhancement—to serve religion in some fashion. This applies as much to the terracotta vases as to sculpture.[30] We must conclude that the representation of myths does not change the function from that presumed for texts or oral

recitation; a mythical scene does not embellish the appearance of an object but carries meaning that is attached to the object as a function of its ritual or votive use. The meaning is elucidated by the particular actions; the story is the carrier of an idea.[31]

The covering of objects with mythical deeds is similar to the Egyptian practice of covering walls of tombs with scenes of life, rituals of the gods, etc.[32] For the Egyptians, the images relate to the causing-to-be of the eternal afterlife. They are functional. Can it be a coincidence that Himmelmann so persuasively finds in the Homeric epics that the early sense of artistic quality is life-likeness? The inscription on an Attic red-figure hydria ναὶ ζῶν (they live!) certainly suggests a parallel to the function of Egyptian images.[33] Equally the use of sculpture, particularly statues, on Greek tombs from the end of the seventh century suggests a parallel function for the funerary sculpture in Greece and Egypt: the eternalization of the deceased.[34] Indeed, it seems very likely that not only the extended left leg of kouroi indicates the inherent quality of mobility, but the enigmatic smile communicates in the form of a hieroglyph "speech." J. Svenbro's commentary on the practice of reading aloud in Greece makes the inscriptions that accompany early Greek sculpture all the more impressive.[35] When one reads the inscription on a base, one reads it aloud, giving voice to the monument in front of which one stands, providing the sound that is precisely the jarring element in the epic description of objects.

The Archaic image is primarily a carrier of meaning; the subject is primarily an activity that presents the meaning; the forms that elucidate the content are hieroglyphs that carry an absolute meaning in themselves. This is true to some extent of the figures and their particular stances. The stance of Paris running away from the approach of the goddesses he is to judge is, as already pointed out, a hieroglyph in itself, though it is true that the function of the hieroglyph is partly contingent on the narrative of the particular myth depicted.[36] But this is the manner in which hieroglyphs are created; an element of the experienced world is abstracted to bear a particular meaning: beard-wisdom, helmet-courage. Hieroglyphs are derived from generalizations that are thought of as true. Their function is to convey the internal aspects of a situation that have no ready pictorial form. The exigencies of Greek imagery in describing not only the externals of an activity or situation but also the internal implications do come to a natural barrier. It is here that naturalism has its place.

Both G. M. A. Hanfmann and Ernst Gombrich proposed long ago an intimate relationship between the nature of Greek narrative images and the development of naturalism as a stylistic phenomenon.[37] Scholars have long known that Greek painting from the Geometric period onward always sets the human figure in a scene of action. Yet the scenes always had implications beyond the

simple activity depicted: prothesis and exphora, battle and hunt expressed the social position and the ideals of those for whom the vessels were made. When mythological scenes appear in the seventh century, the exploits of the heroes and gods represent the nature of the heroic and the divine. Thus action is not depicted for itself but for its implications. Naturalism has an obvious role in such representations to allow an increasingly precise definition of the implications that the purely symbolic hieroglyph cannot but superficially express. This is most easily seen in sculpture. The abstraction of the kouros statue is increasingly blended with the naturalism of anatomical rendition. The anomaly is clearly recognized by the Greeks of the Late Archaic period, since naturalistic rendition increasingly dominates the statue type until it affects the whole concept in the statue we call the Kritios Boy (fig. 58).

In the wide-ranging essay "Some Characteristics of the Representation of Gods in Classical Art," Himmelmann provides essential new insights into the role of naturalism in Greek art. At the end of the sixth century, a major change occurs in the manner in which the gods are depicted.[38] Henceforth a fixed iconography of each god is usually presented, so that there can be no doubt about identification. The gods are also depicted "enduring their own power."[39] For example, Dionysos participates in the revels of his thiasos rather than being a spectator or attendant. Second, whereas the gods in the Archaic period are depicted in scenes, either mythological or cultic, at the end of the sixth century divinities are often depicted alone, frequently pouring a libation. In each case the new images attempt to grasp the nature of the particular divinity or divinity itself. The most powerful illustration of Himmelmann's point occurs at the beginning of the essay: the contrast of an Archaic statue of a kore and figure M of the east pediment of the Parthenon (figs. 22, 23). The former is a generic image of a woman even though she wears a *polos*; the latter is unanimously identified as Aphrodite even though she has no attribute. Her character as an erotic presence is depicted directly. The tool is naturalism.

A prime element of the new representations is the character of space. In the new scenes of the Judgment of Paris, the modern viewer may first perceive an attempt to depict a spatial continuum commensurate with perception (fig. 28). Indeed, this is partly the case. The character of the situation is even expressed effectively in the naturalistic, foreshortened gestures of Paris.[40] But the space of the scenes is not our perceived continuum; rather the goddesses do not interact with Paris but stand each by herself, clearly individualized. They are not actors on a stage in a story but epiphanies that Paris sees with his inner eye. For the first time the coherent naturalism of the individual figures allows the artist to depict convincingly the noncontinuity of the space of the scene. This is more explicit on the east frieze of the Parthenon where the

gods and mortals, juxtaposed in the frieze space, are separated into their own worlds.

Since the issue of space played such a large role in our discussion of Archaic images, it must be discussed here too. The next essay, "The Divine Assembly on the Sosias Cup," elaborates on the essential points at issue. Although the scene on the cup is indisputably the Apotheosis of Herakles, the depiction of the gods each pouring a libation has formerly been misidentified and misunderstood (fig. 49). As Himmelmann demonstrates in the previous essay, "Some Characteristics of the Gods," divinities who pour libations are representations of the archetypal divinity—what divinity is.[41] On the Sosias cup the assembly of gods pouring libations defines a special space that Herakles confronts: the sacred space to which he is introduced.[42] Just as the character of a god or the nature of divinity itself can be described directly in the new, naturalistic images of the gods, so too can the nature of space finally be described. In each case naturalism allows the invisible to be made visible. The implications of an image are no longer implicit but explicit; action is no longer necessary to carry meaning.

We have observed that as the Archaic period progresses, the apparent conflict between increasing naturalism in depicting the human body and the expressive function of hieroglyphs becomes difficult for the modern mind to resolve. This problem is not resolved in the art of the Classical period. It is true that many scenes are constructed in a way that eliminates spatial or temporal conflict, since they are composed of protagonists rendered in a convincingly naturalistic manner and focused on a single, usually dramatic moment of an event. But a fair number of Classical scenes continue to use discontinuous elements of narrative, so that the hieroglyph is not dead.[43] Indeed, the observations of Himmelmann on the representation of divinities indicates that the very naturalism of the Classical images, which we see as an acceptance of the objectification of perception, can be understood as the reverse—a tool to express the transcendental. As so often, once an idea is expressed, its accuracy may be judged by its obvious correctness. Panofsky's observation that ancient images never adopt the structure of space expressed by linear perspective has the logical corollary that space to the ancient mind is not the structured container of human experience; the "failure" to develop linear perspective in antiquity is not a failure at all, but a powerful statement that space is experienced as something quite different from a continuum. Himmelmann suggests that space is distance, a separator of objects. Moreover, the three-dimensional naturalism of the object expresses its independence or unlimitedness rather than its subjection to the limits of time and fixed location. The conflict of coherent object and disjointed space work together to produce a highly expres-

sive image, which is precisely the effect the viewer had read into the images of the shield of Achilles and the brooch of Odysseus.

The impressive development, in Classical images, of a heightened expressive content is apparent in sculpture as well as vase-painting. This is the subject of the two following essays on "The Stance of the Polykleitan Diadoumenos" and "The Knidian Aphrodite." Himmelmann's point of departure in each case is an apparent ambiguity of the representation to the modern viewer. The lively stance of the Diadoumenos and the sultry eroticism of the Knidian Aphrodite are easily understood as simple and modern techniques to catch the interest of viewers for whom naturalism is no longer a shocking novelty (figs. 56, 80). The symbolic activity of the Archaic kouros, expressed in the forward-set left leg, had long been replaced by a natural contrapposto for standing figures in the Early Classical style. The rhythmic motion of both the Diadoumenos's arms and legs seems quite unnatural or at best rather nervous. The nudity of the Knidian Aphrodite is perhaps somewhat crass if compared to the feminine voluptuousness of the "Sandalbinder" of the parapet of the Nike Temple and many other works of the end of the fifth and beginning of the fourth century.

If we follow Himmelmann's earlier argument that heightened naturalism serves increased expression, it is not difficult to see the ambiguous, nervous activity of the Diadoumenos in the same light: the active position of the legs for a man who ties a fillet around his head is disturbing unless we read the stance as a new hieroglyph to express the ideal concept of the liveliness of the figure. The growing eroticism of female figures in the second half of the fifth century and the first half of the fourth century can hardly be a simple aesthetic trick to entice the viewer, but a commentary on the inner character of the figures depicted. Just as he points out in the essay on the Sosias cup, the second half of the fifth century gives up the depiction of god or gods pouring libation(s) as a representation of divinity in itself in favor of more portrait-like, that is, naturalistic representations of the particular divinity in terms of its idiosyncratic *ēthos*, for example in the pediments or on the east frieze of the Parthenon.

The fact that naturalism has a specific expressive function in Classical art was clear to the contemporary Greek. When E. Gombrich speaks of the convincing quality of an image, he is referring to the approximation of perception.[44] But in reality the term *convincing* must refer to the content of the image—in the case of a god, to the nature and power of the divinity. Thus, when the Greeks speak of *mimesis* or we today of imitation, the naïve interpretation of a correspondence between image and perception must be rejected. It seems likely that the modern emphasis on the equation of real image and per-

ception was in part stimulated by the invention of photography in the nineteenth century. It was not long before the craft of photography was abandoned for the art of photography; the accurate record was given up as an impossibility in favor of the expressive record.[45]

It seems clear that the major change in the development of Greek art from the eighth century through the Late Classical period (the fourth century) is the gradual discovery of new expressive forms inherent in the subjective representation. Here the subjective is the imitative, the realistic in the sense that concerns Plato in the *Kratylos*.[46] Curiously a contemporary computer enthusiast can still miss the point, when he perceives no distinction between the virtual reality of a computer monitor and the actuality of the experienced world.[47] The more the human agent, the artist, tries to capture the manifold levels of character of an object, the less the image is an approximation of the concrete physical thing; we can almost consider the cubist image by Marcel Duchamp of a woman descending a stair as the ultimate statement of the Greek search for the fully descriptive image.[48] But this is not actually the case, because the Renaissance interposed the idea that there is a concrete reality that can be described by linear perspective and the anatomical study of the human figure, for example, as well as by an imposed regular and linear sequence of time-moments. For the Greeks the absolute integrity of the object—its objectness—remains paramount and unaltered by space and time, neither of which has concrete structure. Yet it is the very concreteness of the object, its three-dimensional mass and resultant multifaceted appearances, that produces a subjective image, which is relative to the viewer, not to a picture space-time continuum.[49] For this reason the expressive hieroglyph never loses its function in Greek art, since the hieroglyph captures an objective reality of the object which has nothing to do with a coherent structure of space or time but is part of the knowledge of the reality of the object even though not part of a perception of it within an experienced space and time.

In the case of the Diadoumenos and many Classical statues, the highly movemented stance is a hieroglyph that communicates a range of meanings relevant to the figure depicted, from a simple aliveness to a more specific characterization of the particular personality represented. In the statue of Diomedes (fig. 62), as Himmelmann points out, the stance "certainly does not indicate a momentary activity in a continuous sequence, and yet it describes eminently well the mythical narrative of the clear-hearing night-wanderer of no-man's-land."[50]

The nudity of the Knidian Aphrodite is also descriptive of the character and power of the goddess. The problem for the modern viewer is to distinguish between the objective characterization and the appealing, erotic form of its pre-

sentation. We do not experience the nudity as quite the same kind of ambigu-
ity as that in the movemented stance of the Diadoumenos, but we are clearly
unconvinced of the religious meaning, which has led so many scholars to sup-
pose that the fourth-century artists created aesthetically appealing images
largely devoid of religious significance.[51] If this were the case, it would be nor-
mal to suppose that such statues were set up as "works of art" to be looked at
in the context of a museum. But, as Himmelmann shows, the nudity can be
understood as a hieroglyph for epiphany; it is an attribute that defines the
whole religious meaning of the statue.

We are again hampered in our discussion by the meaning today of words
such as *art*. As far as we know, statues in the fourth century were still only set
up in the religious contexts of sanctuary, cemetery, and agora, though they did
begin to invade marketplace and theater. As we have already suggested, the
"art" value that Himmelmann discovers in objects of the Homeric epic, the
aliveness of images, remains valid for the Classical period. The adoption of
highly naturalistic forms enhances this quality for the modern viewer; for the
ancient viewer the same applies, yet in a nuanced manner. Naturalism allows
for a far greater range of expressive possibilities that focus on the content of
the image. Although naturalism of rendition depends on an objectification of
the thing represented, it also introduces a subjective element of interpreta-
tion. Is this subjective element as clear a break with the past as is generally as-
sumed? The fourth-century Greek commentaries, Aristotle's *Poetics* and
Xenokrates of Athens's history of art, assume a progress in the technique of
image-making that can be attributed to individual artists. The stylistic differ-
ences between Aeschylos and Euripides and the expressive qualities of such
differences are already clearly defined by Aristophanes in the *Frogs* (405 B.C.).
As Oscar Wilde points out, the Greeks knew art criticism;[52] does this not im-
ply that they also knew art as we understand it today? But what is art as we un-
derstand it today? A general but viable answer is that art is manufactured sen-
suous form. Since this can apply to any object made by human beings, a fur-
ther limitation is necessary: art is manufactured sensuous form where the sen-
suous form is a primary function of the object rather than a contingent ele-
ment of it. To cite Oscar Wilde again: "A picture has no meaning but its
beauty, no message but its joy. That is the first truth about art you must never
lose sight of. A picture is a purely decorative thing."[53]

That the aesthetic form of objects becomes in the fourth century B.C. a
conscious concern may be deduced both from the writings of Plato on art and
from the increased attention to the personal style of masters in later accounts.[54]
Yet it is a mistake to equate this concern with the "aetheticization" of the
object in the sense of Oscar Wilde cited above. As Himmelmann points out,

objects in antiquity retain a primarily religious function.[55] Therefore the conscious aesthetic form, idiosyncratic to a particular artist, can be nothing but a new tool of the expressive content and depends on the new subjective character of the image. The artist in the Greek tradition from the Homeric epics on had never been anonymous, as Himmelmann points out.[56] Vase-painters and sculptors signed their works from an early date. But in the fourth century the artist makes a new claim: to be an authoritative interpreter of truth. The individual style of each artist is a statement concerning the content of the image he makes. Thus we believe we can distinguish works by Praxiteles and Skopas by their style alone. Although this is more difficult than frequently believed, nonetheless we must admit that multiple styles are apparent in the sculpture of the fourth century and these are very different. For example, the works attributed to Praxiteles are softly modeled and graceful; those of Skopas strongly modeled and active.[57] The issue is not that earlier artists did not have a personal style, but that the personal style in the fourth century is elevated to an important vehicle of expression.

The problem for modern viewers is that art objects have today become emancipated from religious function. The three essays in the second part of this volume address this issue. The "sarcophagus" from Megiste is subjected to an intense inquiry to arrive at an understanding of its figural decoration (fig. 84). But the iconography appears at variance with the small size of the casket, which had been taken as that of a child. However, in Asia Minor, whence the "sarcophagus" comes, there existed the practice of using ossuaries for burial, and it is to this category of monument that the casket from Megiste belongs. Once this is realized, the iconographic program of its figural decoration becomes readily understandable. Here the misunderstanding of the context or function of the object had stood in the way of a correct interpretation. There can be no clearer proof that images have not become emancipated from a function that determines their choice and communicates the intended meaning.

It is a similar process of inquiry that informs Himmelmann's study of "Winckelmann's Hermeneutic." Here the successful interpretation by Winckelmann of the decoration of Roman sarcophagi is examined. Contrary to the majority of contemporary writers, Winckelmann correctly (for the most part) saw Greek myths as the subjects of these widely known Roman monuments. Himmelmann surmises that Winckelmann's success in interpreting the subjects represented on sarcophagi was based not so much on erudition, but on his contemporary "baroque concept of the learned artist."[58] Himmelmann points out further that Winckelmann's method suited particularly well the body of material at hand: the Roman sarcophagi did extensively depict myths known from Classical literature. However, his method failed dismally when

he applied it to real Classical Greek monuments, which must be understood in terms of a thorough knowledge of the original, religious-social context.[59]

Professor Himmelmann presents in the last selection in this volume, "The Utopian Past," a wide-ranging inquiry into the reception of ancient art from the Roman period to the present. Beginning with a highly critical review of contemporary expectations of art and culture pandered to by travel companies, Himmelmann contrasts the utilitarian attitude to travel from antiquity to the eighteenth century, which first came under assault in the cultural revolution launched by J. J. Winckelmann. This implies not so much a question of Winckelmann's rigor in transforming the study of antiquity into an academic discipline, as his role in elevating art onto an aesthetic pedestal. It should be noted that Winckelmann's success in this regard was at least partly based on a general tendency of the times toward the rigorous analysis of art and aesthetics as represented in the work of Edmund Burke, among others.[60]

The effect of Winckelmann's work deeply affected Goethe and Hegel and, indeed, the whole nineteenth century. Himmelmann's account is lively and informative, describing with trenchant clarity the history of classical scholarship and the permutations of that antiquity in the eyes of the modern world. It is a record of the emancipation of the art object, quite a contrary approach to Winckelmann's own, since he was deeply interested in the cultural matrix from which ancient art grew. Perhaps most significant and jarring in Himmelmann's exposition is his analysis of the contemplation of the art object, that is, "silent, pious observation and meditation, during which aesthetic appreciation and interpretive insight meld together in loose association."[61] Considered today to be the essence of correctness among cultivated people confronted by art, Himmelmann's exposition nevertheless questions the appropriateness of this contemplation. The removal of objects from their original contexts and their seclusion in modern museums changes their original purpose. For ancient art, this purpose was religious, not aesthetic, as discussed above. A good parallel to the modern treatment of ancient art is the twentieth century's aesthetization of common household objects, which has resulted in museum displays of all sorts of items such as toasters and typewriters. Created for a functional purpose, these were not given a higher cash value because of their aesthetic form, which, though attractive and probably intended to lure customers, responded primarily to the practical function of the machine. Today, of course, such functional items are frequently designed by famous artists, and a definite supplementary cash value is charged for this "artistic quality." It is precisely this latter aspect of the modern attitude toward art that is lacking in antiquity:

the artist, at least into the fourth century, was not paid for "an artistic quality" but for the labor of manufacture.[62]

The concreteness of the object in antiquity is attached to its functionality; an object has a purpose similar to that of a modern machine: it does something. The inscription on the Mantiklos Apollo of the early seventh century B.C. remains valid for all later objects: "Mantiklos dedicated me to the far-shooter of the silver bow; you, Phoibos, give me a blessing in return."[63] Divinity is immanent, and those objects we designate as art were largely created to serve religion, the structured relationship of mortals and immortals. Although we may stress the study of the formal presentation of objects through time, we miss a large part of the point if we view the formal as separate from the content. The development of naturalistic form is a tool to express a greater range and nuance of content; in the fourth century the development of sensuous form is also a tool of expression. It seems likely that these tools are objectified in the course of the Classical period and thus are no longer intuitive elements of style, but they are not emancipated from the function and meaning of the object.

NOTES

1. C. Robert, *Bild und Lied: Archäologische Beiträge zur Geschichte des griechischen Heldensage* (Berlin 1881; reprint New York 1975); *Archaeologische Hermeneutik: Anleitung zur Deutung klassischer Bildwerke* (Berlin 1919; reprint New York 1975).

2. E. Panofsky, *Studies in Iconology: Humanistic Themes in the Art of the Renaissance* (Oxford 1939).

3. J. J. Pollitt, *The Ancient View of Greek Art: Criticism, History, and Terminology* (New Haven 1974).

4. Ibid., 74–76; B. Schweitzer, "Xenokrates von Athen. Beiträge zur Geschichte der antiken Kunstforschung und Kunstanschauung," in Bernard Schweitzer, *Zur Kunst der Antike: Ausgewählte Schriften*, ed. U. Hausmann and H.-V. Hermann (Tübingen 1963) 105–64.

5. J. Isager, *Pliny on Art and Society: The Elder Pliny's Chapters on the History of Art*, trans. H. Rosenmeier (New York 1991).

6. See, for example, the observations of Xenophon *Mem.* 3.10.1–8; discussed by Pollitt, *Ancient View* (above, n. 3) 184–89.

7. Isager, *Pliny on Art* (above, n. 5) 97–103.

8. See below, *The Utopian Past*, pp. 259–70; "Winckelmann's Hermeneutic," pp. 217–32.

9. The architects J. Stewart and N. Revett were sent by the Society of the Dilettanti to record the ancient monuments of Athens in 1750. They returned to England in 1755, and thus their time in Athens coincided precisely with the beginning of Winckelmann's stay in Rome. The publication of their work, *The Antiquities of Athens* (London 1762–87; reprint New York 1968) predated by two years Winckelmann's *History of Ancient Art*. Equally important was the publication of the first collection of Greek vases made by Sir William Hamilton: P. F. Hugues, Baron d'Hancarville, *Collection of Etruscan, Greek and Roman Antiquities from the Cabinet of the Honourable William Hamilton* (Naples 1766–67).

10. See particularly Franciscus Junius, *De Pitura veterum* (Basel 1554) recently reedited by K. Aldrich, P. Fehl, and R. Fehl, and issued under the title *Franciscus Junius: The Literature of Classical Art* (Berkeley 1991).

11. I. Morris, ed., *Classical Greece: Ancient Histories and Modern Archaeologies* (Cambridge 1994).

12. R. L. Gordon, "The Real and the Imaginary: Production and Religion in the Graeco-Roman World," *Art History* 2 (1979) 5–34.

13. R. G. Collingwood, *The Principles of Art* (Oxford 1938) 5–6, 15ff.

14. The memory of the aliveness of early sculpture is amply recorded in the literature of the fifth and fourth centuries: S. P. Morris, *Daidalos and the Origins of Greek Art* (Princeton 1992) 215–37. The anomaly of the reputation of Daidalos's works and their schematic form seems to be apparent, however, to Pausanias (2.4.5). See also Philostratos's account of an archaic statue of Milo at Olympia: *Life of Apollonios of Tyana* 4.28.

15. See also Himmelmann's masterful study of Geometric bronze figurines: *Bemerkungen zur geometrischen Plastik* (Berlin 1964).

16. E. Panofsky, "Die Perspektive als 'symbolische Form,'" in *Vorträge der Bibliothek Warburg 1924–1925* (Leipzig-Berlin 1927) 258–330; *Perspective as Symbolic Form*, trans. C. S. Wood (New York 1991).

17. *Vom Sinn der Perspektive* (Tübingen 1953).

18. See below, pp. 73–74, 108.

19. E. Irwin, *Colour Terms in Greek Poetry* (Toronto 1974) 17–18 and passim; B. H. Fowler, "The Archaic Aesthetic," *AJP* 105 (1984) 119–49.

20. C. Geertz, "Art as a Cultural System," in his *Local Knowledge* (1983) 100–102.

21. E. H. Gombrich, *Art and Illusion*[2] (Princeton 1969) 29.

22. D. Carr, *Time, Narrative, and History* (Bloomington [IN] 1986); W. Davis, "Narrativity and the Narmer Palette," in *Narrative and Event in Ancient Art*, ed. P. J. Holliday (Cambridge 1993) 14–54.

23. N. Himmelmann, *Ideale Nacktheit in der griechischen Kunst*, *JdIEH* 26 (Berlin 1990) 47. Irwin, *Colour Terms* (above, n. 19) 112–21, finds that the color white indicates beauty and vulnerability; connected with a completely naked woman, the sense must be emphatically erotic. See also C. Bérard, "La Chasseresse traquée," in *Kanon: Festschrift Ernst Berger*, ed. M. Schmidt, *AntK BH* 15 (Basel 1988) 282–83, pl. 84.3.

24. Boston 99.518: *ABV* 198; *Beazley Addenda*[2] 53; K. Schefold, *Gods and Heroes in Late Archaic Greek Art*, trans. A. Griffiths (Cambridge 1992) 296, fig. 354.

25. See the particularly good treatment of all the images on a vase by F. Lissarrague, "*Epiktetos egraphsen*: The Writing on the Cup," in *Art and Text in Ancient Greek Culture*, ed. S. Goldhill and R. Osborne (Cambridge 1994) 12–27. Perhaps the best in-

stance of such interpretive vase-painting is the death of Priam. See O. Touchefeu, "Lectures des images mythologiques: Un Example d'images sans texte: La mort d'Astyanax," in *Images et céramique grecque. Actes du colloque de Rouen, 25–26 novembre 1982* (Rouen 1983) 21–28; W. Childs in *Greek Vases in the J. Paul Getty Museum* 5 (1991) 34–36.

26. See below, p. 73.

27. Also observed by I. Raab, *Zu den Darstellungen des Parisurteils in der griechischen Kunst* (Bern 1972) 92–94; and W. Raeck, "Zur Erzählweise archaischer und klassischer Mythenbilder," *JdI* 99 (1984) 20–24.

28. Vases or objects with multiple scenes have consistently defied full analysis, as H. A. Shapiro, "Old and New Heroes: Narrative, Composition, and Subject in Attic Black-Figure," *Classical Antiquity* 9 (1990) 139, points out with reference to the François Vase and the Chest of Kypselos. On the former see most recently A. Stewart, "Stesichoros and the François Vase," in *Ancient Greek Art and Iconography*, ed. W. G. Moon (Madison [WI] 1983) 53–74; and H. Hoffmann, "Notizien zur Françoisvase (Versuch einer historischen Situierung für die Museumsdidaktik," in *Images et société en Grèce ancienne: Actes du colloque international, 8–11 février 1984*, ed. C. Bérard, C. Bron, A. Pomari (Lausanne 1987) 27–32. When Shapiro speaks of the "randomness" of the various images on these objects, it simply means we have not yet found the key to their interpretation.

29. A. Schnapp, "Why Did the Greek Need Images?" in *Proceedings of the 3rd Symposium on Ancient Greek and Related Pottery, Copenhagen, August 31–September 4, 1987*, ed. J. Christiansen and T. Melander (Copenhagen 1988) 568–74. See also J. Bažant, *Studies on the Use and Decoration of Athenian Vases* (Prague 1981: Rozpravy Československè Akedemie Věd, Ročník 91, Sešit 3).

30. H. Hoffmann, "*Dulce et decorum est pro patria mori*: The Image of Heroic Immortality on Athenian Painted Vases," in *Art and Text in Ancient Greek Culture* (above, n. 25) 28–51.

31. The manipulation and even invention of myths to refer to political events or to serve as propaganda is obviously not excluded by these observations. See J. Boardman, "Images and Politics in Sixth-Century Athens," in *Ancient Greek and Related Pottery, Proceedings of the International Symposium in Amsterdam 1984*, ed. H. A. G. Brijder (Amsterdam 1984) 239–47; D. Castriota, *Myth, Ethos, and Actuality: Official Art in Fifth-Century B.C. Athens* (Madison [WI] 1992).

32. H. A. Groenewegen-Frankfort, *Arrest and Movement: Space and Time in the Art of the Ancient Near East* ([1951] Cambridge 1987) 28ff.

33. See below, p. 64 n. 53.

34. J.-P. Vernant, "From the 'Presentification' of the Invisible to the Institution of Appearance," in *Mortals and Immortals*, ed. and trans. F. Zeitlin (Princeton 1991) 162–63; C. Sourvinou-Inwood, *"Reading" Greek Death to the End of the Classical Period* (Oxford 1995) 140–294. It should be noted that the image is not that of the deceased so much as one of the self-presentation of the deceased, an important distinction.

35. J. Svenbro, *Phrasikleia: An Anthropology of Reading in Ancient Greece*, trans. J. Lloyd (Ithaca [NY] 1993), especially chap. 3.

36. Raab, *Parisurteil* (above, n. 27) 97–98; Raeck, *JdI* 99 (1984) 7–8.

37. G.M.A. Hanfmann, "Narration in Greek Art," *AJA* 61 (1957) 74–75; Gombrich, *Art and Illusion*[2], 129.

38. Telling in this regard is a brief exposition in a footnote; see below, p. 130 n. 7.

Here Himmelmann observes that the appearance of the beardless Apollo in the Late Archaic period does *not* represent a new belief about the character of the god, but a new imagery that dictates what visual characteristics are attributed to the god. This observation runs counter, as he himself notes, to the prevalent view that the belief in the nature of the gods changed through time.

39. See below, p. 106.

40. See below, p. 110.

41. See below, pp. 120ff.

42. See below, p. 146.

43. See below, p. 76; Raeck, *JdI* 99 (1984) 22–23.

44. Gombrich, *Art and Illusion*², 130–33.

45. W. Morris, *Time Pieces: Photography, Writing, and Memory* (New York 1989) 4–6.

46. W. Childs, "Platon, les images et l'art grec du IVᵉ siècle avant J.-C.," *RA* (1994) 33–56.

47. N. Negroponte, *being digital* (New York 1995) 60.

48. J. Clair, *Marcel Duchamp* (Paris 1977) pl. 14.

49. F. Frontisi-Ducroux, *Le dieu-masque: une figure du Dionysos d'Athènes* (Paris 1991) 10–11, on the face (*prosōpon*) and its importance as representative of the individual "inséparable de son contexte, celui d'une culture de l'extériorité, celui de la sociabilité grecque où le citoyen construit son identité dans la face à face."

50. See below, p. 163.

51. Himmelmann, *Ideale Nacktheit in der griechischen Kunst*, 14; see also Childs, *RA* 1994, 46–47.

52. *The Critic as Artist*, Part One, in *The Complete Works of Oscar Wilde* (London 1966; reprint 1989) 1015ff.

53. O. Wilde, "Lecture to Art Students," in *Art and Decoration: Being Extracts from Reviews and Miscellanies* (London 1920) 39–52; see generally J. Barzun, *The Use and Abuse of Art* (Princeton 1974) 49ff.

54. Childs, *RA* 1994, 33–56; C. Janaway, *Images of Excellence: Plato's Critique of the Arts* (Oxford 1995); on the issue of artistic personalities in Greek art, see O. Palagia and J. J. Pollitt, eds., *Personal Styles in Greek Sculpture*, YCS 30 (1996).

55. See below, pp. 193–94, 250. See also J. Bažant, *Studies on the Use and Decoration of Athenian Vases* (Prague 1981), for a more strictly sociological function.

56. See below, pp. 27–28, 57–58.

57. A. F. Stewart, *Greek Sculpture: An Exploration* (New Haven 1990) 176–79, 182–85.

58. See below, p. 222.

59. See below, pp. 225ff.

60. *A Philosophical Enquiry into the Origin of our Ideas of the Sublime and Beautiful* (1757), ed. J. T. Boulton (New York 1958; reprint Notre Dame [IN] 1968).

61. See below, pp. 247, 270ff.

62. N. Himmelmann, "Zur Entlohnung künstlerischer Tätigkeit in klassischen Bauinschriften," *JdI* 94 (1979) 127–42. He treats the subject more broadly in *Realistische Themen in der griechischen Kunst der archaischen und klassischen Zeit* (Berlin 1994) 23–48.

PARTI

GREEK ART

THE PLASTIC ARTS

IN HOMERIC SOCIETY

EPIC POETRY provides critical evidence on the contemporary plastic arts, though past and present, mythological and mortal are all mixed together. It is my aim here merely to describe the relationship and not to draw detailed comparisons between poetry and the monuments. My study is limited to the epic poems themselves and their explicit statements about art, which demonstrate clearly that a complete picture cannot be derived from such an inquiry. There are material gaps,[1] and only a few but important passages go beyond the functional significance of the art object (for example the shield of Achilles or the brooch of Odysseus). In accordance with the requirements and objectives of heroic epic, the social meaning of the plastic arts is paramount.

The conclusiveness of this conceptual pattern in epic poetry ought to indicate a historical phase and a concomitant group of preserved monuments. The general and traditional validity of this interpretation, however, forbids narrow limits. The Late Geometric and Early Archaic phases of Greek art appear most closely related to Homeric poetry. Yet essentially the same societal structures, which persist long into the Archaic period, are also evident in the earlier Geometric period.

The characteristics that epic attributes to works of art are indeed present in the preserved monuments. Sometimes they are so obvious that they hardly

"Über bildende Kunst in der homerischen Gesellschaft," *AbhMainz*, (1969) no. 7, 177–223, trans. William Childs.

need to be mentioned. A more rigorous attempt to describe the "artistic qualities" of art objects, however, raises serious methodological problems,[2] discussed further below.

The Plastic Arts in Homeric Society

After a long period directed primarily to the study of the style of Greek art, scholarly interest is now investigating the concrete historical function of Greek art, that is, its social context above all. The basic elements of the issue were already set down by the founder of modern archaeology, J. J. Winckelmann:

> The superiority which art acquired among the Greeks is to be ascribed partly to the influence of the climate, partly to their constitution and government and the habits of thinking which originated therefrom, and, in an equal degree also, to respect for the artist, and the use and application of art.[3]

This statement, the cultural background of which cannot be treated here, contains all the key words important to a "sociological" study[4] with the exception of *economics*. The sketchy deliberations that follow in Winckelmann's inquiry are, despite fruitful considerations such as the meaning of artists' signatures, so idealistically oriented that they contribute little to a further definition of the problem. In the following years the idealistic interpretation of art elevated Greek art to the point of exemplifying the timeless concept of the classical.

Around 1830 K. O. Müller defined art as a "representation, that is, an activity through which an inner, spiritual quality is made manifest. The only purpose of art is to represent and in doing so it differentiates itself from all practical activities that have a particular function in daily life in that it fulfills itself in this purpose."[5] This is already the modern concept of art in its purest form: art is by nature both subjective and idealistic. Consequently it is primarily a representation of spiritual and inner qualities; that is, it is above all a message, expression, and revelation of the self. On the basis of this definition, there is no path to the concept of art in early Greek society.[6] K. O. Müller himself realized this and stated that his definition did not apply to early Greek art:

> Rather, in this whole period, the plastic arts concerned themselves partly with decorating utensils (δαιδάλλειν) and partly with making cult idols, in which activities it is not the artist's purpose to represent in concrete forms his imagined conception of divinity, but rather only to make a figure of conventional form.

Thus the plastic arts remained for some time set on the accomplishment of external purposes, subject to the requirements of simple craft. The real spirit of the plastic arts is only present in germ.[7]

The many and varied characteristics of the art theories of nineteenth-century archaeologists cannot be treated here in detail. Suffice it to note they maintained an idealistic bent.[8] Historical positivism had, of course, its proponents in archaeological circles, such as O. Jahn, H. Blümner, A. Furtwängler, and G. Loeschcke, but even among these scholars the actual concept of art remained in the classical tradition.[9]

The most significant stimulus to the development of thought on these issues in archaeology, even though only from a special point of view, came from an outsider to the field, the politically engaged historian, Jacob Burckhardt. In a popular lecture of the year 1883, he pointed to the profound contradiction in Greek culture between the positive evaluation of the art object and the low public opinion of the artist.[10] He cited unambiguous evidence for the low appreciation of artists as *banausoi*, such as Plutarch, and stressed that the relatively late sources he cited only reflected the attitude of the Classical period. He could, in fact, have easily demonstrated his claim with passages from authors such as Herodotos, Sophokles, Xenophon, and Aristotle. Following Burckhardt's presentation of the evidence, a surprising twist returns directly to the traditional concept of art.[11] According to Burckhardt the low status of sculptors was actually lucky for their art,[12] because it allowed sculpture to pursue its ideal goals behind a kind of screen against the social and political crises and the destructive analyses of the sophists. Expressions such as "inner drive" and "inner luck" betray a link to the ideal concept of art, and the oxymoron "elevated *banausoi*" puts the Greek artists in a romantically subdued twilight. The fascination implicit in this unreal picture is still clearly evident in the work of B. Schweitzer, the archaeologist who first took up the issue again in the early 1920s.[13]

The deep chasm Burckhardt believed he detected in the sources is still not bridged over. On the one hand, there is evidence in early Greek culture of a specific "artistic" quality suggesting a definable human sphere of activity.[14] This is already fully the case in the world of epic. Mythical figures such as Hephaistos, Prometheus, Daidalos, and Epeios are prototypes of artists with their light and dark sides and prefigure all the essential characteristics of historical artistic personalities of the later periods. This is also true of the religious bond of the craftsman to Athena and Hephaistos, a genuine parallel to the poet's rapport with the Muses. The artist's consciousness is attested by signatures and more extensive inscriptions. Even in the social context, factors

promote the development of artistic qualities. The epic poems are full of admiration for costly and well-crafted objects, an admiration that, with limitations, extends to the craftsman himself. Even the heroes do not consider skilled craftsmanship beneath their honor; to the contrary, they carry on such work without prejudice and are proud of it. The specialist craftsman is often called in from afar, and the designation *dēmiourgos*, which links architect, singer, doctor, seer, and herald, is clearly favorable. The conditions the epic poems depict must correspond to historical realities. This is clear not only from the artistic activity of the Archaic period itself, but also from the fame of individual artists, whose names are preserved even in the latest sources. After the middle of the sixth century B.C., the evidence increases and, at least in Athens, suggests that the financial and social position of craftsmen was improving. Important artists of the Archaic and Classical periods such as Antenor and Pheidias were citizens, and so was the vase-painter Euthymides, while Agorakritos was a respected metic.

This evidence of a favorable position of the artists contrasts with a series of negative indications, which clearly deny the existence of an emancipated body of artists.[15] This is true equally for the type of person as well as his social status. The mythical "artist" has a marked physical or personality flaw, which alienates him from heroic society. The clearly stated disdain among citizens in the fifth century B.C. for all craftsmanship (and thus for the majority of the arts) must certainly be valid for earlier periods. This is evident above all in early representations of artists which depict them with markedly banausic traits.[16] In some regions manual labor by the ruling classes was forbidden by law, and consequently the developed art of Archaic Sparta must be ascribed exclusively to *perioikoi*.[17] In Athens slaves, who were generally excluded from military service, could practice crafts together with free laborers without discrimination. But even in the Late Classical period, the distinction between "mere" craft and "art" was not made, even though the difference between Pheidias and a coroplast was noticed.[18] Similarly, even though one paid collector's prices for the works of Parrhasios and Praxiteles, there was no general emancipation of the artists within society. The pseudo-Platonic dialogue *Alcibiades* mentions sculptor and cobbler in one breath, and in numerous building inscriptions there is no indication that the actual creative and spiritual achievement of artists had a cash value. The fact that among vase-painters the occupation was not viewed as a "profession" is suggested by the startling decline in drawing ability among older painters and the fact that first-class artists such as Euthymides and Euphronios gave up their work as soon as they were financially able to.[19]

The contradictory nature of the evidence cannot be affected by shifting the

emphasis nor by chronological arguments that assign the "negative" evaluation of artists to the Classical period only. Nor is contradiction rooted in the tenets of an idealistic philosophy that might have opposed a bourgeois point of view.[20] When Xenophon remarks that it is self-evident that the crafts are slavish (ἀνδραποδώδεις), he speaks for the general Greek tradition documented by Herodotos and Sophokles.[21] His is not a significant hardening of the position as is indicated by the "slavelike" characteristics attributed to artists in the crafts pictured in the Archaic and Early Classical periods. The issue cannot be confined exclusively to the field of social theory and its assertions but arises also from practical considerations of life itself. This is obvious in any attempt to describe the artistic quality of a preserved monument, to distinguish the craft from the art. In what characteristics do we discover the "originality" of the sculptor of an Archaic kouros? Can we really call the vases by the Affecter Painter spiritual creations, as Buschor does?[22] Other than for the purposes of classification, is there an art-historical value in speaking of an "oeuvre" of a vase-painter like Oltos, for example; that is, are we dealing with a purposeful, developed artistic achievement? Everyone experiences the difficulty here of characterizing the "artistic quality" not because it is not there or because it can be reduced to "mere" craft, but because an ancient vase has its own qualities that, from the modern point of view, are not a priori understandable. We arrive here at an aspect of "the artistic" that to be sure entails formal achievement, style, and "quality" but is hardly limited to these elements. Neither creativity, nor originality, nor skill, nor inventiveness are criteria by which to judge the Archaic artist, for the most accomplished master would appear unremarkable in these terms, even though the self-consciousness of their inscriptions appears to point in precisely the other direction.

We may surmise that the aspect of the Archaic and Classical concept of art that escapes formal analysis is based rather in the social function of "art" and "artist" in early Greek culture. The task of substantiating such a claim is particularly limited by the paucity of external and literary evidence.

Historical accounts are lacking or are so isolated that they cannot be used to create a coherent picture. Our knowledge is faulty in two areas that are basic to our understanding: the physical conditions under which the crafts were practiced, and the political and legal position of the craftsman in society. Even in the fifth century B.C., there are few references to the ownership of tools and raw materials, to the time required for work, or to remuneration for it (μισθός). Neither, apparently, is there precise information on the cost of living (βίος). The political status of professional craftsmen differs from polis to polis: in Athens and Corinth it was completely different from the situation in Sparta and Thebes, where the practice of a craft was forbidden to full citizens. The

relatively complete information we have on the financially based social struc-
ture of Archaic Athens does not, however, clarify the position of the craftsman
there.[23]

Even poetry and the archaeological record, the two fullest bodies of evi-
dence we have, are in many respects limited in scope. In the epic poems we
must not only translate the mythical stories into daily life but also evaluate
their prejudices or ideological character. Composed completely from the per-
spective of the ruling aristocratic society, the poems depict social relations as
harmonious and unproblematical. Yet this picture is not totally one-sided, and
in lyric poetry of the seventh and sixth centuries B.C. we are transported into
bitter social upheavals, in which the professional craftsman plays nonetheless
only a small role. Archaeology reveals a similarly limited concern. It is an ex-
traordinary fact that in the many thousand black-figure vase-paintings pre-
served from this period there is no reference to the exhausting and bloody
social strife that occurred throughout the seventh and sixth centuries. The
subject matter of painted vases is almost limited to the aristocratic worldview,
that is, heroic myth and heroized themes of daily life. The ideological limita-
tion is here complete and depends on the unified "pictorial" character of the
material in contrast to the discursive nature of poetry. For a long time depic-
tion of the life of craftsmen is confined to personal votives and even during the
democratization of society does not approach the importance of aristocratic
subjects. Social polemic is nowhere to be found.

The archaeological evidence is limited and one-sided in the pictorial tradi-
tion, exactly where one might have hoped to discover valuable insight. This
does not render the material useless, though, because the circumscribed
subject matter is itself an important historical phenomenon. Moreover, if
approached cautiously, some antiquarian details can be found to illustrate
contemporary cultural developments, such as the introduction of the hoplite
phalanx, though even here the evidence is ambiguous at best.[24] The narrow
scope of such deductions is emphasized by the numerous black-figure repre-
sentations of battle chariots and armored cavalry with mounted squires, all of
which clearly have no relationship to contemporary military practice and can
only be understood as the expression of an ideal Homeric world.

The evidence the monuments provide for their artistic quality, totally apart
from what they depict, is difficult to grasp. The treatises of B. Schweitzer and
H. Philipp (above, nn. 13, 14) characteristically make little or no use of the
monuments themselves. The practice recently reattempted by A. Hauser to
derive stylistic structures directly from social ones leads only to a fictitious so-
lution, since the methodology is open to serious criticism.[25] The present study

cannot claim to resolve these problems but merely to create a conceptual structure in which the monuments can be better understood.

A way to approach this problem relates to the concept of "art," and to the pointed observation of, for example, Buschor that "art has not always been 'art.'"[26] Consequently we must search for what makes art in a given period "art." What are the essential characteristics that constitute the concept "art" even when there is no contemporary formulation of it? The claims of a society on the art object are always more functional than formal, but the formal qualities themselves then have a functional role.

If we examine the epic poems from this point of view, we discover that Homeric language does not have terms for categories of either plastic art or artists but only words that generally signify concepts more or less similar to our own. This is not coincidental but reflects a real situation, since not even a word for "craftsman" occurs—nor even, by way of contrast, one for "farmer."[27] The only name of a category that subsumes the craftsman and artist describes interestingly neither a technical nor an economic concept but is a sociological term, dēmiourgos, which includes doctor, seer, singer, and herald. The word τέχνη designates only a special skill, while σοφία is the ability that guides the τέχνη and is not the same as our concept of art. Accordingly the question of the meaning of *art* and *artist* cannot be posed so precisely but must be rephrased in terms of the Homeric equivalents. This caution is justified, since the pertinent passages reveal that the significant characteristics attached to a modern definition of art are lacking or have a different meaning. Because the distinction of classes of works of art did not yet exist as it would later,[28] the sequence in which the relevant monuments are analyzed is unimportant.

Cult buildings (νηοί) are known to the epic poems in Troy (*Iliad* 6.88), Athens (2.549), Delphi (9.404; *Od.* 8.80), and Khryse (*Iliad* 1.39). The poet nowhere describes them coherently. Only occasionally does one learn that the building is on the acropolis (*Iliad* 6.88; 6.297), that the door is opened with a key (6.89, 298), and that there is a large space inside (μέγα ἄδυτον: 5.448) and a stone threshold (9.404; *Od.* 8.80). In general the temple is only mentioned when the action requires it, and thus appears primarily in terms of its function. In the first place it serves the cult and is "sacred" (ἱερὸς δόμος: *Iliad* 6.89).[29] The divinity receives votives there (δῶρα, ἀγάλματα); the sacrifice of animals can apparently also take place in the temple (6.93). Hektor hangs shields taken from the enemy on the Temple of Apollo (7.83).[30] The frequent epithet πίων designates the wealth of votive gifts (the phrase πίονα νηὸν τεύξομεν in *Od.* 12.346–47 does not need to refer to the building itself, since ἀγάλματα πολλά occurs in the same sentence). Even though the temple is

separated from the profane world and is richly decorated, it is characterized neither as architecture nor as an object of aesthetic appreciation. In *Iliad* 1.39 it is uncertain whether χαρίεις refers to the expression of piety or to aesthetic pleasure. Even in the latter case, a specific aesthetic effect could only be intended indirectly.

The city of the Phaiakians is a wonder to behold (θαῦμα ἰδέσθαι), a colonial foundation with harbor, marketplace, houses, temples, and fortification wall, the whole apparently laid out by the *ktistēs*, Nausithoös (*Od.* 6.9; 7.43).

The poet is more generous with distinctive details of palaces even to the extent of occasionally giving brief descriptions. In *Odyssey* 10.211, the house of Kirke is built of smoothed stones and lies in a conspicuous spot (περισκέπτῳ ἐνὶ χώρῳ). The palace (δόμος) of Priam in *Iliad* 6.243 is built with polished halls (ξεστῆς αἰθούσῃσι τετυγμένος), and in it are fifty θάλαμοι for his sons; across the court are a further twelve rooms for his daughters. Hephaistos built a bedchamber for Hera with a secret lock (*Iliad* 14.166). In the palaces of Menelaos (*Od.* 4.43 and 71) and of Alkinoös (*Od.* 7.81), there are inlays of ivory and κύανος as well as thresholds, walls, and doors covered in bronze, gold, and silver. The builder, for whom there is no specific word, needed "art." Hephaistos built the house of Zeus with skillful mind (ἰδυίῃσι πραπίδεσσιν: *Iliad* 20.12), the same expression used in the *Odyssey* 7.92, to describe Hephaistos's artful making of the gold and silver dogs at the gates of Alkinoös's palace. Paris, who according to *Iliad* 6.314, built his own house, did so "with men who were the best *tektones* in fertile Troy."[31] In the *Odyssey* the wondrous reaction of the viewer of these magnificent palaces also finds a place in the narrator's repertory: the palace of Alkinoös shines like the sun or moon (7.84; see also 4.45); the splendid rooms of Menelaos's palace echo (δώματα ἠχήεντα: 4.72); the viewers are amazed (θαύμαζον: 4.44); they comment to each other on the splendor (φράζεο: 4.71); they are overcome with reverential awe (σέβας: 4.75); Odysseus's heart is stirred (κῆρ ὥρμαινε: 7.82–83). In the *Iliad* 6.242 an "aesthetic" epithet is used (δόμος περικαλλής: "exceedingly beautiful"); in the *Odyssey* 7.82 fame is attached to the palace (δώματα κλυτά).

In the case of skillfully made utensils such as furniture, weapons, etc., consideration of their "artistic" character is clearer and more frequent. Even so the descriptions limit themselves to distinctive details of material, workmanship, or use. A chair is turned on the lathe, inlaid with silver and ivory, and studded with silver nails (*Od.* 19.55). A bed is drilled, smoothed, decorated with inlay, and fitted with purple leather straps (*Od.* 23.189ff.). Hephaistos attaches handles and wheels to automotive tripods (*Iliad* 18.373–77). A silver krater is made by Sidonian craftsmen and carried across the sea by Phoenician

traders (*Iliad* 23.740). The breastplate of Agamemnon is made of gold, tin, and κύανος; on it snakes writhe up toward the neck (*Iliad* 11.24–28).

The outstanding qualities of objects are the value and effect of the material of which they are made, while their form is hardly mentioned except as part of the description of the manufacturing process. This may be a feature of the narrative style, yet the chosen elements constitute a "concept of art." It is certainly informative of a society that it prizes table-dogs as a sign of splendor (ἀγλαΐης ἕνεκεν: *Od.* 17.309), values tables and bathtubs made of silver (*Od.* 4.128; 10.354); kyanos-footed tables (τράπεζα κυανόπεζα: *Iliad* 11.629), buys Phoenician baubles (ἀθύρματα: *Od.* 15.416), and men wear gold ornaments in their hair (*Iliad* 2.872; 17.52). Next to the material splendor and just as important is the quality of skilled workmanship, which appears mostly in words made up from δαιδάλλω, of which the telling name of the artist Daidalos is an obvious example. The process of making is described by a whole series of rather general terms (ποιέω, κάμνω, τεύχω, πονέομαι, δαιδάλλω, ἀσκέω, ἐργάζομαι, ποικίλλω, τεκταίνομαι, ἀθλέω, τεχνησάμενος, ἀνδρόκμητος), while others are more technical and related to a specific material (ξέω, χαλκεύω, περιχεύομαι, etc.). For the meaning of χαλκεύω, see especially *Iliad* 18.400: χάλκευον δαίδαλα πολλά, πόρπας τε γναμπτάς θ' ἕλικας κάλυκάς τε καὶ ὅρμους (he forged many wondrous things: brooches and supple coils, flower ornaments, and necklaces).

Insight into and understanding of art play an important role in numerous passages: The woodcutter is better by far in knowing than in strength (μήτι τοι δρυτόμος μέγ' ἀμείνων ἠὲ βίηφιν: *Iliad* 23.315); one knows how to do something (χερσὶν ἐπίστατο δαίδαλα πάντα τεύχειν: *Iliad* 5.60; ἐπιστάμενος: *Od.* 5.245); δαήμων (*Iliad* 23.671), to which one should compare the phrase κεδνὰ ἔργα ἰδυῖαι (valued [= careful-skilled] works). This artistic ability, which for example a skilled gilder possesses and has learned from Hephaistos and Athena, is the τέχνη (τέχνη παντοίη: *Od.* 6.234; see also 11.613). The word obviously does not have the range of meaning of "art"; it describes manual skill and ingenuity, for which reason it also can be used in a transferred meaning, indicating ability in the sense of craftiness.[32] The word only appears once in the *Iliad* (3.61) and is applied to a man who hacks a ship-beam from a tree trunk with an adze. In *Iliad* 15.411 the same task, in this case carried out by an experienced carpenter (τέκτων), is guided by σοφία (πάσης εὖ εἰδῇ σοφίης ὑποθημοσύνῃσιν Ἀθήνης). This σοφία is more inclusive than τέχνη, at least to judge from later usage, since the word occurs nowhere else in the *Iliad* and the *Odyssey*.[33] To be specific, it implies a broader insight and mastery but still has no specific implication of artistry, so one cannot distinguish σοφία from

τέχνη in terms of "art" and "craft"—an additional indication that such a distinction did not exist in the social sphere.

We would require a long study to review the extensive vocabulary used to describe "artistic" qualities of objects as well as their value and effect. In fact, one can hardly ever distinguish between the "artistic" and the material value, as the context of such ideas reveals. The word καλός and its derivatives refer to both aesthetic and material qualities.[34] Epithets that describe "brilliance" are used in the same manner (φαεινός, ἀστὴρ ὥς, ἡέλιος ὥς, χάρις ἀπελάμπετο). The word ποικίλος also has a material quality that at the same time indicates an artistically complicated work and is thus related to δαίδαλον: Iliad 18.590. The idea of material value lies behind the word ἄγαλμα, the "valuable treasure," which can be used for jewelry (Od. 19.257), for votive gifts in general, for sacrificial animals, and even for horses (including the wooden horse: Od. 8.509). The connection with the verb ἀγάλλομαι makes ἄγαλμα really mean something like "showpiece," an object of prestige to the owner.[35] This aspect of the showpiece is clearest at Iliad 4.141, where an ivory cheek decoration for horses (παρήιον ἵππων) is mentioned, which a Maionian or Karian woman had dyed, and the valued possession is kept in the θάλαμος (143–45):

> though many horsemen pray to put it on; but it lies there as a king's delight, both an ornament for the horse and a glory to the driver.[36]

Clearer and more complete answers to the question of the concept of art in the epic poems can be gleaned from those passages in which figural monuments are mentioned. Indeed, these provide some additional information, though not as much as one might expect.

In various episodes of the Iliad, one learns that the poet knows of cult statues and images of the gods in general. In Book 6 it seems likely, though hardly certain, that when the Trojan women dedicate a peplos, it is for a three-dimensional figure of Athena in the temple. If this is in fact the case, it is noteworthy that nothing in the text actually indicates a statue; rather, there is no difference drawn between the goddess and her image. When Theano opens the door of the temple, suggesting the real place in which the action unfolds, the text says simply, "she then laid the peplos on the knees of fair-haired Athena": Ἀθηναίης ἐπὶ γούνασιν ἠϋκόμοιο (6.303).

If we leave aside the wooden horse and the magical image of Aeneas made by Apollo as a mirage in Book 5, the epic poems mention several three-dimensional figures made by the hand of Hephaistos. These also have magical characteristics that are, however, not so much fantastic but reappear in modi-

fied form in other images, for which reason they are discussed here. One example is the extraordinary golden girls (ἀμφίπολοι: *Iliad* 18.417) who are like living beings, since they possess reason and voices and aid the limping Hephaistos to get about. This living quality is shared with the gold and silver dogs that guard the palace of Alkinoös in *Odyssey* 7.91, and probably as well the torch-bearing golden youths who stand on plinths (ἐπὶ βωμῶν) to light the dining table (7.100).

None of these figures is intended simply to be looked at. The cult statue of Athena, certainly correctly identified as such, is, despite the narrative matrix, in an extraordinary way identified with the divinity herself and therefore functions like a living recipient of the votive gift. The same living quality is attributed to the other figures, though there is no identification of them with living people. Rather, they function as utensils and represent the acme of artistic skill.[37]

With the consideration of functional objects, we return to two-dimensional images. In this area, ornament is the primary subject: δαίδαλα in the veil of Hera (*Iliad* 14.179), flowers (θρόνα ποικίλα) in the dress of Andromache (22.441), vegetal patterns on metal ware (23.885), the modeled doves around Nestor's cup (11.634), snakes of κύανος on the breastplate of Agamemnon (11.26). Helen weaves battle groups of Trojans and Achaeans into a dress (3.125), and battles and fighting animals decorate Herakles' baldric (*Od.* 11.609).[38] The last two examples of figural decoration are also decoration of utensils: the animals fighting on the brooch of Odysseus (*Od.* 19.226; an ἄγαλμα according to line 257), and the great depiction of the human condition on the shield that Hephaistos makes for Achilles (*Iliad* 18.468ff.). The animal group on the brooch is called δαίδαλον in line 227 and should not be interpreted differently from the similar decoration of Herakles' baldric. But here the description plays a particular role in the narrative, since the brooch identifies Odysseus. Consequently the narrator lingers in his description, which is particularly complete. On the brooch a dog has seized with his forepaws a dappled fawn that struggles: "all wondered at it, how though they were of gold, the dog seizes the fawn and strangles it, but it trying to flee was struggling with its feet" (229–31).[39] The living quality of the representation appears here again, though in a less fantastic manner and yet is not at all naïve (χρύσεοι ὄντες is interjected adversatively). Here the requirement of naturalness and lifelikeness, which appeared to be magical in the figures made by Hephaistos, is shown to be a requirement of art itself.

Finally, there remains to be discussed the greatest pictorial scene in the epic poems, the ca. 130 lines beginning at *Iliad* 18.468 which describe the decoration of another utensil, the shield of Achilles. The passage is particularly

outstanding because of both its position in the narrative and its composition: it prepares for the return of Achilles to battle and, in terms of its dense series of images and its rare and beautiful words, is itself an *agalma*. The shield is made by Hephaistos and for this reason alone it is extraordinary. Hephaistos makes the pictures on the shield with cunning skill (ἰδυίῃσι πραπίδεσσιν), and they are called δαίδαλα, a word that emphasizes the importance of their appearance. Earth, sky, and sea; sun, moon, and stars serve as a cosmic frame, enclosing the human world, which is represented by antithetical pictures of peace and war. In the city at peace, there are again two opposed images: marriage and a court action. The other city is at war, besieged by two armies. The besieged send the women, children, and old people to guard the wall, while the rest of the inhabitants prepare an ambush, led by Ares and Pallas Athena. The two gods are made of gold and easily recognizable, that is, they are bigger than the other figures: καλὼ καὶ μεγάλω σὺν τεύχεσιν, ὥς τε θεώ περ ἀμφὶς ἀριζήλω. From the ambush develops a battle in which Eris, Kydoimos, and ruinous Kēr participate and fight like mortals (ὡμίλευν δ᾽ ὥς τε ζωοὶ βροτοὶ ἠδὲ μάχοντο). The phrase can mean either that they fight in the manner of mortals or that, though only images, they appear alive.

The world of humans also includes life on the land from which three aspects are chosen for description. These are like pictures of the seasons: plowing of a fallow field, harvesting grain, and work in a vineyard. The first picture strikes the viewer with the naturalness of the representation. The earth (ἄρουρα) is described thus (548–49):

> It turned black behind, and seemed plowed
> though being of gold. He wrought indeed a great wonder.[40]

The harvesting scene also has antithetical elements: the work of the ἔριθοι in the grain and the preparation of the meal by the servants of the king, the κήρυκες. The slaughtering of cattle, always a ritual event in the Greek mind, is the only indirect reference to cultic activity on the shield, since the connection of the words *marriage* and *revellers* (γάμοι, εἰλαπίναι) at line 491 in the description of the marriage shows that no religious significance is intended.[41] In the scene of the vineyard, the vintage is accompanied by the phorminx and dance. The amazement of the viewer is partially directed at the materials used for the representations: gold, silver, κύανος, and tin, from which a fully natural picture is achieved.

The next scene depicts a herd of cattle with golden cattleherds and cows of gold and tin. A bull is attacked by lions. A herd of sheep is then sketchily presented, and finally the last scene is a great dance with youths and maidens, a

phorminx player, two acrobats, and a large audience. Here we encounter a fine naturalistic touch, used as a special characteristic in the epic poems in the same way as it is in Geometric art (lines 595–96): they were dressed in fine gowns, which glistened faintly with oil (οἳ δὲ χιτῶνας εἵατ᾿ ἐυννήτους, ἦκα στίλβοντας ἐλαίῳ). It is noteworthy that the poet recalls another work of art as a parallel for the dance scene, the χορός that Daidalos had made for Ariadne in Knossos.

The only reference to craft in the description of the shield is at line 600, where the circular motion of the dance is compared to the potter's wheel that the κεραμεύς tests by running it through his hands. It is of course questionable whether one may make deductions from the absence of any given theme, yet one misses any reference to basic human activities such as shipping, divine cult, and the celebration of funerals. The exclusion of trade is sufficiently explained by heroic society's contempt for it (Od. 8.162ff.).

It may seem doubtful that the description of the shield is helpful in determining the characteristics of the plastic arts in Homeric society. As the product of a god, the scenes have in themselves something extraordinary. In addition, the narrative includes both visual and aural phenomena, even to the point of recounting the content of speeches and the feelings of people. The form of the description of the scenes may therefore seem an artificial device to present a basically poetic conception of the shield. That this is true at one level cannot be disputed. And yet can we claim that the fiction is really so artificial that the poet forgets it as soon as he has introduced it?

The making of the shield is, in fact, not just a vague allusion to a material frame within which poetic fantasy freely wanders. Not only are the preparations for the manufacture of the shield extensively reported, but also, when the poet has freed himself from the purported fiction of the material object and appears to be describing actual realities, he returns in his narrative quite unexpectedly back to the material qualities of the scenes. In the picture of the siege, the remark is interjected that Ares and Athena are made of gold and larger than the other figures. In the scene of plowing, the poet comments on the amazement at the deceptive coloring of the furrows though they were also made of gold. Gold, silver, tin, and κύανος are used in other scenes too. At the beginning of the description of each new scene, it is recalled that Hephaistos is making the object (ἐν δ᾿ ἐτίθει), and that he finally pulls the whole together by representing Okeanos around the outer rim. This movement back and forth between the technical process and untrammeled description of real life is at first glance foreign to the modern mind and might easily be taken for mere naïveté. The foreignness does not reside in the unreal aspect of the account, since we are dealing here with the work of a god in which the miraculous is

completely understandable and appropriate. At issue is rather an apparent stylistic dichotomy in the narrative technique which fuses in an unusual manner the technical manufacture and the depiction of scenes of real life. The modern viewer is accustomed to see in a work of art an objective world that can only be observed at a certain distance. We are therefore disconcerted when the poet departs from the framework of such presuppositions and repeatedly exceeds the possibilities of the plastic arts. If, however, we posit for the epic poems a point of view that neither perceives in a "work of art" an objective reality nor draws the boundary between art and reality with modern precision, then the description of a picture in terms of a lifelike reality no longer constitutes a dichotomy in the style. Consequently the criticism is untenable that the poet is caught in a contradiction between his narrative fiction and reality.

The issue cannot be resolved in a simple manner, because the modern viewer cannot easily disregard his own premises. If we approach the matter on another level, however, we can show that the problem really resides in the inappropriateness of our modern conceptual structure. Our inquiry is moreover hindered by the fact that the description of the shield is presented as a fiction, a proposition based in part on the superhuman character of Hephaistos. But it seems to me that the poet has pursued this fiction further than we have so far noticed and that his narrative can justifiably be used to discern the characteristics that Homeric society saw in a work of art.

The fictional character of the description of the shield is purposeful, both externally and internally. It was long ago demonstrated that both the motifs on the shield and its composition were inspired by contemporary objects. It seems likely that the shield was round, to judge by the placement of Okeanos on the ἄντυξ, and such shields occur on Geometric vases next to the cut-out, elliptical, so-called Dipylon shields. The rest of the scenes should be thought of as forming concentric circular bands; at least the author of the pseudo-Hesiodic *Shield of Herakles* is explicit on this point in his copy of the description of Achilles' shield. This is also the pattern that we find on contemporary objects such as the Phoenician bowls and early orientalizing shields.[42] On these, too, we find scenes of tree-studded mountains and city-sieges, while bands of warriors, battles, cattle with herds, lions attacking bulls, dances, musicians and acrobats, as well as a king with mantle and sceptre all occur on Geometric vases.[43] On the vases women can be identified holding branches or wreathes, and youths are shown wearing a sword. The poet specifically compares the dance to another, the χορός of Daidalos in Knossos.

The fictional character of the δαίδαλον has, however, colored the narrative technique. The figures are without names. The presence of Ares and Athena

at the city-siege detaches it from a specific myth and gives it a typological character. The individual scenes, juxtaposed in additive fashion, are symmetrical or at least contain, much like scenes on Geometric vases, a central motif (the trial, king at the harvest, musicians and dancers). It is particularly noteworthy that two armies besiege the city. This has a profound influence on the narrative form, as K. Reinhardt and H. Philipp have remarked.[44] Contrary to the pattern of mythological narration, the scenes do not develop in a continuous temporal line but show only a single state or the high point of an action to which there is no sequel. A temporal element might have been realized in the description of the city-siege, since the series of scenes could be understood as a sequence. But even here there are no continuous events, merely a group of typical scenes each with its own identity. Characteristic of the pattern is that the outcome of the final battle scene is not mentioned.

Since the time of Lessing, a criterion of the reality of the shield has been whether the unity of time is maintained in its scenes.[45] But even if there is no such unity, which seems likely on the basis of the trial and siege scenes alone, there could still be a connection with known patterns of early Greek art, which regularly combines widely separate temporal elements in a single picture.[46] For example, a Geometric funerary krater depicts in the same panel the prothesis in the house and the subsequent procession of carts (fig. 10, below). The painter combines the different temporal elements freely and pays no attention to the unity of place, arranging the carts on both sides of the klinē.

The poet has in many respects, therefore, consistently maintained the fiction of a pictorial representation. This is true also of the seamless transition from description to presentation of real life, which is not a dichotomy of style but arises out of the contemporary expectations of a "work of art." We have already seen a similar phenomenon in the animal group of the brooch of Odysseus, which had no miraculous character. In this case the artistic achievement consisted in the amazing way the figures, though of gold, nonetheless possessed the lifelikeness of real animals. We have already referred to a very similar passage in the description of Achilles' shield (18.548). Again amazement is expressed that the earth behind the plough takes on a darker color exactly as in reality, even though it is made of gold. Lifelikeness and naturalness are not merely miraculous traits of the pictures but are clearly part of the definition of an "artistic" representation.

That a picture, for Homeric society, did not present a circumscribed and objective representation of reality to be seen as though at a distance, which became true later, has astounded modern viewers. The reasonable deduction that it is merely a poetic technique to make the transition from description to an apparently real-life situation appears to some scholars to be an insufficient

explanation of the phenomenon. They claim that a certain "early" conscious structure informs the pattern. Thus H. Philipp proposes that the poet of the *Iliad* did not yet possess the ability to reflect on the distinction of a "merely" depicted action from that of a real one.[47] She suggests further that consciousness of such a distinction developed slowly and in part brought about the gradual recognition of an artistic element in craft.

Let me recall at this point an unusual statement of E. Buschor, which was not made about Homer, whom Buschor considered the pioneer of the Archaic period, but about Geometric sculpture.[48] On the one hand, he rejects out of hand that Geometric figurines appear so "lively"[49] because of magical conceptions. On the other hand, he also rejects "artistic" objectification. Rather, to Buschor a primitive plastic ability allows life as such to be recreated "without translation into the vocabulary of art." Accordingly we can posit that the artist had no particular artistic consciousness in the period, and the figurines were not thought of as works of art at all. The radical rejection of any artistic character in Geometric sculpture is an unusual suggestion that hardly stems from its appearance, and in the presence of the monuments it even seems to do them violence. The strongly "conventional" character of the pictorial elements[50] and the virtuosity evident in the extreme stylization of forms suggests to the contrary very conscious "artistic" pretensions. These appear to contradict the apparently spontaneous liveliness that Buschor describes so impressively and that is evident both in the preserved images and in the epic poems.[51] Buschor apparently thought of these phenomena only as the product of an artistically unreflective consciousness, and therefore he had to disregard the evident "artistic" traits.

Buschor did not believe that the epic poems agreed with this interpretation but that they contained "later" characteristics.

In fact, the attentive reader cannot but reject an unreflective equation of picture and reality in Homeric poetry. The relationship between these two domains is fully differentiated, many-layered, and completely conscious. This is particularly evident in the case of the δαίδαλον on the brooch of Odysseus: the narrative creates a tension precisely from the contrast of natural and "artistic" qualities, since it links the amazement at the lifelikeness of the group to the observation on the material of which it is made. The attraction lies chiefly in the fact that the greatest artistry strives to achieve the greatest naturalness. One cannot object that here the *Odyssey* bears witness to an advanced stage in the emancipation of artistic thought, since already in the description of Achilles' shield in the *Iliad* wonder is expressed at the earth (ἄρουρα) turning dark χρυσείη περ ἐοῦσα, which attests to the same differentiation as in the *Odyssey*. This is true also of the astonishing lifelikeness of Hephaistos's golden maid-

ens, who have reason and voices. Alone the remark that they resemble (εἰκυῖαι) living maidens and are of gold indicates that there is no simple equation of art and nature here. The lifelikeness of the images in no way proves, therefore, the existence of a pre-artistic consciousness that does not distinguish between reality and art. Quite to the contrary, lifelikeness is an eminently "artistic" trait and constitutes one of the most important premises of the Greek conception of art.[52]

The idea that the highest "art" confers the highest lifelikeness on images to the extent that they appear to pass the border into true reality or, in myth, actually do make the transition, plays an important role in subsequent commentaries. It is the origin of the old folk tradition of the running and seeing figures made by Daidalos as well as of the phrase "verily they live" (ναὶ ζῶν), which vase-painters sometimes inscribe next to their figures.[53] The poet of the Archaic, pseudo-Hesiodic *Shield of Herakles* tries to use the idea to the fullest effect. In sublimated form as τὸ ζωτικόν, the idea resurfaces in Xenophon's *Memorabilia* (3.10.6) when Sokrates asks a sculptor: "How do you produce in your statues that which is most alluring to the sight of men, to appear lifelike?"[54] The Hellenistic poet Herondas uses it as a folk motif in the conversation of two naïve women, who are astonished at the lifelikeness of a sculptural group of a young boy strangling a goose: "Ah! Sometime men will be able to put life into stone."[55] The idea is repeated ad nauseam in epigrams.

The pseudo-Hesiodic *Shield of Herakles* does show differences from Homer which point to a hardening of the way one sees.[56] The assertions that a representation is "lifelike" appear more forced, particularly because of their number. The loss of directness is reflected in the fact that the lifelike qualities are more frequently conveyed by calling on similarities, which are secondary to lifelikeness itself in Homer. Equally, Pseudo-Hesiod focuses more on things and qualities than on movement and actions as in Homer. Moreover, despite poetic freedom, the description is more closely tied to the prosaic reality of the object.

We can now attempt a summary of the preceding observations on the evidence of the epic poems relevant to the characteristics of the plastic arts. First, in Homer the art object does not exist by itself in an isolated world, it is not a microcosm. Rather, it is attached to various life-situations and always has a functional use. As a rule it is a utensil, which also applies to statues.

The selection of objects that the epic poems give as examples of the plastic arts is clearly not complete. Those objects made and "used" only for their figural value are almost totally missing in the poems. The figured votives so often found in early sanctuaries are cited nowhere.[57] The subjects of these votives range from pictures of property (horses, cattle, etc.) to heroic representations

of contemporary social ideals (knights, charioteers, lion hunters). These were attached in part to utensils, particularly to cauldrons, but were also dedicated independently. There is in any case no doubt that a primary function of such objects was to take the place of the real things they depicted. The related function of cult images, which must be supposed to have existed wherever νηοί are mentioned, is only indicated in one passage, the procession of the Trojan women to the Temple of Athena in Book 6 of the *Iliad*. The image is cited neither as statue nor as representation and certainly not as an art object, but only in its function as a replacement for the divinity, since it is identified with her. Representations of particular people are unknown in the epic poems and are not found in the archaeological record. The earliest monument for which such an interpretation is probable is a sub-Geometric grave stele in Paros which bears the engraved picture of a "king" enthroned.[58]

The whole field in which an art object functions as a replacement for what is depicted is as good as ignored by the epic poems. Therefore, poetry provides us no further criteria to judge art in early Greek culture, since it avoids dealing with probably the most important purpose of the plastic arts at the time, from which doubtless the concept "art" was largely derived. The silence of the poems allows us nevertheless some clarity on two points. The function of a representational image as standing in place of what is depicted, whether cult image, votive figure, or even a grave relief, belongs to the cultic sphere. The absence of such objects in the epic poems must be connected with the poems' known neglect of cultic topics; if they do appear, they are treated only in the light of proper behavior, in which the religious function is not primary. The silence surrounding the "art object" is therefore to be explained by the fact that the religious side of the object is more important than its other function. If, for example, bronze figures are meant to be included under the praised δῶρα, it is not because of the manner of representation but because of what is represented. In the case of the cult image, this conclusion leads to the realization that the statue as cult image, that is, as the representation of the divinity, disappears completely as a concept separate from the divinity herself and as such leaves no trace. It would, however, be wrong to posit a stronger drive toward artistic emancipation here, because the figure is not attached to a utensil. The isolated figure may in this respect take second place to the utensil as an object of art. Moreover, the equation of picture and object depicted should not be so strong as to exclude an "artistic" element. Perhaps there is some evidence to elucidate this aspect of the phenomenon.

Throughout the description of the shield of Achilles in *Iliad* 18.478ff., "artistic" qualities are strongly emphasized (δαιδάλλων, δαίδαλα, ἰδυίῃσι πραπίδεσσιν, θαῦμα). In the description of the χορός, which appears in the

last scene on the shield, the word ποίκιλλε is also to be interpreted in this sense; in addition, the "comparison" with another χορός brings in the name of Daidalos as its creator, which, with the verb ἤσκησεν (fashioned), intensifies the idea of "art." In this case the poem introduces a work solely on the basis of its being a "work of art" and ignores any other function it may have. Since the representation of round dances was a favorite subject of contemporary art, we cannot doubt the reality of the χορός in Knossos.[59] It must, of course, remain open whether it designates a work in relief or in-the-round. The context could suggest the former, but there is no reference to a utensil. In the second case one might imagine a votive of the type of the primitive Peloponnesian groups, which clearly derive from important prototypes, but there is also no indication of this in the text.[60]

Almost all of the objects to which the epic poems attribute explicitly artistic qualities are utensils in the broadest meaning of the word (furniture, weapons, clothes, etc.). The figural representation has within this functional framework primarily the purpose of decoration, as, for example, on the shield of Achilles. It is accordingly subsidiary to the utensil, and yet it also has its own independent world of existence and is no mere reflection of the utensil's function. In this polarity between functional utensil and representation lies a distinction that justifies the specific use of the term *art*, not just artistry in the sense of craftsmanship.[61] We encounter here a tension that remained valid for all later developments of Greek art. In this context it is important to recall the notably fluid and apparently free relationship between later representations on vases and buildings and their matrices. We perceive here one of the reasons that "art" became more emancipated from necessary social functions in Greek culture than in any of the other ancient Mediterranean cultures. The relative independence from the utensil, which imparts the decorative function, creates room for the "poetic" in contrast to the limitations of the symbolic. This poetic quality, constituting both a deepening and broadening of pictorial expression, is communicated by the preserved monuments just as much as by the scenes on the shield of Achilles.[62]

In the decorative function of a work coalesce two characteristics that constitute the value of a work of art in the eyes of Homeric society: the value of the material and the artistry or quality of the craftsmanship. Both together make the object a δαίδαλον (a piece of "art") and an ἄγαλμα (an object to take pride in). This aspect as an ἄγαλμα points to a second function of the work of art which is of an explicitly social nature: κῦδος, which designates the respect due to the owner. In *Iliad* 4.145 the close relationship of κόσμος[63] and κῦδος is formulaic.

We encounter here a remarkable aspect of the Homeric work of art that is

of great importance for our understanding of its meaning, namely its role as a *possession*. Accordingly we must inquire into the social function of possessions in Homeric society, since some particularities of the meaning and character of the work of art are determined by this role.

On the scale of values of the Homeric nobility, property and wealth came at the top, though these held a particular political and social meaning somewhat different from that in other plutocracies. Agamemnon takes undisputed precedence in rank over Achilles even though the latter was the son of a god and was superior both in stature and character, because Agamemnon commands a larger following, which means that he controlled more property (*Iliad* 1.281: ἀλλ᾿ ὅ γε φέρτερός ἐστιν, ἐπεὶ πλεόνεσσιν ἀνάσσει). A rich king like Menelaos can even contemplate bringing a poorer colleague such as Odysseus to live near him by conferring on him property in his own territory (*Od.* 4.174ff.). But property plays an enormous role for all levels of aristocratic society, not just for those at its pinnacle. Even a slave may own property (*Od.* 14.62, 450; 21.214) and with respect to property master and slave are in accord (Eumaios to Telemachos in *Od.* 17.594: σὸν καὶ ἐμὸν βίοτον). Numerous adjectives glorify property and owner: πολύκληροι, πολυβοῦται, πολύχρυσος, πολύχαλκος, πολύμηλος, ἄλοχος πολύδωρος, etc. The poet employs the most elevated epithets to glorify the rich (ὄλβιος, μάκαρ). In this context belongs the well-known fact that normally no conceptual difference separates "material" and "moral" values. A corresponding contrast occurs only in extraordinary circumstances such as the relationship between Agamemnon and Achilles cited above. When Agamemnon stands alone outside of the comparison, then the equation of values comes back into effect (*Iliad* 2.579 and particularly 3.167). As a rule wealth, social power, and ethical superiority form an indissoluble unity: ἀφνειός τ᾿ ἀγαθός τε (*Iliad* 13.664; 17.576).[64] The richest suitor gives the most presents, is the best man, and gets the bride (*Od.* 15.16). This attitude recalls the similar case of the evaluation of a work of art, in that the material value and art value are not distinguished.

Much of the epic poems is dedicated to the fame of wealth in all its manifestations (see especially *Iliad* 23.296). The full description of the property of Agamemnon, Menelaos, Odysseus (*Od.* 14.96: ζωὴ ἄσπετος), Priam (*Iliad* 24.543), and his sons delineates their respective roles. Even in the case of those individual warriors, introduced only to be struck down by the main heroes, mention of their wealth (or that of their fathers) marks the appropriate importance of their death as well as the prestige of the victor (*Iliad* 13.596; 6.14; 5.9; 13.661ff.). The heroes are constantly concerned about the acquisition of wealth through pillage (*Od.* 23.357; 14.86), gifts (14.284–86), prizes of competitions (*Iliad* 9.124), the ἔργα of their household and of themselves (ἔργον

in contrast to pillage in *Od.* 14.222), or worry about the management of their amassed property. They argue about booty or the distribution of substantial prizes of contests. When Telemachos breaks off his search for his father on Athena's command, he gives Menelaos as the reason that he fears that an object of value (κειμήλιον) might be lost from the treasury at home (*Od.* 15.91).

Wealth is above all not an economic but a political issue involving prestige, and this is its most important social function. Odysseus expresses this clearly when he remarks that if he returns home rich, he will be better loved and revered (φίλτερος, αἰδοιότερος: *Od.* 11.360). The degree to which this is essentially a political matter is shown above all by the honorific gift or γέρας, which the hero can expect from the people or his noble following. The dispute between Agamemnon and Achilles, which sets the stage for the course of the *Iliad*, arises over a γέρας, Briseis, who is a prize of war. The superiority of Agamemnon is demonstrated by the fact that he can claim this γέρας for himself, even though it had already been given to Achilles. The abstract concept of political precedence itself can be designated by the same word (*Od.* 7.150; 11.175).

Property has more of a social function than an economic one, which gives it an aristocratic character manifested in two further traits. Just as heroes are distinguished personally through a genealogy (*Iliad* 12.450; 14.113), so are their property or individual possessions. The previous owners of numerous objects such as gifts, booty, prizes, weapons, etc. are named, and just as for the heroes themselves, origins are occasionally traced all the way back to the divine sphere (Hephaistos in *Od.* 15.115 = 4.615; Dionysos in *Od.* 24.74). The second trait is the storing up of treasure. Material wealth is not normally put to work but is stored in the treasury, *thalamos*, trunk, and barrel (*Od.* 2.337; 21.9, 45).[65] Nothing is removed except to fill an immediate need. The *thalamos* of the rich man (*Iliad* 24.317–19) contains not only the supplies of food but also metal and clothes as well as all valuables, the γλήνεα or κειμήλια. The storage instead of the productive use of property is a particularly determining factor among the material premises of Greek art. Not only was the property of the individual stored in this manner but also that of the sanctuary and later that of the political community of the polis. The last two actually are one and the same, since government possessions were dedicated in sanctuaries. Still, in the Athens of Perikles, the stored part of the state possessions in the form of silver coin, votive offerings, and the gold of the Parthenos exceeded many times the yearly income of the state. The extraordinary number of more than 500 large bronze tripods in Olympia demonstrates that an enormous part of the material wealth of society in the Geometric period was stored up in this fashion. In addition, the dead receive a reflection of their treasury in the form of objects such as

axes, roasting skewers (obeloi), gilded caskets, etc., placed in the grave with them. The usual expression for "to bury," κτέρεα κτερείζω, means actually to give the deceased his belongings.[66] The storage of worked objects such as axes, roasting skewers, weapons, etc., that is, the private property of the individual (Od. 21.61 and 74) rather than raw materials, may have a practical reason. The massing of votive offerings in sanctuaries, however, must have a religious motive; the worked offerings belonging to the god are elevated to ἀγάλματα by the "art" of their manufacture. Even in the case of ephemera such as sacrificial animals, including the bull in the sacrifice of Odyssey 3.438, the horns are artfully covered in gold so that the goddess should rejoice in seeing the ἄγαλμα (ἵν᾽ ἄγαλμα θεὰ κεχάροιτο ἰδοῦσα). This reveals an insight into the "artistic character" of the innumerable bronze votive animals and the often huge (in practice unusable) tripods that were dedicated to the god both as a portion of and reflection of the property. It is out of this conceptual world that the artist holds his important function in heroic society, since he alone can make an object into an ἄγαλμα. This society indeed appreciates his services and does not withhold the artist's share of κῦδος.[67]

Material is taken from the treasury or storeroom (the epic poems do not use the word thesauros) according to need, but it is not altogether put to a regular economic service. That does not mean, however, that such material is considered merely private property to be used at the owner's will. In reality property plays an important social, political, and religious role.[68] Just as the later polis takes from the state treasury not only funds for the costs of war and temple construction, etc., but also for political gifts such as feasts, costs of the theater, etc., so the Homeric kings use their wealth primarily for the fitting out and feeding of their followers. This is made particularly clear in the abnormal cases in which a foreigner joins the followers of a king, such as when Peleus receives Phoinix (Iliad 9.483: μ᾽ ἀφνειὸν ἔθηκε [made me wealthy]) or when Patroklos became the follower (θεράπων) of Achilles (Iliad 23.89–90: ἔνθα με δεξάμενος ἐν δώμασιν ἱππότα Πηλεὺς ἔτραφε τ᾽ ἐνδυκέως καὶ σὸν θεράποντ᾽ ὀνόμηνεν [There having received me in his house, horseman Peleus raised me carefully and named me your servant]). Indeed, the epic poems reveal clearly that the free followers consisting of θεράποντες, ἑταῖροι, and κήρυκες had a far higher value for the Homeric nobility than the slaves, who were used for hard work in the fields but, with the exception of female slaves in the service of the mistress of the house, did not serve in the proximity of the master.[69] It was a right and obligation to host one's peers or to bring one's share to the communal meals (ἔρανος: Od. 1.226). To partake of a feast (δαῖτας δαίνυται: Od. 11.185–86) is a precise expression of political rights parallel to holding one's plot of land (τεμένη νέμεται), while to be excluded from the

meals was equivalent to a loss of rights (*Iliad* 22.498). It is accordingly not surprising that andirons and roasting skewers were deposited as status symbols in graves.[70]

The political prestige of property as a social function is even clearer in a remarkable custom, the giving and receiving of gifts.[71] Homeric noble families appear to have been largely autonomous on their estates. Food, clothing, shoes, etc. are all produced within the household itself. Trade is correspondingly rudimentary. Apart from unusual circumstances (*Iliad* 7.472), purchases are limited to slaves, metals, and luxury items. In the epic poems such purchases are made only from foreigners and there is no sign that trade was practiced by the Greeks. The exchange of property among the nobles themselves is limited to items of prestige, particularly to objects of the *thalamos* such as containers, weapons, luxurious garments, jewelry, utensils, and metals. But slaves, horses, and carts can be included. All these things are not exchanged through purchase or barter but by gift. One may wonder whether this is all true or whether it stems from the poetically transfigured character of the epic poems, stimulated by the interest of the traveling poet in such matters. That the picture is true is suggested by the fact that the giving and receiving of gifts is surrounded by strictly observed rules.

The gift concept includes many meanings that are only later distinguished. Everything that falls under the rubric γέρας belongs to it, such as the share of booty of the nobleman or the payments made on a regular basis "to honor" the king (*Iliad* 9.155: τιμήσουσιν). Even the tribute that Hektor must raise from his people to support auxiliary troops (17.225) is called δῶρα. Equally encompassed by the concept of gift are all forms of remuneration such as the expected plot of land (τέμενος) in *Iliad* 20.184 as a distinction for bravery. In *Iliad* 10.304, δῶρον is plainly synonymous with μισθός, though this is not payment for work as such but is presented as a distinguishing reward for a particular heroic deed. Δῶρα also encompass the fines paid by Agamemnon in *Iliad* 19.147 and the ransom that Priam pays for Hektor's corpse (24.76). Real δῶρα in our modern sense are the ἔεδνα, "bridal gifts."[72] Although it is always the case that he who gives the most costly present gets the bride (*Od.* 15.16), this is not understood as the purchase price, since the unsuccessful suitors also give presents that, as a rule, they do not get back. Of particular importance is the original meaning of δῶρα, which sheds light on sacrifices to the gods, which Zeus in *Iliad* 24.68 refers to as both δῶρα and γέρας. The gift character of sacrifice remained long after it had disappeared in other situations.[73] A related phenomenon is the γέρας due the deceased in the form of tomb and marker (*Iliad* 16.457).

The above-cited passages indicate that presents were a fixed social custom

connected to particular forms of giving and receiving. The unstructured, spontaneous pleasure gift has no importance in Homeric society (*Od.* 17.164). It is revealing that Hermes in *Iliad* 24.434 refuses to accept such a gift, which would infringe on his loyalty to his master. In this case the acceptance of a spontaneously offered gift would be a breach of accepted social forms.

There is another aspect to the socially structured giving of gifts which is of special importance. I refer to δῶρα that are so closely related to γέρας that they too involve an explicit element of prestige and are required by custom. Only in this case the κῦδος of the giver is just as positively affected as that of the receiver. These are the types of gifts exchanged by the participants after single combats such as that between Ajax and Hektor in *Iliad* 7.303 and that between Glaukos and Diomedes in 6.235. Aristocratic grandeur also explains the gift of the valuable breastplate by the Cypriot king Kinyras to Agamemnon to mark the κλέος of the Trojan campaign (*Iliad* 11.19).

A well-loved theme of the epic poems is the guest-present, and the poet does not fail to emphasize that this is a fixed element of good manners (θέμις: *Iliad* 11.779; ἐπιεικές: *Od.* 8.389). Odysseus even expects ξείνια from the barbarous Kyklopes, calling on θέμις (*Od.* 9.229, 268). The gifts that Odysseus collects on his travels represent to him the coherent amassing of a fortune no less appropriate to his rank than booty or prizes of competitions (*Od.* 19.293; 14.286). The Phaiakian βουληφόροι make two rounds of gifts to him; the second time he receives a great bronze cauldron and tripod that is so expensive that the people are called on to repay the counselors (*Od.* 11.339, 352, 357; 13.13). Menelaos tries to convince Telemachos to stay with him by suggesting that he make a circuit of the neighboring cities to collect presents, since in each at least a valuable gift could be expected (*Od.* 15.82).

The poet cannot do enough to extol the value of the gifts made (κλυτὰ περικαλλέα δῶρα: *Od.* 8.417, 420; ἀγλαὰ δῶρα: *Iliad* 16.86; κειμήλιον τιμήεστατον: *Od.* 4.613–14, 600; the wonder felt at looking on a present: *Od.* 15.131–32). Choice gifts are tripods, kraters (with genealogy in *Od.* 4.617), weapons, silver bathtubs (4.128), rich cloth, as well as male (17.441) and female slaves (7.9; 24.278). The prestigious character of guest-presents in the epic poems extends to contest prizes (ἄεθλα) which, in contrast with the custom of the Classical period, often have enormous value (e.g., *Iliad* 23.702: for participation in the wrestling match, the prize is a tripod δυωδεκάβοιος and a skilled slave τεσσαράβοιος).[74] The prominent occasion, the funeral games, is really an opportunity to display splendor (περικαλλέα ἄεθλα: *Od.* 24.85). Splendid burial plays an important and disputed role in later Greek culture, which gives evidence of its political character.

A certain reciprocity is attached to the custom of giving, since everybody is

required to give a present under the same circumstances. Thus the receiver of a present must give one when another comes to him. This is the ἀμοιβή (δώροισιν ἀμειψάμενος: *Od.* 24.285; δῶρον ἄξιον ἀμοιβῆς: 1.318), a concept whose original sense survived in the sphere of sacrifice, as in the formula χαρίεσσα ἀμοιβή in the sacrifice at *Odyssey* 3.58. Nonetheless, it is not a matter of a simple exchange of more or less equal objects. To be sure, present and counterpresent are meant as a rule to be similar, but in actual practice the participants tended to try to outdo one another. Sometimes the value in a gift exchange can be very unequal (χρύσεα χαλκείων: *Iliad* 6.236).[75] The giver also runs the risk that his presents go unreciprocated (ἐτώσια), because the recipient dies or loses his fortune (*Od.* 24.283). But the demands placed on an individual can be quite various according to the situation. Rank and wealth can oblige one to make particularly valuable gifts. If one lives on a much-frequented route, one must host more than others (*Iliad* 6.15). It is consequently clear that Homeric gift-giving customs do not constitute barter as a primitive economic system, but above all reflect κλέος, that is, they are politically motivated (ξεῖνοι φορέουσιν κλέος: *Od.* 19.333).

The aristocratic character of property and its social meaning in the Homeric world are among the essential underlying principles of Greek art. The majority of and the best "art" works are stamped with the function of "property," to which they either belong or which they depict. The numerous vases made for the grave have this special role, since they are given as the deceased's share. Among these, storage vessels are most numerous, such as pyxides and amphoras, as well as objects that could be interpreted as status symbols.[76] Among the numerous bronze votives dedicated in the sanctuaries, the horse as such is not depicted, but, in accordance with the religious function of the statuettes as part of the property of the god, it is clearly presented as a piece of property, as a carriage horse.[77] The bronze tripods, perhaps the greatest of the "works of art" of the period, are also a type of property, and even through their multiplication in sanctuaries and in *thalamoi* they become a measure of value and could be considered "utensil currency"; at least they are a particularly expressive form of wealth.

The derivation of meaning of a "work of art" from its function as property indicates that the (ideal) structure of Homeric society is mirrored precisely in art. The work of art above all serves the politically and religiously motivated delineation of the mutually competitive noble families and their entourages, at a time when the monarchy had already largely lost its power. This determines on the one hand the splendid form of the votives, competition prizes, and the tombs as well as the richness of the tomb gifts. It explains further why the material value, the artistry, the exotic or mythical origin of the work of art plays so

great a role in its valuation. On the other hand, it explains how the artists and their works (such as Daidalos and his *choros* in Knossos) attained such fame even though the former occupied a low economic and legal position in society. These are all traits that do not just constitute the external premises of art, but, in the view of the period, define what art actually was considered to be. From another point of view, the essential element of property in the concept of art explains why there was no tendency to produce monumental works such as monarchies, tyrannies, and to some extent democracies commission. There is indeed nothing in the preserved record to set beside the Mycenaean palaces or the enormous temples of the Archaic period. The nonmonumental form of the sanctuaries shows that they were at this time simply places to assemble splendid votives of individual families and were not the product of the communal effort typical of monarchic, oligarchic, or democratic societies. Only incipient signs of such sanctuaries occur in the city of the Phaiakians or in the great sacrifice in Pylos (*Od.* 3.5ff.).

The function of the work of art in Homeric society also determines the picture that the epic poems give of the nature of the artist. Since the poems know of no autonomous work of representation independent of some useful function, they equally do not possess the conceptual possibility to distinguish "art" from artful craft. The corresponding concept of the artist is also lacking. In order to learn something of the artist's social position, one must consult the general statements about craft. Yet in a period of autonomous estates, the concept of the craftsman does not really exist as distinct, say, from the farmer. The inquiry can only treat the Homeric equivalent of the group of people designated later by the names χειρῶναξ, τεχνίτης, δημιουργός, βάναυσος, etc. This preliminary observation is not superfluous, because the Homeric craftsman is by no means completely described by the social categories contained in the later conceptual structures.

A general picture of the economic and social context of the craftsman is only faintly discernible, in line with the myth-heroic character of the epic poems. Agricultural towns and aristocratic estates with largely self-supporting economies appear to have been the rule, as a well-known passage in the *Iliad*, 23.832–35, suggests.[78] Both King Odysseus and his slave Eumaios make many things for themselves, and all the women in the house spin and weave. The epic poems draw no full picture of trade, which heroic society deprecated (*Od.* 8.162). There is no mention of local commerce, nor do the Archaic nobles carry manufactured goods and metals overseas the way that the Phoenicians and Taphians did. It is not even clear how they paid for the purchase of oriental luxury goods. The archaeological evidence confirms the whole range of oriental "imports" but does not reveal what the Greeks gave in exchange and

what they themselves supplied in their eastern trade emporia. The deposits of pottery cannot alone answer the question, even if one estimates its market value to have been relatively high. What other goods the Greeks had to offer and what share of these manufactured items they may have had is open only to speculation.

It is hard to determine the position of the craftsman in this world. At the level of the nobles (ἀριστῆες), the extremely fine differentiation of social rank[79] presented in the epic poems applies only to a certain point, below which distinctions are blurred. Dedicated to the ideal of the ruling nobility, the poet harmonizes the real social contrasts to the point of unrecognizability. Only occasionally can we discern that this apparent harmony based on respect and trust was very fragile. For example, Poseidon, who had built the walls of Troy in the guise of a traveling craftsman (θητεύσαμεν εἰς ἐνιαυτὸν μισθῷ ἔπι ῥητῷ: *Iliad* 21.444) is cheated of his pay as is Apollo when he served as a cattleherd.

There are some references in the epic poems to profound social differences and contrasts, to high and low, poor and rich, masters' sons, just and unjust kings, etc.[80] But the conflicts cited take place almost exclusively among the ἀριστῆες themselves or between them and the largely powerless monarchy. For example, Thersites, who objects to the orders of Agamemnon, is not a man of the "people" in the later sense of the word (δῆμος = πένητες); he is a noble of low rank who was related to Diomedes according to tradition and whose murder puts Achilles in the greatest of difficulty. In Homer the word δῆμος refers without exception only to the ἀριστῆες themselves as is abundantly clear in *Iliad* 12.212, where Polydamas calls himself a man of the people and is immediately reprimanded by Hektor, as soon as he expresses his own opinion, and yet he is one of the brothers of Hektor.

The small farmer (*Od.* 11.490) and the craftsman play only a minor role in the poems. The latter most often possesses no land, because he travels for his work and is anyway largely without rights. Yet it should be noted that craft as such does not determine the social status of the latter, since even the ἀριστῆες can be specialized craftsmen.[81] Rather, it is the social situation of the landless which often forces them to take up a craft to make their way. It is therefore impossible to define the craftsman on the basis of social criteria.

The lack of the concept "craftsman" in the epic poems must reflect social reality and is based on the near autonomy of the private estates in manufacturing as in all else. In fact the whole realm of craftsmanship in Homer, with regard to both technique as well as those who practiced crafts, is so complex that it is difficult to unify all the variations under a single name. It is hardly possible to evaluate on equal terms such different craftsmen as the swineherd

Eumaios, who makes his own sandals and builds his stables with his own hands, the specialized smith who has a fixed smithy, and the jack-of-all-trades, Daidalos, who creates figures of legendary lifelikeness. The unspecialized craft in the framework of the private estate is of no importance to our present inquiry; it is the other two types of craftsmen that may shed some light on the subject. Contrary to the group to which Eumaios as slave belongs, the epic poems only know free men in the legal sense among the craftsmen with fixed place of work or those who travel. The absence of slaves among the latter derives from the nature of the occupation. In order to become a specialist, the craftsman needs many similar commissions that exceed the needs of the household. He must be to some degree free and able to take on commissions from others. Only in cases where repetitive work is needed for one's own use, such as spinning and weaving, is specialization within the household possible. Here slaves are to be found.

The free position of the specialized craftsmen is, however, greatly limited by the general uncertainty of their legal status and by their economic dependence. For example Laomedon having cheated Apollo of his pay, threatens to sell him into slavery, as happened at times to passengers on foreign ships. Such a fate is proposed even by a slave to Odysseus, disguised as a free beggar, in *Odyssey* 17.250.

Whether there were other binding relationships, such as the authority Nestor held over the goldsmith, Laerkes, whom he had brought to work for him, is not certain. We must presuppose them, at least from the economic point of view. Laerkes brings his own tools with him but receives the raw material from Nestor, who hires him.[82] His job is merely to carry out a specialized labor for an unspecified salary. It is plausible that he always worked on commission and never made things on his own account to sell ready-made. In this respect the relationship of the artist to commissioner remained the same into the Classical period and beyond. Pheidias was the contractor (ἐργολάβος) of the Athenian administration that furnished him with the material for his work. The building inscriptions show that this was not only the normal practice but extended to the provision of the most insignificant items—not only to the gold, for example, of the Athena Parthenos.

We learn nothing in the epic poems of the payments made for specialized craftwork. Before the introduction of money, both service and salary have a somewhat imprecise nature. Μισθός is both payment and reward and in the latter case is synonymous with δῶρον (*Iliad* 10.304). The salary of a free craftsman would be worked out as a rule in advance just as Poseidon and Apollo work for Laomedon for an agreed-upon remuneration (μισθῷ ἔπι ῥητῷ: *Iliad* 21.445). The free worker in the fields of an estate received his μισθὸς ἄρκιος

in the form of food and clothing (*Od.* 18.358). Whether and in what manner the work of the specialized craftsman was rewarded beyond payments of field-workers is unclear. To judge from later evidence, it appears likely that for a very long time the specifically artistic tasks such as planning, etc. were not paid for. In the Classical building inscriptions nothing indicates that intellectual work was differentiated from regular craftsmanship.[83] Such work could only be rewarded insofar as it fitted traditional categories of time and piecework. The planning itself is not paid for, but the concrete models (παραδείγματα). The remuneration of the chief architect is based on the number of days worked and as a rule is not higher than that of other craftsmen.[84] If the fragmentary nature of the evidence does not deceive, the payment for planning is included in the daily work of the architect. The lack of differentiation between artistic work and craftsmanship has always amazed modern commentators. But it is clearly the very concrete consequence of the traditional fact that "art" and craftsmanship were not conceptually distinguished from each other. If the artist-craftsman becomes wealthy, that depends, as for the potter, on commercial causes and does not prove the existence of an ideal and distinct evaluation of artistic qualities.[85] The first people to receive payment as artists appear to have been the great Classical painters, in whose personalities we can also most clearly detect the emancipation of the "artist." The public may also have praised a particular artistic achievement more highly than others,[86] but it never went so far as to consider certain fields such as sculpture as "artistic" professions per se, distinct from "mere" craft.

The epic poems present a breathtakingly fine differentiation of terminology for the crafts, yet they do not define categories clearly. In certain cases it is unclear whether a term designates a permanent or an occasional occupation such as wainwright (ἁρματοπηγὸς ἀνήρ: *Iliad* 4.485) or an irrigator (ἀνὴρ ὀχετηγός: 21.257). Of all the terms designating a craftsman, τέκτων has the greatest range and includes not only the carpenter but also the builder, shipwright, lathe-operator, inlayor, and anyone who works with wood, stone, and horn, such as the maker of a bow in *Iliad* 4.110: κεραοξόος τέκτων. Equally the meaning of σκυτοτόμος (*Iliad* 7.221) and χρυσοχόος (*Od.* 3.425) appears to extend well beyond the virtual meaning of the words. In the case of χαλκεύς, though the term is limited to metalworkers, it is applied to all the various aspects of such work. Thus the maker of a shield is called σκυτοτόμος at *Iliad* 7.221 but χαλκεύς at 12.295, apparently because leather and bronze are both materials used in making a shield. Laerkes, who in *Odyssey* 3.425 gilds the horns of a bull, is called both χρυσοχόος and χαλκεύς. In *Iliad* 18.400–401, Hephaistos indicates the making of decorative pieces with the phrase χάλκευον δαίδαλα πολλά (πόρπας τε γναμπτάς θ'ἕλικας κάλυκάς τε καὶ ὅρμους

[brooches and supple coils, flower ornaments and necklaces]). This expression certainly covers also the narrower idea of the artistic making of figured works by Hephaistos and Daidalos: Hephaistos as the maker of the aegis is called χαλκεύς in *Iliad* 15.309.

In contrast to other ancient cultures, the epic poems do not reveal craftwork as limited to a special social group of people. Crafts are as a rule practiced as livelihood by people who have no land, but they are not at all limited to this group. In an economy based on autonomous estates, the noble landowner such as Odysseus is also a skilled and active craftsman. But beyond the general needs of estate life, there is at least one noble personage who is described as a fully fledged craftsman. This is Phereklos who built the ships for Paris and "with his hands could make all manner of fine things, for Pallas Athena loved him exceedingly" (χερσὶν ἐπίστατο δαίδαλα πάντα τεύχειν· ἔξοχα γάρ μιν ἐφίλατο Παλλὰς Ἀθήνη: *Iliad* 5.60–61). Finally, the expressive names of his ancestors, Tekton and Harmonides, leave no doubt that Phereklos was above all a craftsman.[87] Nevertheless, Phereklos, who is killed in combat by Meriones, is of equal rank with the other warriors before Troy. The builder of the wooden horse, Epeios, who at least according to the later tradition was viewed as the prototype of the artist-craftsman, belonged to the ἀριστῆες and naturally took part in the funeral games for Patroklos. The evidence of the epic poems in the case of Phereklos is at least so clear that one must accept his position as a true reflection of contemporary social reality. This does not mean that the craftsman as such was either an equal member of heroic society or that he could rise to such a distinction. Rather, we can phrase the position in the reverse: the nobleman did not dishonor himself if he practiced a craft. He occasionally even worked for his peers, and his craft could become a characteristic of his identity. This observation is perhaps not very convincing in view of the later lack of respect paid to the practice of crafts, but it can be defended. That crafts were practiced by other members of the ἀριστῆες is proved by the legislation in later aristocratic states that expressly forbade noblemen such work. In addition, the epic poems show no disrespect for work as such but depict the most august personalities engaged in it with no apology. This is all the more noteworthy, because the disrespect for trade does express a clear class prejudice against a profession. Manual labor, on the other hand, is practiced by both gods and heroes. Zeus harnesses his horses (*Iliad* 8.41), Athena weaves (5.733) just as does Helen (*Od.* 15.105; *Iliad* 3.125), Trojan princes are shepherds (*Iliad* 15.547; 11.106; 20.188), Lykaon cuts reeds for his chariot box (21.37–38), and Paris builds his house together with the best τέκτονες ἄνδρες (6.313ff.). Odysseus makes his raft and his bed like a professional, and as a beggar he suggests to a βασιλεύς an ἔρις ἔργοιο in

mowing grass and plowing (*Od.* 18.366). This picture contrasts starkly with the later deprecation of crafts, such as that of Herodotos (2.167), who presents the general attitude most clearly. Behind his statement that the Greeks "learned" their attitude from the Egyptians is probably the consciousness that the Greek attitude had originally been different. Of importance in this context is the occasionally expressed opinion in the later sources that the practice of crafts itself did not make men base, but the greed connected with the profession. Labor on the land never attracted the same criticism as did the practice of crafts but always retained a certain respect. It is therefore not the manual labor that determines the negative evaluation of crafts but the social context.

There is also no true class distinction provided by the single instance of a term indicating a limited group of craftsmen in *Odyssey* 17.383. The swineherd Eumaios contrasts the undesirable beggars with a group of people who are desirable and sought out because of their services: the δημιοεργοί. He counts among these the "prophet or healer of ills, or carpenter, or even the inspired singer who gives pleasure singing" (μάντιν ἢ ἰητῆρα κακῶν ἢ τέκτονα δούρων ἢ καὶ θέσπιν ἀοιδόν, ὅ κεν τέρπῃσιν ἀείδων). In another passage of the *Odyssey* (19.135; the word does not occur in the *Iliad*), Penelope uses the term for the "herald" (κήρυκες) in conjunction with foreigners and suppliants (ξεῖνοι, ἱκέται), people to whom one should give hospitality. The term *dēmiourgos* therefore includes both the craftsman and completely different professions. It is not a technical term but a "sociological" one, and as such it provides important evidence for the predominance of the political in early Greek thought. According to the enumerated professions, it is clear that the term does not apply to a particular "class." Machaon, the doctor par excellence, is both ἥρως and king of Trika (*Iliad* 4.200); the τέκτων Phereklos is at least a free warrior. Singers and heralds are also free, though mostly in a dependent position in the household of a great lord.[88] The activity of a herald often had a servile character; he did many things that a free Greek in service later would have considered unworthy and have given to a slave to perform, such as preparing the meal for the reapers (*Iliad* 18.558), mixing the wine (*Od.* 18.423), serving at table (17.334), or picking up the mantle of the king (*Iliad* 2.184). Nonetheless, the word *dēmiourgos* had a very positive connotation, as its use by Eumaios demonstrates.[89] The *dēmiourgoi* appear in both passages of the *Odyssey* as traveling foreigners as opposed to members of a household. But whether this was the conceptual basis that determined which groups were included under the term is doubtful. Phereklos and the household heralds would not fit this interpretation.[90] The guiding criterion is probably service to the larger community, the δῆμος, rather than activities limited to one's own household alone. At least this appears to be the point of departure for the later history of the word's

meaning. In the account of the transitional class divisions of Athens after the departure of Solon, the δημιουργοί, apparently mainly craftsmen, are contrasted with the ἄγροικοι.[91] The occupations of the *dēmiourgoi* listed in *Odyssey* 17.384 recur in Solon together with seafaring and farming as possible livelihoods.[92] Doctors are *dēmiourgoi* in Plato (*Grg.* 455). The word is also used specifically for craftsmen and reflects the respective social picture of this group.[93] As expected, we also find the artist included in the group.[94] The use of the term in Dorian communities for a public office and the meaning "creator" or "creative god" occasionally given the word,[95] which suggests artistry, demonstrate that the original, positive meaning of the word was not totally obliterated by the low esteem in which the crafts were later held.

The social position of craftsmen in Homeric society remains in many respects undefined. This may in part derive from the fragmentary evidence and the aristocratic nature of the sources, but, in fact, it also appears to point to an actual openness in society that prevented the formation of a conceptual structure for the crafts. Yet the lack of a conceptual structure does not exclude that there was an image of the artist-craftsman on a different plane that was both more general and more concrete, that is, physiognomically circumscribed. This image is to be found in the mythological realm and applies particularly to those members of the group whom we would deem artists in the narrower sense of the word. The mythological type replaces the abstract concept and is of prime importance for the self-understanding of the artists. Sokrates, who, it is well known, was by profession a sculptor, can still call Daidalos his ancestor,[96] and an Attic deme of craftsmen with the name of Daidalidai shows that this was a reflection of a popular belief, though Sokrates as always makes the claim not without irony.

Characteristics of art in the epic poems are often connected with a mythical background. Artistry is always a gift of the gods. In *Iliad* 5.61 it is said of Phereklos, who helped Paris build his ships, that "Pallas Athena loved him exceedingly" (ἔξοχα γάρ μιν ἐφίλατο Παλλὰς Ἀθήνη). More generally *Odyssey* 6.233 (= 23.160) speaks of a goldsmith whom Hephaistos and Athena taught in every τέχνη and how to make χαρίεντα ἔργα. Even a carpenter who hews a ship's beam true possesses his σοφία through the guidance (ὑποθημοσύνῃσιν) of Athena (*Iliad* 15.411–12). The building of the wooden horse was carried out by Epeios with Athena (*Od.* 8.492); its artful character is indicated by the word κόσμος, which means in this context "building well." The plastic artist receives his ability from Athena and Hephaistos just as the seer receives his from Apollo and the singer his from the Muses.

The parallel of the singer is another matter altogether. The significance of the singer is particularly dear to poetry and accordingly there is more clarity in

the picture drawn than in that of the plastic artist. The singer also serves the κῦδος of heroic society, which precisely sees the purpose of its fate to be "a song for those who come after" (ἐσσομένοισιν ἀοιδή: Od. 8.580; see also 24.197). This function confers on the singer his value and the poet represents him, that is himself, as sought after and honored, during whose performance the guests fall reverently silent and to whom the best piece of meat is given at meal (Od. 8.475).[97] These passages not only reflect the prestige of the singer but also reveal concerns of a specific artistic nature. And it is again in the structures of mythical thought that these are expressed. Friendship with the gods is particularly close and constitutes, as is often repeated, the real artistic stimulus. "In whatever way his heart is moved" (ὅππῃ οἱ νόος ὄρνυται: Od. 1.347) and "in whatever way his spirit prompts him to sing" (ὅππῃ θυμὸς ἐποτρύνῃσιν ἀείδειν: 8.45) are astonishing artistic experiences that are mostly expressed in mythical terms: "The Muse then moved the singer" (Μοῦσ᾽ ἄρ᾽ ἀοιδὸν ἀνῆκεν: 8.73); "the Muse taught" (Μοῦσ᾽ ἐδίδαξε: 8.481); "moved by the god he began" (ὁρμηθεὶς θεοῦ ἤρχετο: 8.499). The singer is "taught by the gods" (θεῶν ἐξ δεδαὼς: 17.518), and self-taught (αὐτοδίδακτος) is equated with "The god planted all manner of songs in my heart" (θεὸς δέ μοι ἐν φρεσὶν οἴμας παντοίας ἐνέφυσεν: 22.347–48).

Does this elevated and specifically artistic self-understanding of the poet say anything about an artistic aspect of craftsmen? B. Schweitzer deduced from the fact that there is no muse of the plastic arts that no parallel can be drawn, and he considered the mythical transfiguration of poetry to be the clear opposite of the depreciation of the craft-based arts.[98] The absence of a muse appeared to him as the mythical expression for the nonspiritual conception of craftsmanship. It is a fact that the position of the poet in Greek society was in some, but not all, respects more illustrious than that of the plastic artist, and poetry did not fall pray to the increasingly negative attitude to the plastic arts. Nonetheless, it does form a parallel both in its social function and in its mythical presentation. The self-understanding of the poet can legitimately be compared to that of the craftsman, at least as a type in the structures of mythical thought, and thereby a specific artistic aspect of the craftsman is confirmed. The comparable mythical view is particularly clear in the poem of Solon already cited: the craftsman is instructed in works (ἔργα δαείς) by Athena and Hephaistos; the poet-singer is διδαχθείς by the Olympian Muses.[99] A similar conception can also be found in the epic poems. In Odyssey 8.493ff. the help Athena gives Epeios in the building of the wooden horse is mentioned together with the divine friendship of the singer, though not expressly stated as a parallel. Later the accounts of cults, artists' inscriptions, and numerous vase-paintings reveal the mythical background of the crafts, subjects that cannot be

addressed here. But this material demonstrates an extraordinarily high self-consciousness that rivals that of the poet. And this appears to have been the case also in the world of epic, as we can hypothesize from the fame of individual works and the naming of various craftsmen. Buschor put great weight on the fact that Geometric objects carry no signatures of artists.[100] Yet we cannot attribute to this fact so much importance, since the epic poems do record the names of the makers of shields, thrones, and gaming balls.

Two additional points remain concerning the relationship of poet and plastic artist which confirm the above observations. The first is the use of metaphors drawn from the plastic arts, particularly in Pindar, to characterize poetic "craft," a subject studied already by H. Philipp.[101] The other is a body of evidence that has not yet been introduced to the discussion according to which poetry, sculpture, and painting could very well be considered together under the rubric "art." This is all the more noteworthy because the evidence comes from the same Xenophon who calls craftsmen generally (πλεῖστοι) slavish (ἀνδραποδώδεις) in *Memorabilia* 4.2.22. However, this remark does not exhaust the possibility of "art," as is shown by the conversation between Sokrates and Aristodemos: "'Tell me Aristodemos,' he said, 'are there men you admire for their wisdom?' 'Indeed,' he replied. 'Tell us their names,' he said. 'In epic poetry I admire Homer most, in dithyramb Melanippos, in tragedy Sophokles, in sculpture Polykleitos, and in painting Zeuxis.'"[102] The fact that the σοφία here in question is not just mechanical ability but a specifically artistic quality is shown by the context of the discussion which deals with creators (ἀπεργαζόμενοι) of εἴδωλα and ζῷα.

The friendship of the gods as a mythological expression of something artistic (creative) that had no abstract conceptual form could not prevent the depreciation of the crafts. Yet it is an important phenomenon. The mythical picture, however, does not transfigure the artist but indicates a clear limitation of personal perfection in comparison to the dominant aristocratic ideal. Indeed, these negative traits are fundamental for the moral physiognomy of the artistic type proper. Nor are they lacking in the description of the singer, since blindness is an integral aspect of the type. In *Odyssey* 8.62 it is said that the Muse gave him both good and bad. In the case of the craftsman, the deformation of the exterior, above all else still emphasized by Xenophon, is also found in the mythical prototypes. Hephaistos (*Iliad* 18.371, 410) is a limping (χωλεύων, κυλλοποδίων), hairy, sweating, snorting monster (πέλωρ αἴητον) with the neck of a bull but weak legs (κνῆμαι ἀραιαί). The Rhodian art demons, the Telchines, who concerned themselves particularly with ἀνδριαντοποιία, are dwarflike ἀμφίβιοι with webbed skin between the toes and are called φθονεροὶ δαίμονες because of their evil eye. The Kyklopes, according to later

sources workers in Hephaistos's shop, are, like the Cretan smith-gods, the Daktyloi, uncouth giants. In addition to these external characteristics, they are outside society. Hephaistos in *Iliad* 1.600 is ridiculed by the gods when he pants (ποιπνύων) while waiting at table. Zeus throws him out of Olympos so that he flies through the air a whole day (1.590). The Olympians consider Xanthos, the river god, a worthy opponent for him (*Iliad* 21.331). The sovereign low esteem in which the Greeks held things technical is demonstrated by a myth found in a late source which relates that only Hephaistos could not be victorious in the battle of the gods and giants.[103] He is cuckolded by Ares, although the story also presents his technical preeminence: εἷλεν . . . ὠκύτατον . . . χωλὸς ἐών, τέχνῃσιν (*Od.* 8.332). He also overpowers Ares in the story of the binding of Hera, but he is himself overcome by Dionysos. Another kind of social rejection occurs in the myth of Prometheus in his conflict with Zeus.

The limitations of personal perfection are also found among the mortal artists of mythology. The clearest example is Epeios, who built the wooden horse with Athena and whom Plato still considered the prototype of the artist together with Daidalos. In the funeral games of Patroklos, Epeios is the swaggering victor in boxing over Euryalos (*Iliad* 23.669), but in putting the iron shot he is ridiculed (23.670). Later Stesichoros made fun of him as the water carrier of the Atreidai.[104] It is no coincidence that the epic puts in his mouth a saying concerning one-sidedness: "I deem myself best (in boxing). Or is it not enough that I am inferior in battle? For no one can be skilled in all works" (πυγμῇ εὔχομαι εἶναι ἄριστος. ἦ οὐχ ἅλις ὅττι μάχης ἐπιδεύομαι; οὐδ᾽ ἄρα πως ἦν ἐν πάντεσσ᾽ ἔργοισι δαήμονα φῶτα γενέσθαι: 23.669–71). Daidalos has a characteristic imperfection, since he kills his nephew Talos out of jealousy and must flee Athens. The wanderings to which he is subjected by the inducements and threats of the great constitute a typical fate for an artist. The one-sidedness and imperfect character of the artist is a topic of long duration in ancient literature. Pheidias's purported fall belongs to it. His contemporaries apparently did not shrink from branding him with wrongdoing and condemning him (Φειδίας πράξας κακῶς: Aristophanes *Peace* 605), even though the theft could not be proved (κλοπαὶ μὲν οὐκ ἠλέγχοντο: Plutarch *Per.* 31.3).

Even though the evidence is fragmentary and prejudiced, the picture of the artist in early Greece nevertheless gains a certain solid contour. Homeric poetry does not recognize art as an isolated representation, expression, or experience. The works always have a social or even more a functional value (as utensils), which in this respect eliminates the concept of both art and artist. In the activity of the artist, the technical cannot be distinguished from the creative. As a type of person, the artist is not differentiated from the craftsman, just as the craftsman cannot be set off clearly from the other participants in the man-

agement of the estates. This is not to say that there were no artists. The artists still belonged to a broader group, just as other members of society were submerged in big units. The noble lords themselves, the ἥρωες and ἀριστῆες, were kings, farmers, and even craftsmen. And yet the plastic arts cannot be described in the epic poems as mere craft, because this concept itself can only come into being in contrast to the emancipated concept of art. But it can also be shown in positive terms that the maker of ἀγάλματα and δαίδαλα in the Homeric period clearly possessed artistic traits in the later sense of the word. This is shown by his self-consciousness expressed in mythical terms, his understanding of material and technique, his ability to call into being κάλλος and χάρις, and above all lifelikeness and naturalness. No less important than these positive traits were the imperfection and misshapen form, the character flaws and existence outside of society. For this reason alone epic figures such as Prometheus, Hephaistos, Daidalos, and Epeios could serve as prototypes for artists through all later antiquity and still do for their modern descendants.

NOTES

The present sketch served as the introduction to a lecture course in the winter semester of 1968–69. It is not meant to compete with philological and historical studies of Homer but as preliminary to an archaeological inquiry.

The cursory form of the lecture has prevented meticulous citation of sources for all the evidence and opinions discussed. Further references can easily be found in the excellent book by A. Riedenauer, *Handwerk und Handwerker bei Homer* (Erlangen 1873), as well as in the works cited by B. Schweitzer, M. Finley, and H. Philipp (all cited below). F. Eckstein was kind enough to allow me to read his manuscript on a new treatment of Homeric craftsmanship, since published in the *Archaeologia Homerica*: "Handwerk, Teil 1" (Vol. II, Chapter L, Part 1: Tübingen 1974). I have consulted the secondary literature on historical and philological matters only to a limited extent. References to passages in the epics are intended to be complete only in a few expressly cited cases.

I thank M. Bergmann and H. Mielsch for manifold help in preparing the text for print, and I am indebted to H. Diller, H. Drerup, H. Gabelmann, H. Herter. B. Snell, and J. Vogt for reading my manuscript critically.

1. See especially pp. 41–42.
2. See below, pp. 27–28, 30–31.
3. J. J. Winckelmann, *Geschichte der Kunst des Altertums*, ed. J. Lessing (Dresden

1764) (*The History of Ancient Art*, tr. G. Henry Lodge [New York 1968]) I, Book IV, Chapter 1, §4 (p. 176).

4. The expression is here and in the following text used in a more general sense than that common in the modern discipline of sociology.

5. K. O. Müller, *Handbuch der Archäologie der Kunst*[3], revised by F. G. Welcker (Stuttgart 1878) p. 1, §1 (*Ancient Art and Its Remains, or a Manual of the Archaeology of Art*, trans. J. Leitch [London 1852]). See also Hegel's discussion of the concept of art in *Werke* 13, *Vorlesungen über die Aesthetik* (Suhrkamp edition: Frankfurt/Main 1970) I, 16ff.

6. I use this expression for convenience, since clearly a "concept" of art was never formulated in the period.

7. Müller, *Handbuch* (above, n. 5) 25–26, §44 (English edition, p. 20).

8. In this context note the observation of H. Brunn, *Geschichte der griechischen Künstler*[2] (Stuttgart 1889) 4f., who for the most part saw that it was difficult to separate art and craft in antiquity.

9. On the relationship of positivism to idealism and classicism among archaeologists, see Himmelmann, "Der Entwicklungsbegriff der modernen Archäologie," *MarbWPr* (1960) 15f.

I cannot here treat the meaning of philosophical idealism relevant to archaeological concepts of art. Its real contribution was, in the tradition of Winckelmann, to recognize the ideal, that is, archetypal and objective character of Greek art, and to contrast this with the contemporary subjectism. Hegel's aesthetic developed out of this contrast.

On the ideal in Greek art as a historical phenomenon, see most recently H. Protzmann, *Paradeigma als Schlüsselbegriff des hochklassischen Stilbewusstseins* in *Dissertationes Berolinenses* 3: *Das Problem der Klassik im Alten Orient und in der Antike*, ed. B. Döhle and H. L. Nickel (Berlin 1967) 48–70, and Himmelmann, "Die 'Schrittstellung' des polykletischen Diadoumenos," 32 (trans. below, pp. 166–67); on the meaning in this context of Geometric form, see the references cited below, nn. 49 and 50. With reference to the content of the phenomenon, see Himmelmann, *MarbWPr* (1960) 23f., 35f., 44, 47.

10. J. C. Burckhardt, "Die Griechen und ihre Künstler," in *Vorträge 1844–1887*[3] (Basel 1919) 202–14 (30 October 1883).

11. "The disregard for the sculptor, however, even in the period of full splendor, was perhaps lucky for sculpture, which escaped the fate of being picked to pieces by those of the period who could pick anything to pieces. . . . Art could continue to create in total naïveté the most beautiful works as though the Peloponnesian War and other turmoil in daily life had not existed. It alone was not dragged into the general crisis. It alone maintained the ideal vision of the gods, while philosophy gave up and Middle Comedy dragged them through the dirt" (ibid., 206–7).

12. The situation was, as Burckhardt already saw, somewhat different for painters (ibid., 208f.); see further below.

13. B. Schweitzer, "Der bildende Künstler und der Begriff des Künstlerischen in der Antike," in *Zur Kunst der Antike*, ed. H.-V. Hermann and U. Hausmann (Tübingen 1963) I, 11–104 (originally published in *Neue Heidelberger Jahrbücher* [1925] 28–132).

14. The critical words used here are explained in the course of my argument. See also H. Philipp, *Tektonon Daidala: Der bildende Künstler und sein Werk im vorplatonischen Schrifttum* (Berlin 1968), and my review of her book in *Gnomon* 42 (1970) 290–97.

15. In reality the two bodies of evidence are, of course, complementary.

16. For example, the seventh-century votive bronze statuette of a helmet-smith squatting on the ground in the Metropolitan Museum, New York: Himmelmann, *Bemerkungen*, figs. 49–50. See also Himmelmann, *Gnomon* 42 (1970) 294f.

17. For Boiotia, see Aristotle *Pol.* 1278a25. The monuments found in Boiotia are largely imports from other regions or the work of foreign craftsmen either traveling or resident with restricted rights. Since the "Boiotian" relief-pithoi have turned out to be from the islands, the evidence is increasing that the "Boiotian" fibulae are foreign-made, probably of Peloponnesian origin: Himmelmann, *Antiken aus dem Akademischen Kunstmuseum Bonn, Kunst und Altertum am Rhein* 19 (Düsseldorf 1971) 26f. If the name Hyle in *Iliad* 7.221 refers to the Boiotian town (*RE, s.v.,* and *Roscher, s.v.* Tychios), then the famous *skutotomos* Tychios must be considered Boiotian.

18. Isokrates *Antidosis* 2. Although the context just about requires that one distinguish "art" from "mere" craft, no such conceptual distinction occurs, but the word τέχνη is used for both areas: "just as if someone would have the effrontery to call Pheidias, who made the statue of Athena, a coroplast, or say that Zeuxis and Parrhasios have the same *technē* as do those who paint signs . . ." (ὥσπερ ἂν εἴ τις Φειδίαν τὸν τὸ τῆς Ἀθηνᾶς ἕδος ἐργασάμενον τολμῴη καλεῖν κορόπλαθον, ἢ Ζεῦξιν καὶ Παρράσιον τὴν αὐτὴν ἔχειν φαίη τέχνην τοῖς τὰ πινάκια γράφουσιν. . . .).

19. See also Himmelmann, *Gnomon* 42 (1970) 295f.

20. G. Glotz, *Le Travail dans la Grèce ancienne* (Paris 1920) 194ff. (*Ancient Greece at Work: An Economic History of Greece from the Homeric Period to the Roman Conquest,* trans. M. R. Dobie [New York 1926] 161ff.).

21. Himmelmann, *Gnomon* 42 (1970) 294; Xenophon *Mem.* 4.2.22.

22. E. Buschor in FR, text to plate 153.2. See also the characteristics Buschor ascribes to painters (particularly to Euphronios) in *Griechische Vasenmalerei*[2] (Munich 1914) 164ff. and *Griechische Vasen* (Munich 1940) 150 (second edition Munich 1969, revised by M. Dumm, p. 158). Equally problematic is the comparison of a certain group of vase-painters with the "mannerists" of the Antwerp School: J. D. Beazley, *Der Pan Maler* (Berlin 1931) 18 (*The Pan Painter* [Mainz 1974] 8f.); A.-B. Follmann, *Der Pan-Maler* (Bonn 1968) 78. And again the treatment of vase-painters, for example Oltos, in the *Encyclopedia dell'arte antica* is dubious.

23. Among other things our judgment of this depends on whether the evidence in Pollux VIII.130 for the reckoning of the assessment into monetary values is of Archaic origin; J. Hasebroek, *Griechische Wirtschafts- und Gesellschafts-Geschichte bis zur Perserzeit* (Tübingen 1931) 290f., does not accept it.

24. A. M. Snodgrass, "The Hoplite Reform and History," *JHS* 85 (1965) 110–22.

25. A. Hauser, *Sozialgeschichte der Kunst und der Literatur* (Munich 1953) (*The Social History of Art,* trans. A. Hauser and S. Godman [London 1951]). According to Hauser (p. 67 in both editions) the Geometric style is the "expression of a country people, a people of farmers and shepherds who have rigorously shut themselves off from foreign influences." This opinion is derived partly from the old and incorrect view that there was no Geometric style in East Greece.

26. E. Buschor, *Vom Sinn der griechischen Standbilder* (Berlin 1942) 7 (*On the Meaning of Greek Statues,* trans. J. L. Benson [Amherst 1980] 3).

27. ἀγροιῶται does not designate a farmer as such but people who live with animals in the pasture (in the μέσσαυλος). The word is used pejoratively in *Od.* 21.85.

28. See further below, p. 53.

29. On ἱερός see P. Wülfing von Martitz, *Glotta* 38 (1960) 272ff.; 39 (1961) 24ff.; J. P. Locher, *Untersuchungen zu* ἱερός (Diss. Bern 1963).

30. In the same sense in the *Od.* 3.274, Aigisthos hangs up cloth and gold: πολλὰ δ᾽ ἀγάλματ᾽ ἀνῆψεν, ὑφάσματά τε χρυσόν τε.

31. σὺν ἀνδράσιν, οἳ τότ᾽ ἄριστοι ἦσαν ἐνὶ Τροίῃ ἐριβώλακι τέκτονες ἄνδρες. For the meaning of τέκτων, see below, p. 53.

32. Aigisthos in *Od.* 4.529 δολίην ἐράσσατο τέχνην: "planned a treacherous device."

33. For example, see P. Friedländer and H. B. Hoffleit, *Epigrammata: Greek Inscriptions in Verse from the Beginnings to the Persian Wars* (Berkeley 1948) nos. 58, 152. See also *AA* (1967) 15. According to Aristotle, σοφία is an ἀρετὴ τέχνης (*EN* 1141a12).

34. Such as the flowery phrase καλὴ χρυσείη, among others.

35. Hektor in *Iliad* 18.131, ἔντεα . . . αὐτὸς ἔχων ὤμοισιν ἀγάλλεται: "wears the armor on his own shoulders and exults in it." See also 16.91 and Hesychios: ἄ. πᾶν ἐφ᾽ ᾧ τις ἀγάλλεται.

36. πολέες τέ μιν ἠρήσαντο / ἱππῆες φορέειν· βασιλῆι δὲ κεῖται ἄγαλμα / ἀμφότερον, κόσμος θ᾽ ἵππῳ ἐλατῆρί τε κῦδος.

37. See below, pp. 40–41.

38. This passage may be a late interpolation.

39. τὸ δὲ θαυμάζεσκον ἅπαντες, / ὡς οἳ χρύσεοι ὄντες ὁ μὲν λάε νεβρὸν ἀπάγχων, / αὐτὰρ ὁ ἐκθυγέειν μεμαὼς ἤσπαιρε πόδεσσιν.

40. ἣ δὲ μελαίνετ᾽ ὄπισθεν, ἀρηρομένῃ δὲ ἐῴκει / χρυσείη περ ἐοῦσα· τὸ δὴ πέρι θαῦμα τέτυκτο.

41. It is noteworthy that among Geometric votive figures hardly any ritual scenes are depicted. The well-known praying figures are mostly of lesser quality and apparently were dedicated by the simpler levels of society; see also E. Kunze, *Bericht über die Ausgrabungen in Olympia* VII (Berlin 1961) 138ff., figs. 78–82. An obvious exception is an armored warrior in the pose of praying, probably from Thessaly: L. H. Biesantz, *Die thessalischen Grabreliefs* (Mainz 1965) pl. 51 (L61). Cult activities are more frequent on funerary vases, which are, however, of an aristocratic nature.

42. G. Markoe, *Phoenician Bronze and Silver Bowls from Cyprus and the Mediterranean* (Berkeley 1985); E. Kunze, *Kretische Bronzereliefs* (Stuttgart 1931).

43. See generally K. Fittschen, *Untersuchungen zum Beginn der Sagendarstellungen bei den Griechen* (Berlin 1969) 18–67, 76–88; and T. Rombos, *The Iconography of Attic Late Geometric II Pottery* (Jonsered 1988) 369ff. For a king: K. Fittschen, *Der Schild des Achilleus*, in *Archaeologia Homerica* II, Kapitel N, *Bildkunst* 1 (Tübingen 1973) 15, who refers to an amphora in New York (21.88.18): J. M. Davison, "Attic Geometric Workshops," *YCS* 16 (New Haven 1961) fig. 57.

44. K. Reinhardt, "Der Schild des Achilleus," in *Freundesgabe für Ernst Robert Curtius zum 14. April 1956*, ed. M. R.-W. Boehlich (Bern 1956) 67–78; Philipp, *Tektonon Daidala* (above, n. 14) 7.

45. Philipp, *Tektonon Daidala* (above, n. 14) 7 and n. 17.

46. Himmelmann, "Erzählung und Figur," 6ff. and 15, on the Geometric krater pl. 1 (below, pp. 67–71, 76, and fig. 10).

47. Philipp, *Tektonon Daidala* (above, n. 14) 4 and elsewhere.

48. Buschor, *Sinn* (above, n. 26) 9f. (English edition, 4f.).

49. On the phenomenon of the "liveliness" of Geometric figures, which I cannot treat here, see my essay "Erzählung und Figur," 15ff., 19ff. (trans. below, pp. 76ff., 81ff.).

50. Himmelmann, *Bemerkungen*, 15; "Erzählung und Figur," 16 (trans. below, p. 77).

51. Buschor, *Sinn* (above, n. 26) 9f. (English edition, 4f.); Buschor, *Die Plastik der Griechen*[2] (Munich 1958) 10ff. and further above, n. 49.

52. See also Hesiod *Theog.* 581ff., who describes the κνώδαλα on the diadem of Pandora as works of Hephaistos, and the same expressions are used: δαίδαλα, χάρις ἀπελάμπετο πολλή (the great charm shone out) see also *Od.* 18.298; θαυμάσια, ζῴοισι ἐοικότα φωνήεσσιν (like living things with voices).

53. The inscription appears on a hydria of Phintias in Munich (2421) according to the reading of A. Furtwängler (FR text to pl. 71, p. 64). This was accepted by J. C. Hoppin, *Euthymides and His Fellows* (Cambridge [MA] 1917) 115 n.1, and R. Lullies, CVA D 20, Munich 4 (Munich 1961) 17 (text to pl. 222.1). The references were kindly supplied by Professor Henry R. Immerwahr.

54. ὃ δὲ μάλιστα ψυχαγωγεῖ διὰ τῆς ὄψεως τοὺς ἀνθρώπους, τὸ ζωτικὸν φαίνεσθαι, πῶς τοῦτο ἐνεργάζει τοῖς ἀνδριᾶσιν.

55. *Mime* IV, 33–34: μᾶ, χρόνῳ κοτ' ὤνθρωποι κῆς τοὺς λίθους ἕξουσιν τὴν ζοὴν θεῖναι.

56. Philipp, *Tektonon Daidala* (above, n. 14) 15f.

57. The custom of dedicating figures is presupposed in the story of the wooden horse (*Od.* 8.492ff.) and certainly in the χορός of Ariadne (*Iliad* 18.592). Among the ἀγάλματα in temples such as *Od.* 12.346 we may suppose cloth, gold, etc. to be included as is expressly stated in 3.274.

58. *Deltion* 16 (1960) pl. 215; J. Boardman, *Greek Sculpture: The Archaic Period* (London 1978) fig. 250; B. S. Ridgway, *The Archaic Style of Greek Sculpture*[2] (Chicago 1993) 231. [Editor's note: The figure on the relief is now usually identified as a woman.]

59. The occasionally found translation of χορός as "dancing floor" is excluded because the comparison of the poet expressly cites the representation of figures.

60. J. Floren, *Griechische Plastik*, I: *Die geometrische und archaische Plastik*, in *Handbuch der Archäologie*, ed. W. Fuchs (Munich 1987) pl. 1.6, p. 61.

61. A similar observation can be made on the evaluation of the artist and his work (see below, p. 50). The artist as a person is never himself the subject; he is depicted as a dependant of a master who commands his services and glories in this as in the objects made. Nevertheless, the artist asserts himself as a person and a name, which is not self-evident in an "early" society and is not totally overshadowed by his function. Thus the maker of a ball for play is cited by name (*Od.* 8.373). The same is true for artistic activity. It never has its own raison d'être but serves the manufacture of a utensil. It is nonetheless not limited to this role but develops its own world of existence which is described in great detail with interest and appreciation. A characteristic of this aspect of manufacture is the wealth of specifically craft-oriented terms and the richly differentiated and nuanced vocabulary for both the activities of making and materials.

62. See also R. Hampe, *Die Gleichnisse Homers und die Bildkunst seiner Zeit* (Tübingen 1952), and Himmelmann, "Erzählung und Figur" (trans. below, pp. 67–90).

63. Κόσμος seems to me to have the meaning of "decoration" both in *Iliad* 4.145 and in 14.187. See also H. Diller, "Der vorphilosophische Gebrauch von ΚΟΣΜΟΣ und ΚΟΣΜΕΙΝ," in *Festschrift Bruno Snell* (Munich 1956) 47–60.

64. Ἀγαθός alone contains both qualities in *Iliad* 1.131; see also ἀρετή in 15.642 and 23.571.

65. Note the painterly detail of the moldy shield in *Od.* 22.184; see also *Iliad* 24.228ff.

66. Κτέρεα is still used in *Iliad* 10.216 and 24.235 in the sense of belongings.

67. See below, pp. 50ff.

68. In *Iliad* 18.300 it is possible to see the inception of the later system of liturgies.

69. Certain privileged slaves such as Eumaios or Melanthios (*Od.* 17.256 among the suitors) were treated as θεράποντες. I treat this in a study of the iconography of servants in Archaic and Classical imagery.

70. [Editor's note: See, for example, P. Courbin, "Une Tombe géométrique d'Argos," *BCH* 81 (1957) 322–86.]

71. M. I. Finley, *The World of Odysseus*² (New York 1954) 66ff.

72. M. I. Finley, "Marriage, Sale and Gift in the Homeric World," *RevInt des droits de l'antiquité* 3 (1955) vol. 2, 167ff.

73. See below, p. 49.

74. The value of the slave, τεσσαράβοιος, is approximately that of the Classical Period. There is therefore no reason to doubt the value of the tripod and its value relative to that of the slave.

75. The poet even criticizes Glaukos for his excessive generosity: Γλαύκῳ Κρονίδης φρένας ἐξέλετο Ζεύς.

76. See, for example, the grave published by E. L. Smithson, "The Tomb of a Rich Athenian Lady," *Hesperia* 37 (1968) 77–116, pls. 18–33.

77. Himmelmann, "Über einige gegenständliche Bedeutungsmöglichkeiten des frühgriechischen Ornaments," *AbhMainz* (1968) no. 7, 63; Himmelmann, *Antiken aus dem Akad. Kunstmuseum* (above, n. 17) 26.
Perhaps the difference in the social status of the votary does actually find expression in the generally inferior quality of the Geometric bronze bulls compared with the bronze horses.

78. The passage suggests a clear distinction between rural plots on which the workers live and the "city house" that served the master as manor house, similar to the situation described for Alkinoös and Odysseus. But even the manor house takes on some rural character through the management of produce and the keeping of cattle.

79. *Iliad* 1.80; 14.110ff.; 16.54. A particularly good example is 23.789; see also 23.891. Similar distinctions are made among the gods in 20.106.

80. Meaner serve better people at table (οἷά τε τοῖς᾽ ἀγαθοῖσι παραδρώωσι χέρηες): *Od.* 15.324; disrespect for traders: 8.159; avengers of beggars (Ἐρινύες πτωχῶν): 17.475; reflections on character and family: "he does not seem to me bad nor of bad family" (οὐ μέν μοι κακὸς εἴδεται οὐδὲ κακῶν ἔξ): *Iliad* 14.472; wanderer without honor (ἀτίμητος μετανάστης): 16.59. *Iliad* 1.80; 16.59; 12.269; and *Od.* 3.214; 14.214; 16.114, 381, 425; and 24.427 refer to differences of rank and conflicts among the nobles themselves. *Od.* 13.222ff. treats a master's son: (Athena) like a delicate young man, such as are the children of lords (ἀνδρὶ . . . ἐικυῖα νεῷ [Athena] . . . παναπάλῳ, οἷοί τε ἀνάκτων παῖδες ἔασι). Just and unjust kings: *Od.* 19.109–14; 4.690; *Iliad* 16.387, 542.

81. See below, p. 54.

82. In *Iliad* 4.110 Pandaros gives the bow-maker (κεραοξόος τέκτων) the horn of the ram he himself had killed with which to make a bow.

83. A special case was the competition, which, however, was not limited to the specifically artistic realm.

84. If the architect is normally paid for more days than the other workers from whose salaries holidays are deducted, this does not mean, as is often claimed, that the work of planning was more highly regarded than the other. More likely the reason is that the architect's task of overseeing the work continued on holidays. Never is the number of paid days of an architect greater than the number of calendar days. See in general Himmelmann, "Zur Entlohnung künstlerische Tätigkeit in klassischen Bauinschriften," *JdI* 94 (1979) 127–42.

85. Himmelmann, *Gnomon* 42 (1970) 293.

86. See the passage of Isokrates cited above, n. 18.

87. Tektōn (Τέκτων) as a personal name recurs in *Od.* 8.114.

88. The singer Phemios (*Od.* 1.154) is a special case: the suitors had forced him into their service.

89. See also κλυτὸς τέκτων: *Iliad* 23.712.

90. Tychios also belongs to a household: Ὕλῃ ἔνι οἰκία ναίων (*Iliad* 7.220).

91. G. Busolt, *Griechische Geschichte bis zur Schlacht bei Chaeroneia* (Gotha 1895) II, 302; see also Aristotle *AthPol* 13.2.

92. Solon fr. 1 (Diehl) lines 43–56 (13 Edmonds [Loeb]).

93. [Plato] *Alc.* 2.140b: "We consider *dēmiourgoi* those such as cobblers and carpenters and sculptors and many others . . . all these are *dēmiourgoi*" (δημιουργούς τινας ὑπολαμβάνομεν . . . τοὺς σκυτοτόμους καὶ τέκτονας καὶ ἀνδριαντοποιοὺς καὶ ἑτέρους παμπληθεῖς . . . πάντες οὗτοι εἰσι δημιουργοί). The δημιουργός is χρηματιστής in Plato *Resp.* 434a.

94. Plutarch *Per.* 13.9: "Pheidias made the golden image of the goddess, and the *dēmiourgos* of this is inscribed in the stele" Ὁ δὲ Φειδίας εἰργάζετο μὲν τῆς θεοῦ τὸ χρυσοῦν ἕδος, καὶ τούτου δημιουργός ἐν τῇ στήλῃ εἶναι γέγραπται. Pheidias and Leochares are *dēmiourgoi* in Plato *Hp. Ma.* 290a; *Letter* 13.361a.

95. See also LSJ, *s.v.* δημιουργ-.

96. Plato *Euthphr.* 11b; *Alc.* 1.121a.

97. See also *Od.* 3.267: Agamemnon puts his trust in a singer, whom he appoints to watch over his wife, Klytaimnestra, while he is away at Troy. Reality does not always agree with this picture, since the suitors force Phemios into their service in *Od.* 1.154.

98. B. Schweitzer, "Mimesis und Phantasia," *Philologus* 89 (1934) 288; Philipp, *Tektonon Daidala* (above, n. 14) 62ff., correctly counters this argument.

99. Ibid., 66. Solon fr. 1 (Diehl) lines 49–51 (13 Edmonds [Loeb]).

100. Buschor, *Sinn* (above, n. 26) 9 (English edition, p. 5).

101. Philipp, *Tektonon Daidala* (above, n. 14) 20, 37f.

102. *Mem.* 1.4.2–3: Εἰπέ μοι, ἔφη, ὦ Ἀριστόδημε, ἔστιν οὕστινας ἀνθρώπους τεθαύμακας ἐπὶ σοφίᾳ; Ἔγωγε, ἔφη. Καὶ ὅς, Λέξον ἡμῖν, ἔφη, τὰ ὀνόματα αὐτῶν. Ἐπὶ μὲν τοίνυν ἐπῶν ποιήσει Ὅμηρον ἔγωγε μάλιστα τεθαύμακα, ἐπὶ δε διθυράμβῳ Μελανιππίδην, ἐπὶ δὲ τραγῳδια Σοφοκλέα, ἐπὶ δὲ ἀνδριαντοποιίᾳ Πολύκλειτον, ἐπὶ δὲ ζωγραφίᾳ Ζεῦξιν.

103. Apollonios Rhodios 3.233 with scholia.

104. Stesichoros fr. 9 (Diehl) (200 Cambell [Loeb]).

NARRATIVE AND FIGURE

IN ARCHAIC ART

Τὰ Δαιδάλεια πάντα κινεῖσθαι δοκεῖ
βλέπειν τ'ἀγάλμαθ', ὧδ' ἀνὴρ κεῖνος σοφός.

EURIPIDES, *Eurystheus Satyrikos*

THE FIRST SYSTEMATIC attempt to interpret Archaic Greek mythological scenes not simply as illustrations of the texts, but as representatives of a genre in their own right and from the perspective of their own era, was made by Carl Robert. In a lecture delivered in 1880—long before the aesthetic discovery of Archaic art—he suggested a series of basic principles that characterize Archaic narrative, principles that are still valid today as heuristic tools. Robert formulated his insights basically in terms of practical guidelines for hermeneutics, and for both him and his followers the question of the theoretical basis underlying their correctness or usefulness was of secondary importance.[1] I try to clarify this underlying issue, primarily using a series of vase-paintings that have often been adduced as textbook examples of the Archaic art of narrative.

I begin with a knob-handled cup in Boston (fig. 1), painted about 560, which, as is immediately obvious, presents the story of Kirke and Odysseus.[2]

"Erzählung und Figur in der archaischen Kunst," *AbhMainz* (1967) no. 2, 73–97, trans. H. A. Shapiro.

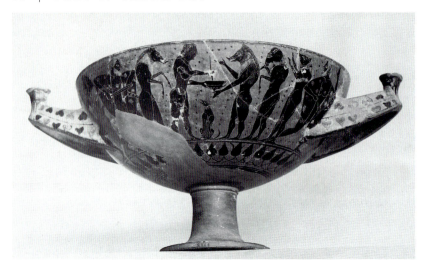

1. Kirke and Odysseus, Attic black-figure kylix. Boston, Museum of Fine Arts

The narrative is set within a closed and symmetrical composition whose cen-
ter is occupied by Kirke and one of Odysseus's companions transformed into a
pig.[3] In addition to four more transformed companions, there are also two
Greeks who have not been affected by Kirke's magic, a man with drawn sword
at the left, and a man fleeing to the right. The latter is Eurylochos, who runs to
bring the news of his companions' misfortune to the ship, and the figure at left
is Odysseus, who, at a much later point in the story, will appear at Kirke's
house and threaten her. It would not occur to anyone reading the scene straight-
forwardly to call this figure Odysseus. The preference is to take him, as Bu-
schor once did, for an invention of the vase-painter unknown in the original
myth.[4] To arrive at the correct interpretation presupposes two conditions: 1) a
knowledge of the story, and 2) the assumption that the scene, despite the self-
contained composition, does not present a unified situation. The second con-
dition can be inferred from the picture itself, since it juxtaposes the compan-
ions who have already been transformed with a Kirke who is still stirring her
potion. But the interpretation of the swordsman as Odysseus introduces such
a radical shift in time that one would not like to make this assumption without
further evidence. Happily, the evidence is indeed available, in the form of
some Ionian vase fragments with the same subject (fig. 2), which repeat this
figure, only now not attacking from the rear but standing before Kirke, as in
the narrative of the *Odyssey*.[5] The fragments also include traces of the meta-
morphosed companions, but not enough to tell whether the figure of Eurylo-

2a–b. Kirke and Odysseus,
fragments of Ionian amphora.
London, British Museum

chos was also present. It is thus uncertain whether this vase also combined such widely divergent moments of the story as does the Boston cup.[6]

At the same time, we must also consider the possibility that the painter has reinterpreted the figure of Odysseus and thereby embellished his narrative with an otherwise unknown episode, e.g., that one of the companions actually tried to fend off Kirke's magic with his weapon. On this assumption, which modern viewers have found hard to avoid in other cases, the vase-painter would have also had to rewrite the literary tradition.[7] In fact, this kind of inter-

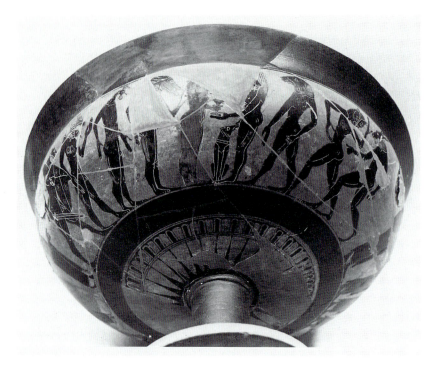

3. Kirke and Odysseus, Attic black-figure kylix. Boston, Museum of Fine Arts

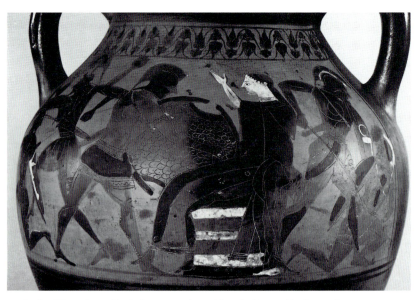

4. Sack of Troy, Attic black-figure amphora (detail). Bonn, Akademisches Kunstmuseum

pretation is occasionally placed beyond any doubt by inscriptions or otherwise made apparent by the context (fig. 4).[8] We might also ask whether, in the original pictorial tradition, the metamorphosis of the companions and Odysseus threatening Kirke were separate episodes that have been merged for the first time in this representation into an apparently simultaneous event. A model for such a procedure would be offered by the familiar image of the Sack of Troy (fig. 5), in which Neoptolemos kills both Astyanax and Priam in one blow.[9] In the epic these had been two separate events, and it has been suggested—though for dubious reasons—that originally they were also independent in the visual tradition and were first combined in these scenes.[10] The scene is usually interpreted as a unified composition[11] and as such would be a particularly striking example of the willful rewriting of myth through a simple contamination of visual types. In principle, however, it is apparently no different from the Kirke cup, which also suggests a unified composition. But, in a manner that is difficult for us to grasp, the cup links the composition to a "hieroglyphic" double meaning, whereby the figure of Odysseus seems, on the one hand, to be a participant in the action while, on the other, he represents a separate episode. We must therefore ask whether, in the case of the Ilioupersis scene, it is sufficient to describe it as simultaneous narration.[12]

If we start looking still further, it begins to seem as if the Boston cup is such an extreme example of the possibilities of Archaic narration that we should not use it as any kind of standard. Some scenes, like that on the famous cup in Munich signed by Archicles and Glaukytes, at first seem quite innocuous (fig.

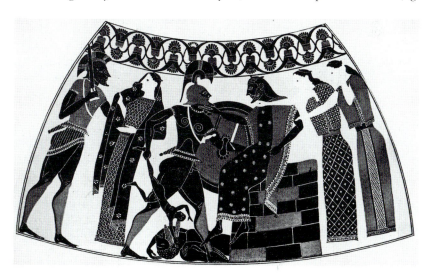

5. Sack of Troy, Attic black-figure amphora (detail), drawing. Berlin, Antikensammlung, Staatliche Museen, Preussischer Kulturbesitz

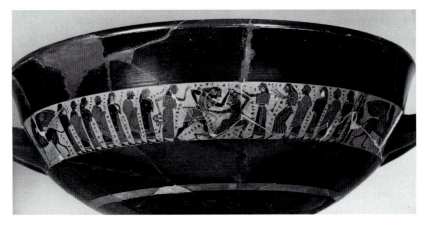

6. Theseus and the Minotaur, Attic black-figure kylix (detail). Munich, Staatliche Antikensammlungen und Glyptothek

6).[13] Once again we have a closed composition, this time with the combat of Theseus and the Minotaur in the middle, Athena at the left, and Ariadne with her nurse (identified by inscription) at the right. On both sides follow the Athenian maidens and youths, one of whom is, exceptionally, shown bearded.[14] Again, the closed nature of the composition gives the viewer the impression of a unified moment, but in reality, as has long been recognized, several details refer to events beyond the main action. Athena holds Theseus's lyre, which he will play after his victory over the Minotaur, when he leads the Geranos dance of the young Athenians. The instrument in fact appears in Theseus's hands on the early depiction by Kleitias, on the famous François Vase in Florence (fig. 7).[15] Here Ariadne once again holds out the ball of yarn in one hand, and the nurse, again identified by inscription, is also present. It is clear that both

7. Theseus and the Delian Crane Dance with Ariadne and Nurse, Attic black-figure volute krater (François Vase) (detail), drawing. Florence, Museo Archeologico

scenes contain elements that refer beyond the main action. We seem to be confronted with two alternatives in reading these images, either to break them up into temporally separate episodes, or to try to associate all the elements with the main action. The lyre truly seems to be just a pictorial symbol of the later Geranos dance, while the nurse, who doesn't belong in the Labyrinth either, nevertheless appears, because of her excited gesture, to be explicitly connected to the combat. The modern viewer, who would like to understand the picture as unified (i.e., simultaneous) narration, will have to ascribe most elements to the painter's own rewriting of the story, and the rest, which still seem to refer beyond the basic situation, will be considered additions that can, if necessary, be dispensed with. In this sense, the practice of Archaic narration is often referred to as "complementary."[16]

There are, however, two difficulties with this view. First, it is doubtful whether we can speak of a "basic situation," even in the broadest sense, since there are images, like the scene on the Boston Kirke cup, in which the figures represent several episodes of equal importance and thus no action stands out as the basic one. Second, in many cases the narrative value of persons or objects (independent of a "situation") is so obvious as to exclude the possibility that the poetic source has been rewritten. On the well-known Lakonian cup that depicts the blinding of Polyphemos, it is clear that the wine cup and the pair of legs represent a temporally separate episode in the narrative, even though they are not simply "hieroglyphs" suspended in the composition (any more than the lyre and the nurse on the Theseus cup just discussed) but are rather incorporated directly into the "main" action.[17]

The specific narrative content of an individual figure or object is particularly evident in scenes of simpler actions, in which the protagonist's outward appearance is not tied to the action. If these scenes were interpreted as free reworkings of the epic source, they would completely lose their point. As we know from Classical vase-paintings, the narrative of the Judgment of Paris first introduced the figure of Paris as the prince disguised as a young shepherd on a lonely mountainside.[18] Archaic representations, however, such as the much-discussed ivory comb from Sparta, could picture him as a bearded king with royal cloak and throne.[19] This is not another version of the myth, but rather Paris has been depicted independently of the action, that is, as something he cannot be in this "situation" but inherently is. In any case, being a shepherd is not necessarily a contradiction in a story like this, since there are a number of images in which the figure in kingly garment is combined with attributes of the shepherd, such as a dog and a rocky seat.[20] A detail such as the beard, if interpreted as a sign of age,[21] would contradict the context of the story. Apparently this is one of those elements that is independent of the nar-

rative, which should warn us not to interpret the bearded figure among the youths on the Theseus cup in Munich as simply a mistake.

A further sign that an individual figure also has these "hieroglyphic" qualities is the fact that often, while it appears in a particular narrative action, there is no narrative framework, that is, the figure looks more or less like an excerpt.[22] A good example is the bearded, running figure in the interior of a cup in Paris, whose long garment shows that he cannot be either a warrior or an athlete.[23] He is undoubtedly Paris excerpted from the scene, familiar on Attic vases that show him fleeing at the advent of the three goddesses. The remains of an inscription (now overpainted) confirm this interpretation. Even the running Gorgon, so frequently used as an emblematic figure, seems to be an excerpt as well. She is in fact one of the two sisters of Medusa, who pursued Perseus over the sea, as we can tell, for example, from an Attic cup that adds two dolphins (fig. 8) and a Corinthian oinochoe with the inscription "Sthenno" (fig. 9).[24] It is, of course, hard to say whether the Greek viewer thought of that episode every time he saw this figure in a pediment, on a gravestone, or elsewhere. What these examples show, however, is that the figure could at any time be restored to its narrative context.[25]

This kind of "hieroglyphic" narrative used even for such simple situations as the Judgment of Paris, indicates more than a primitive solution compared to more complex narrative structures. In order to define the characteristics of this method of representation, we return to the multifigure images with which we began, the adventures with Kirke and the Minotaur. If we try to look for common elements, the following three emerge:

1. They are self-contained compositions, usually evolving symmetrically outward from a central motif, in which every detail is assigned its place from the formal context of the whole.

2. In spite of the apparently self-contained composition, there is no unified action. Sometimes there seems to be a principal action that dominates, with others complementary to it.[26] But in principle each figure and each object has its own meaning, which cannot be connected to a "basic" situation, even if such a thing existed. Every figure, we might say, carries its own story within it.

3. In spite of their own particular narrative value, the figures do not simply stand as independent units but participate actively in the overall self-contained composition, such as the nurse on the Theseus cup (fig. 6). The individual "hieroglyph" has communicative potential; in fact, due to a kind of overabundance of action, it is virtually driven to participate in the quite separate episodes represented by the other figures.[27]

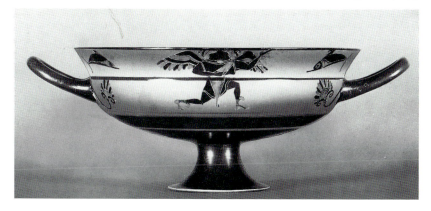

8. Running Gorgon, Attic black-figure kylix. Kassel, Staatliche Museen, Antiken-sammlung

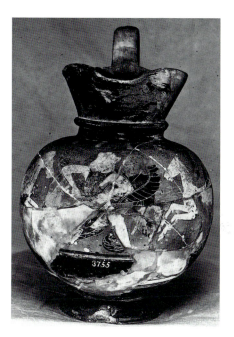

9. Gorgon, Corinthian oinochoe. Florence, Museo Archeologico

These characteristics, difficult for the modern viewer to put into words, seem to introduce insolvable contradictions into the images. Yet we have no doubt that they have an artistic unity within the definition of Archaic art. The observations listed above are not intended to be combined into a new general theory, but only for heuristic purposes. Examining the material on this basis frees us from modern preconceptions better than the various theories that

start with the notion of "complementary" narration. In addition, this approach enables us to adduce the evidence of the earliest Greek visual tradition, that of Geometric art, for a greater understanding of the phenomenon.

There is no precedent in the ancient Mediterranean for our first character-istic, the self-contained composition of the mythological narrative, and it is questionable that this was ever developed in the native Greek Geometric tra-dition. As is well known, the art of the Orient dissolved consecutive narration into a flowing juxtaposition of short episodes, in which the protagonist is re-peated several times, so-called continuous narration.[28] The familiar Phoeni-cian silver bowl, which shows a hunting expedition of the king divided up into nine scenes, represents a type that was no doubt familiar to the Greeks from such imported pieces and which, thanks to the constraints of its shape, makes a good comparison with Greek vase-paintings.[29] Alongside this, it becomes ob-vious what an achievement the invention of the closed composition of Archaic art represents. By singling out and amalgamating the various pictorial ele-ments into a complex whole, the individual object gains a tension, is made more profound and more dramatic, in a way that is foreign to Oriental images, in which tension can only be expressed through motion.[30] The self-contained composition anticipates, as we shall see, in its multilayered nature the most important qualities of Classical mythological narrative and, even after the ad-vent of continuous narration, remains as an option, indeed as the higher form of narrative.[31]

Unfortunately, we cannot answer the question whether self-contained nar-ration was familiar to Geometric art, since we have no examples of complex "historical" or mythological representations. A general examination, however, leads to the suspicion that perhaps a kind of precursor, or model, existed, though not the developed form we find in Archaic art. Out of all the images that show scenes of daily life juxtaposed in timeless fashion, we may perhaps single out one that, at least to judge from the content, does combine a tempo-ral sequence into one representation, even if depicted as timelessly as all the others (fig. 10).[32] The laying out of the dead takes place in the house (or, rather, its courtyard), while the procession of chariots takes place later, out-doors. The Geometric painter does not simply juxtapose the two scenes like a frieze, but rather, by surrounding the bier with chariots, he merges the ele-ments in a way that recalls the self-contained composition. But it does no more than recall it, for the chariots aligned in the same direction introduce the idea of a friezelike continuation. The overall composition is unique and diffi-cult to describe. It remains uniquely between the conventional alternatives of "open" and "closed."

In the present context, I am not able to explore the ramifications of the self-

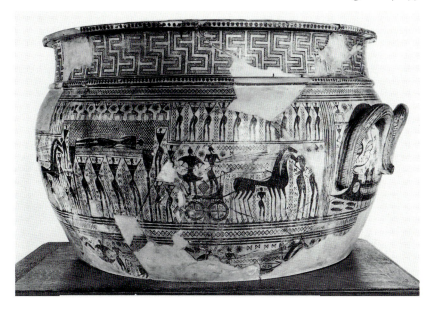

10. Prothesis and Ekphora, Attic Geometric krater. Paris, Musée du Louvre

contained composition for later art, though in some respects this is the most important issue. Instead, I would like to consider the two other observations listed above in relation to Geometric art, namely, the independent narrative value of the individual figure and its communicative potential. Even a casual look at the material shows that both phenomena are deeply rooted in the earliest Greek art. It is true that, for the modern viewer, a scene like the lion pouncing on a deer on the neck of an amphora in London (fig. 11) gives an impression of complete spontaneity. Yet in reality such scenes are completely "hieroglyphic."[33] The lion with outspread claws, raised haunches, and open jaws, the generic type for this period, occurs in very different contexts, even lined up in procession (figs. 14, 15).[34] The deer that seems to be folded upon itself is an exact duplicate of the type that is used most often to show the animal in repose (figs. 12, 13).[35] The artist's ability to reinterpret the type so persuasively already suggests the communicative potential that we have observed in Archaic narrative. This potential is evident in a most astonishing way in the sculptured and painted groups, which conjure up the feeling of a lively action through the simple combination of figures tightly joined to one another like hieroglyphs.[36] This is true, for example, of the group in Olympia, in which three dogs with the same rigid limbs fall upon a deer totally convincingly, or the oinochoe in Boston, where animals that are similarly schematic nevertheless

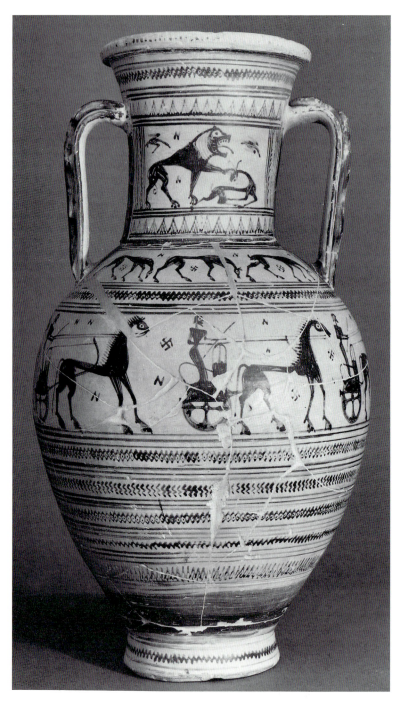

11. Lion/deer and chariot procession, Attic Geometric amphora. London, British Museum

12. Deer, Attic Geometric kantharos (detail), drawing. Copenhagen, National Museum

13. Pair of deer, Attic Geometric kylix (detail), drawing. Athens, National Museum

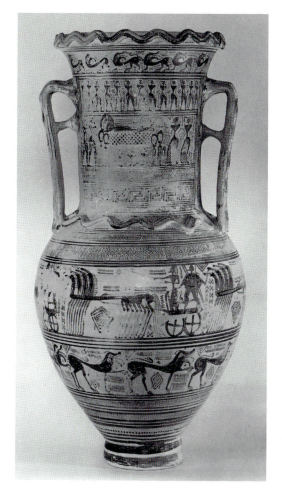

14. Procession of lions and funeral scenes, Attic Geometric amphora. Essen, Folkwang Museum

15. Lions attacking war-
rior, Attic Geometric
kantharos (detail),
drawing. Copenhagen,
National Museum

suggest a lively tumult.[37] It is only on this basis that we can understand the
group of man and centaur in New York, whose apparent lack of movement has
misled some recent observers into taking it for a peaceful group, or even the
depiction of a hieratic relationship.[38] In reality, the group depicts a combat in
full swing, as is proven by the remains of a weapon with which the human war-
rior has stabbed the monster in the ribs.

One of the characteristics of these images is the polyvalent narrative signifi-
cance within a story with which even inanimate objects may be endowed.
Thus, for example, a helmet could be taken literally if worn by the hero, but
not by the centaur, who by nature fights without any manufactured arms and
armor. And indeed Archaic art, which is quite consistent in this respect, never
shows a centaur equipped with a helmet or any other armor. For the Geomet-
ric artist, the helmet is simply a "hieroglyph" for bravery, which becomes clear
when we see it worn by hunters, for whom this detail cannot be interpreted lit-
erally.[39] Evidently, individual attributes can be used in a narrative, indepen-
dent of the "situation," even independent of the natural practices of the figure
wearing it, in a "transferred" sense that may seem at first paradoxical.[40] This
phenomenon of Geometric art may explain a characteristic of Archaic narra-
tive that is otherwise a mystery.

As in later Greek art, the Archaic artist uses the beard as a means of distin-
guishing a mature man from a youth as, for example, when Orestes kills
Aigisthos.[41] Yet with the bearded youth on the Theseus cup (fig. 6, above) and
the bearded Paris in scenes of the Judgment, we already have two instances
that seem to contradict the context of the narrative. In fact, this trait is quite
common in Archaic art on figures for whom it cannot be read literally as an in-
dication of age.[42] I need only mention figures like Apollo, Troilos, and Hyakin-
thos.[43] Apparently what we are dealing with is an attribute with independent
and "metaphorical" narrative meaning which, without being tied to a particu-
lar situation or moment in time, signifies the bravery, fortitude, beauty, and
dignity of the man who wears it. It should be recalled, as suggested earlier,

that Paris's beard must be understood together with his long robe, which like-
wise seems to contradict the actual situation. In fact, the helmet also occa-
sionally has this metaphorical use in Archaic art, at least in the case of figures
such as Apollo and Artemis, who by the Classical period no longer wore it.[44]
On Archaic and Classical monuments, we still sometimes find heroic hunters
wearing helmets in the Geometric manner.[45]

The Geometric roots of Archaic narrative can be seen even more clearly in
another phenomenon, which also provides convincing proof of the connection
between "hieroglyphic" interpretation and its almost boundless powers of com-
munication. Geometric art, which composes the human figure as if out of the
epithets of epic verse,[46] normally depicts people with slightly bent knees, in
order to convey the motion of the legs, the *laipsera gouna* of epic (fig. 10,
above). In terms of narrative, it is important to note that the Geometric artist
uses this formula quite independently of the situation, e.g., for the standing
figures in prothesis scenes, for whom this emphasis on *laipsera gouna* seems to
us rather odd.[47] In the occurrences of this epic formula for figures standing
still, the notion of a specific movement tied to a specific, instantaneous action
becomes secondary to the evocation of timeless qualities. This is surely one
basic reason why Geometric artists depict scarcely any stories from epic,
which would require the representation of a unique, unmistakable moment,
even though they had a full supply of mythological creatures in their reper-
toire.[48] A figure very like those of the mourners in a prothesis scene could also
be placed on a chariot, and the artist would not object if we were to interpret
the same pose in this context as the graceful stance of a charioteer. Further-
more, the same characteristics are found in striding figures, and even for the
dead.[49] The pose of the male figures in Archaic art, with one foot advanced,
most familiar from nude kouros statues, possesses a similar quality of latent
movement, though not as easily transferred to other contexts. Thus, for exam-
ple, the painter of a black-figure vase in Munich could use the same formula
for both standing and striding figures (fig. 16), even though the context leaves
no doubt as to the different narrative meaning of each.[50] The latent, potential
energy, which can be activated at any moment, was surely also understood in
the pose of the kouros statues, which nowadays is often erroneously character-
ized as one at rest.[51] In any case, one would like to connect this type with the
curious story of the moving statues of Daidalos, which is attested in Demokri-
tos and Euripides and surely goes back even earlier, into the Archaic period.[52]

The meaning of the Archaic stance has a close parallel in the representa-
tion of chariots, which likewise has its antecedents in Geometric art. The
horses yoked to the big Geometric chariots usually have their legs stiffly bent,
clearly recalling the *laipsera gouna* of the people and carrying a similar mean-

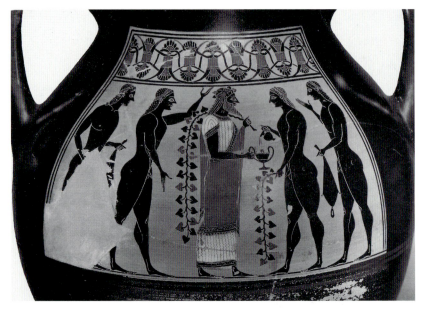

16a. Dionysos and Youths, Attic black-figure amphora (detail). Munich, Staatliche
Antikensammlungen und Glyptothek

16b. Menelaos recovers Helen, Attic black-figure amphora (detail). Munich,
Staatliche Antikensammlungen und Glyptothek

17. Chariot, Attic Geometric krater (detail), drawing. Sydney, Nicholson Museum

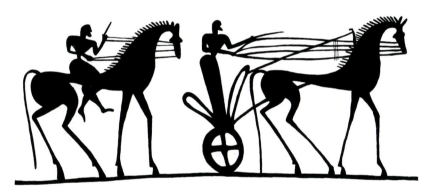

18. Single-horse chariot and horse and rider, Attic Geometric krater (detail), drawing. London, British Museum

ing (see figs. 10, 17). In the case of seeming "single-horse carts" (fig. 18), the horse is even more clearly in motion, almost as if galloping, though that is of course not necessarily its only meaning.[53] We need only observe that the horse with rider in the same scene (fig. 18) is depicted in the same manner.[54] Archaic art regularly employs a similarly mobile image of a chariot in a great variety of settings, including some when the motif would make no sense if read as actually signifying forward movement. For example, on the well-known krater once in Berlin (fig. 19), the movement of the horses accords with the figure of

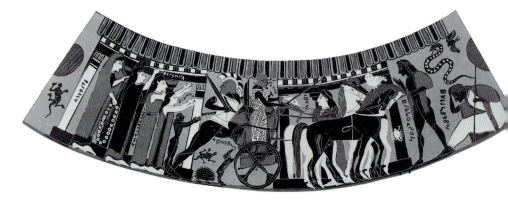

19. Departure of Amphiaraos, Corinthian krater once in Berlin (detail), drawing

Amphiaraos leaping onto the car but cannot be combined, either with the charioteer's farewell libation or with the figures lined up at the left into a temporally continuous narrative.[55] Corinthian painters even use the same type for the empty chariot that waits for Herakles during the adventure with the Hydra or the horses with their attendants who often flank scenes of warriors in combat.[56] The excess of movement that we spoke of earlier, which helps to explain the amazing communicative potential and narrative power of Archaic figures, is especially clear in this instance. Just like Daidalos's kouroi, these horses would run away by themselves, so to speak, if we did not tie them down to a specific context. Furthermore, perhaps the familiar image of the frontal chariot and rider should be understood as a deliberate contrast to the almost "automated" type of horses in profile.[57] The most logical context for these scenes is to interpret the chariot teams as standing at rest, as is clear, for example, on a shield band from Olympia with riders standing alongside.[58] This phenomenon in turn seems to have a parallel in the representation of human figures, since the rare type of the frontal standing figure is used to characterize a person standing at rest, or even a statue.[59] As a rule, however, representations of sculpture in the round share the same latent movement as those of human figures.[60]

In this context, I should like to mention another important aspect without pursuing it in detail.[61] Just as the individual figure, in carrying the action, is not embedded in a temporal or spatial continuum, neither does it represent an intrinsic continuum by means of its own movement. This is a parallel phenomenon to that which we observed of the remarkable merging of self-contained composition and independent narrative elements. Geometric art does not possess any self-contained representation of a human figure but rather endows each body part with the form that will express most clearly its characteristics.

The frontal view of the chest is especially illustrative of this notion. But in Archaic art, the profile is rather the method of representation par excellence, and, as a closed form, corresponds precisely to the new mythological narratives.[62] Just as these narratives are filled with elements that refer beyond a specific point in time, so too the profile image is filled with elements that are independent of the context of one seemingly fixed view. It is well known, for example, that even in profile figures the eye is usually shown frontal. The same is true of the representation of a cuirass, in which pieces are shown frontally within a profile image (e.g., the pectoral of the side that is turned away and the outline of the belly).[63]

The drawing of the cuirass is in turn the key to understanding the remarkable representation of the male chest as a semicircle or volute. Even this detail, which seems so appropriate to a profile form, is actually, like the volute of the cuirass, taken from another context and in origin represents the chest on the other side of the body. The same significance is manifested for figures whose movement seems to approach a three-quarter view.[64]

I cannot go into a more detailed analysis of the influence of Archaic narrative on Classical art here. The assumption often made nowadays, that the Classical mythological representation, in contrast to the Archaic, possesses a temporal and spatial unity determined by the situation, proves to be only partially true when examined more closely from this point of view.[65] Robert already called attention to one example which, although rather extreme for its time, illustrates the possibility of Archaic narrative techniques continuing well into the fifth century.[66] It is a fragmentary calyx-krater from the Acropolis showing the slaying of the Minotaur in the presence of Minos and Ariadne. The figures of four Attic kings are associated with the scene, occupying the reverse of the vase yet clearly involved in the action of the front side. Even later, at the turn of the fourth century, we find complex narratives executed in the same manner rich in allusions, for example the Attic krater decorated with the story of Iphigeneia in Tauris, inspired by Euripides' play (fig. 20).[67] The most striking single action—Iphigeneia handing Pylades the letter that will lead to the recognition—does not represent the basic situation. This would be incompatible with the arms carried by the two youths, which also occur on South Italian vases, not to mention the presence of King Thoas, whose gesture suggests that he is involved in the action.

Even in scenes that appear to be unified, a closer look will reveal that the image has been conceived not so much in terms of the situation as, rather, the narrative meaning of the individual figure. This is the case, for example, with a red-figure scene of the Judgment of Paris, in which the young shepherd on the mountain is outfitted with sceptre and civilian dress.[68] In general, the nuances

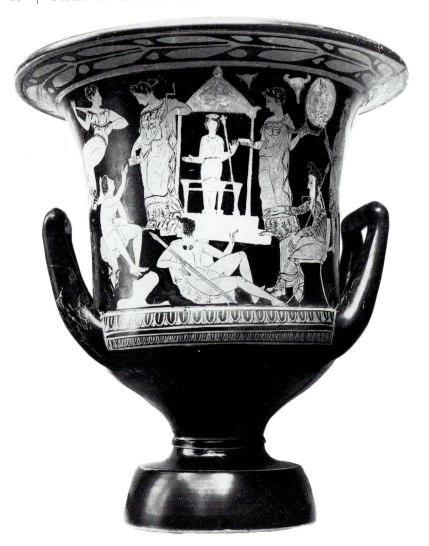

20. Iphigeneia in Tauris, Attic red-figure calyx-krater. Ferrara, Museo Nazionale Archaeologico

of Classical iconography can only be appreciated once we recognize the continuity of Archaic narrative techniques. Thus, for example, it is not sufficient to describe Odysseus's gesture on a familiar type of Melian relief simply as the greeting of a new arrival when, as the beggar, he takes Penelope by the wrist.[69] When we consider that the handshake for the Greeks is by no means an everyday gesture but is a token of a special intimacy, even between friends, then its

 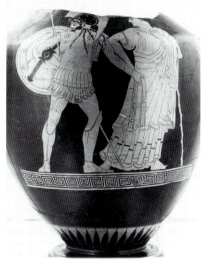

21a. Ajax, Attic red-figure amphora.
Würzburg, Martin von Wagner
Museum

21b. Hektor, Attic red-figure amphora.
Würzburg, Martin von Wagner
Museum

appearance in this situation, the entrance of a beggar before the queen, would
be quite improbable. In this case, it is not a simple handshake but rather the
erotic gesture, *cheir' epi karpōi*, that is traditionally used for a bride and groom.
The meaning of the scene is therefore multilayered. On the one hand, it is
charged with the tension that precedes the recognition, while, on the other,
the gesture designates Odysseus as the loving husband, quite independently
of the situation in which he must still be a stranger to his wife.

I end this chapter by considering the scene on an important amphora in
Würzburg by the Kleophrades Painter (fig. 21), whose interpretation, when
based on the situation alone, has predictably ended in contradiction.[70] The
painter has placed Ajax and Hektor on opposite sides of the vase; the two
heroes who in the *Iliad* end their duel peacefully, exchange gifts, and part in
mutual respect, conducted by heralds to their respective camps. The painter
has departed from Homer not only in replacing the heralds with the more im-
portant figures of Phoenix and (probably) Priam, but also in giving the two
warriors a threatening aspect, as if they could only be kept apart with great dif-
ficulty—this despite the fact that, as their swords and belts show, they have al-
ready exchanged gifts. The image thus not only departs from the poetic source
but is self-contradictory if we try to read it strictly as a self-contained action.
In reality, however, the narrative content of the individual figures goes far be-

yond the momentary action, in that they display openly their bitter hostility from the preceding struggle, even though the present situation implies a temporary reconciliation.[71] We may be reminded of those Archaic images of Paris, wearing regal dress and beard at the Judgment, thus depicted as precisely what he cannot possibly be in this very situation, yet what he intrinsically is. In the one case—Paris—the independent narrative value of the individual figure and, with it, the multilayered meaning of the scene are achieved through concrete attributes, while in the other—Ajax and Hektor—they are achieved by internal characterization. But the narrative principle is in both cases the same. The interior drama of the Classical image does not represent a contrast to the Archaic narrative but is rather its logical continuation.

Appendix: Robert's Interpretation of the Berlin Amphiaraos Krater (fig. 19, above)

Annali del' Istituto (1874) 86f.:

The meaning of the scene is clear. Amphiaraos, on the verge of departing for the fatal battle, sacrificed by his treacherous wife, now wishes to murder her, the traitor, at the very moment of his departure. What is it that holds him back? The representation on our vase seems to give the clearest answer to this question. It is his small children, who beseech him on behalf of their mother. The moment depicted has been chosen with a shrewd subtlety. If Amphiaraos had been represented threatening Eriphyle face-to-face, we might remain in doubt about the catastrophe, while if he were shown actually departing, the meaning of the scene would be rather obscure. But with Amphiaraos shown as he is, at the point of departing, with all the signs of his wrath, the painter has made us understand both what went before and what is to come.

In a nice contrast to this lively and dynamic group—the agitated hero, the suppliant children, and Eriphyle, holding the price of her betrayal and remaining cautiously at a distance—the scene on the other side is calmer. An artist of a later period would have placed all the figures in relation to the principal action. But in accordance with the practices of Archaic art, which follows principles that are similar to those of epic poetry, the persons at the right side are not concerned with those at the left. At the right we have Leontis, perhaps his wife, who offers Baton the farewell cup. In front of the horses, restraining them from leaving, stands a companion of Amphiaraos named Hippotion. Similar figures are almost always present in scenes of the departure of a quadriga. The

figure of Halimedes, who sits on the ground as if in great pain, is very difficult to explain.

It is important to note that Halimedes is the only figure who displays a profound sense of grief, which no doubt refers not to the action taking place on the other side of the scene, or to the danger facing Eriphyle, but rather to the fate of Amphiaraos who, as he himself well knows, is going to certain death.

Bild und Lied, 14ff.:

When Archaic Greek art wants to show the departure of Amphiaraos, the great king and seer, it tries to show the viewer all the episodes of the story at once: he was betrayed by his wife Eriphyle and forced to take part in the unholy expedition of the Seven Against Thebes; at first, at the height of his wrath, he wants to kill his treacherous wife but is persuaded by his children's prayers to spare her and leaves to his son Alkmaion the role of avenger. Thus the scene shows Aphiaraos, armed for battle and mounting the car in which the charioteer Baton, known from the myth, is already standing. He holds his drawn sword and looks angrily toward Eriphyle. His children stand before him: two young daughters, the youth Alkmaion, who has been chosen to avenge his father, and the little Amphilochos, whom the nurse carries on her shoulder. All of them, even the littlest, stretch their hands out to their father, pleading with him for their mother's life. She herself stands in the background, the big necklace of Harmonia, the price of her treason, in her hand. Meanwhile Baton receives a farewell drink from the housekeeper. A servant stands in front of the horses, and another figure sits mourning on the ground.

What is lacking in this representation is the clear definition and rendering of a very specific moment in the action, a particular situation, within which, or in relation to which, all the figures shown must be imagined. If that moment were the one in which Amphiaraos wants to kill his wife, then he would not already have one foot in the car and only be looking around at Eriphyle. But if it were the moment in which he has abandoned his thoughts of vengeance and prepares for departure, then he would not still be holding his drawn sword, or he would at least be in the act of replacing it in the scabbard, and the arms of the children, raised in supplication, would also be inappropriate. Eriphyle's calm demeanor is equally out of place for both situations. We would expect her either to take flight at the sight of her husband's sword or to beg for mercy, either to display fear at the threat, or joy at being unexpectedly spared. But she stands completely motionless, with no trace of emotion, calm, almost detached, holding the oversized necklace apparently more for the benefit of the

viewer than the other people in the scene. Likewise, Baton and the other attendants are not in poses that seem to correspond to the action. We would expect that, at the very moment when their master, in his wrath, is about to kill his wife, or had been just about to do so, his servants would be full of shock and horror and would be riveted to the terrifying scene. Instead, Baton calmly receives the farewell drink from the hand of the housekeeper, and no one on the right side of the scene seems even to be aware of, or to pay attention to, what is happening on the left. It is clear that what we observe at one glance cannot actually have happened simultaneously. There is no specific situation that can accommodate all the figures at once and there is no unity of action. All the figures are more or less involved with themselves, and each is caught up in one or another different moment in the action. Or rather, the painter has left the exact moment of the action undetermined. The reason for this uncertainty is that Archaic Greek art does not want to admit any limits; it believes it cannot do enough for the viewer and wants to narrate everything at once.

NOTES

This paper was first presented as a lecture in Tübingen in 1966. The following kindly provided information and photographs: D. Haynes, B. Kaeser, W. Marg, E. Rohde, K. Schefold, W. Schmoll gen. Eisenwerth, E. Simon, and E. Vermeule. In addition, K. Fittschen and H. v. Steuben made available copies of their then-unpublished dissertations: K. Fittschen, *Untersuchungen zum Beginn der Sagendarstellungen bei den Griechen* (Berlin 1969); H. von Steuben, *Frühe Sagendarstellungen in Korinth und Athen* (Berlin 1968). I have also dealt with this topic in *Zur Eigenart des klassischen Götterbildes* (Munich 1959) 20ff., 35 (included in this book, below, pp. 103–29); *Bemerkungen zur geometrischen Plastik* (Berlin 1964) 12, 15ff., 21; and in *JdI* 80 (1965) 125 n. 4.

Translation of the epigraph on p. 67, excerpted from Euripides' *Eurystheus Satyrikos* (frag. 372.2–3): "All the *daidaleia* seem to move and the statues to see, so clever is that man."

1. C. Robert, *Die Entwicklung des griechischen Mythos in Kunst und Poesie* (the title of lecture), published in *Bild und Lied: Archäologische Beiträge zur Geschichte des griechischen Heldensage* (Berlin 1881; reprint New York 1975) 4ff. Robert's progress can be seen in his interpretation of the Amphiaraos krater once in Berlin (*Bild und Lied*, 14ff.), as compared with his own treatment of the same vase in *AdI* 1874, 82ff. (see the appendix to this chapter). Robert's practical goals are most obvious in the great work of his later years, *Archaeologische Hermeneutik: Anleitung zur Deutung klassischer Bild-*

werke (Berlin 1919; reprint New York 1975), which is presented as a series of guidelines for correct interpretation. It is revealing that at first Robert did not coin any new terminology for the phenomena he had discovered. Only later, influenced by Wickhoff's expression *komplettierend*, did he use the term *kompletiv* [complementary] as a general category. The adoption of this unsatisfactory term (a step backward in comparison with *Bild und Lied*, 15f., where the problem was better understood), along with its lack of specificity, is chiefly responsible for these weaknesses in Robert's observations: 1) The idea of spatial and temporal unity is, in his view, not obligatory for Archaic art yet remains the standard measure of development (see below, n. 64); and 2) Important structural differences between time periods are not taken into account, so that, for example, he uses the term *complementary* both for the closed compositions of Archaic art and for the conflated narrative of Roman sarcophagi, which arises from abbreviations within a "continuous" representation (see below, n. 16). Also, the term *cyclical* is not used specifically enough. See also *Hermeneutik*, 100, 116, and 239, where this leads to the anachronistic notion that the Late Archaic Theseus cycle–cups have anticipated the narrative technique of medieval book illumination. For a more correct view, see E. Buschor in FR, vol. III, p. 119 and K. Weitzmann, *Illustrations in Roll and Codex* (1947; second edition, Princeton 1970) 25f.

Robert later found in Goethe a precursor of his own view (see also *Hermeneutik*, 422ff.). One could also cite in this context K.O. Müller, *Handbuch der Archäologie der Kunst*[3], revised by F. G. Welcker (Stuttgart 1878) 507, §345.** (*Ancient Art and Its Remains, or a Manual of the Archaeology of Art*, trans. J. Leitch [London 1852] 416): "In like manner, great distances in time and space are (as in the trilogies of Aeschylus) brought under view together, and the chief moments of a chain of events, although far divided, are gathered, without external separation, into *one* frame. Thus ancient art is placed in a happy medium between the hieroglyphic picture-writing of the East, and modern art, which is directed to the immediate rendering of the actual appearance. . . ."

The important observations made by G. Loeschcke on the significance of Archaic types and of the pictorial tradition are very closely aligned with the phenomena adduced by Robert. See Loeschcke's *Reliefs der altspartan Basis, Dorpater Programm* (Dorpati 1879); *Boreas und Oreithyia am Kypseloskasten, Dorpater Programm* (Dorpati 1886); *AZ* (1876) 108ff.; *Bonner Studien für R. Kekulé* (Berlin 1890) 248ff.; *AZ* (1881) 30ff. The bold observations of G. Semper, *Der Stil in den technischen und tektonsichen Künsten*[2] II (Munich 1879) 139, helped form the background to Loeschcke's thought process.

2. Boston 99.518; *ABV* 198; *Beazley Addenda*[2] 53; F. Müller, *Die antiken Odyssee-Illustrationen in ihrer kusthistorischen Entwicklung* (Berlin 1913) 52, fig. 4. On the interpretation see also C. Hofkes-Brukker, "Die Umformung des homerischen Bildstoffes in den archaischen Darstellungen," *BABesch* 15 (1940) 15ff. and fig. 4; *LIMC, s.v.* Kirke, no. 14, pl. 25.

3. In order to convey Kirke's supernatural status, the painter has rendered her not as a usual woman of this period, that is, fully dressed and with legs slightly apart, but in the male walking pose of the kouroi and in full nudity, which should also be understood as a kind of "hieroglyph." The hetairai on a cup in Paris by the Amasis Painter are characterized in the same way: S. Karouzou, *The Amasis Painter* (Oxford 1956) pl. 13; *ABV* 156.80; *Beazley Addenda*[2] 46.

4. E. Buschor, *Griechische Vasenmalerei*[2] (Munich 1921) 129.

5. *CVA* GB 13, British Museum 8, IID, pl. 9, nos. 20–21. See F. Dümmler, *JdI* 10 (1895) 41, fig. 3; E. Petersen, *JdI* 12 (1897) 55f.; *LIMC, s.v.* Kirke, no. 18.

6. A second cup in Boston (fig. 3) shows Odysseus behind Kirke and separated from her by three companions, while Eurylochos is absent: Boston 99.519; *ABV* 69.1; Beazley *Addenda*[2] 18; Müller (above, n. 2) 55, fig. 5; *LIMC, s.v.* Odysseus, no. 139, pl. 63.1.

7. On such rewriting see Robert, *Hermeneutik*, 156, 159, 168, 178; Buschor, *Griechische Vasenmalerei*[2] (above, n. 4) 85f.; K. Schauenburg, in *AA* (1962) 67 n.10, who refers to these instances as "mistakes."

8. Robert, *Hermeneutik*, 203, fig. 157; F. Lorber, *Inschriften auf korinthischen Vasen* (Berlin 1979) pl. 7; K. Schefold, *Myth and Legend in Early Greek Art* (London 1966) 87, fig. 36. On the François Vase, Odysseus wins the chariot race at the funeral games for Patroklos (J. D. Beazley, *The Development of Attic Black-Figure*[2], ed. D. von Bothmer and M. B. Moore [Berkeley 1986] pl. 26), whereas in the *Iliad* (23.499ff.) it is Diomedes. On the amphora by the Princeton Painter in Bonn (45), here fig. 4 (above), Neoptolemos brandishes the head of Astyanax: *ABV* 299.16; A. Greifenhagen, "Attische schwarzfigurige Vasen in Bonn," *AA* (1935) 420–22, figs. 12–13 (with further references).

9. M. I. Wiencke, "An Epic Theme in Greek Art," *AJA* 58 (1954) pls. 56ff. See also now *LIMC, s.v.* Priamos, nos. 87–95 (pls. 405–6); *s.v.* Astyanax I, nos. 7–29 (pls. 682–86).

10. See M. Schmidt, *Troika: Archäologische Beiträge zu den Epen des troischen Sagenkreises* (Diss. Göttingen 1917) 39ff., who assumes that the motif of dashing the boy to death was originally invented for the slaying of Troilos, then was borrowed for the death of Astyanax and combined with that of Priam. So also R. Hampe, *Frühe griechische Sagenbilder in Böotien* (Athens 1936) 84 and C. Dugas, in *AntCl* 6 (1937) 23ff. See also the earlier comments of E. Gabrici, in *RM* 27 (1912) 130, with reference to Gardner. But Robert, *Bild und Lied*, 74, and *Hermeneutik*, 159, as well as E. Kunze, *Archaische Schildbänder*, *OlForsch* II (Berlin 1950) 159ff., are correct in seeing the association of Neoptolemos, Astyanax, and Priam as an original creation, alongside the type of the death of Priam without Astyanax. While Robert, *Bild und Lied*, 74, rightly associates this type with the death of Astyanax in the *Little Iliad*, Kunze, 161, takes the simultaneous notion of the scene so far that he considers this version of the narrative virtually precluded by the representations. This is now rectified by H. von Steuben (above, first unnumbered note) 70.

11. Robert, *Bild und Lied*, 74; *Hermeneutik*, 159; and the passages cited in Hampe and Kunze in n. 10 above.

12. See also the variant in which Priam lies already dead on the altar: e.g., the pyxis Berlin 3988; *AJA* 58 (1954) pl. 56.7; *LIMC, s.v.* Astyanax I, no. 10, pl. 683; see also the amphora illustrated here (fig. 4).

13. *ABV* 163.2; Beazley *Addenda*[2] 20; FR, III, 219ff. and pl. 153.1; *LIMC, s.v.* Theseus, no. 233, pl. 66.1.

14. See Buschor in FR, III, 221 ("schon bärtige Knaben").

15. Florence, Mus. Arch. 4209: *ABV* 76.1; Beazley *Addenda*[2] 21; FR, III, pls. 1–3, 11–13; *LIMC, s.v.* Meleagros, no. 7, pl. 208.

16. E.g., Robert, *Hermeneutik*, 142, evidently derived from F. Wickhoff, *Die Wiener Genesis* (Vienna 1895) 9. According to Robert's definition, "All persons either involved in the action or having an interest in it are brought into the picture" (p. 142). Accord-

ingly, the term is used primarily to refer to subsidiary figures (ibid., 147, 155, 201, 278, 283). Nevertheless, other contexts are also suggested: "It is likewise a consequence of the complementary method of narration when, in Archaic representations, the unity of place is disregarded just as is the unity of time, and many sequential moments are combined into one" (p. 148 and see also p. 167). According to *Bild und Lied*, 16, where the expression *complementary* is not yet employed, the reason for this phenomenon is that Archaic art "believed it could not do enough to satisfy the viewer and wanted to tell everything at once" (see also 21f.). In *Hermeneutik*, Robert extends the idea of complementary narration to Roman art and in fact sees it as a characteristic of ancient narration in general: "Even the art of the Imperial period employs it, almost more strongly than ever" (p. 171 and see also 141, 173, 176, 186, 192, 288). We should, however, make a clear distinction between the use of abbreviation in continuous narration (e.g., on Roman sarcophagi) and the self-contained compositions of Archaic narrative. In situations of contamination in later art, the narrative value of the single figure is not derived from its "hieroglyphic" nature or its communicative potential. Rather, it represents an excerpt from a specific phase of continuous narration. The combination of figures does not result in a self-contained composition (even if it has that appearance), but only in a series of symbols, most of which have in any case a continuous character. See Weitzmann, *Roll and Codex* (above, n. 1) 25f. As an allusion to literary models, Robert occasionally uses the terms *contaminating* and *eclectic* of Archaic representations, in the sense of a decreasing selection: *Hermeneutik*, 157.

17. Robert, *Hermeneutik*, 182, fig. 141; C. M. Stibbe, *Lakonische Vasenmaler des sechsten Jahrhunderts v. Chr.* (Amsterdam-London 1972) pl. 94.1.

18. See Himmelmann, *Eigenart*, figs. 15, 17, 18 (here, figs. 27, 28, 29).

19. R. Hampe in *Neue Beiträge zur klassischen Altertumswissenschaft: Festschrift B. Schweitzer*, ed. R. Lullies (Stuttgart 1954) pls. 11–12; *LIMC*, s.v. Paridis Iudicium, no. 22, pl. 109.

20. Dog: J. D. Beazley, *The Development of Attic Black-Figure* (Berkeley 1951) pl. 15.1 (second edition 1986, pl. 35.3); *LIMC*, s.v. Hermes, no. 455b, pl. 238; *ABV* 108.8; *Beazley Addenda*[2] 29 (below, fig. 26). Rock: CVA D3, Munich 1, pls. 27.4, 28.5 (no. 1392); *ABV* 281.16; *Beazley Addenda*[2] 73; C. Clairmont, *Das Parisurteil in der antiken Kunst* (Zurich 1951) K 55.

21. See K. Schefold, *Frühgriechische Sagenbilder* (Munich 1964) 78 (*Myth and Legend in Early Greek Art*, trans. Audrey Hicks [London 1966] 82).

22. I use the expression *hieroglyphic* to mean the phenomenon that every figure and every object has by nature its own narrative value, which cannot be tied to any one "basic" situation. See further below. I use the term, as also *metaphoric* below, purely for convenience. In both cases, these phenomena combine the intrinsic qualities with fully realized manifestation of the object, in a way that is difficult to grasp. I plan to examine the problems that this implies, including the existence of a conception of reality entirely different from our own, in a study of the meaning of ornament in Geometric vase-painting, first presented as a lecture in the winter of 1966 and which has now appeared as: "Über einige gegenständliche Bedeutungsmöglichkeiten des frühgriechischen Ornaments," *AbhMainz* (1968) no. 7.

23. CVA F 12, Louvre 8, III He, pl. 77.12. See also *JHS* 53 (1933) 310, and Himmelmann, *Eigenart*, 22. Similar figures who show this excerpted quality include the Dolon on the cup in Brussels illustrated by Robert, *Hermeneutik*, 203, fig. 157a (*LIMC*, s.v.

Dolon, no. 1, pl. 525), or the fleeing centaur on the cup in Basel: *ABV* 60.6; *Beazley Addenda*[2] 16; K. Schefold, *Meisterwerke griechischer Kunst*[2] (Basel-Stuttgart 1960) 151, no. 130. According to an attractive suggestion of K. Schefold, the warrior in the tondo of the cup in Kassel (T663: *LIMC, s.v.* Achilleus, no. 22, and further below, n. 24) represents Achilles waiting in ambush from the Troilos story; see also Schefold, *Führer durch das Antiken-Museum Basel* (Basel 1966) 62, no. 102.4.

24. Attic black-figure cup, now in Kassel (T663): *Kunstwerke der Antike*, Münzen und Medaillen Auktion 22 (1961) pl. 35, no. 122; *LIMC, s.v.* Gorgo, Gorgones, no. 236, pl. 178. For the Corinthian oinochoe in Florence (3755), see H. Payne, *Necrocorinthia: A Study of Corinthian Art of the Archaic Period* (Oxford 1931; reprint College Park [MD] 1971) 96; *LIMC, s.v.* Gorgo, Gorgones, no. 241, pl. 179. Kunze, *Archaische Schildbänder* (above, n. 10) 66, explicitly rejects the possibility of "hieroglyphic" meaning for this type of Gorgon, whereby the visual tradition, which, typologically at least, looks consistent, becomes artificially divided. For the opposing view see H. Besig, *Gorgo und Gorgoneion in der archaischen griechischen Kunst* (Diss. Berlin 1937) 43ff., and the following note.

25. Even in the case of the Gorgon on the Korfu pediment, who is identified as Medusa by the presence of her two children, the emblematic character, though no doubt dominant, does not exclude a narrative content. For a different interpretation see Robert, *Hermeneutik*, 149, and E. Kunze, "Zum Giebel des Artemistempels in Korfu," *AM* 78 (1963) 74–89. There is no justification for the antithesis postulated by Kunze (p. 79) between a "timeless representation, rather than an excerpt from the temporal sequence of an event." Temporal sequence, as the above-mentioned excerpts show, is not a method used by Archaic mythological narrative. Kunze's argument leads to equally unsatisfactory alternatives in his discussion of the *Knielauf* and of the Selinus metope (pp. 74 n. 1; 78 n. 16). There is likewise no good reason to posit these and related representations as a contrast to the Hesiodic folk tradition, as Kunze does (p. 84). In fact they fit more easily into that tradition as visual symbols with narrative reference. This is proved by the simple observation that the master of the Selinus metope could use this same type to represent the Perseus myth. See Kunze in *AM* (1963) 78 n. 16, who doubts the narrative allusion of the metope and writes that it "does not really (?) show the birth of Pegasos, but borrows for Pegasos (?) the type of image of Medusa that was especially widespread in Sicily."

26. G. M. A. Hanfmann, "Narration in Greek Art," *AJA* 61 (1957) 74, speaks of a "major action." See also E. Vermeule, in *BMFA* 63 (1965) 47.

27. See *Eigenart*, 20f. The result of these characteristics is that we cannot even speak of a "situation" in Archaic narrative, in the strictly temporal sense, but only as a convenience. The Archaic equivalent of the notion "situation" is the self-contained composition as a form that has tension and movement, but no continuous flow of time, no defined moment.

28. See the collection of papers on narrative in *AJA* 61 (1957) 44ff., in particular, for Greek art, the valuable contribution of G. M. A. Hanfmann, 71ff.

29. See Robert, *Hermeneutik*, 101, fig. 84; G. Markoe, *Phoenician Bronze and Silver Bowls from Cyprus and the Mediterranean* (Berkeley 1985) cat. E2, figs. on 278–83.

30. It is impossible to say for certain whether Archaic Greek art, alongside its self-contained compositions, also produced images in the Oriental narrative technique, as Schefold, *Frühgriechische Sagenbilder* (above, n. 21) 70, 91 (English edition, 74, 96),

seems to assume. The possibility cannot be completely dismissed. Even in the Classical period, we have a monument of popular art that apparently combines in one scene the same figure in three separate episodes: U. Hausmann, *Kunst und Heiligtum: Untersuchungen zu den griechischen Asklepiosreliefs* (Potsdam 1948) fig. 2. From the Archaic period, no certain example survives. The Etruscan works discussed by L. Curtius in *Festschrift P. Arndt* (Munich 1925) 36ff. are quite uncertain in this respect. Robert, *Hermeneutik*, 116ff., does interpret the black-figure scenes in his figs. 90–91 as examples of continuous narration. Another questionable example is the Polyphemos scene on a black-figure oinochoe, C. H. E. Haspels, *Attic Black-Figured Lekythoi* (Paris 1936) pls. 42, 3a–b. In early red-figure, there are the well-known cups that depict the struggle over the arms of Achilles or the death of Troilos in a sequence of actions that are very close in time, but always in self-contained compositions. The familiar Oriental type of heraldic groups do not have closed compositions in the Greek sense, but rather movable elements and symbols which can be arranged into a frieze.

31. See also Aristotle's requirements for the internal unity of action in tragedy, as opposed to historical representation, which achieves its unity only through time: *Poet.* 23f. (1459a–b) and *passim*.

32. Paris, Louvre A517: G. Ahlberg, *Prothesis and Ekphora in Greek Geometric Art* (Göteborg 1971) 25, no. 4, figs. 4a–e; J. M. Davison, *Attic Geometric Workshops*, YCS 16 (New Haven 1961) figs. 3, 24. See also H. Marwitz, "Das Bahrtuch. Homerische Totenbrauch auf Geometrichen Vasen," *Antike und Abendland* 10 (1961) 13f.

33. On this late Geometric amphora, London, British Museum 1936.10–17.1, see Arias-Hirmer, pl. 10; Davison, *Attic Geometric Workshops* (above, n. 32) fig. 55. On the representation of the lion in Geometric and Protoattic, see Davison, figs. 61, 64, 128, 130; also R. Hampe, *Ein frühattischer Grabfund* (Mainz 1960) 39, fig. 21. For the recumbent deer alone, see also Arias-Hirmer, pl. 8, and P. Courbin, *La céramique géometrique de l'Argolide* (Paris 1966) pl. 41.

34. Kantharos, Copenhagen, National Museum 727: B. Schweitzer, *Greek Geometric Art*, trans. P. and C. Usborne (New York 1971) fig. 69; T. Rombos, *The Iconography of Attic Late Geometric II Pottery* (Jonsered 1988) 499, no. 305, pls. 37c, 39a. Amphora, Essen, Folkwang Museum K 969: ibid., 446, no. 169; Ahlberg, *Prothesis and Ekphora* (above, n. 32) 28, no. 41, figs. 41a–f.

35. Athens, National Museum 866: *AJA* 44 (1940) pl. 26.2; Davison, *Attic Geometric Workshops* (above, n. 32) fig. 20.

36. See E. Hinrichs, *Totenkultbilder der attischen Frühzeit (Frühe attische Kultdarstellungen* [Diss. Munich 1951]) (Saarbrücken 1955) (*Annales Universitatis Saraviensis* IV [1955] no. 3) 128; Himmelmann, *Bemerkungen*, 12.

37. Himmelmann, *Bemerkungen*, fig. 42; for the Boston vase see A. Fairbanks, *Catalogue of Greek and Etruscan Vases* (Cambridge [MA] 1928) no. 269b and pl. 23; R. Hampe, *Die Gleichnisse Homers und die Bildkunst seiner Zeit* (Tübingen 1952) pls. 5–6.

38. See Himmelmann, *Bemerkungen*, 12; Schefold, *Frühgriechische Sagenbilder* (above, n. 21) 19 (English edition, 21).

39. Himmelmann, *Bemerkungen*, 12. See also A. von Salis, *Neue Darstellungen griechischer Sagen* (*SBHeid.* 1935–36 [1936–37]) I, 44 n. 3 and F. Willemsen, in *JdI* 70 (1955) 94.

40. See above, n. 22.

41. E.g., Schefold, *Frühgriechische Sagenbilder* (above, n. 21) text fig. 44; see also pl. 36a, where both are bearded, and pl. 80, where both are beardless, if this is the correct interpretation. For an Early Classical example, see *JdI* 29 (1914) 30, fig. 3 (*ARV*² 208.151). The impression given by published illustrations of the metope from the Foce del Sele, that a bearded Orestes is attacking a beardless Aigisthos, has been shown to be erroneous by the excavators: P. Zancani Montuoro and U. Zanotti Bianco, *Heraion alla Foce del Sele* II (Rome 1954) pl. 88 and p. 278. In terms of iconography, however, this variant is not at all inconceivable. The distinction between bearded and beardless is a standard part of the imagery of *erastēs* and *eromenos*: see K. Schauenburg, "Erastes und Eromenos," *AA* (1965) 849–67.

42. This remarkable phenomenon has been commented on by archaeologists since the early nineteenth century: see F. Creuzer, *Deutsche Schriften* II, part 2, vol. 1 (Leipzig 1836–47) 145; F. G. Welcker, *Alte Denkmäler* V (Göttingen 1864) 375f., 450. Robert, *Hermeneutik*, 19, tried to resolve the problem by suggesting that only the first down of the beard is intended, but this is contradicted by scenes by the Amasis Painter and others, who clearly distinguish the full beard from the first down. See Karouzou, *The Amasis Painter* (above, n. 3) pls. 3, 13, 18 (*ABV* 150.7; 156.80; 152.30; *Beazley Addenda*² 42, 46, 44). On the mistaken notion, argued by J. Fink and W. Zschietzschmann, that the beards reflect religious-historical change, see Himmelmann, *Eigenart*, 35f. (trans. below, p. 130 n. 7).

43. For Apollo see W. Zschietzschmann, *Welt als Geschichte* 1 (1935) 21ff. Apollo in an assembly of the gods on a pyxis in Florence has the first down of a beard (here, fig. 50): L. Milani, *Monumenti scelti del R. Museo archeologico di Firenze* (Florence 1905) pl. 1; *MarbWPr* 1960, pl. 7, right. For Troilos see *ActaArch* 15 (1944) 148. For Hyakinthos see Pausanias 3.19.4. For another example see J. Fink, in *Hermes* 80 (1952) 110ff. and K. Schauenburg, *Perseus in der Kunst des Altertums* (Bonn 1960) 117.

44. See *JBerlMus* 1 (1959) 10ff. and figs. 4, 6, 7; also the bronze statuette in Berlin, K. Neugebauer, *Die minoischen und archaischen griechischen Bronzen* (Berlin 1931) 214, pl. 39. See also L. Preller, *Griechische Mythologie*⁴, revised by C. Robert (Berlin 1894) I, 274 n. 3. Images of Apollo wearing a helmet because of the nature of a particular dedication may have occurred after the end of the Archaic period.

45. E.g., the Dodwell pyxis, Munich 327: Payne, *Necrocorinthia* (above, n. 24) 305–6, no. 861, and 163, no. 11; D. A. Amyx, *Corinthian Vase-Painting of the Archaic Period* (Berkeley 1988) pl. 86:1a–b. See also the frieze from Gjölbaschi: F. Eichler, *Die Reliefs des Heroon von Gjölbaschi-Trysa* (Vienna 1950) pls. 8–9.

46. See B. Snell, *Die Entdeckung des Geistes*² (Hamburg 1955) 17ff. (*The Discovery of the Mind in Greek Philosophy and Literature*, trans. T. G. Rosenmeyer [New York 1982] 1ff.); Himmelmann, *Bemerkungen*, 13, 16f.

47. Himmelmann, *Bemerkungen*, 17f.

48. See now the broad and thorough study by K. Fittschen (above, first unnumbered note), which does not, however, deal with this particular point.

49. For charioteers see F. Matz, *Geschichte der griechischen Kunst* (Frankfurt/Main 1950) pl. 10; see also the bronze from Olympia, ibid., pl. 29a. For what may be a striding figure, see Davison, *Attic Geometric Workshops* (above, n. 32) figs. 10, 11, 13, 16, 33. For dancers see Matz, *Geschichte*, pl. 12. For dead figures see Matz, pls. 10, 13, but see also Himmelmann, *Bemerkungen*, 21 and fig. 2.

50. *CVA* D 3, Munich 1, pl. 21; Karouzou, *The Amasis Painter* (above, n. 3) pls. 3 and

6; *ABV* 150.7; *Beazley Addenda*[2] 42. One side shows a youth pouring wine for Dionysos, the other, the recovery of Helen by Menelaos. Within the single type, however, there are slight variations, so that the legs of the striding figures are somewhat further apart than those of the standing ones. See also E. Kunze, *Bericht über die Ausgrabungen in Olympia*, VII (Berlin 1961) 171.

51. E.g., G. Hafner, *Geschichte der griechischen Kunst* (Zurich 1961) 109. This interpretation has a long tradition, connected with the derivation of the kouros type from Egyptian prototypes with their supposedly immobile stance. Aside from the dubious nature of this derivation (see Himmelmann, *Bemerkungen*, 18f., 22), it would be incorrect to assume that the Egyptian figures in question are at rest, rather than that they too have a "hieroglyphic" meaning, that is, latent movement. Egyptologists still dispute this, however. For example, W. Wolf, *Die Kunst Agyptens* (Stuttgart 1957) 132f., explicitly rejects the possibility of movement: "The standing pose is thus an expression of the corporeal sensation of rest, of being, and embodies so perfectly the banishing of temporal anxiety that it henceforth became as popular for funerary sculpture as the seated pose." Yet Wolf himself also mentions characteristics of the standing pose that undoubtedly signify movement. His statement is therefore fully applicable only to the early years of the Old Kingdom. See also ibid., 281, on Egyptian two-dimensional representation. For an ancient viewer like Diodoros, there was no contradiction between the Egyptian influence on Greek art and the amazing movement of the statues made by Daidalos: Overbeck, *Schriftquellen*, nos. 128 and 138. For earlier opinions on this question, see J. J. Winckelmann, *Geschichte der Kunst des Altertums*, ed. J. Lessing (Dresden 1764) 20 (on a kouros statuette in the Nani Collection) and 40 (a characterization of comparable Egyptian figures); Winckelmann, *The History of Ancient Art*, trans. G. Henry Lodge (New York 1968) 34 [I.1.§12], 63ff. [II.1.§1ff.]. Winckelmann does not derive the Greek type from the Egyptian but considers it comparable. See also H. Brunn, *Griechische Kunstgeschichte* (Munich 1893–97) II.94: ". . . not as an expression of striding, but rather of arriving at a stable point of equilibrium in standing." There follows, on pp. 95ff., Brunn's fundamental statement of "the difference in formative principles of Greek and Egyptian art," deriving from an early work of 1856. See also J. Lange, *Darstellung des Menschen in der älteren griechischen Kunst* (Stuttgart 1899) 53. W. Deonna offers the technical explanation, in *Les 'Apollons archaiques'* (Geneva 1909) 25f.; 57ff.: "The advancing of one leg does not mean that the figure is walking, as has sometimes been maintained [e.g., T. Homolle, in *BCH* 24 (1900) 450]; the figure is at rest, and the separation of the legs serves only to give it stability." Homolle had expressed the view that the kouroi from Delphi, unlike other "motionless" kouroi, are represented in motion, drawing the cart. E. Buschor, who gives a penetrating analysis of the "inner movement" of Archaic kouroi, maintains both the Egyptian origin of the motif and the interpretation of the pose as one at rest: *Die Plastik der Griechen*[2] (Munich 1958) 17, 19, 30, 47, 58. See also Buschor's *Frühgriechische Jünglinge* (Munich 1950) 5. His often-quoted formulation of the "Ewigkeitshaltung" of Archaic statues was no doubt partly derived from this mistaken belief (*Die Plastik der Griechen*[2], 58). On this problem see also the apposite observations of Kunze, *Bericht über die Ausgrabungen in Olympia,* VII (above, n. 50) 171. The marked walking pose of the figure discussed here is made possible by the narrative context of several figures lined up as in a relief (see above, n. 50). If the same motif is less pronounced in single, three-dimensional figures, that is a consequence of the genre of monumental sculpture and does not imply a contrast between

"standing" and "walking." Likewise, the differentiation that we find in the scenes on the amphora illustrated in figs. 16a–b above should not lead to such an inference, because of the constraints of the different media. The persistence of an ambivalence between rest and movement in the standing pose of Classical sculpture must surely be a consequence of the Archaic type. The apparent discrepancy in the pose of, say, the Polykleitan Diadoumenos (A. Furtwängler, *Meisterwerke der griechischen Plastik* [Leipzig-Berlin 1893] 444; *Masterpieces of Greek Sculpture: A Series of Essays on Greek Art* [New York 1895, reprint Chicago 1964] 244; see also F. Hiller, *MarbWPr* [1965] 8f.), shows that even the Classical figure has an "overdose" of the motif, that is, movement independent of the situation, which can assume a variety of narrative meanings or temporal nuances, depending on content and context (e.g., the Diomedes from Cumae, whose movement alludes to a specific episode). Of course this type of narrative is also subject to a stylistic development. Yet, for these same reasons, I cannot agree with F. Hiller when, in his pioneering study (ibid., 8f.), he attributes to this phenomenon only a formal meaning. The Archaic stance is only one aspect of a larger complex of issues, to which the position of the arms (see *JdI* 80 [1965] 125; and now Himmelmann, "Die 'Schrittstellung' des polykletischen Diadoumenos," trans. below, pp. 156–81) and the "Archaic smile" as a facial expression—that is, the mobility of the expression—also belong. Just how little determined by situation the Archaic smile is, is illustrated by such figures as Chrysaor in the Korfu Pediment, Bluebeard from the Acropolis, the Boreads and Harpies on the ivory appliqués from Delphi, Apollo in the Gigantomachy on the Siphnian Treasury Frieze, the warriors on the older Aegina Pediment (where at least the expression of the dying figure is somewhat different), the Amazon being abducted in the Eretria Pediment, Theseus and his female opponent on the Athenian Treasury metope, Athena on the amphora in Munich by the Andokides Painter, and many others. See also the interesting exchange between H. Kenner, *Weinen und Lachen in der griechischen Kunst* (Vienna 1960), and E. Simon, in *Gnomon* 33 (1961) 646ff., which I cannot discuss further here.

52. Overbeck, *Schriftquellen*, 15ff., nos. 119ff. For Demokritos see H. Diels, *Die Fragmente der Vorsokratiker*[6], ed. W. Kranz (Berlin 1951–52) II.109.27 (fr. 104 = Aristotle *De An.* 406b). See also Homer's automated figures and utensils belonging to Hephaistos (*Iliad* 18.373–77). For further discussion see Kenner (above, n. 51) 65f.

53. See Davison, *Attic Geometric Workshops* (above, n. 32) figs. 3, 10c, 21, 23, 25, and see also figs. 24, 55, 93, 98. The sense of movement is also indicated by the horses standing on the tips of their hooves, as on the Sydney krater 46.41 (fig. 18), on which see Ahlberg, *Prothesis and Ekphora* (above, n. 32) 26, no. 14, figs. 14a–d. I cannot offer here a complete typology of Geometric chariots, which would prove to consist of relatively few basic forms, despite the impression of great variety.

54. Krater in London, British Museum 1899.2–19.1: Matz, *Geschichte* (above, n. 49) pl. 14. See also Davison, *Attic Geometric Workshops* (above, n. 32) figs. 58, 70.

55. Formerly Berlin F 1655: Amyx, *Corinthian Vase-Painting* (above, n. 45) 263; FR, III, pl. 121 (whence our illustration). See W. Wrede, "Kriegers Ausfahrt in der archaisch-griechischen Kunst," *AM* 41 (1916) 241, the only scholar, as far as I can see, who has so far touched on this phenomenon.

56. Payne, *Necrocorinthia* (above, n. 24) 127, fig. 45. See also the chariots in the second and fourth scenes of the Phoenician silver bowl illustrated by Robert, *Hermeneutik*, 101, fig. 84, which lead us back to the question of the relationship between Greek

and Oriental art. When Beazley says of a Corinthian scene, "the horses are at the walk" (Ἑλένης ἀπαίτησις [London 1958] 237), this is already, in the light of the examples considered above, an overstatement.

57. On "automata" see above, n. 52, and Hanfmann, *AJA* 61 (1957) 74. On frontal horses see Payne, *Necrocorinthia* (above, n. 24) 74f., and Hafner in n. 58, following.

58. G. Hafner, *Viergespanne in Vorderansicht* (Berlin 1938) 47, 59. See Kunze, *Archaische Schildbänder* (above, n. 10) pl. 46, XVIIIa. But see also also Schefold, *Frühgriechische Sagenbilder* (above, n. 21) 84 (English edition, 88) and pl. 76a. With profile horses, the motif of standing at rest is only developed out of the generalized image with the scenes of the harnessing of the chariot: see Wrede, *AM* 41 (1916) 335ff. On a Protocorinthian aryballos in Berlin (*AA* 1895, 34, fig. 5), the type of moving horses even occurs in a harnessing scene.

59. E.g., a relief in Chania: F. Matz, *Forschungen auf Kreta* (Berlin 1951) pl. 56.5. See also the figure of "Kybele" on a black-figure amphora, "Statuen auf Vasenbilder," *JdI* 52 (1937) 39, fig. 5. On the warrior standing beside the horses, see n. 58, above. But see also the Athena on a black-figure amphora, G. M. A. Richter, *The Furniture of the Greeks, Etruscans and Romans* (London 1966) fig. 95.

60. K. Schefold, *JdI* 52 (1937) 30ff.; Beazley, *Development* (above, n. 20) pl. 18 (second edition, pl. 92.1).

61. See also my comments in "Archaischer Bronzekouros in Wien," *JdI* 80 (1965) 125.

62. See Himmelmann, *Bemerkungen*, 21f., where I try to demonstrate the connection between the profile figure and the new, self-contained nature of Archaic sculpture and the concept of the "view." H. Marwitz's review, in *GGA* 218 (1966) 220ff., which is no doubt serious and well-informed, nevertheless confuses this point and virtually the entire content of the brochure as well. For example, in the passages cited from Matz and Kunze on p. 222, the terms "cubic," "four-sided angularity," and "development of the frontal view" are applied to works of Geometric sculpture. One of my main concerns was to show that these notions, which were formulated to describe Archaic sculpture, do not capture an essential feature of the Geometric. Marwitz's association of these citations with my discussion on pp. 12 and 14 is thus completely erroneous, since I do not even speak of four views, but say only that the parts of the body are lined up at right angles to one another. Cf. p. 25, where this is further clarified with a reference to the median line of intersections. As far as his accusation that my methodology opens up an unnatural gulf between Geometric and Archaic art, see 22 n. 55, and "Der Mäander auf geometrischen Gefäßen," *MarbWPr* (1962) 34, where I explicitly warned against such a misunderstanding. My observations are entirely consistent with the differentiation that is already implicit in the conventional designations of "Geometric" and "Archaic." My proposed method results in a process of development within Greek art itself, while usually Oriental art is considered to be the determining influence. See also my comments in n. 48. I shall not respond to other instances of Marwitz's confusion, as on pp. 225f. and 228.

63. See also Beazley, *Development* (above, n. 20) pl. 14.2 (second edition, pl. 33.1), and G. Bruns, *Antike Bronzen* (Berlin 1947) 29, fig. 18.

64. For example, Lydos regularly places the pectoral muscle for his profile figures at the outer contour: G. M. A. Richter, "Lydos," *MMS* 4 (1932–33) 170, pl. 1, fig. 1; *ABV* 108.5; and an amphora in Nicosia (C440): *ABV* 109.28; V. Karageorghis, *Treasures in the*

Cyprus Museum (Nicosia 1962) pl. 27.2; J. D. Beazley, *Some Attic Vases in the Cyprus Museum*[2], ed. D. C. Kurtz (Oxford 1989) pls. 4–5. The Amasis Painter, in contrast, can also put it on axis: Karouzou, *The Amasis Painter* (above, n. 3) pls. 1, 5, 13 (*ABV* 150.2, 150.8, 156.80). On the interpretation of this detail, see also Richter, "Lydos," fig. 1, and Arias-Hirmer, pl. 52, by the Phrynos Painter (Würzburg 241: *ABV* 169.5). Both ways are already seen on the Acropolis fragment, Schefold, *Frühgriechische Sagenbilder* (above, n. 21) pl. 65, showing Melanios and Iphitos (*LIMC, s.v.* Peliou athla, no. 8, pl. 484). In other words, the contour of the chest in profile figures also signifies the contour of the figure as turned away from the viewer, while the contour of the back also signifies the figure as turned toward the viewer. This ambivalence also had antecedents in Geometric art, where the breasts may be shown on both sides of the chest or both on one side of the triangle representing the torso. The representation of the male chest described for black-figure, which is only one of several possibilities, finds a parallel in the construction of female draped figures. For women wearing either the peplos or the chiton, the breast turned away from the viewer may be incorporated into the forward contour: e.g., Arias-Hirmer, pls. 46 (handle of the François Vase), 67 (amphora of Psiax in Brescia: *ABV* 292.1). See also the frequent phenomenon that elements of the frontal view are not cut off in profile but are completely and intelligibly incorporated: the crease in the middle of the lower part of the peplos, the fastening of the shoulder-pieces of the cuirass, the middle of the leg bone, the joints, the opening in the mantle, etc. These phenomena have nothing to do with the "point of view," as is clear from such extraordinary features as the curving of the soles of both feet for walking figures, the depiction of both spiraling flanks of the greaves of profile figures, the transfer of elements of the back to the front side of a figure (e.g., in the draping of a short mantle or the attachment of wings), the relation of belt to overfold, the drapery of Beazley's "penguin" women, whose garments seem to be cut out in a concave shape, and the confusion of front and back when figures overlap. See also the remarkable depiction of the eye of a dead person in Schefold, *Frühgriechische Sagenbilder* (above, n. 21) pl. 61b; *Paralipomena* 42; *LIMC, s.v.* Meleagros, no. 9: a diagonal line across the eyeball, which nevertheless has a reserved area around it as in representations of the open eye. I should like to present elsewhere a more detailed investigation of the human figure in black-figure. B. Kaeser is preparing a related study of chariots, utensils, buildings, etc., in black-figure (now published as *Zur Darstellungsweise der griechischen Flächenkunst von der geometrischen Zeit bis zum Ausgang der Archaik* [Diss. Bonn 1981]).

65. According to Robert, *Bild und Lied*, 29, fifth-century drama leads to the unity of the representation around a given situation: "The uncertainty and imprecision of Archaic representations have disappeared. The artist has in mind a very specific moment, the most dramatic one, and all the figures in the scene are conceived of at this very moment and as closely connected as possible with the principal group." In accordance with this, classicism continues to be measured against the standard of spatial and temporal unity. By this standard, the Medea krater in Munich (*LIMC, s.v.* Medeia, no. 29, pl. 197) seems to fall short of perfection, even if "it is conceivable that all these actions could come together in a single moment" (Robert, *Bild und Lied*, 41). The same view is retained in principle in his *Hermeneutik*, though formulated with greater restrictions. Robert writes, "that Greek art first achieves, gradually and evidently under the influence of drama, the creation of a perfectly unified representation, in which all the figures can be related to the principal action, and that even then slight traces of dishar-

mony may remain" (184 and see also 208). The interpretation of the Medea vase is accordingly modified in *Hermeneutik*, 163ff. The artificial solution of positing that the unity of the moment is theoretically conceivable is no longer decisive, and instead several elements of the scene are admitted that appear to refer beyond the one moment. The requirement is enforced even less stringently for other Classical images (pp. 147ff.). Buschor in FR, III, 127, who cites Robert's *Hermeneutik* on this point, writes that "the drawing together of the principal actors of the story into a pictorial unity" is also in the Classical age a possibility that is taken for granted. In more recent scholarship, however, this important nuance has curiously been overlooked. See, e.g., Weitzmann, *Roll and Codex* (above, n. 1) 12ff., 17, where the interpretation of the Medea vase is again derived from Robert in *Bild und Lied*. See also Hanfmann, in *AJA* 61 (1957) 76, and U. Hausmann, *Hellenistische Reliefbecher aus attischen und böotischen Werkstätten* (Stuttgart 1959) 11. I cannot here go into the issue of the positive characteristics of Classical myth scenes, one of which is certainly the existence of unifying moments. Robert had already made some important comments on this topic as well.

66. Robert, *Hermeneutik*, 142f. and figs. 111f.; B. Graef and E. Langlotz, *Die antiken Vasen von der Akropolis zu Athen* II.2 (Berlin 1931) no. 735, pl. 61; *LIMC, s.v.* Minos I, no. 18, pl. 155 (= Lykos II, no. 1).

67. S. Aurigemma, *Scavi di Spina* I. 2: *La necropoli di Spina in Valle Trabba* (Rome 1965) pls. 24ff.; *ARV*² 1440.1; H. Metzger, *Les représentations dans la céramique attique du IVe siècle* (Paris 1951) 289 and pl. 39.3; *LIMC, s.v.* Iphigeneia, no. 19, pl. 149. See also the South Italian scenes collected by L. Séchan, *Etudes sur la tragédie grecque dans ses rapports avec la céramique* (Paris 1926; reprint Paris 1967) 384, figs. 112ff. and see p. 382 n. 7. The weapons occur again in a comparable scene on a Roman imperial sarcophagus: *Die antiken Sarcophag-Reliefs* II (Berlin 1890) 177, where Robert takes it as an oversight of the artist. The same multilayered (and self-contained) narrative technique was no doubt characteristic of Classical and Hellenistic panel painting, as can be seen even in distant reflections in the Roman period. It is possible that the painting of Iphigeneia in Tauris that is the source of the Pompeian wall-paintings used this technique, but the surviving material does not allow any certain conclusions. See Robert, *Hermeneutik*, 194f. This seems even more likely in the case of the scene on wall-paintings and sarcophagi that combines Phaedra, the nurse, and Hippolytos, which evidently goes back to a "closed" composition of an earlier period. It is unlikely that we have here a contamination of elements from a continuous narration, since the group occurs mainly on Attic sarcophagi, which as a rule do not feature continuous narratives. As far as I can see, there has been no systematic study of the influence of panel painting on book illustration and sarcophagi with continuous narration. The concept of the "closed composition" would constitute a useful criterion for this question.

68. Stamnos, Berlin F 2182; *ARV*² 251.32; Clairmont, *Parisurteil* (above, n. 20) 104, K136; *LIMC, s.v.* Paridis Iudicium, no. 104, pl. 126.

69. G. Neumann, *Gesten und Gebärden in der griechischen Kunst* (Berlin 1965) 133. See also P. Jacobsthal, *Die Melischen Reliefs* (Berlin 1931) nos. 87ff. and pls. 48ff.

70. Würzburg 508: *ARV*² 182.5; E. Langlotz, *Griechische Vasen in Würzburg* (Munich 1932) pl. 176; FR, pl. 104; Buschor, *Griechische Vasenmalerei*² (above, n. 4) fig. 187; K. Friis Johansen, *Aias und Hektor* (Copenhagen 1961) 12f; *LIMC, s.v.* Aiax, no. 43, pl. 237.

71. See also Hektor's words at 7.291: ὕστερον αὖτε μαχησόμεθα [hereafter we will

fight again]. On contemporary scenes of the death of Hektor, Apollo alludes to the coming death of Achilles with his raised spear: *ARV*² 449.2; *Beazley Addenda*² 242; Robert, *Hermeneutik*, 204, fig. 158; *LIMC*, *s.v.* Achilleus, no. 570, pl. 115. Ajax and Hektor will meet again in the battle, at 13.190, 14.402, 15.415, 16.114, and 17.304.

SOME CHARACTERISTICS
OF THE REPRESENTATION
OF GODS IN CLASSICAL ART

L UCKILY A CONSIDERABLE number of statues from Archaic times representing women have withstood the adversities of time. If, however, we try to name them, we encounter great difficulties. Without inscriptions or attributes, we can neither distinguish human beings from goddesses, nor can we say what precise divinity is intended.[1] From her headgear we learn that the ripe Archaic statue from the Acropolis in figure 22 is a goddess, but there are no individual traits that would distinguish her from human figures, such as grave-statues.[2] Even less can be made out if she is to be called Hera or Aphrodite, Artemis or Demeter. In the Classical period things are completely different: not only by her size but also by her sovereign attitude the lying figure from the east pediment of the Parthenon (fig. 23) is characterized as a goddess, and there is not the slightest doubt that she is Aphrodite.[3] Her voluptuous pose and the feminine charms of her lightly clad body make it abundantly clear: "Reizend ermattet, als hätte die Nacht ihr zur Ruhe nicht genüget" (Goethe, *Achilleis*).[4]

Archaic images always have something festive about them; they are not touched by human conditions whatsoever. This unity is no longer maintained

A shortened and revised version of *Zur Eigenart des klassischen Götterbildes* (Munich 1959), trans. Nikolaus Himmelmann.

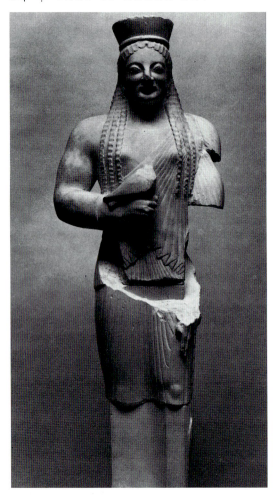

22. Lyons Kore. Lyons, Musée des Beaux Arts, and Athens, Acropolis Museum

in the Classical period; the images of gods and humans take on different characteristics. The personal traits of a god, as they had always been described by the poets, now become elements of a tangible pictorial characterization of a type, and sometimes even fragments betray the identity of the god represented.

When we try to describe the essentials of this new kind of portrait of superhuman beings, it is of general relevance that the gods are represented enjoying, or rather enduring, their own power. This is obvious with Dionysos, who is shown in different degrees of ecstasy, or with Aphrodite, who is enraptured by "limb-relaxing" love. So too Apollo is entranced by the spirit of the oracle or Ares by gloomy visions of war and murder.

This species of divine portrait, this self-representation, so to speak, of the

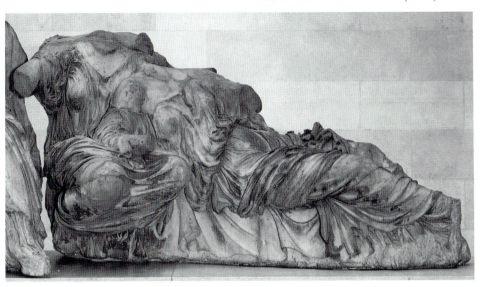

23. Aphrodite from the east pediment of the Parthenon. London, British Museum

gods, has Archaic forerunners, but it is only at the beginning of the Classical age that it becomes a more general phenomenon.[5] The date, of course, is not coincidental, but it is not easy to explain. As to the formal qualities, on the one hand, new achievements like contrapposto, perspective, and so on lend the character representation a much broader range of possibilities than before. On the other hand, the content or message of the image may be explained by a new humanizing tendency in the Classical view of the gods.

At first sight these answers seem plausible, and it is not easy to propose the existence of even more fundamental issues in the Classical image of divinities. Yet certain phenomena cannot be explained only by new formal or conceptual constructs. The most important of them is a new category of representation that shows a single god quite alone, e.g., flying, pouring a libation, hunting, making music, etc. These life-images, or *Daseinsbilder*, are not bound to new formal qualities and could have been created within the strictures of Archaic art.[6] But they appear only in the transitional period leading to the Classical epoch contemporaneously depicting gods of all sorts.[7] If we propose to derive these pictures from ancient *aitia* of cult or from mythical episodes, the question remains why similar, earlier representations are lacking.

It has often been noted before that Archaic art as a rule does not depict the Olympian gods isolated, involved in some characteristic activity.[8] They are, rather, integrated mostly in a narrative context. With rare exceptions divine

life-images do not appear before the last third of the sixth century, and then they appear to be connected with the pictures already mentioned of the gods enjoying or enduring their own power.

This kind of image does not depend on the new formal qualities offered by the Classical period. For example, Dionysos is already known to Homer (*Iliad* 6.130) as *mainomenos* and is shown by a few vase-painters performing ecstatic dances in the middle of the sixth century.[9] As a rule, however, he is shown walking solemnly among his frenzied followers of silens and maenads.[10] From the end of the sixth century, however, the situation is reversed.[11] From now on the ecstatic god is the rule: pictures show him intoxicated and enraptured by music, dance, or mere revelry.[12] This is not a problem of statistics, because from now on the wine god enjoying his own powers appears not only in narrative pictures of the thiasos, but also in other media such as sculpture,[13] which represents the same paradoxical idea by means of the characterization of his nature, the expression of his eyes, and so on.

It is clear that the individual characterization of the gods cannot be explained in terms of formal developments of representation. In fact, one must turn the question around and ask whether the formal characteristics of the Classic are not vehicles of content in themselves which inform the phenomenon in question. This certainly is the case for the apparently pure formal category of the definition of space in a picture. Space in a picture is in no way just a neutral medium of an object isolated in itself, but lends the object its symbolic level of existence. Space in a picture is accordingly not a simple issue of form, but also most importantly of content, which one can describe as the symbolic power of the image. The symbolic function of picture-space confers on the object its meaning: if the gold ground of mediaeval pictures is easily understood by us in this vein, equally we must understand that space in the Classical image of the gods is not that of everyday life but possesses its own symbolic content. This observation is not just to be understood generally but in particular in comparison to Archaic images of the gods. It is almost self-evident that the sundering of the coherent pictorial world of the Archaic period must correspond with a new concept of pictorial space in the Classical period.[14] In the following inquiry I hope to make clear that in fact the development of a pictorial characterization of the inner nature of the individual gods is intimately related to the discovery of a new symbolism of space in which the divine image is for the first time imbued with a supernatural distance and meaning. We therefore seek to elucidate the connection between interiorization and space in the Classical image of the gods. Our discussion must accommodate itself to the manifold nature of the problem and must consequently touch on many differ-

ent issues. Because these have been examined in the past only as independent phenomena, the fundamental problem has not been recognized.

From these observations we may assume that the rise of a new category of pictures showing the gods isolated in their own sphere is in many cases related to their enjoyment of the same power that they otherwise exert outwardly on their fellow gods or on human beings. To further our inquiry into the origin of these new representations of the character of the gods, let us turn to images of Aphrodite, especially in scenes of the Judgment of Paris in which she is markedly contrasted with her rivals.

Archaic representations, of course, do not attempt to characterize the goddess by unique personal traits; even attributes are scarce and late. Only Athena is clearly distinguished by a specific iconography.[15] Just at the beginning of the fifth century B.C., new elements intrude into the picture. On a kylix by Makron, Aphrodite holds a dove as her traditional attribute, but at the same time four Erotes hover around her and offer twigs as well as wreaths (fig. 24).[16] This clearly presents a new vision of Aphrodite; compare the fragment of an Archaic pinax that shows the goddess with Himeros and Eros (fig. 25).[17] Here she holds the two small figures in her arms like a human mother her children;

24. Aphrodite with Erotes, Attic red-figure kylix (detail). Berlin, Antikensammlung, Staatliche Museen, Preussischer Kulturbesitz

25. Aphrodite with
 Himeros and Eros,
 pinax fragment.
 Athens, Acropolis

they both look to the right and react with raised arms to some event taking place in that direction.[18] Obviously they are distinct persons acting in a narrative context. Their function on the kylix is quite different; they are no longer individuals taking part in a specific event but contribute to an atmosphere that characterizes the appearance of their mother and the power that emanates from her.[19] Symptomatic of this new role is the multiplication of their number, which seems to be lacking in earlier Archaic times in pictures as well as poetry.[20] From now on even the inscribed names Eros and Himeros may be multiplied in the same context.[21]

The new vision of Aphrodite represented in her own erotic sphere is only one element of several that appear about the same time. In Archaic pictures of the Judgment of Paris, the three goddesses are led by Hermes to Paris, who is deeply embarrassed or even frightened by their sudden arrival; on most Attic vases Paris takes to flight (fig. 26).[22] Quite obviously the scene is meant as an epiphany. The arrival is depicted rarely in early red-figure pictures and, after a while, it disappears altogether.[23] Instead we see the goddesses standing quietly in front of Paris, whom they do not seem to notice, since they are shown isolated from each other and absorbed in themselves. In quite a few cases, they are even turned away from him, and sometimes Aphrodite converses with Eros (fig. 27).[24] The lively scene of the Archaic tradition has become very quiet. But still an epiphany is intended. It is, however, not a sudden event as in the earlier pictures, but a kind of vision before the inner eye of Paris, who has now become a tender boy. In spite of the seeming stillness of the picture,

26. Judgment of Paris, Attic black-figure column-krater (detail). London, British Museum

27. Judgment of Paris, Attic red-figure amphora (detail). London, British Museum

he is deeply touched by the apparition: he stops playing the lyre or even draws his himation before his face.[25]

For the next generation of vase-painters, the quiet presence of the goddesses has become a firm rule. Paris is now a heroic youth with petasos and club. Seemingly a later moment of the tale is represented: the hero is not shown receiving the goddesses, but he is already absorbed by his vision and is uncertain of the choice he is to make (figs. 28, 29).[26] This is clear from the gesture of resting his chin in his hand, which is later enhanced by the frontal presentation of his head.[27]

All these observations are obviously related to each other. The quiet attitude of the goddesses and their isolation is mirrored in the absorbed expression of Paris, who confronts them not concretely but only in an inner vision. Compared to the Archaic pictures and their naïve narrative, the scene has lost its external logic and substituted a spiritual atmosphere. An epiphany is still intended in the encounter, but now it is not so much an event as a representation of the quality or character of the goddesses present.

An excellent parallel from the Apollonian realm may corroborate this interpretation of the images of the Judgment of Paris. On a wonderful white-ground kylix in Boston, a Muse with chin propped up on her hand has a vision of Apollo who opens his mantle with a great gesture of epiphany (fig. 30).[28] Something similar must also be meant on a white-ground pyxis also in Boston, on which six Muses are shown quite by themselves and absorbed in making music or holding sacred objects (libation bowl, ribbon; one stretches out her hand with an apple) (fig. 31).[29] Among them there is a cowherd, who, as the faint traces suggest, raised his left hand to his head. He is Archilochos, who, on his way to

28. Judgment of Paris, Attic white-ground pyxis. New York, Metropolitan Museum of Art

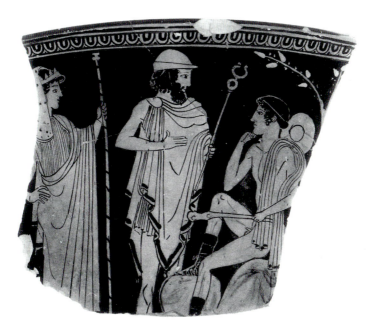

29. Judgment of Paris, Attic red-figure fragment. Athens, Agora Museum

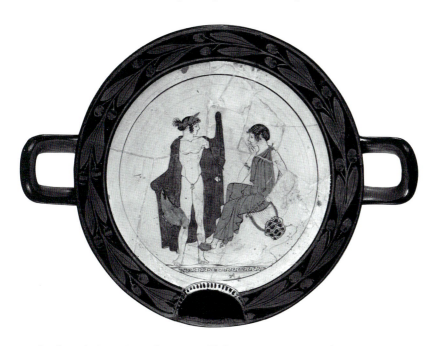

30. Apollo and Muse, Attic white-ground kylix. Boston, Museum of Fine Arts

31a–d. Muses with Archilochos, Attic white-ground pyxis. Boston, Museum of Fine Arts

the market one early morning, experiences an apparition of the Muses, and by this encounter is called to be a poet.

Another argument that seems to support our interpretation is offered by the beautiful Judgment of Paris on the ivories from Kul Oba of the first half of the fourth century B.C. (figs. 32, 33).[30] The characterization of the goddesses in Homeric terms reaches here a zenith of pictorial expression.[31] A new gesture is performed by Paris, who raises his right arm across his head. This does not mean merely that he is relaxing but indicates a ravishing vision, as is shown by so many pictures of Dionysos in ecstasy.[32] The gesture is also performed by a herdsman on the beautiful Late-Classical bronze relief in the British Museum, who is mostly identified as Anchises but might just as well be Paris.[33] Here too an inner vision is obviously intended: the hero does not look upon the nude goddess beside him but into the void.

A pyxis lid in Copenhagen of the second half of the fifth century B.C. offers a unique scene (fig. 34).[34] Paris is an oriental prince as on the ivories from Kul Oba, but the goddesses are shown riding fantastic chariots—horses draw Hera's and snakes draw Athena's; Erotes with libation bowls accompany Aph-

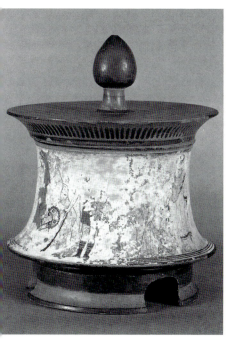
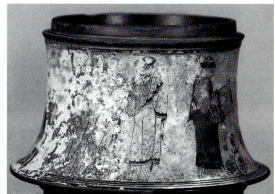

rodite. At first sight the scene resembles a noisy arrival, but closer scrutiny shows otherwise. Hera is clearly not descending from but stepping into her vehicle.[35] The goddesses are not arriving but departing, and this produces the same notion of distance that is conveyed by the gesture of Paris, who raises his right hand to his face, entranced by the vision before him.

Another unique representation of the Judgment of Paris still to be explained is found on a red-figure pyxis in Athens from the early fifth century B.C. (fig. 35).[36] Paris is shown seated and playing the lyre while the goddesses make libations. Hera and Athena pour the liquid with outstretched hands;[37] Aphrodite is served by a flying Eros holding a jug and bowl in his hands. Quite obviously the picture cannot be interpreted as a narrative in which the goddesses, for example, are thought to be making libations for a favorable outcome of the contest. This is excluded by Aphrodite, who admires some kind of necklace or wreath in her hands, an activity that does not fit such a situation. Nor does the throne on which she is seated, which can only be understood as an indication that she is in her own sphere, presumably on Mt. Olympos. Again we find the visionary character we noticed already in contemporary pictures, in which

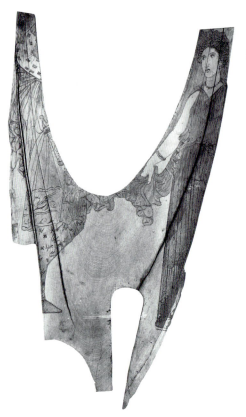

32. Judgment of Paris, ivory cas-
ket veneer from Kul Oba.
St. Petersburg, Hermitage

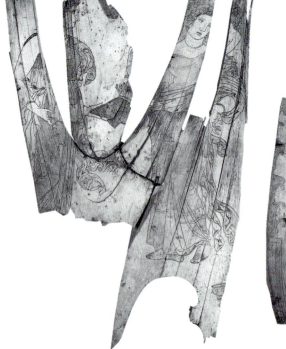

33. Judgment of Paris,
ivory casket veneer
from Kul Oba.
St. Petersburg,
Hermitage

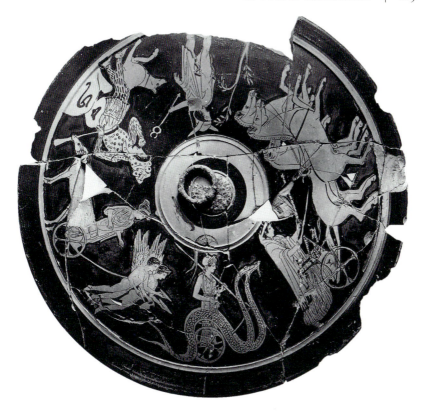

34. Judgment of Paris, Attic red-figure pyxis lid. Copenhagen, National Museum

Paris contemplates the goddesses with his inner eye or ponders his choice. Recall here that an epiphany was the central iconographic theme even in the Archaic tradition. To convey this message the painter of the pyxis has chosen representations of the goddesses from the typical repertory of divine life-images, the so-called *Daseinsbilder*: gods by themselves making libations. The traditional context of the Judgment of Paris called for goddesses shown in the act or state of epiphany. From this it is legitimate to ask if life-images, and especially those showing the gods pouring a libation, may be pictorial patterns that visualize epiphany.

Life-images, or *Daseinsbilder*, are marked by several interrelated qualities. They mostly show gods isolated, "enjoying" their own powers, performing characteristic acts.[38] In these pictures the gods are not enmeshed in an episodic narrative but are presented in a timeless vision. A fine example is offered by a very modest lekythos of the Bowdoin Painter in Athens (fig. 36).[39] Artemis

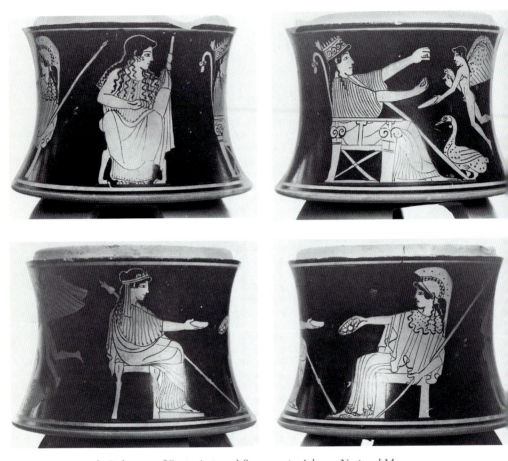

35a–d. Judgment of Paris, Attic red-figure pyxis. Athens, National Museum

rushes forward holding her bow out in front of her as if hunting, a notion pre-cluded by the burning altar in front of her. It becomes quite clear that the pic-ture is not meant to be a mythical episode but an apparition of the goddess in her sanctuary. Another pictorial element leads us in the same direction: the gesture of her right hand with the index finger raised. This has nothing to do with shooting the bow, but is a typical gesture of prayer as illustrated by a man on a well-known vase in New York.[40] From the lekythos we may conclude that it is not primarily confined to prayer but has a wider meaning in the realm of sanctification.

One hundred years later we find the same life-image of Artemis on a pelike of the British Museum in a context that leaves no doubt about the picture's

meaning as an epiphany of the goddess (fig. 37).[41] Artemis is shown in violent motion killing a stag with her torch while Nike crowns her with a wreath. In strong contrast to the dramatic scene in the center, Zeus at the left and Apollo at the right are watching in poses of relaxed leisure. It is this juxtaposition of violent motion and complete quiet that visualizes the sudden apparition of the goddess in a specific but timeless act observed by her fellow gods as "witnesses" and honored by Nike. Doing what is peculiar to her (τὰ αὐτῆς), of which she is prototypical, she manifests the essence of her divine personality in an epiphany.

As hunting is a characteristic activity for Artemis, so binding a wreath is for Aphrodite. On a white-ground cup in Florence from the middle of the fifth

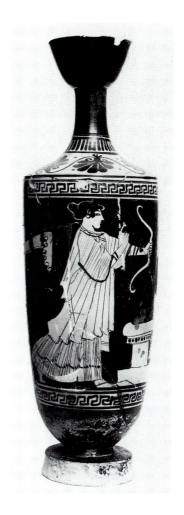

36. Artemis, Attic red-figure lekythos. Athens, National Museum

37. Artemis, Attic red-figure pelike (detail). London, British Museum

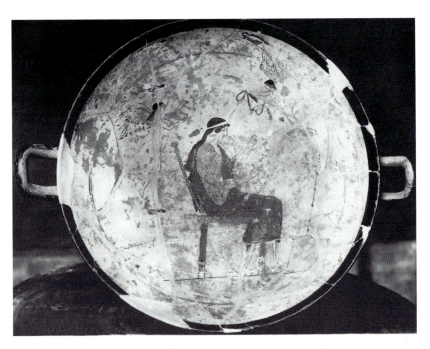

38. Aphrodite, Attic white-ground kylix. Florence, Museo Archeologico

century, the motif constitutes a typical life-image (fig. 38).[42] The goddess is shown sitting on a throne and absorbed in her occupation. Acording to Aristophanes (*Thesm.* 400f.) this has a symbolic meaning, that the person so involved is in love. Here Aphrodite is enduring her own power. Hovering Erotes and a thymiaterion indicate the erotic atmosphere of the representation.

On a pelike of about 360 in St. Petersburg, this same life-image visualizes an epiphany of the goddess or some heroic follower of hers, such as Helen (fig. 39).[43] Sitting on a rock before an altar, the half-naked figure binds a wreath while Eros crowns her. The girl flute-player and the vessel for incense on the altar indicate a sacred act. Again epiphany is made clear by "witnesses," especially the nude hero on the right, who turns to watch and gestures in surprise.[44] As a "witness" he is a typical figure in pictures of epiphany par excellence, i.e., representations of Aphrodite born from the sea (fig. 40)[45] or appearing as a star in the sky, riding a goose or a goat. His widespread arms on the pelike, signifying surprise, find a parallel on a hydria in New York, on which a woman takes to flight with the same gesture while watching the goddess sacri-

39. Aphrodite, Attic red-figure pelike. St. Petersburg, Hermitage

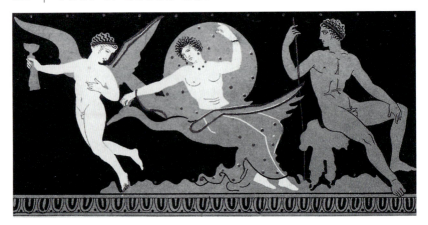

40. Birth of Aphrodite, Attic red-figure lekythos, drawing. Berlin, Antikensammlung, Staatliche Museen, Preussischer Kulturbesitz

fice incense (fig. 41).[46] This too is a life-image that shows Aphrodite absorbed in a sacred act; at the same time the image is marked as an epiphany by the frightened "witness."

Two things seem clear from these observations: life-images are, so to speak, self-representations of gods who enjoy their own power and reveal their nature in timeless activities particular to each of them. They are seen in their own divine sphere that must be thought of as far removed from the human realm and perceptible only in a vision, i.e., in an epiphany.

Life-images show the gods with different occupations partly peculiar to each, partly common to all of them. The most important of the latter is libation pouring; most every divine individual could be represented performing this sacred rite. That gods pouring a libation may constitute genuine life-images and signify epiphany appeared obvious to us in the discussion of the pyxis in Athens (fig. 35) in the light of the earlier iconography of the Judgment of Paris, which requires that it represent epiphany—an extremely strange phenomenon. By making a libation, mortals try to attract the attention of the gods, and it seems paradoxical to find the phiale in the hands of the immortals themselves. From the beginning of the fifth century, countless representations show them holding a phiale partly as an attribute, partly pouring the liquid from it. Examples are so numerous that it seems impossible to find a common denominator for all of them. The mythical tradition does know episodic occasions when gods apparently or in fact pour libations in the context of departure or arrival, oath, prayer, purification, the symposium, and so on. But numerous as they are, these episodes cannot explain the abundance of other, similar

scenes in which the gods carry a phiale as a simple attribute and which are generally acknowledged to lack narrative context.[47] This applies equally to statues that hold a phiale. In all of these instances, the motif is said to have a symbolic significance that marks the god as a recipient of sacrifice and visualizes his communication with humans.[48] Opinions differ completely, however, on pictures of gods, either singly or in groups, performing the rite by pouring the liquid from their bowls. According to one interpretation this is only a narrative extension of the idea of the communication with humanity, while another interpretation favors separating these pictures from the others and explaining them as mythical episodes.[49] Both proposals, however, are open to critical objections.

The first proposition, inspired by Buschor's reading of white-ground leky-

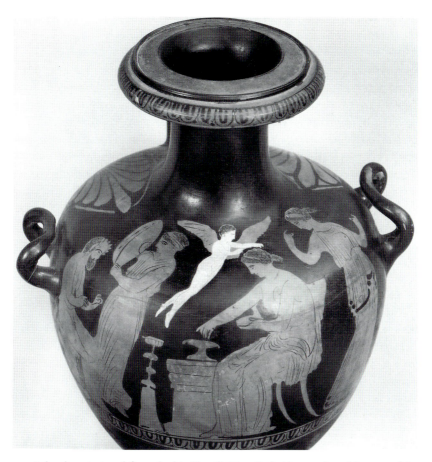

41. Aphrodite, Attic red-figure hydria (detail). New York, Metropolitan Museum of Art

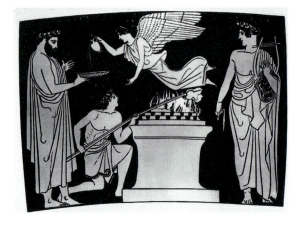

42. Apollo at altar with
worshipers, Attic
red-figure stamnos
(drawing). Gotha

thoi, does not need to explain the scenes literally; in the act of pouring a liba-
tion, the human and divine are fused into a visionary unit indivisible by ordi-
nary logic.[50] A parallel exists on white-ground lekythoi on which elements
from the realm of both the living and of the dead, of home, grave, and under-
world, make up a single supernatural vision.[51] This apparent parallel suffers,
however, from two shortcomings. The visionary scenes we meet on the leky-
thoi appear only around the middle of the fifth century; they are clearly con-
nected with tendencies of the High Classical period and arise only with
them.[52] On the other hand, multifigured pictures of gods pouring libations ap-
pear already at the beginning of the century. The second objection is even
more decisive. If pouring a libation means communication with humans, the
latter must appear in the picture. Indeed, the formula for this is well known:
the god invisibly present looks at the worshipers performing the rite (fig. 42).[53]
The pictures of gods pouring libations all by themselves and absorbed in their
activity are of completely different character: they are genuine life-images,
i.e., self-representations of gods within their own sphere and without any allu-
sion to a specific context or narrative episode.

An apparent alternative would be to explain the pictures of gods actively
pouring a libation as illustrations of a mythic episode. One objection has al-
ready been mentioned. Examples are so numerous that it is practically impos-
sible to find specific sources for each of them. When Zeus is shown pouring a
libation in the presence of Hera, one might think of the sacred oath they swear
on the occasion of their marriage.[54] But Zeus is depicted doing the same thing
in the presence of Athena, Apollo, Ares, and Nike;[55] in these cases quite dif-
ferent and remote explanations would be necessary. There is also little chance
to find episodic occasions when, e.g., Poseidon, Dionysos, or Athena are per-
forming the rite.[56] A second objection is even more momentous. If our scenes

are taken literally, the god pouring the libation cannot be the recipient of the sacred gesture, which must be directed at somebody else. The one for whom the rite is performed is therefore not represented, and there is not even an allusion to the recipient in the picture.[57] Such an assumption is completely unlikely; as with our argument above, we require that the recipient of the prayer be physically present. The problem becomes clear in the pertinent pictures of Apollo, by far the most impressive representations of the theme (fig. 43).[58]

Many vases show Apollo performing a libation seated all by himself; this

43. Apollo pouring libation, Attic red-figure amphora. Würzburg, Martin von Wagner Museum

configuration rules out any explanation from a mythical episode, such as ar-
rival or departure.[59] Another supposition has met with wide approval: from
myth and local rites it is known that Apollo performed a purifying sacrifice in
the Valley of Tempe after he killed the dragon, Python; this might be the sub-
ject of these pictures.[60] In this case, and if the subject is obvious in itself, we
need not require the presence of a recipient such as the Erinyes or other
demons of the Underworld.[61] But we must demand that the sacrifice be marked
as chthonic and that the liquid be poured on the earth, not on an altar, as
shown in so many of the pictures (fig. 43).[62] Other allusions to a purification,
such as the slaughter of a piglet, are completely lacking.[63] The main argument,
however, against the proposed explanation comes from the appearance of the
god himself: he is regularly portrayed as a lyre-player with mantle or even as a
solemnly clad Kitharoidos, not the nude hero we would expect as the con-
queror of Python.[64] In fact, the few early pictures of Apollo killing Python
show him as a child on his mother's arm, not as an adult. A child is still indi-
cated on the well-known coin from Kroton of the end of the fifth century.[65]

Besides these factual difficulties, the proposal to identify pictures of Apollo
pouring a libation by himself disregards the message of the pictures in suppos-
ing that the god acts on behalf of some invisible recipient. Quite obviously
Apollo is the sole theme of the representation that is meant to honor him.[66]
There are pictures in which a god is wreathed by a person of his entourage
while he pours the libation (fig. 44).[67] For this same reason, the figure of
Apollo actively performing the rite can appear on votive reliefs, which, as a
class of monuments, do not depict mythical episodes but life-images.[68]

44. Dionysos pouring liba-
tion, Attic red-figure ca-
lyx-krater. Copenhagen,
National Museum

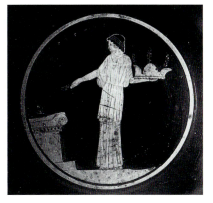

45. Artemis making sacrifice, Attic
red-figure stemmed dish (detail).
Copenhagen, National Museum

Both the theories discussed are misleading in that they do not seek the
meaning of the representations in the pictures themselves but in an abstract
way relate them to humanity or to an invisible mythical recipient. This is con-
tradicted by the countless scenes showing the god as the main and only theme
of the representation, completely absorbed in pouring a libation. These pic-
tures all have the marks of *Daseinsbilder*, "life-images," insofar as they depict
the god alone in a self-sufficient occupation and in his own divine sphere.
Since life-images reveal the nature of the gods represented by specific acts or
particular character-traits, the rite of pouring a libation that is performed by all
of them must be related to a quality they share.[69] From the conditions of the
life-image, it may be assumed that pouring a libation is primarily not a rite di-
rected at somebody else but a self-sufficient act in which sanctity is revealed.
In performing the rite, the gods represent themselves by manifesting their
sanctity—an assumption corroborated by a fact fundamental to the under-
standing of life-images: beside the common gesture of pouring a libation, the
gods perform specific rites particular to each individual; for example, Dionysos
performs Dionysiac rites, Aphrodite Aphrodisian ones, etc.

On a red-figure cup by the Dish Painter in Copenhagen, Artemis holds in
her left hand a *kanoun* decorated with twigs while, with her right hand, she
probably offers barley from the basket (fig. 45).[70] The scene is repeated with
more details on Hellenistic votive reliefs.[71] Here Artemis with her torch kin-
dles a fire on the altar while she holds the same *kanoun* as before in her left
hand. As shown long ago, this is a special rite for brides, a typical kind of
Kanephoria offered to Artemis for a propitious marriage.[72] It seems highly
paradoxical that this same rite is performed by Artemis, who never becomes a
bride herself. The only reason for her to do so can be that it is *her* rite and she
performs it in an archetypal way.

Like her fellow gods, Aphrodite too pours libations. This has been denied

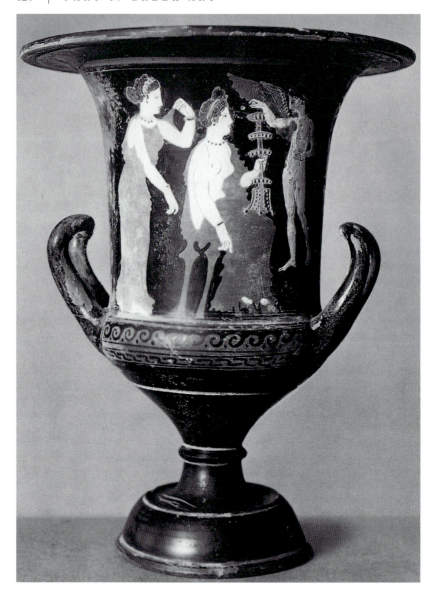

46. Aphrodite with thymiaterion, Attic red-figure calyx-krater. Universität Tübingen

unconvincingly on the basis of an interpretation that tries but fails to connect
the pictures with mythical episodes.[73] Parallel to this rite Aphrodite offers in-
cense holding either a thymiaterion, as on a superb lekythos in St. Petersburg
(fig. 81c),[74] or strewing incense into an open bowl, as on a hydria in New York

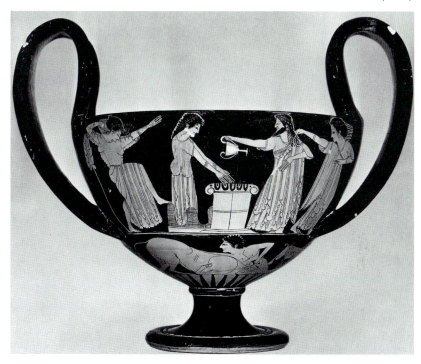

47. Dionysos pouring libation, Attic red-figure kantharos. Boston, Museum of Fine Arts

(fig. 41, above).[75] Offering incense is not at all confined to Aphrodite;[76] rather, it is found also in many other contexts, religious and profane. Nevertheless it seems to be typical of Aphrodite and of Eros, who holds the thymiaterion as his characteristic attribute.[77] In some cases Aphrodite even actively performs the rite, as on the hydria just mentioned or on a calyx-krater in Tübingen, on which she holds a thymiaterion that is filled by Eros (fig. 46).[78]

These offerings cannot be meant for invisible fellow gods but are rather a manifestation of Aphrodite's own divinity. For the same reason, these pictures can serve as the visualization of epiphany, as shown by the "witness" on the hydria in New York (fig. 41, above).[79] In terms of this iconography, the rites portrayed are not human acts but manifestations of sanctity archetypically performed by the gods and imitated by humans in order to partake of this quality: θνητοὶ θεῶν νόμοισι χρώμεθα (Euripides *Hipp.* 98).[80]

The principle of the particularity of respective offerings is further borne out by Dionysos, who pours a libation from his kantharos (fig. 47),[81] or by Demeter, identified by inscription, who puts ears of corn on an altar (fig. 48).[82]

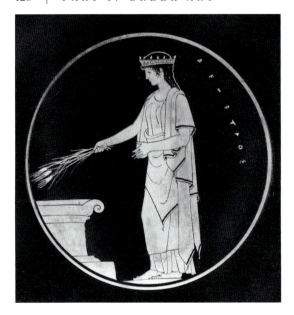

48. Demeter making sac-
rifice, Attic red-figure
kylix (detail).
Brussels, Biblio-
thèque Royale

To sum up the argument, we may say that gods who pour a libation or perform other rites are manifesting their own sanctity in a timeless and self-sufficient act that has the qualities of an epiphany. This may seem paradoxical, but it is no more so than the related phenomenon of the god who enjoys or endures his own power.

Finally we may inquire what the consequences are of the above observations for the meaning of the gods. Greek gods are not almighty in terms of exercising their free will. On the contrary, the pictures discussed here show them conditioned and limited by their own powers. The message, however, of these representations is to praise the might of the gods, not their weakness. How can they do this in the framework of the life-image? The answer must be that the might of the gods does not emanate from their will but from their mere existence, from the fact that they are archetypes of living nature. The representation of the life-image, or *Daseinsbild*, which shows the god all by himself and conditioned by his own powers, confirms his identity as an archetype. In terms of this iconography, Plato uses elements of the life-image to visualize the archetypal functions of the Olympians. The great myth in the *Phaedrus* (246ff.) presents the gods moving through the sky in eleven groups guided by Zeus in his winged chariot. Motivated by their respective affinities (see also 252f.), human souls join the god of their own choice and gaze steadfastly on them (see also 253a): "Now within the heavens are many spectacles

of bliss upon the highways whereon the blessed gods pass to and fro, each doing his own work (πράττων ἕκαστος αὐτῶν τὸ αὑτοῦ); and with them are all such as will and can follow them." (247a)

In this grand vision of the gods, identity is their foremost quality: identity in terms of their eternal existence and eternal character as manifested by eternal self-representation. Under this aspect they anticipate Plato's ἰδέα as living archetypes of the universe.

NOTES

The unpublished work of Himmelmann, *Erscheinung und Götterbild: Studien zur Ikonographie Aphrodites*, is cited in the following notes as *Studien* with the page numbers of the manuscript. Himmelmann's plan was to publish the parts of this work not touched on in the present essay as separate articles, of which one has appeared and is included in this collection: "On the Knidian Aphrodite," which originally appeared in the *Marburger Winckelmann-Programm* for 1957 (below, pp. 187–94).

1. It seems probable that the size did not constitute a significant distinction, since none appears to exist among contemporary kouroi. See also Himmelmann, *Studien zum Ilissos-Relief* (Munich 1956) 38 n. 84.

2. Kore Lyons-Acropolis: H. Payne, *Archaic Marble Sculpture from the Acropolis* (London 1936, reprint 1950) pls. 22–26; G. M. A. Richter, *Korai: Archaic Greek Maidens* (London 1968) no. 89, figs. 275–81.

3. F. Brommer, *Die Skulpturen der Parthenon-Giebel* (Mainz 1963) pls. 48–49.

4. "Charming and languid, as though the night had not given her sufficient rest."

5. I do not intend to suggest that there was no individual characterization in Archaic pictures. Obviously the gods are always mythical personalities and this is expressed by attributes, activities and also physical particularities. Athena is armed and fights, Hephaistos is lame, etc. These traits describe, however, only external characteristics and are to be distinguished from the profoundly paradoxical concept that the divinity is not only master of his power but is also subject to it, suffers it. It is easy to understand that pictorial traits of this type are not external and attributive but arise from the characteristic appearance of the god and seek to render his nature in visual form. The new type of picture is therefore of a visionary kind and dispenses with external logic. See also K. Friederichs, *Praxiteles und die Niobegruppe* (Leipzig 1855) 37f.

6. Consider the Archaic images of gods on winged chariots (which are *not* the precursors of flying gods in the Classical period): black-figured Poseidon on a winged horse, Corinthian krater, Bari: M. Gervasio, *Bronzi arcaici e ceramica geometrica nel*

museo di Bari (Bari 1921) pl. 7.4; *LIMC, s.v.* Poseidon, no. 151. Black-figured carriers of phiales (not always portraying libators): *MMS* 5 (1934–36) 96, fig. 5 (reception of a victor); FR pl. 121, *LIMC, s.v.* Amphiaraos, no. 3 (Departure of Amphiaraos: here fig. 19 [above]). E. Gerhard, *Auserlesene Vasenbilder*, I (Berlin 1840) pl. 19 (Paris, Petit Palais 310: *ABV* 668) and IV (Berlin 1858) pl. 242.1–2 (Nikoxenos Painter, Roman Market: *ABV* 393.20; *Beazley Addenda*[2] 103; contemporary with early red-figure scenes).

7. Here and throughout I mean to indicate the beginning of the red-figure style, that is, the last third of the sixth century. Contemporaneously other important iconographic changes take place. Around 530 B.C. the beardless type of youthful Apollo replaces the bearded type, which had previously been dominant, at least in vase-painting (e.g., here fig. 65 by the Andokides Painter: Louvre G1; *ARV*[2] 3.2; *Beazley Addenda*[2] 149; Pfuhl, *MuZ*, fig. 314; Arias-Hirmer, pls. 82–83). This much-discussed development, which affects other gods and heroes too, does not indicate a revolutionary break with the old beliefs; Apollo was not thought to be older and then suddenly changes into a youth, as was once suggested by B. Zschietzmann, *Welt als Geschichte* 1 (1935), 21ff. The widespread change suggests that a beard did not originally indicate advanced age and only at the end of the sixth century, when age and character are more clearly portrayed (see also E. Buschor, *Frühgriechische Jünglinge* [Munich 1950] 105f.) came to represent the mature man and consequently could no longer be used for gods who had always been thought youthful. This phenomenon clearly is connected with the development of the divine representation: youth takes on a pregnant physical meaning and becomes a characteristic pictorial trait that is required in the picture of the god (he is never again depicted with a beard). The new divine image, which is a life-image (*Daseinsbild*; see further below), does not indicate a change in the nature of the gods that either supersedes or conflicts with earlier beliefs. The widespread scholarly view that there was a historical development of the gods is contradicted by the study of the images: here nothing can be found that was not part of the Homeric view of the gods. What is new, the subject of my discussion, is that this character for the first time is made visible in pictures.

8. For example, G. Bruns, *Jägerin Artemis: Studien über den Ursprung ihrer Darstellung* (Leipzig 1929) 14, who already approaches closely my view. E. Kunze, *Archaische Schildbänder*, *OlForsch* II (Berlin 1950) 72ff., was the first to recognize the problem. He correctly separates off cult images, their reflexions, and gods seen in frontal view. In these cases the concrete presence supersedes all other considerations. It is, however, hardly correct to consider some early representations of single Olympians life-images and exceptions to the rule, as Kunze does. These figures are probably excerpts from large narratives (see further below). This is occasionally indicated by the location of the representation. Compare to Kunze's examples the fleeing warrior in Würzburg, which is certainly an excerpt: *ABV* 103.114; *Beazley Addenda*[2] 27; E. Langlotz, *Griechische Vasen in Würzburg* (Munich 1932) pl. 30, no. 168; Boardman, *Athenian Black Figure Vases* (London 1974) fig. 58. Probably the Lakonian cups with Zeus and eagle should also be excluded from Kunze's list (*Archaische Schildbänder* 73); for the Lakonian cups, see C. M. Stibbe, *Lakonische Vasenmaler des sechsten Jahrhunderts v. Chr.* (Amsterdam-London 1972) pls. 4.3 (Taranto), 15.3 (Louvre E 688). They may depend on a mythical episode as does the scene on the cup in Kassel (A. B. Cook, *Zeus* I [Cambridge 1914] 94, fig. 66), on which Hermes replaces the eagle. The τελειότατον πετεηνῶν (*Iliad* 8.247), the ταχὺς ἄγγελος (*Iliad* 24.292), who conveys the will of Zeus to

humans (for example *Iliad* 8.245ff.), is not a mere attribute but a mythical person. There were stories according to which he announced to Zeus the victory in the Titanomachy.

9. *CVA* DK 3, Copenhagen, National Museum 3, III He, pl. 113.3 a-b; *LIMC*, *s.v.* Dionysos, no. 298, pl. 329; *ABV* 64.24; *Beazley Addenda*² 17. The Lydos fragments in the Louvre show Dionysos less rowdy than the surrounding daimones, yet his extended step and excitedly raised right arm probably have a similar intent: *CVA* F 18, Louvre 11, III He, pls. 127, 1–4; *LIMC*, *s.v.* Dionysos, no. 300, pl. 329; *ABV* 110.31; *Beazley Addenda*² 30. On the François Vase he looks wildly with masklike face out at the viewer (Arias-Hirmer, pl. 40; *LIMC*, *s.v.* Dionysos, no. 496, pl. 357), but it is unclear whether this derives from his ecstatic nature or from the effort of carrying the wine vase, for each of which there are parallels. In these examples the ecstasy of the god is to be interpreted as a mythical activity and not as a constant pictorial trait.

10. For example *CVA* D 7, Karlsruhe 1, pl. 7.2; *CVA* GB 5, British Museum 4, III He, pl. 48.1,b (*ABV* 260.29; *Beazley Addenda*² 68); *CVA* I 20, Naples, Museo Nazionale 1, III He, pl. 4.2; *CVA* F 14, Louvre 9, III He, pls. 81.1–3; *CVA* D 3, Munich 1, pls. 8.4, 32.2 (*ABV* 303.3 [*Beazley Addenda*² 79]; 297.11 [*Beazley Addenda*² 78]); *CVA* USA 1, Gallatin, pl. 2.9 (*ABV* 676, 714); *CVA* USA 11, New York, Metropolitan Museum 2, III He, pls. 19, 31a, 31b (*Paralipomena* 78.1; *Beazley Addenda*² 51); *CVA* F 4, Louvre 3, III He, pls. 10.6, 8, 11.2, 15.2, 8, 9 (*ABV* 297.12; 300.13; 135.43 [*Beazley Addenda*² 36]; 150.6 [*Beazley Addenda*² 42]; 133.4 [*Beazley Addenda*² 35]).

11. Würzburg: Langlotz, *Griechische Vasen* (above, n. 8) pl. 73; *LIMC*, *s.v.* Dionysos, no. 415, pl. 346; *ABV* 151.22; *Beazley Addenda*² 43.

12. For example Pfuhl, *MuZ*, figs. 379, 426, 430 (*LIMC*, *s.v.* Dionysos, nos. 311, 465, pls. 331, 354; *ARV*² 182.6, 371.14; *Beazley Addenda*² 186, 225). See further Himmelmann, *Studien*, 71f.:

> Precisely because the frenzy of Dionysos belongs to ancient myth, it is remarkable that it first becomes general in pictures at the beginning of the Classical period. Behind the statistics lies a more important phenomenon: from now on the ecstasy of the god is no longer just one of several possible themes, however typical, but belongs to his very nature, and characterizes him to a greater or lesser degree even outside of the thiasos. This image of the god suffering his own power appears even in scenes where it conflicts with the mythic narrative. In order to bring Hephaistos back to Mt. Olympos to free Hera, Dionysos tries his powers out on him, makes him drunk, and leads him triumphantly home. [F. Brommer, *JdI* 52 (1937) 207ff., cited by Himmelmann.]

The logic of the narrative requires that he himself remain sober and thus he is depicted in Archaic representations of the story. His commanding superiority is particularly evident in scenes such as that on the Lydos krater in New York (*ABV* 108.5; *Beazley Addenda*² 25; E. Buschor, *Griechische Vasen*², ed. M. Dumm [Munich 1969] fig. 131; *LIMC*, *s.v.* Dionysos, no. 563, pl. 364), in which Dionysos calmly walks among the frenzied silens. At the end of the sixth century, the god is subjected to his own power; and with the tipsiness of a drunkard, he hurries along on a lost kylix by Epiktetos (Brommer in *JdI*, 207, fig. 7; *ARV*² 74.42; *Beazley Addenda*² 168) or must be supported by a silen on a krater of the Kleophrades Painter while Hephaistos is able to sit on his mule without

help (*CVA* F 2, Louvre 3, III Ic, pls. 13.2, 5, 8; *LIMC*, *s.v.* Hephaistos, no. 117; *ARV*[2] 186.47; *Beazley Addenda*[2] 187). As Brommer suggests, the advent of the Satyr play may be responsible to some degree for the change, but because the change is so regular and lasts so long, it can hardly be disassociated from the changes in the other pictures of the thiasos. To what extent the ecstatic nature of the god has become an element of his portrait can be seen in the impetuous attitude of Dionysos on the east frieze of the Parthenon, which, if it is interpreted as derived from a mythic narrative, cannot be understood in terms of the actual scene of the frieze.

13. *LIMC*, *s.v.* Dionysos, nos. 120b, 122a, 158a, 200a, 206, pls. 305ff.

14. This is particularly visible in the manner in which the gods are depicted as present at an event. The freedom with which the Archaic pictorial vocabulary can link mortals and gods (see also, for example, Athena holding a lyre on the Archikles kylix [fig. 6, above]: FR pl. 153.1; *ABV* 163.2; *Beazley Addenda*[2] 20; *LIMC*, *s.v.* Theseus, no. 233; *s.v.* Athena, no. 536, pl. 759) is lost in the Classical period. The presence of the gods in pictures becomes something quite strange: they appear as though in their own world. See further Himmelmann, *Gnomon*, 29 (1957) 219; *Studien, passim*, especially pp. 115ff.

15. Athena with lance in a black-figure Judgment of Paris, for example, on an Eretrian amphora in Athens: M. Collignon and L. Couve, *Catalogue des vases peints du Musée National d'Athènes* (Paris 1902–4) pl. 28, no. 667; *LIMC*, *s.v.* Paridis Iudicium, no. 27, pl. 110. According to Clairmont, *Parisurteil*, 31, this is the earliest example.

16. Berlin 2291: *ARV*[2] 459.4; *Beazley Addenda*[2] 244; Pfuhl, *MuZ*, fig. 441; Boardman, *ARFVAP*, fig. 310.

17. B. Graef and E. Langlotz, *Die antiken Vasen von der Akropolis zu Athen* I.4 (Berlin 1925) no. 2526, pl. 104; A. Greifenhagen, *Griechische Eroten* (Berlin 1957) fig. 29; *LIMC*, *s.v.* Aphrodite, no. 1255, pl. 126. In black-figure examples of the Judgment of Paris, Eros is never depicted. On the pinax (2526) the figures of Himeros and E(ros) are identified by inscriptions, as is Aphrodite on the fragments Graef-Langlotz no. 603, pl. 29. A list of similar, until now unknown, figures of women mainly in Dionysiac contexts may be found in Massow, *AM* 41 (1916) 52. Add an unpublished amphora in Tarquinia: *ABV* 143.2, and Robinson Collection, *AJA* 60 (1956) pl. 4, fig. 22; *ABV* 148.III (now Harvard 1960.312: *Beazley Addenda*[2] 42). See also Greifenhagen, *Griechische Eroten*, 75.

18. The children do not look at their mother but at some activity that must have been depicted to the right, where a section of the pinax is broken away. Eros turns in that direction and lifts his right arm in astonishment; Himeros raises both arms. The second representation from the Acropolis (no. 603; see n. 17 above) depicts part of a divine procession. A mother carries her child in a similar manner in a black-figure scene of the departure of a warrior in the Vatican: C. Albizzati, *Vasi antichi dipinti del Vaticano* I (Rome 1912–39) pl. 45, no. 353, etc.

19. Eros's role as an active mythical figure also remains, of course, in the Classical period.

20. See also A. Furtwängler in *Kleine Schriften von Adolf Furwängler*, ed. J. Sieveking and L. Curtius, I (Munich 1912) 2, and Furtwängler in Roscher, I, *s.v.* Eros. The rule applies only if the word indicates the mythical person.

21. Hydriai of the Meidias Painter in Florence: *ARV*[2] 1312.1–2; *Beazley Addenda*[2] 361: G. Becatti, *Meidias: un manierista antico* (Florence 1947) pls. 3 and 5 (in each case two figures of Himeros); *LIMC*, *s.v.* Himeros, Himeroi, no. 5, pl. 300; *s.v.* Aphrodite, no. 1193, pl. 120.

22. Black-figure column-krater in the British Museum 1948.10–51.1: *ABV* 108.8; *Beazley Addenda*[2] 29; *LIMC, s.v.* Paridis Iudicium, no. 11. For further examples, see Clairmont, *Parisurteil,* K 18, 19, 20, 24, 27, 29, 40, etc. Archaic examples of the type, for which there are no non-Attic examples so far known, are about as numerous as together all the pictures with either Paris standing or seated. In fact, in the first half of the sixth century, they are twice as numerous as all the Attic pictures of the quiet reception.

23. See also Clairmont, *Parisurteil,* 47ff., k 132ff.

24. Nolan amphora in the British Museum, E 289; Charmides Painter, *ARV*[2] 653.6; *LIMC, s.v.* Paridis Iudicium, no. 37, pl. 113.

25. Red-figure examples of the flight: Graef-Langlotz (above, n. 17) II.2 (Berlin 1931) no. 1042, pl. 82; Paris, Cabinet des Médailles, A. de Ridder, *Catalogue des vases peints de la Bibliothèque Nationale* (Paris 1902) pl. 12; *ARV*[2] 648.33. Paris contemplating while playing the lyre on a cup by Makron in Berlin (2291): *ARV*[2] 459.4; *Beazley Addenda*[2] 244; Pfuhl, *MuZ,* fig. 441; *LIMC, s.v.* Alexandros, nos. 10, 63, pls. 377, 388; Boardman, *ARFVAP,* fig. 310. Other examples: *LIMC* VII.2, pls. 112f, Paridis Iudicium, nos. 35–38; hydria, London E 178: *CVA* GB 7, British Museum 5, III Ic, pl. 81.3; *ARV*[2] 503.20; *Beazley Addenda*[2] 251. Pyxis in Athens: see below, n. 36. On a cup in the Louvre by the Briseis Painter, the action is dramatically heightened: Paris sings and plays the lyre still unaware of the approach of the goddesses: G 151; E. Pottier, *Vases antiques du Louvre* III (Paris 1922) pl. 120; *ARV*[2] 406.8; *Beazley Addenda*[2] 232; *LIMC, s.v.* Alexandros, no. 17, pl. 381.

26. My fig. 28 is a white-ground pyxis in New York (07.286.36) by the Penthesileia Painter: *ARV*[2] 890.173; *Beazley Addenda*[2] 302; H. Diepolder, *Der Penthesileia-Maler* (Leipzig 1936) pls. 11.2, 12.1; *LIMC, s.v.* Paridis Iudicium, no. 46, pl. 116. My fig. 29 presents fragments from the Agora in Athens: *Hesperia* 7 (1938) 344, fig. 27. See also *AZ,* 1882, 214; E. Gerhard, *Auserlesene Vasenbilder,* III (Berlin 1847) pl. 176.1 (not in Beazley).

Earlier pictures of the Judgment of Paris depict neither the choice nor the decision but only the arrival of the goddesses, whom Paris quietly receives or from whom he flees, terrified. The only exception is the well-known Lakonian ivory relief on which Paris stretches out his left hand to Aphrodite, who answers him with the same gesture (W.-L. Marangou, *Lakonische Elfenbein- und Beinschnitzereien* [Tübingen 1969] no. 47, pp. 97f., fig. 78a; *LIMC, s.v.* Paridis Iudicium, no. 22, pl. 109). Here is meant the "praise" of the goddess, mentioned in *Iliad* 12.30. Of the greatest interest for the poetic rendition of the story are the first images of Paris's choice, not decision, in the sixties of the fifth century B.C., and his simultaneous transformation into a young hero from a frail youth. Only this new image of the inner struggle of Paris could have made it the model for the moral decision of Herakles at the crossroads in the famous parable of Prodikos (Xenophon *Mem.* 2.1.21–34). Equally, in Sophokles and Euripides, when Paris has become a heroic figure and bests his brothers in duels, this must reflect the new pictures of the Judgment of Paris in the sixties. These observations indicate that the ethical implications of the myth first appear in the Classical period and are not to be projected back into earlier times. See also Himmelmann, *Studien,* 90ff.

27. Particularly pathetic on a pelike in Athens (1181): *ARV*[2] 1475.5; Schefold, *UKV* pls. 36.1–2; *LIMC, s.v.* Paridis Iudicium, no. 53, pl. 119.

28. Covered white-ground kylix in Boston, Museum of Fine Arts 00.356: *ARV*[2] 741; *Beazley Addenda*[2] 283; *LIMC, s.v.* Apollon, no. 689a, pl. 239.

29. White-ground pyxis, Boston Museum of Fine Arts, 98.887: *ARV*² 774.1; *Beazley Addenda*² 287; *LIMC, s.v.* Mousa, Mousai, no. 77, pl. 395. The identification of Archilochos was made by N. Kontoleon, *ArchEph* (1952) 58ff.

30. E. H. Minns, *Scythians and Greeks* (Cambridge 1913) figs. 100f.; *LIMC, s.v.* Paridis Iudicium, no. 63, pl. 121.

31. Himmelmann, *Studien*, 12f.

32. Reveling Dionysos: S. Reinach, *Répertoire de la statuaire grecque et romaine*³ II ([1908] Paris n.d.) 123, 130–32 (sometimes also here interpreted as a gesture of quiet rest).

33. *LIMC, s.v.* Anchises, no. 4, pl. 615.

34. Copenhagen, National Museum inv. 731: *CVA* DK 4, Copenhagen, National Museum 4, III I, pl. 163.1. Clairmont, *Parisurteil,* pl. 35; *LIMC, s.v.* Paridis Iudicium, no. 40, pls. 114–15.

35. See also the departure of Amphiaraos on the Corinthian krater in Berlin: Pfuhl, *MuZ*, fig. 179; *LIMC, s.v.* Amphiaraos, no. 7, pl. 555, here fig. 19 (above), and the arrival of the goddess on the west frieze of the Siphnian Treasury: *Fouilles de Delphes*, IV: *Sculptures grecques de Delphes* (Paris 1927) pl. 8.2; *LIMC, s.v.* Aphrodite, no. 1481, pl. 138.

36. Athens, National Museum 14908: *ARV*² 924; *Beazley Addenda*² 305; *CVA* GR 1, Athens NM 1, pls. 6 [28].4–6; *LIMC, s.v.* Paridis Iudicium, no. 45.

37. Aphrodite also holds a phiale on the white-ground pyxis of fig. 28, above. E. Simon, *Opfernde Götter*, 7f., thinks that is filled with an "enflaming love-potion" (see also H. Luschey, *Die Phiale* [Bleicherode/Harz 1939] 13). The meaning can, however, be no different than that on the Athenian red-figure pyxis (fig. 35, above) and on the Archilochos pyxis in Boston (fig. 31, above). Hera appears twice more with phiale in the Judgment of Paris: Clairmont, *Parisurteil*, K 187 and 185, pl. 37; so does Aphrodite: ibid., K 194 and 188, pl. 38.

38. I have not been able to discover who used the term first. To judge by the nature of the expression, it must have been Winckelmann, Goethe, or someone in their circle. In the most recent scholarly literature, the word appears to be used only to designate the contrast between multiple-figured groups in mythical contexts and the single figure of a god at rest.

39. Athens, National Museum 1272, red-figure lekythos: *ARV*² 678.1; O. Benndorf, *Griechische und sicilische Vasenbilder* (Berlin 1883) pl. 36.8. See also *MonAnt* 17 (1906) 515, fig. 361, and Tübingen E 74: C. Watzinger, *Griechische Vasen in Tübingen* (Reutlingen 1924) pl. 25. F. Matz, *Die Naturpersonificationen in der griechischen Kunst* (Göttingen 1913) 65 with further references, had already interpreted these images as epiphanies.

40. New York, Metropolitan Museum 08.258.25: *ARV*² 776.3; *Beazley Addenda*² 288; G. M. A. Richter and L. F. Hall, *Red-Figured Athenian Vases in the Metropolitan Museum of Art* (New Haven 1936) pl. 88; G. Neumann, *Gesten und Gebärden in der griechischen Kunst* (Berlin 1965) 83, fig. 41; *LIMC, s.v.* Athena, no, 590, pl. 762.

41. Red-figure pelike, London, British Museum E 432: *ARV*² 1472.2; Schefold, *UKV* no. 511; G. Bruns, *AM* 35 (1910) 10, pl. III.

42. Florence, Museo Archeologico 75 409: *ARV*² 835.1; L. A. Milani, *Monumenti scelti del R. Museo Archeologico di Firenze* (Florence 1905) pl. 2; *CVA* I 13, Florence Mus. Arch. 2, III J, pl. 1 (color); *LIMC, s.v.* Aphrodite, no. 1216, pl. 123.

43. St. Petersburg: *CRPétersb* ([1877] 1880), pl. 5.3; S. Reinach, *Répertoire des vases*

peints grecs et étrusques I (Paris 1899) 51.13; Schefold, *UKV* no. 466; the photograph was published for the first time in the German edition thanks to the kindness of A. Peredolski.

44. See also the examples cited in n. 45, below, and H. Metzger, *Les représentations dans la céramique attique du IVe siècle* (Paris 1951) pl. III.2, where the youth is identified as Hermes by his kerykeion. The latter is lacking in the other examples, and on a relief-oinochoe in the Louvre, Hermes appears next to this figure: Schefold, *UKV* fig. 52; *LIMC, s.v.* Aphrodite, no. 1181, pl. 118; *Encyclopédie photographique de l'art* III (Editions "TEL," Paris 1939) fig. 63c; R. Lullies, *Die kauernde Aphrodite* (Munich 1954) fig. 42.

45. Berlin F 2688: *JdI* 1 (1886) pl. 11.1. See also a red-figure lekythos in a private collection on which, in place of the seated male "witness," the epiphany of Aphrodite appears seated without context above the sea, across which Eros and a dove fly to her against a headwind: *RA* N.S. 30 (1875) II, pl. 19; Himmelmann, *Eigenart*, fig. 11.

46. Red-figure hydria, New York, Metropolitan Museum 26.60.75: Schefold, *UKV* no. 191, fig. 3, pl. 11; here the mythical context is proved by the presence of a Satyr and two Maenads.

47. One may, however, identify such mythical scenes in the libations for the departing Triptolemos (Simon, *Opfernde Götter*, 67ff.; the phiale appears here for the first time on red-figure vases) and Artemis (column-krater in Ferrara: S. Aurigemma, *Il R. museo di Spina in Ferrara*² [Ferrara 1936] pl. XXXVII) among others.

48. H. Luschey in *RE*, Supplement VII (Stuttgart 1940), *s.v.* φιάλη, 1030; Simon, *Opfernde Götter*, 7; B. Eckstein-Wolf, "Zur Darstellung spendener Götter," *MdI* 5 (1952) 64, 67. See also Aristophanes *Eccl.* 780.

49. See also Eckstein-Wolf, *MdI* 5 (1952), 39ff., and Simon, *Opfernde Götter, passim.* See also H. Moebius, *Gnomon*, 28 (1956) 61ff.; C. Picard, *RA* 1956, I, 115ff.; K. Schefold in *Robert Boehringer, Eine Freundesgabe*, ed. E. Boehringer and W. Hoffmann (Tübingen 1957) 565 n. 46.

50. Eckstein-Wolf, *MdI* 5 (1952) 64.

51. Ibid., 40, 55, 67.

52. Just shortly before the middle of the fifth century B.C. appear gifts to the dead, tomb rituals, and stelai in the pictures on the lekythoi. See also E. Buschor, "Attische Lekythen der Parthenonzeit," *MüJb* N.F. 2 (1925) 171 (published separately as a monograph, p. 5).

53. Red-figure stamnos, Gotha 51: *ARV*² 1028.10; *MonInst* IX (Rome 1869–73), pl. 53; Apollo with inscription. See further Simon, *Opfernde Götter*, 86 nn. 55, 56; and a volute-krater of the Kleophon Painter: N. Alfieri, P. E. Arias, and M. Hirmer, *Spina: Die neuendeckte Etruskerstadt und die griechischen Vasen ihrer Gräber* (Munich 1958) pl. 85; *ARV*² 1143.1, 1684; *Beazley Addenda*² 334.

54. Simon, *Opfernde Götter*, 58ff.; for a list of examples, see 65f.

55. Zeus pouring a libation with Athena: skyphos in Vienna 3711 (329): *ARV*² 972.3; H. R. W. Smith, *Der Lewismaler* (Leipzig 1939) pl. 3a; *LIMC, s.v.* Athena, no. 186, pl. 726; amphora by the Berlin Painter in Karlsruhe B95: *ARV*² 202.73; *Beazley Addenda*² 192; *CVA* D 7, Karlsruhe 1, pl. 15.3. Zeus with Apollo on an amphora by the Berlin Painter in the British Museum E 444: *ARV*² 208.149; *CVA* GB 4, British Museum 3, III Ic, pl. 21.4 (this might be a scene of welcoming). Zeus with Ares on a kylix in the British Museum E 67: *ARV*² 386.3, 1649; Cook, *Zeus*, III.2 (Cambridge 1940) 1050–51, fig. 845.

Zeus with Nike on a pelike in the Louvre G 223: ARV^2 250.16, 254.6; CVA F 9, Louvre 6, III Ic, pl. 43.1; pelike in the British Museum 95.8–31.1: ARV^2 622.50; Beazley Addenda² 270; Cook, Zeus III.1, pl. 59. Further references are given in Eckstein-Wolf, MdI 5 (1952) 71f. At times, but not always, the subject could be a libation of greeting as in the case of Herakles on Mt. Olympos: Simon, Opfernde Götter, 91f. Simon (pp. 91f.) considers the phiale Zeus holds at the birth of Athena a humorous detail (Paris, Cabinet des Médailles 444: ARV^2 1112.3; Beazley Addenda² 330; Pfuhl, MuZ, fig. 518; LIMC, s.v. Athena, no. 357; s.v. Eileithyia, no. 14, pl. 535). But parodies cannot be recognized among all the known representations of the myth, pace Simon, 92, and there is no occasion in this case to see one either. The phiale takes the place of the thunderbolt in older pictures and is used equally to designate the divinity of the god: Cook, Zeus, III.1, 622ff.

56. Dionysos: Simon, Opfernde Götter, 47ff.; Eckstein-Wolf, MdI 5 (1952) 57ff., 71; Poseidon: ibid., 72; Athena and unknown girl (Pandrosos?): ibid., 62, 73. Athena pours a libation alone on two pseudo-Panathenaic amphoras: CVA F 8, Louvre 5, III Ic, pls. 31.7, 4, 32.1, 6; 31.9, 6, 32.4, 5; ARV^2 221.9–10; Beazley Addenda² 198.

57. Thus Simon, Opfernde Götter, 8, who regularly seeks a recipient of the libation (12, 31; see also 36, 38, 61, etc.). She makes exceptions only for pictures of Dionysos (54), but even these should have some reference to a context (55) when the god sacrifices "in Apollonian form."

58. Ibid., 13ff.; Eckstein-Wolf, MdI 5 (1952) 69f. My fig. 43 is a red-figure amphora by the Niobid Painter in Würzburg (503): ARV^2 611.32; LIMC, s.v. Apollo, no. 653, pl. 236.

59. Examples are given by Eckstein-Wolf, MdI 5 (1952) 69f. See also Furtwängler in Kleine Schriften (above, n. 20) II (Munich 1913) 93.

60. Luschey in RE Supplement VII, 1030. Argued in detail by Simon, Opfernde Götter, 26ff.

61. Ibid., 31–38, imagines a sacrifice for Zeus and the Erinyes.

62. E. Rohde, Psyche, I⁶ (Tübingen 1910) 271f. (Psyche: The Cult of Souls and Belief in Immortality among the Ancient Greeks, trans. W. B. Wells [London 1925; reprinted Chicago 1987] 180 and n. 167 on 213–14), distinguishes in the purification scene in Apollonios Rhodios Argon. 4.712ff., the καθαρμός of lines 704ff. from the ἱλασμός of lines 710ff., which is accomplished by a sacrifice at an altar.

63. See also FR pl. 120.4; LIMC, s.v. Orestes, no. 49, pl. 54.

64. L. Stephani, CRPétersb [1876] 1873, 206ff., had already pointed out that Apollo regularly appears as Kitharoidos in libation scenes (see further below, n. 66). Simon, Opfernde Götter, 16, 23, 32, puts forward the hypothesis that Artemis carries the weapons for Apollo. But the precedence of the Kitharoidos still remains unexplained. However, pictures in which both Apollo and Artemis carry weapons show that the weapons belong to Artemis herself: A. Fairbanks and G. H. Chase, Greek Gods and Heroes (Boston 1948) 26, fig. 16 (both with quiver); CVA USA 10, San Francisco, III K, pl. 18.2; ARV^2 617.1; Beazley Addenda² 269 (bow and quiver above the head of Apollo; Artemis carries the same weapons).

65. LIMC, s.v. Apollon, no. 1000, pl. 269.

66. Eckstein-Wolf, MdI 5 (1952) 53. Both Simon, Opfernde Götter, 17ff., 32, and Eckstein-Wolf, pp. 47ff., saw that the Apollonian scenes of libation are intimately connected with the Late Archaic images of the "musical triad:" e.g., Eckstein-Wolf, pl. 1.1. She notes (49) that in these "the libation vessels (appear) as attributes inserted in an in-

dependent picture." Furthermore, she asserts correctly that the meaning of this is to produce a "Seinsbild" or life-image of Apollo (see also above, n. 55 on the phiale and Zeus). Out of this important insight Eckstein-Wolf was unable to draw, however, the appropriate consequences, because she, as all previous commentators, believed that figures pouring libations belonged to the human sphere: "The libation bowl is not an attribute like other, normal attributes, which express the nature of the god, but incorporates something derived from another conceptual sphere or realm of existence" (ibid., 55; see also also 64ff. and especially 67). Given this interpretation, the image of a god pouring a libation could no longer really be called a life-image, or "Seinsbild," as Eckstein-Wolf calls it.

67. Eckstein-Wolf, *MdI* 5 (1952) pl. 2.2 (Artemis crowns Apollo, who pours a libation). Nike crowns Zeus pouring a libation on a hydria in Goluchow: J. D. Beazley, *Greek Vases in Poland* (Oxford 1928) pl. 13.1. My fig. 44 (above) of Dionysos pouring a libation (the stream of wine is indicated) and crowned by a Maenad is a red-figure calyx-krater, Copenhagen, National Museum ABc 1021: *ARV*² 1035.2; *Beazley Addenda*² 318; *CVA* DK 4, Copenhagen, National Museum 4, III I, pl. 146.1; *LIMC, s.v.* Dionysos, no. 421, pl. 347. For Leto crowning Apollo on a vase in Naples: H. Heydemann, *Dei Vasensammlungen des museo nazionale zu Neapel* (Berlin 1872) no. 3100 (*ARV*² 1061.153).

68. Votive relief in the Sparta museum: M. N. Tod and J. A. B. Wace, *A Catalogue of the Sparta Museum* (Oxford 1906) 181, no. 468.

69. P. Stengel, *Opferbräuche der Griechen* (Leipzig 1910) 178ff.

70. Red-figure stemmed dish, Copenhagen, National Museum inv. 6: *ARV*² 787.3; *CVA* DK 4, Copenhagen, National Museum 4, III I, pl. 159.6

71. *LIMC, s.v.* Artemis, nos. 1023–24, pl. 525.

72. L. Deubner, "Hochzeit und Opferkorb," *JdI* 40 (1925) 210f.

73. Simon, *Opfernde Götter*, 7f.

74. Red-figure lekythos, St. Petersburg, Hermitage St 1929: L. Stephani, *Die Vasen-Sammlung der kaiserlichen Ermitage* (St. Petersburg 1869) II, no. 1929; Himmelmann, "Zur Knidischen Aphrodite," 11ff., fig. 3; see below, pp. 187–94, fig. 81; L. Ghali-Kahil, *Les enlèvements et le retour d'Hélène* (Paris 1955) pl. 6.1; *LIMC, s.v.* Helene, no. 172, pl. 322.

75. See above, n. 46.

76. The thymiaterion appears, for example, in the east frieze of the Parthenon (W. H. Smith, *The Sculpture of the Parthenon* [London 1910] pl. 39; F. Brommer, *Der Parthenonfries* [Mainz 1977] pl. 188), in a Dionysiac sanctuary (FR pls. 175–76: H. B. Walters, *Catalogue of the Greek and Etruscan Vases in the British Museum* IV [London 1896] F 67); at the reception of a heroic rider (G. Nicole, *Meidias et le style fleuri* [Geneva 1908] pl. 7.3); and on the kline of the Dioskouroi (B. Filow, I. Welkow, and V. Mikow, *Die Grabhügelnekropole bei Duvanlij in Südbulgarien* [Sofia 1934] 75, fig. 95). The appearance of it in funeral banquets stems from the Oriental custom of having it present at meals: *BJb* 122 (1912) 69.

77. See the references given by Metzger, *Représentations* (above, n. 44) 286 n. 1.

78. Tübingen E 177: Watzinger, *Griechische Vasen in Tübingen* (above, n. 39) pl. 39.

79. Above, n. 46. A terrified "witness" next to a quiet epiphany of Aphrodite: P. Jacobsthal, *Göttinger Vasen: Nebst einer Abhandlung* Συμποσιακά (Berlin 1912) no. 48, pl. 16; Schefold, *UKV*, figs. 19, 20; *Clara Rhodos*, 2 (Rhodes 1932) 131, fig. 12, pl. 3; mirror in London: W. Züchner, *Griechische Klappspiegel*, *JdI-EH* 14 (Berlin 1942) pl. 14

(KS. 26), but see also S. Karousou, *BCH* 70 (1946) 436ff.; next to Dionysos and Ariadne: *CVA* USA 1, Hoppin, III Id, pls. 18.1–2; *ARV*² 1458.32; next to Herakles: hydria in London: *BCH* 70 (1946) 383, fig. 6. Similar figures are also combined with active figures of gods as epiphanies and thereby prove that the quiescent figures of gods are also epiphanies: hydria in the British Museum: E 232, *CVA* GB 8, British Museum 6, III Ic, pl. 96.3: Satyr before Apollo on swan.

80. "The Greeks' goal is to deify man, not humanize gods—it is theomorphism, not anthropomorphism!" Goethe, *Myrons Kuh*, in *Goethes Werke,* ed. W. Weber and H. J. Schrimpf, XII (Hamburg 1953) 136 (*Myron's Cow* in J. W. Goethe, *Essays on Art and Literature*, trans. E. and E. H. von Nardroff [New York 1986: Suhrkamp edition vol. 3] 28. M. Eliade, *The Sacred and the Profane*, trans. W. R. Trask (New York 1959), especially 85ff., presents numerous examples of the belief that festival and sacrifice are an *imitatio dei*. See also W. F. Otto, *Die Gestalt und das Sein* (Düsseldorf 1955) 13: "The most sacred activities in the service of the gods in all societies are a remembrance and a repetition of that which the gods themselves did in earliest times." According to Plato *Laws* 653d, the gods teach humans to hold festivals. The pictures of Herakles with Athena pouring a libation are to be understood in the spirit of the citation of Goethe above. See, for example, T. B. L. Webster, *Der Niobidenmaler* (Leipzig 1935) pls. 22 c, d: they show that the hero shares in the divine, which his mentor transmits to him and will later raise him to Mt. Olympos. Simon also requires for these pictures an unseen recipient and suggests Hera: *Opfernde Götter*, 12. The phiale is regularly held by heroes in the funeral banquet as a sign of their divine nature; see Luschey in *RE* Supplement VII, 1030.

81. Red-figure kantharos, Boston, Museum of Fine Arts 00.334: *ARV*² 126.27; Pfuhl, *MuZ*, fig. 320. Figure 47 after a new photograph by the kindness of C. Vermeule and H. Palmer. Simon, *Opfernde Götter*, 47ff.; Eckstein-Wolf (above, n. 48) 71. There is, moreover, a contemporary description of a representation of Dionysos pouring a libation in the treasury inscription of Artemis Brauronia: A. Michaelis, *Der Parthenon* (Leipzig 1871) 310, §62 (probably 350–340 B.C.): Κλεοβούλη· ἐπίβλημα ποικίλον καινόν, σημεῖον ἔχει ἐν μέσῳ· Διόνυσος σπένδων καὶ γυνὴ οἰνοχοοῦσα.

82. Red-figure kylix in Brussels, Bibliothèque Royale 12: *ARV*² 797.134; D. Feytmans, *Les vases grecs de la Bibliothèque Royale de Belgique* (Brussels 1948) no. 12, pl. 33. In this case the goddess is identified by her diadem. The inscription in the genitive is also not unique in this period; see also "Dios" written next to Zeus on the Boston Aktaion vase by the Lykaon Painter: L. D. Caskey and J. D. Beazley, *Attic Vase Paintings in the Museum of Fine Arts, Boston* II (Oxford 1954) no. 110, p. 85, pl. LXII; *LIMC, s.v.* Aktaion, no. 81, pl. 357; *ARV*² 1045.7; *Beazley Addenda*² 320.

THE DIVINE ASSEMBLY

ON THE SOSIAS CUP

THE SCENE ON THE exterior of the Sosias Painter's cup in Berlin (fig. 49) does not seem to offer any significant problems of interpretation.[1] The correct identification, as the Introduction of Herakles to Olympos, was long ago recognized by Eduard Gerhard, and O. Jahn, G. Welcker, and F. Hauser later refined this with respect to individual points.[2] The action is clear enough: accompanied by Athena, Apollo (?), and Hermes, Herakles enters the heavenly dwelling of the gods, his right hand raised in a gesture of reverence.[3] Opposite him, at the other end of the frieze, sit Zeus and Hera, holding up phialai into which a winged goddess pours. The inscription beside her may read Hebe. All the other gods, who sit in pairs, with the exception of the Horai, turn their backs on Herakles. Apart from the Horai, who hold their branches of fruit and flowers, each of the gods holds a phiale tilted forward in an outstretched right hand. In a rare consensus of opinion, this part of the scene has always been interpreted as a divine banquet or symposium, and no commentator has failed to cite the famous lines from the beginning of the fourth book of the *Iliad*:

> Now the gods at the side of Zeus were sitting in council
> over the golden floor, and among them the goddess Hebe
> poured them nectar as wine, while they in the golden drinking-cups
> drank to each other, gazing down on the city of the Trojans.
> [*Iliad* 4.1–4, trans. Richmond Lattimore]

"Die Götterversammlung der Sosias-Schale," *MarbWPr* (1960) 41–48, trans. H. A. Shapiro.

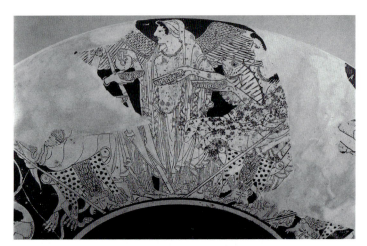

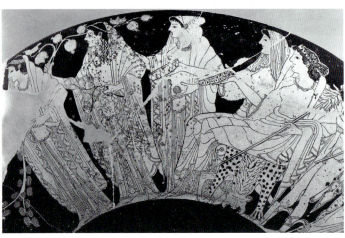

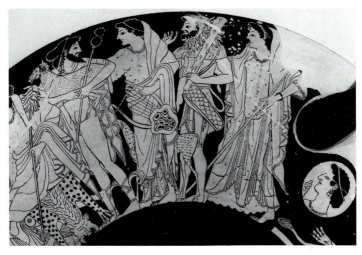

49a–d. Introduction of Herakles to Olympos, Attic red-figure kylix
(details) signed by Sosias. Berlin, Antikensammlung, Staatliche
Museen, Preussischer Kulturbesitz

Two recent studies devoted to the theme of gods performing a libation also
accept the interpretation as a banquet of the gods. B. Eckstein-Wolf would go
so far as to see in this scene the proof that the phiale was also used as a drink-
ing cup.[4] There is, in fact, plenty of evidence to support this, but not on the
Sosias cup, where none of the gods is lifting the phiale to his mouth.[5] E. Si-
mon has tentatively suggested that Zeus is performing a libation to welcome
his son, though this reading cannot, of course, be extended to the other gods
who turn away from Herakles.[6] Simon thus sees in the activity of these figures
a "Götterbankett" and, more specifically, an illustration of the Homeric phrase
that the gods "drink to one another" (δειδέχατ᾽ ἀλλήλους).[7]

Despite the universal agreement on the interpretation as a symposium,
there are some minor differences of opinion in the reading of the Olympian
gods' gestures. In his Berlin catalogue, K. Neugebauer writes, "All the gods
reach out their cups to receive the drink which the winged Hebe distributes,
starting with Zeus and Hera."[8] This is how Hauser had also imagined the
scene, and on this basis, the gods even reminded him of "a table full of chil-
dren, when the soup is dished out."[9] In this reading the most disturbing ele-
ment is the monotony with which all the gods hold their cups stretched out
and tilted down in the same way, a striking departure from the lively gestures
and love of variety that we usually find in the imagery of the symposium and
divine gatherings in Archaic art. It is particularly surprising coming from a

painter who was clearly one of the most original talents of his time. Fortunately, this is not the only possible interpretation of the scene.

The suggestion of E. Simon, mentioned above, who would see in the scene the Homeric custom of drinking a toast, derives from the interpretations of K. Robert and J. von Fritze.[10] Numerous sources attest to a formal ritual associated with drinking. Athenaeus explains as follows: "For they filled and pledged each other with a greeting." And he observes: "For, properly speaking, that is what pledging is, to give another a drink before oneself."[11] This is clearly not what is happening on the Sosias cup. The gods neither extend their cups to one another, nor are they even sitting opposite each other, to create the impression of a personal interaction. This awkward arrangement is a particularly puzzling lapse on the part of the painter, since the motif of figures sitting opposite one another in pairs had long been established in the pictorial tradition (fig. 50).[12] Finally, when Simon says that the toast "consisted of spraying a few drops out of the drinking vessel," the inference is from the picture itself, not from the sources, and carries no weight.[13] However we are to imagine the practice known as δεικνύναι, it certainly entailed a face-to-face encounter and exchange of words, and this is not what we have represented on the Sosias cup.

A further problem has never been dealt with in earlier scholarship, though it certainly needs to be mentioned. As is well known, long before the date of the Sosias cup, the Greeks had adopted the Oriental custom for men of reclining at a symposium or banquet.[14] One could easily object that this Oriental τρυφή would be inappropriate to the dignity of the gods, and they must rather be depicted in the Homeric usage as opposed to that of contemporary life.[15] But things are not that simple. Our early sources do not give the impression that reclining at a meal was considered undignified or slovenly. Kings and heroes are depicted in this manner, even as early as the famous Early Corinthian krater in the Louvre, with King Eurytos and his guests reclining beside tables in the presence of the Princess Iole.[16] The familiar type of the funerary banquet of a dead hero on a couch is attested long before the date of the Sosias cup, on a fragmentary relief from Tegea, on which the hero's consort sits at his feet.[17] The Olympian gods adopt this custom as well. On a cup in London of the Parthenonian period (fig. 51), the gods recline with phialai in their hands, while the goddesses sit on the foot of the couch.[18] That this is not simply an example of "humanizing" the Olympian gods in later times is demonstrated by an early red-figure cup in Florence (fig. 52).[19] Not only Hermes and Herakles (for whom this form of relaxation might be more understandable), but also two of the most dignified gods, Apollo and Poseidon, are shown reclining and holding their drinking cups by the foot.[20] This vase is of

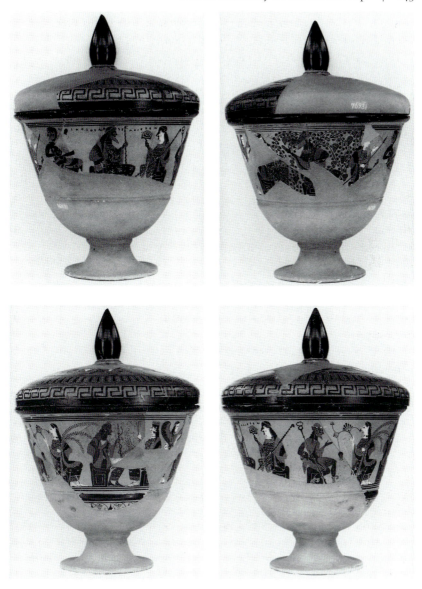

50a–d. Herakles in Olympos, Attic black-figure pyxis. Florence, Museo Archeologico

particular importance because it is probably slightly earlier than the Berlin Sosias Painter's cup.[21]

Of those scenes that can with certainty be identified as divine banquets, one other element is significant in this context. Whenever there is a couple

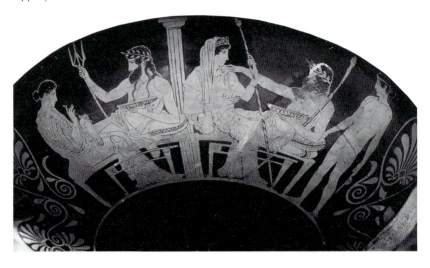

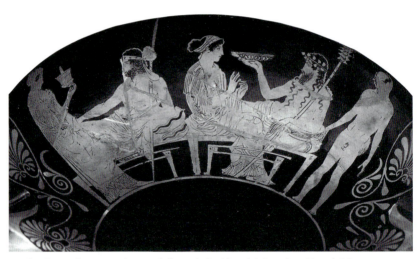

51a–b. Divine banquet, Attic red-figure kylix (details). London, British Museum

consisting of man and woman, as on the many "Totenmahlreliefs" or on the cup in London (fig. 51), only *one* drinking vessel is shown. It belongs to the man and is held by the woman only in a serving capacity. This is evidently a hard and fast rule, to which the Sosias cup would be the only exception, were we to interpret the phialai as drinking vessels.

As we have seen, anyone who reads the scene on the Sosias cup as a divine banquet is faced with contradictions or has to blame a confusion on the vase.

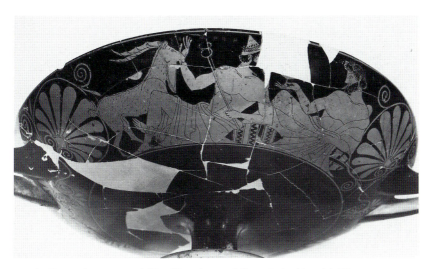

52a–b. Divine banquet with Herakles, Attic red-figure kylix (details). Florence, Museo Archeologico

Yet, as we should expect of a work of such superb quality, the gestures of the Olympians *do* have a specific meaning, one obvious all along were it not for a fixation on the notion of divine banquet.[22] If any of these gods appeared alone on a vase, with the phiale tilted in this manner, we would not hesitate to identify the motif, as in hundreds of examples, as the pouring of a libation. This ex-

plains why the phialai are stretched out so far, to avoid the impression of the gods pouring onto their own clothes. Clearly, the gods on the Sosias cup are performing a libation, and the only question is, what can this action mean in this context? A libation to welcome Herakles is out of the question, since most of the gods are turned away from him. Since it was customary at a symposium to offer a threefold libation (one for the Olympians, one for the heroes, one for Zeus Soter), one could imagine that this human practice has been freely adapted for the gods.[23] In that case, however, why do they not recline as well, like the divine symposiasts on the Florence cup (fig. 52)? We may at least be sure that the Sosias Painter was not concerned with the symposium setting, which he could easily have indicated, but only with the act of libation.[24] Just as each divinity is characterized by his or her own personal attribute, so the libation is the attribute that represents what they all share, their divinity.

The subject of the Sosias cup requires a representation of Olympos, the dwelling of the gods, into which Herakles is received. Here Olympos is of course not a physical location, but rather a sacred space, which is defined by the presence of the gods and can only be represented in this way. The Sosias Painter, in having his gods perform a libation, uses a relatively recent idea.[25] In the human realm, the libation, as a ritual act on specific occasions, establishes a link to the divine sphere, toward which it is always directed.[26] When, however, the gods pour a libation, there is neither an occasion nor the sense of direction. Rather, the act is entirely self-referential.[27] Insofar as the libation of the gods has no other object, the action is for them nothing more than a form of expression, by which they represent themselves and express visually the essence of who they are. I have argued in the previous chapter that in this same period we get images of a particular god expressing through his own person the powers unique to him (most clearly in the case of the ecstatic Dionysos).[28] The libation as an act no longer directed outward, but by which the gods express their own essence, has a distancing effect on this image of the gods that was unknown previously. Thus a new category of images is created, in which the gods are removed from any narrative context and instead are represented in a state of complete self-sufficiency.[29] This also explains why the Sosias Painter could not simply add the phialai, like other attributes, to an existing pictorial type but had to create an essentially new composition.

The apotheosis of Herakles is depicted in Archaic art in three different ways. There is, first, the chariot procession, in which Athena drives her protégé to heaven, accompanied usually by Apollo, Hermes, and other gods.[30] Second is the type in which Athena brings Herakles on foot into the presence of Zeus. These images already have the explicitly religious tone that we find on the Sosias cup. Herakles raises his right hand in a reverent gesture or, awe-

struck, he turns to flee; or Athena must physically push him forward as he tries to hang back.[31] Finally, there is the third type, in which the hero has already been received into the company of the gods and takes a place of honor beside his father Zeus (fig. 50, above).[32] We might consider that the composition of the Sosias cup is made up of elements from the second and third types, but the combination produces a different meaning. The gods do not turn to receive Herakles, as they do, for example, when they watch Hephaistos returning to Olympos on the François Vase.[33] Rather, they turn their backs on him, completely absorbed in the act of libation. The painter could easily have characterized the libation as a greeting by having the gods look at the actual protagonist of the scene. Since he specifically denies this association and instead introduces a rather pointed contrast, it can only be an indication that the libation is *not* occasioned by this particular episode but is a timeless action performed by the gods. This reformulation has a distancing effect on the subject of the divine assembly, and impresses on us the special nature of the sphere into which Herakles enters. For the first time in Greek art,[34] Olympos is not merely characterized as the setting required by a particular mythological narrative. Here we have purely a "Daseinsbild," or life-image, removed from the episodic into the timeless realm unique to the gods, where their presence is a kind of epiphany.[35]

The theme of the divine assembly has never received a separate scholarly treatment.[36] It seems, however, that originally the gathering of the gods was never depicted solely for its own sake,[37] but rather the true life-image first appears toward the end of the sixth century, that is, at the time of the Sosias cup. In earlier art, there is always a specific mythological occasion for which the Olympians assemble and thereby define Olympos: the Return of Hephaistos, the Introduction of Herakles, the Birth of Athena, or Thetis supplicating Zeus.[38] Out of these representations develop scenes that may be considered preliminary stages to the life-image. So, for example, we might imagine that the group of Apollo playing his lyre with Leto and Artemis, so popular in Late Archaic art, has been excerpted from a much larger mythological scene, for example, the Birth of Athena in the presence of the assembled gods.[39] On an amphora of about 540 in Orvieto (fig. 53a), Apollo is absent on the side depicting the Birth of Athena, although he is often present in such scenes (see also fig. 54).[40] Yet on the other side of the Orvieto amphora, Apollo appears in the traditional form, but now combined with his mother and sister into a new group (fig. 53b). It remains uncertain whether this group actually belongs with the Birth of Athena on the other side or not.[41] What is more important is that, by the end of the century, this same group had been transformed into the new type of life-image through the addition of the libation motif.[42] In the same pe-

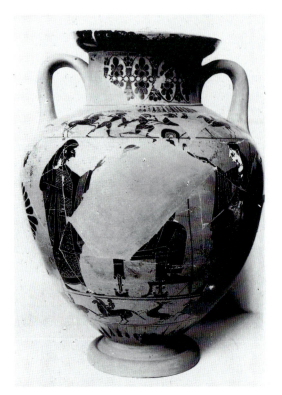

53a. Birth of Athena, Attic black-figure amphora. Orvieto, Duomo

53b. Apollo, Artemis, and Leto, Attic black-figure amphora (detail). Orvieto, Duomo

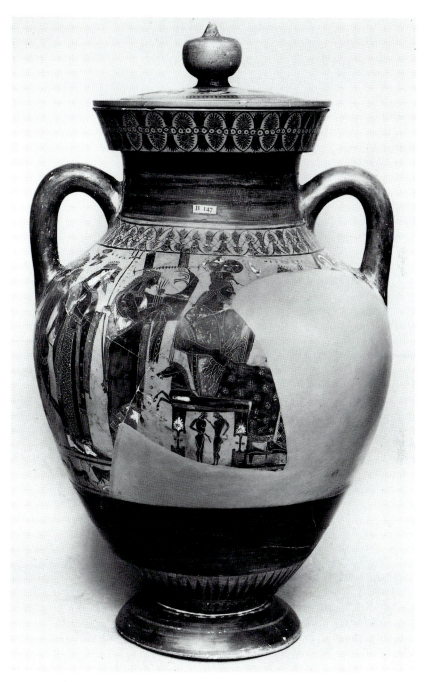

54. Birth of Athena, Attic black-figure amphora. London, British Museum

riod we also find large gatherings of Olympian gods, in which there is no recognizable mythological narrative nor, most likely, was one intended, such as on a cup by Oltos and an amphora by the Nikoxenos Painter.[43] Significantly, in both instances the libation motif occurs at a central point in the scene.

The studies of B. Eckstein-Wolf and E. Simon have recently demonstrated most impressively how closely associated the libation motif is with the imagery of the gods in the first half of the fifth century. It survives as a living tradition throughout the rest of antiquity but will never again play as important a role as it did in this early period. It is particularly striking that the libation has already lost much of its importance by the second half of the fifth century and into the fourth. In the gathering of gods on the east frieze of the Parthenon, none of the figures holds a phiale, nor do the Eleusinian gods on the Kerch pelike in St. Petersburg, which translates the old theme of the Introduction of Herakles

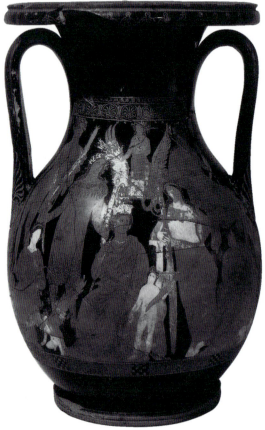

55. Introduction of Herakles to Olympos, Kerch pelike. St. Petersburg, Hermitage

into the distinctive pictorial language of the fourth century (fig. 55).[44] Only one explanation is possible for the decline of importance of the libation motif, which at the same time will help to illuminate its original meaning.

The art of the Parthenon in particular opened up new possibilities for representing the ethos of the gods, and beside these, the by now rather formulaic act of libation paled.[45] If it had been the purpose of this motif to present the gods as remote apparitions representing themselves, later art achieves this effect by means of interior characterization. The Eleusinian pelike is a particularly striking example (fig. 55). The solemn frontality of the gods, with their gaze directed into the void, makes them seem utterly remote. A representation of Herakles' initiation a century earlier had used lively gestures to narrate the event,[46] while here all visible activity is suppressed to the point where it is negligible, so that we seem to see a timeless vision rather than a particular mythological episode. The figures have something of the quality of Platonic "ideas," vividly recalling the kind of vision propounded in the *Phaedrus*.[47]

NOTES

1. Berlin 2278: *ARV*[2] 21.1; *Beazley Addenda*[2] 154.

2. For the older literature see F. Hauser in FR, III, 13ff., pl. 123. See most recently A. Greifenhagen, *Antike Kunstwerke*[2] (Berlin 1966) 26, figs. 66–67; *LIMC, s.v.* Herakles, no. 2859.

3. Hauser in FR (above, n. 2) identified the figure with a lyre as Apollo, although the inscription reads "Artemis." The mantle drawn up over the head is unusual for Apollo. For Herakles' gesture, see also other scenes of the Introduction, e.g., E. Gerhard, *Auserlesene Vasenbilder*, II (Berlin 1843) pl. 128, or *AZ* 1870, pl. 33; *LIMC, s.v.* Herakles, no. 2867. That this gesture is one of prayer is shown by the oinochoe in New York, *JdI* 52 (1937) 45, fig. 8; *LIMC, s.v.* Athena, no. 590, pl. 762.

4. B. Eckstein-Wolf, "Zur Darstellung spendender Götter," *MdI* 5 (1952) 47, 60.

5. E.g., Athena giving Erichthonios a drink from a phiale: H. Diepolder, *Der Penthesilea-Maler* (Leipzig 1936) pl. 27.1 (fragments from the Acropolis of Athens not listed by Beazley in *ARV*[2] but formerly *ARV*[1] 628.1); a mythical king drinks from a phiale: *CVA* GB 3, Oxford 1, pl. 17.3; *ARV*[2] 820.52; *Beazley Addenda*[2] 293. According to Pindar *Nem*. 9.50f., the wine at the victory feast of Chromios was distributed in phialai that Chromios had brought as prizes from Sikyon. On the other hand, one can also pour a libation from a kantharos; see also the recently discovered votive relief to the Nymphs from Penteli: U. Hausmann, *Griechische Weihreliefs* (Berlin 1960) fig. 31.

6. E. Simon, *Opfernde Götter* (Berlin 1953) 89.

7. Ibid., 109 n. 143.

8. K. A. Neugebauer, *Führer durch das Antiquarium*, II: *Vasen* (Berlin 1932) 85.

9. Hauser in FR (above, n. 2).

10. K. Robert, *Commentationes philologae in honorem Th. Mommseni* (Berlin 1877) 149f.; J. von Fritze, *De libatione veterum Graecorum* (Diss. Berlin 1893) 59ff.

11. Athenaeus 11.498d and 498c: πληροῦντες γὰρ προέπινον ἀλλήλοις μετὰ προσαγορεύσεως. . . . κυρίως γάρ ἐστι τοῦτο προπίνειν τὸ ἑτέρῳ πρὸ ἑαυτοῦ δοῦναι πιεῖν. The translations in the text are by C. B. Gulick (Loeb edition).

12. Pyxis, Florence 76931: L. A. Milani, *Monumenti Scelti del R. Museo Archeologico di Firenze* (Florence 1905) pl. 1; *ABV* 229; *Beazley Addenda*² 59; Boardman, *ARFVAP*, fig. 153. Zeus carries a knotty stick, as on the kothon in the Louvre (*ABV* 58.122; *Beazley Addenda*² 16; J. D. Beazley, *The Development of Attic Black-Figure* (Berkeley 1951) pl. 9 [second edition 1986, pl. 20.2]; *LIMC, s.v.* Athena, no. 345, pl. 743) and the cup in Heidelberg (*ABV* 63.1; *Beazley Addenda*² 17; *JHS* 51 [1931] 276; *LIMC*, no. 485, pl. 754).

13. Simon, *Opfernde Götter*, 109.

14. H. Blümner, *Die römischen Privataltertümer*³, *Handbuch der klassischen Altertumswissenschaft* 4.2 (Munich 1911) 386ff.; P. Jacobsthal, *Theseus auf dem Meeresgrunde: Ein Beitrag zur Geschichte der griechischen Malerei* (Leipzig 1911) 14ff.; H. Payne, *Necrocorinthia: A Study of Corinthian Art in the Archaic Period* (Oxford 1932; reprint College Park [MD] 1971) 118; P. von der Mühll, in *Xenophon, Gastmahl (Rowohlts Klassiker,* vol. 7) 81.

15. See Jacobsthal, *Theseus auf dem Meeresgrunde* (above, n. 14); see also *Iliad* 1.531ff.

16. Payne, *Necrocorinthia* (above, n. 14) pl. 27; *LIMC, s.v.* Eurytos I, no. 1, pl. 62. It is rather an exception when Phineus is shown enthroned next to the table on a red-figure amphora, London E 302: *CVA GB* 7, British Museum 5, pl. 53.2a; *LIMC, s.v.* Harpyiai, no. 10, pl. 268; *ARV*² 652.2; *Beazley Addenda*² 276. Phineus already reclines on the black-figure Chalkidian cup in Würzburg: FR, pl. 41; *LIMC, s.v.* Boreadai, no. 7, pl. 101.

17. *AM* 4 (1879) pl. 7. See Himmelmann, *Studien zum Ilissos-Relief* (Munich 1956) 33 n. 16.

18. London E 82 (Kodros Painter): *ARV*² 1269.3; Jacobsthal, *Theseus auf dem Meeresgrunde* (above, n. 14) pls. V.9–VI; *LIMC, s.v.* Amphitrite, no. 52, pl. 585. For other divine banquets with the reclining motif, see also the calyx-krater in Bologna: *ARV*² 1184–85.6; Jacobsthal, *Theseus,* pl. IV.7; another calyx-krater in Adolphseck: *CVA* D 11, Schloss Fasanerie 1, pls. 46–48; *ARV*² 1346.1; *Beazley Addenda*² 368; and a relief from the Piraeus, *AM* 7 (1882) pl. 14.

19. Florence 73127: *CVA* I 30, Florence 3, pl. 75; *ARV*² 173.4 (Ambrosios Painter); *LIMC, s.v.* Hermes, no. 550, pl. 246.

20. See also the Mythological Index to *ABV, s.v.* "Heracles resting," "Hermes resting" (726), and "Dionysos resting" (724). The footed cups depicted in the scene in Florence are replaced by phialai on the cup in London (above, n. 18). See also H. Luschey in *RE*, Supplement 7 (Stuttgart 1940) 1030.

21. The difference in time cannot be very great, but notice the outline of the hair, which is here still done with incision, while on the Sosias cup it is reserved.

22. Simon's observation (above, n. 13) comes close to the solution offered here.

23. See Sappho fr. 136–136D. On libations at the symposium, see von Fritze (above, n. 10) 39ff. The exact sequence is not clear and was probably not the same everywhere.

24. On the cups in London (figs. 51a–b, above) and Florence (figs. 52a–b, above), the vessels are held in various ways. Besides, the latter shows the gods holding footed kylikes, while on the former Ares has a kantharos, which Aphrodite holds for him. The fact that on the Sosias cup Hebe is pouring for Zeus and Hera does not mean, of course, that these are the last to receive their serving, but rather reflects a "demonstrative" narrative technique, which associates the attendant with the most important couple.

25. See Eckstein-Wolf, *MdI* 5 (1952) 39–75; Simon, *Opfernde Götter*, and Himmelmann, *Eigenart* (trans. above, pp. 103–29). J. Dörig, *Universitas* 14 (1959) 1274, claims erroneously that I had maintained that images of gods libating are an invention of the fifth century. Rather, I believe that scenes of libation as "Daseinsbilder" first appear in the course of the last third of the sixth century, whereas in the context of mythological episodes they might have existed at any earlier time (see also *Eigenart*, nn. 5a, 4, 55 [trans. above, pp. 130, 129, 135, nn. 7, 6, 47]). The earliest known example for the first type I would see on the cup by Oltos in Tarquinia [below, n. 43]). For the bronze Apollo from the Piraeus (see also Dörig), it seems to me that restoring a phiale in his hand is entirely possible and likely.

26. See Eckstein-Wolf, *MdI* 5 (1952) 40ff.

27. This is also the view of Eckstein-Wolf, *MdI* 5 (1952) 60f; see also Himmelmann, *Eigenart* (trans. above, pp. 103–29). For a different view, see von Fritze (above, n. 10); Simon, *Opfernde Götter*; and, most recently, K. Schefold, *Griechische Kunst als religiöses Phänomen* (Hamburg 1959) 86f.

28. Himmelmann, *Eigenart*, 11ff., 19f. (trans. above, pp. 105–8, 117–19). Hausmann, *Griechische Weihreliefs* (above, n. 5) 52f., has expressed reservations about this thesis which, I believe, are obviated if we dispense with the notion of "Affekt" that he introduces. My thesis may have been somewhat overstated, but I would still stress that, formulated in theological terms, it refers not to affect but "power." Apart from this question of nuance, Hausmann's observations are generally in agreement with my thesis.

29. G. von Kaschnitz in *Neue Beiträge zur klassischen Altertumswissenschaft: Festschrift B. Schweitzer*, ed. R. Lullies (Stuttgart 1954) 156, defines a very similar phenomenon, only with more general application, in his felicitous description of the "increasingly microcosmic character" of Late Archaic figures.

30. F. Brommer, *Vasenlisten zur griechischen Heldensage*[3] (Marburg 1973) 159ff.

31. Brommer, *Vasenlisten*[3] (above, n. 30) 172ff. See also the introduction pediment from the Acropolis (A. F. Stewart, *Greek Sculpture: An Exploration* [New Haven 1990] fig. 73) and Pausanias 3.19.1.

32. Brommer, *Vasenlisten*[3] (above, n. 30) 174. We may perhaps add the careless late black-figure neck-amphora, Louvre F225: E. Pottier, *Vases antiques du Louvre*, II (Paris 1901) pl. 80; *CVA* F 8, Louvre 5, pl. 57, nos. 2 and 7; *LIMC*, s.v. Hermes, no. 776, pl. 263 (where the vase is said to be Etruscan). The scene is very garbled, and Zeus is missing.

33. FR, pls. 11–12; *LIMC*, s.v. Dionysos, no. 567, pl. 564. See also the black-figure version of the Introduction of Herakles on Louvre E 733 (Pottier, *Vases antiques du Louvre*, II [above, n. 32] pl. 54; *LIMC*, s.v. Herakles, no. 2854).

34. Apart from the cup by Oltos (above, n. 25; see below, n. 43).

35. I mean *epiphany* in the sense that they make themselves appear, or (re)present themselves (above, p. 146 and n. 27); Himmelmann, *Eigenart*, *passim* (trans. above, pp. 103–29). I now realize that Hegel tried to grasp the nature of the Greek gods in terms very similar to mine: G. W. Hegel, *Vorlesungen über die Philosophie der Weltgeschichte*

III: *Die griechische und die römische Welt*, in his *Sämtliche Werke*[2], ed. G. Lasson, IX (Leipzig 1923) 580f.: "The true deficiency of Greek religion, as opposed to Christianity, is therefore that *the epiphany constitutes the highest form, indeed the totality of the divine*, while in Christianity the epiphany is assumed to be only one moment of the divine. . . . Among the Greek gods, the epiphany occurs in a dignified, artistic form; and the sensual is transfigured through beauty into an expression of the spiritual; the Greek gods are ideals. But the epiphany remains the exclusive and highest form in which the divine is expressed. The god in epiphany is not an expression of the moment; the form of the epiphany is the highest form, the ideal is not at the same time idealized. Both characteristics are connected with the fact that for the Greeks, the gods were still an *otherworldly* phenomenon; the spirit is absolutely this: *in the epiphany he is in and by himself*. But if the epiphany is a perennial form, then the spirit that appears is, in its transfigured beauty, *an otherworldly phenomenon for the subjective spirit* (italics mine).

36. A. Herzog, *Die olympischen Göttervereine in der griechischen Kunst* (Leipzig 1884) is unusable.

37. See E. Kunze, *Archaische Schildbänder*, *OlForsch* II (Berlin 1950) 74. It is often impossible to tell the significance of early groups of divine figures with no narrative, e.g., the enigmatic scene on a Little Master cup of Zeus and his brothers, London B425: *ABV* 184; *LIMC*, s.v. Hades, no. 14, pl. 211. Sometimes they seem to be just "decorative."

38. For Hephaistos see F. Brommer, *JdI* 52 (1937) 198ff. On Herakles see above, n. 30. On Thetis see P. de la Coste-Messelière and G. de Miré, *Delphes* (Paris 1943) pls. 76–81; *LIMC*, s.v. Apollon, no. 861a, pl. 260. On this see also Hausmann's perceptive remarks, *Griechische Weihreliefs* (above, n. 5) 37.

39. So also Eckstein-Wolf, *MdI* 5 (1952) 47.

40. Orvieto, Duomo 333 (not in *ABV* or *LIMC*). On Apollo playing the lyre at the Birth of Athena, see A. B. Cook, *Zeus* III.1 (Cambridge 1940) figs. 477, 492 (*LIMC*, s.v. Athena, no. 367, pl. 746), 493 (*LIMC*, no. 368, pl. 746), 517 (*LIMC*, no. 349, pl. 744 [detail]). The latter is British Museum B 147, here fig. 54. For Apollo with a bow instead of lyre, see also Cook fig. 485, *LIMC*, s.v. Apollon, no. 817, pl. 255; for Leto at the Birth of Athena, Cook, fig. 491, *LIMC*, s.v. Athena, no. 334, pl. 742. See also [Hesiod] *Shield* 201ff.

41. On the roughly contemporary amphora London B212 (*CVA* GB 5, British Museum 4, pls. 50–51; *ABV* 297.1), the group of Apollo, Artemis, and Leto appears on one side, the departure of a warrior on the other. The Delian Triad is accompanied by Poseidon and a winged Hermes, which suggests that the original context was even larger: *LIMC*, s.v. Hermes, no. 708, pl. 257.

42. Eckstein-Wolf, *MdI* 5 (1952) 47ff.

43. The cup by Oltos in Tarquinia (RC 6848): *ARV*[2] 60.66; *Beazley Addenda*[2] 165; Pfuhl, *MuZ*, fig. 360; A. Bruhn, *Oltos and Early Red-Figure Vase Painting* (Copenhagen 1943) fig. 1; Arias-Hirmer, pls. 100ff.; *LIMC*, s.v. Hestia, no. 7, pl. 292. The presence of Hestia here, as on the Sosias cup and the François Vase, marks the setting as Olympos (Pindar *Nem.* 9.1ff.; *Homeric Hymn* 4.32; see also the base of the Pheidian Zeus at Olympia: Pausanias 5.11.8). The seated Hebe on the Oltos cup is perhaps an indication that the scene derives from the tradition of the Introduction of Herakles. The other side depicts the departure of Dionysos, and it is difficult to say whether there is an association between the two scenes. The hastily painted black-figure cup Berlin F2060 has on one side a divine assembly and, on the other, Herakles' departure in a chariot

(*ABV* 435.1, 697; *Beazley Addenda*[2] 112; E. Gerhard, *Griechische und etruskische Trink-schalen des königlichen Museums zu Berlin* [Berlin 1840] pls. IV–V; *LIMC*, *s.v.* Athena, no. 446, pl. 752 [side A only]). But the painter has surrounded the central group with warriors, perhaps only as filler figures, so that he might have intended Herakles' depar-ture for battle, rather than for Olympos (see also Brommer, *Vasenlisten*[3] [above, n. 30] 159). For the amphora by the Nikoxenos Painter, see FR, III, pl. 158; *CVA* D 12, Mu-nich 4, pls. 178ff; *LIMC*, *s.v.* Hera, no. 211, pl. 417; *ARV*[2] 220.1; *Beazley Addenda*[2] 198. Both sides depict variations on the divine assembly, and Hermes appears in both.

44. FR, pl. 70; *LIMC*, *s.v.* Aphrodite, no. 1371, pl. 135; *ARV*[2] 1476.1; *Beazley Addenda*[2] 381.

45. This is true, on the one hand, of the "physiognomic" representation of the gods, the inner grasp of the "portraiture" of the gods (see *Eigenart* 11ff. [trans. above, pp. 105–8]). It is also expressed in new compositional ideas, such as the divine epiphanies in the pediments and the presence of the gods as incidental figures on the east frieze. Un-like on the votive reliefs that reflect popular religion, the gods are here invisible to mor-tals and remain in their own sphere. The outermost of the eponymous heroes is turned away from the leading figure of the procession, a marshall (A. Michaelis, *Der Parthe-non* [Leipzig 1870] pl. 14, no. 47; F. Brommer, *Der Parthenonfries* [Mainz 1977] pls. 183–84; J. Boardman, *Greek Sculpture: The Classical Period* [London 1985] fig. 96.16). The latter's gesture is not to be understood as one of prayer, but rather ordering, and it is di-rected past the gods, as if they were not present at all (see also the similar gesture on the north frieze: Michaelis, pl. 13, no. 89; Brommer, pl. 88; Boardman, fig. 96.10). The girls at the head of the procession on the other side do not look toward the gods, but downward. The notion of the numinous presence of the gods had been developed ear-lier in vase-painting, where mortals act as if unaware of them and they remain by them-selves on a more distant plane of the picture. See also my preliminary remarks in *Gnomon* 29 (1957) 219f. This way of thinking seems to have influenced drama as well, as I have discussed in *Studien*, 115ff.

46. The skyphos in Brussels: *CVA* B 2, Brussels 2, pl. 18.1; *ARV*[2] 661.86; *Beazley Ad-denda*[2] 277.

47. 246Eff, 250B, 253A.

THE STANCE OF

THE POLYKLEITAN

DIADOUMENOS

THE MOTION IMPLICIT in the stance of the Polykleitan Diadou-
menos (fig. 56), with its free leg set well back, has elicited a certain
consternation in modern commentators, among whom Adolf Furt-
wängler has expressed himself bluntly: "The pause in the act of walking is not
appropriate to the principal action represented. No one walks along while tying
a ribbon round his head. Polykleitos, as we saw in his Amazon statues cannot
identify himself with his subject sufficiently to create the motive from the cen-
tre outwards. The first consideration for him is the beauty of rhythmic move-
ment: the meaning of the movement comes second. The result of this is that
movement is beautiful indeed, but appears unnatural, nay, even affected."[1]

The contemporary viewer is inclined to consider Furtwängler's criticism as
a too literal interpretation, a positivist misinterpretation of only historical in-
terest. However, the consternation of viewers of the statue remains—even re-
cent analyses still find the statue ambiguous. The point of departure is that the
timeless kouros type of the Archaic period is replaced in the 80s of the fifth
century by figures that develop a variety of new, realistic stances. These partic-
ularly simple and natural representations are given an increasingly move-
mented rhythm in the course of stylistic development,[2] which finally leads to

"Die 'Schrittstellung' des polykletischen Diadoumenos," *MarbWPr* (1967) 27–39, trans.
William Childs.

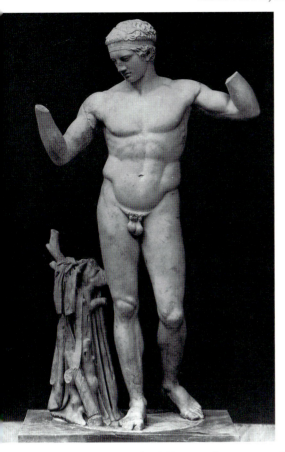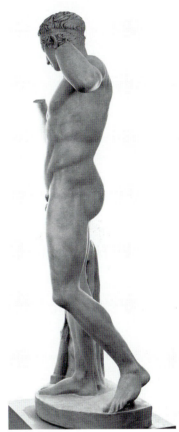

56a–b. Diadoumenos of Polykleitos. Athens, National Museum

the perception of the motif as no longer standing still in the Polykleitan Dia-
doumenos and related statues, even though the subjects depicted must still be
demonstrating this meaning through their poses. A formal law unto itself, so-
called style makes the natural situation unrecognizable and the relationship
between the quiet subject and the movemented form ambiguous.

Furtwängler had in mind the personal style of Polykleitos in the criticism
cited above, and he could base himself on ancient art-historical accounts, for
which the alleged formalism of the master was already a well-known element.[3]
A general stylistic observation nonetheless has to acknowledge that the same
phenomena occur in the most disparate areas of contemporary art, all of
which can hardly depend on Polykleitos personally. In many cases the appar-
ent discrepancy between the so-called Polykleitan stance and the subject,

57. Athenian decree relief of 410 B.C. Paris, Musée du Louvre

which requires a static standing, is even greater than in the statues of the master himself. This observation applies, for example, to two very different works: the statuette of the youth pouring a libation in the Louvre and the hero leaning on a staff of the decree relief of 410 B.C. (fig. 57).[4] In the case of the Eleusinian Goddess who puts on her mantle with both hands,[5] and the Athena of the above-cited decree relief of 410, the motif is transferred to female figures even though statues of women are traditionally far less active than those of men. The number of examples can easily be multiplied and excludes in any case that the phenomenon is simply to be attributed to a particular trait of the style of Polykleitos. F. Hiller, in his seminal study of the Canon of Polykleitos, correctly described the stance as a general characteristic of the period.[6] His discussion is important for the present issue in another respect:

> It is clear that these changes [those in connection with the greater displacement of the free-leg], in contrast with the stance of the Kritios Boy [here fig. 58], indicate only a quantitative change and clarification, and are not to be understood as reflecting a change in meaning. The older stance indicated "relaxed standing."

The new approach to this motif in most cases does not indicate clearly whether it is meant to depict walking, a stopped moment in walking, or simply standing. Consequently at times commentators speak of an actual walking pose. It is in fact a deliberately schematic pose for all standing figures—except for a few figures with free-leg set forward. Out of the earlier, functional position of the legs developed a sharp contrast which, because of its general use even where it is unmotivated by the subject, can only have a formal, not an actual, meaning.

The formal side of the situation is thus accurately described. It does not need to be stressed that "formal" describes not a simple exterior quality but an artistic quality of great importance—to wit, the amalgamation of stasis and motion, an inner motion that scholars since Winckelmann have repeatedly tried to describe.[7] The question remains, however, whether this quality was only to be achieved at the expense of thematic suitability, or whether there is a level at which the unity of subject and motion can be reintegrated. This question is difficult to answer; if the so-called Polykleitan stance is considered a heightened formal pattern developed out of an old motif for standing, no ground is left to interpret it as meaningful. Consequently, the Polykleitan stance is a pattern with only a loose relationship to the subject depicted and occasionally is even in opposition to it. And yet the phenomenon is not disputed: apparently it is impossible, for example, to see the activity and motion of the Polykleitan Diadoumenos as parts of a temporally unified situation in which the subject and stance are in harmony. Yet it would be rash to content oneself with this apparently ambiguous evaluation. Rather, it appears useful to investigate more generally the relationship of the stance and the motion to the subject, and to consider the most important works of the period from this point of view—a task that cannot be accomplished in this paper, though several examples may suffice to shed some light on the basic issue.

The so-called Polykleitan stance is ambiguous in relation to the temporal aspect of a given activity. The Doryphoros, which has no obvious specific subject, has been described by modern commentators as standing, walking, and stopped in a walking pose (fig. 59).[8] The stance motif itself, which has been described as "a play between rest and movement," by which the body's "ability to move freely" "in the repose of the statue is represented,"[9] doesn't say very much, and so it appears altogether unnecessary to pursue the matter further. Yet the stance, derived from a tradition of the standing motif, is a heightened version of an older formal pattern, which apparently meant a particularly simple and natural representation of standing still. Accordingly it appears reasonable to interpret the figure as standing, so long as one does not wish to posit that the stance has gained some other meaning through stylistic development.

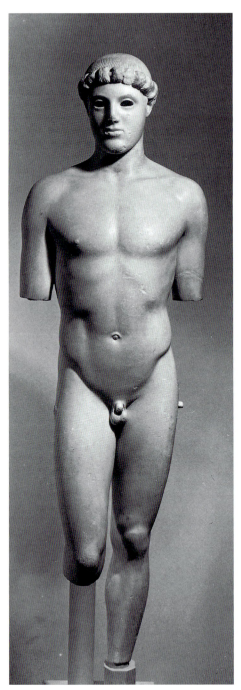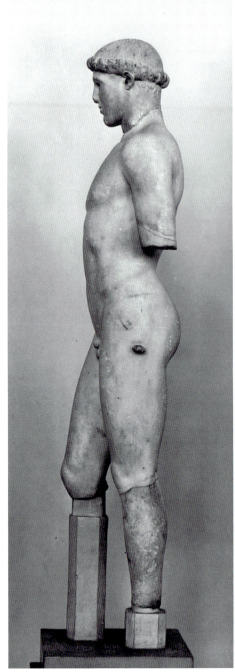

58a–b. Kritios Boy. Athens, Acropolis Museum

59. Doryphoros of Polykleitos. Naples, Museo Archeologico

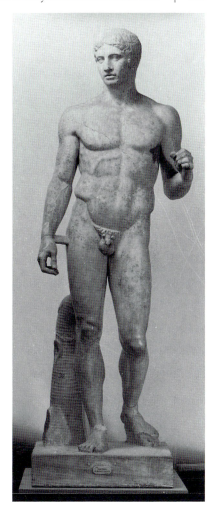

A series of monuments indeed does suggest that the stance was used in the majority of cases to depict figures standing still, even though the motif appears to us so full of movement. In free-standing sculpture, in addition to the numerous Diadoumenoi and Stephanoumenoi, there are libation bearers, youths oiling themselves, pourers, and leaning figures. In relief there are many different examples on the Parthenon frieze alone. The sculptor who reproduced the Doryphoros on a votive relief in Argos in the 30s of the fourth century saw a pronounced movement in the figure, since he combines it with a moving horse.[10] This, however, does not prove that he wished to characterize the Doryphoros as walking, because the movement of the animal indicated by the

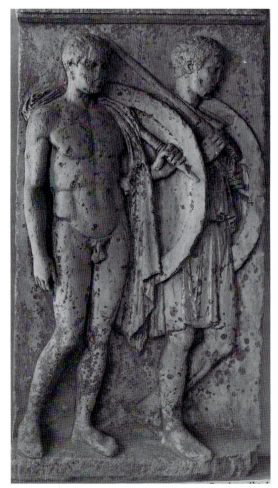

60. Grave relief of
Chairodemos and
Lykeas. Piraeus,
Archaeological
Museum

raised foreleg is no more certainly indicative of movement than the stance of
the hero.

In addition to the numerous monuments that use the "walking motif" to
depict an apparently timeless standing pose in which the motion is only to be
thought of as internal, other monuments apparently represent a specific ac-
tion with the same pose. In each case the "walking motif" takes on a certain
meaning, which arises merely out of a slight nuance of the motif or is actually
only to be derived from the context. The motif represents walking on the grave
relief of Chairodemos and Lykeas in the Piraeus and in the case of Hermes on
the nymph relief in Berlin (figs. 60, 61).[11] In the latter example the meaning of
the motif is clear from the context of the dance; in the former the meaning

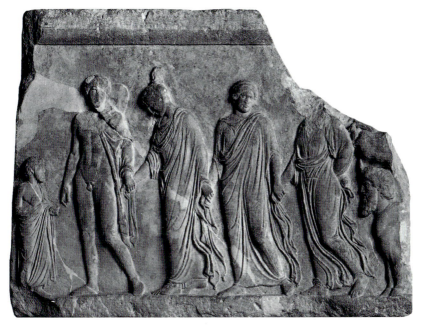

61. Hermes and Nymphs, votive relief. Berlin, Staatliche Museen, Preussischer
Kulturbesitz, Pergamon Museum

may be derived from the arrangement of the figures in parallel and in one di-
rection, which gives the representation a strong, expressive weight through the
timeless motif of soldiers on the march. The walking motif does not actually
derive its specific meaning primarily from the context; in fact, the motif is able
both to retain its general character and at the same time depict a specific ac-
tivity. This is, for example, the case for the Diomedes from Cumae, whose
"walking pose" certainly does not indicate a momentary activity in a continu-
ous sequence, and yet it describes eminently well the mythical narrative of the
clear-hearing night wanderer of no-man's-land (fig. 62).[12]

In relief the situation is similar on the three-figure relief of Orpheus and
Eurydike (fig. 63).[13] The "Polykleitan" motif of both figures, somewhat con-
ventionally represented, acquires here a highly pregnant narrative meaning,
which expresses strongly and dramatically the togetherness and separation of
the figures without indicating a particular moment. A century later a similar
expression can be detected even on a nonmythological monument such as the
grave relief from Rhamnus,[14] on which the apparently "statuesque" pose of the
woman nonetheless achieves with its sense of motion, through contrast with

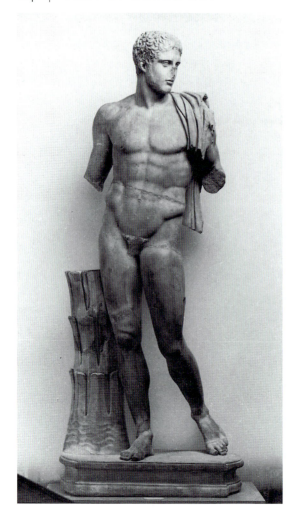

62. Diomedes from Cumae. Naples, Museo Archeologico

the crossed legs of the man, the dramatic illustration of the distance of the deceased.

Finally, let us note that the motif can take on a specific meaning even without external context simply through the character of the individual figure. Accordingly the ponderation of Polykleitan statues is not only to be understood as a product of stylistic evolution; rather, the slightly forward-stepping Diskophoros, the light-footed advance of Hermes, and the "walking" of the Doryphoros must be distinguished thematically from each other (if one may transfer the interpretation of the Chairodemos-Lykeas relief to the statues).

If one examines the "Polykleitan" figures on the basis of the relationship of

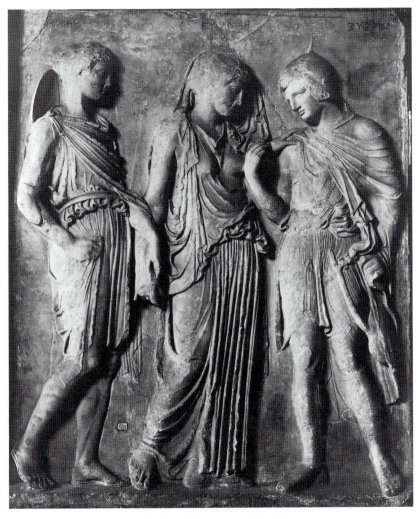

63. Orpheus and Eurydike, relief. Naples, Museo Archeologico

subject and motion, two observations may be made: 1) The figures that may from the point of view of their subject be considered as standing at rest gain from the walking pose an element of movement that directs attention beyond the apparent state of the figure, and 2) The same motif in figures whose subject requires a specific movement can be interpreted to have not only a fully concrete meaning but also a highly nuanced one. The expressive potential in each case does not prevent the use of the "walking pose" in a general way and

to describe various narrative meanings. The apparent ambiguity of motion and subject noted in some statues is thus completely dispelled in a single stroke.

The coexistence of these two observations—the apparently unmotivated motion on the one hand and, on the other hand, a motion completely motivated by the depicted action—makes the phenomenon at first appear even more curious. The fact that some figures are not, in Furtwängler's terms, developed out of their context, is evident particularly in statues whose subject indicates that they are understood as standing still. Even the other figures, whose motion corresponds obviously to a specific narrative content, are not conceived independently of each other in diverse "situations" but use a common scheme of representation, which is equivalent to the timeless motif of "standing." This manner of representation does not belong more to one or the other type of figure, so that one could say that it suits the subject in one case while it is only formal in the other. If the derivation of the stance from an old motif for standing is correct, one would have to accept for it the priority of the meaning "standing," the interpretation precisely of figures that display an apparent ambiguity between subject and motion.

If the above analysis of the "Polykleitan" stance is correct, we must ask whether the phenomenon does not relate to patterns of early Greek art that in part have been well known for a long time. It is exactly the ambivalence of stance between standing and walking, or more accurately, between nonspecific and specific motion, that characterizes the early periods of Greek art. As early as the Geometric period, we find figures that in subject are meant to be standing yet have an additional element of motion.[15] For example, in representations of the *prothesis* on Geometric vases, the mourners who stand next to the kline of the deceased show motion in their flexed knees, which has no obvious connection with their context (fig. 10, above). The same multivalent interpretation of potential motion is seen in the stance of the Archaic kouros, which according to the evidence of two-dimensional representations can just as well mean walking as standing. In the latter case the stance has the same additional element of motion as the standing "Polykleitan" statue. Here we have a manner of representation that in every respect is independent of the context. The stance and movement of the individual figure are no more to be characterized as unified than the elements of action in the larger mythological scenes, which, as is well known, have neither temporal nor spatial unity in the modern sense.[16] This applies largely also to Classical scenes, as it would be easy to demonstrate. "Polykleitan" figures show that the timeless, "automatic" potential of movement of kouroi had also not died out in the Classical period. The representation of a standing person was still not the representation of just standing. Rather, statues reflected a more general, timeless human image,

which subsumed the quality of motion. Even the simple motif of standing was, in other words, not taken from a context however simple, but was already a modification of a more general condition, which was defined from the beginning by potential motion. Rest is only a particular modification of this manner of representation, not its opposite. Modern interpretations based on empathy are thwarted by apparently insurmountable difficulties and lead to significant contradictions, as the apparent discrepancy in the reading of the stance of the Polykleitan Diadoumenos shows.[17] The ability to move is not the only a priori, latent ability of the Greek figure; there is a similar manifestation with regard to expression and (portrait)-likeness. One consequence of this is a priori a strong dependence on types (G. Loeschcke) and the so-called ideal character of Greek art altogether.

It remains to investigate whether the more restrained movement of statues of the Severe style depicts a natural standing or whether those works equally display the contextless potential for motion, which would allow us to consider them links between the Archaic and the "Polykleitan" figures. We may assume that the "Polykleitan" stance is not a personal construction and is indeed developed from the older tradition in the sense of a formal heightening of the motif (and accordingly it cannot be separated iconographically from the tradition). In this regard I need only cite the Omphalos Apollo or the even better example of the libation pourer in Mt. Holyoke (fig. 64).[18] The latter, definitely made before the middle of the century, appears to presage the refinements of the Doryphoros in the loosening and lengthening of the free leg, although the heel of the free leg does not yet rise off the ground.

An examination of the beginning and earliest development of contrapposto in sculpture is lacking, as is a systematic discussion of similar representations in two-dimensional images. In the present context it must therefore be enough to point to a few particularly obvious examples.

In early Greek art the representation of people and animals in profile contains a standard element of motion independent of the context. In the representation of chariots, only the context allows one to judge whether standing or moving horses are intended. For people the "walking pose" can be differentiated in two-dimensional representations by the length of the stride,[19] yet even here the character remains basically "automatic." By contrast frontal representations appear by nature to have a more static quality but are often connected with a strongly expressive, presentational, or demonic nature.[20] Even in these cases the context provides the guide to the various nuances of meaning.

In the time of Exekias, a new form is worked out for standing animals in representations of chariots depicted in profile. The draftsman still represents them in profile, but with rigid forelegs set closely together.[21] The "walking

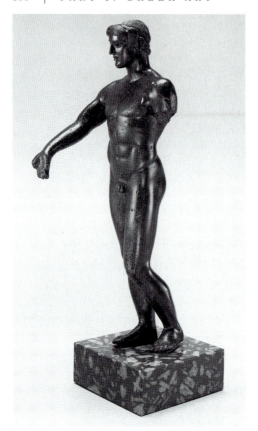

64. Libation pourer, bronze. South Hadley, Massachusetts, Mt. Holyoke College Art Museum

pose" of the kouroi remains dominant for a long time for human figures, though from the middle of the sixth century a new type is introduced of the *epistatēs* leaning forward on his staff,[22] which the Andokides Painter depicts in one case with the heel of the set-back leg raised (fig. 65).[23] Only the next generation of painters used the new possibilities of overlapping and foreshortening to depict the (relatively) meaningful differentiation of standing leg and free leg. Immediately a whole new series of standing poses is developed for which the meaning of "standing" derives actually less from the often very active pose of the legs than from the approach to a frontal view. The Euphronios krater in Berlin combines several of the new types, among which are the athlete, who places the free leg with raised heel behind the standing leg, and the relatively frequent figure that places the free leg forward and at an angle (fig. 66).[24] Nonetheless, the figure in profile and in the old "walking pose" continue to play an important role.[25] Although the stance shows a slight flexion of the knee, as do the free-standing kouroi of the period, Euphronios and his con-

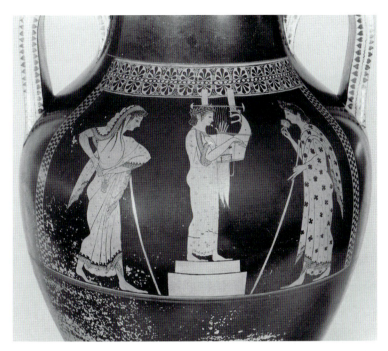

65. Musical performance, Attic red-figure amphora (detail). Paris, Musée du Louvre

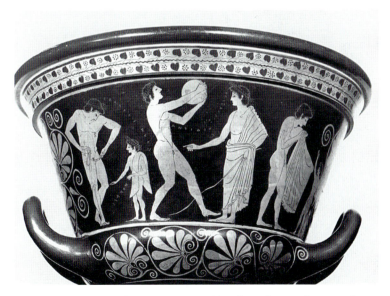

66. Athletes, Attic red-figure calyx-krater (detail). Berlin, Antikensammlung, Staatliche Museen, Preussischer Kulturbesitz

temporaries strangely do not distinguish in profile figures between the stand-
ing leg and the free leg, even when standing still is clearly intended.

Only at the turn of the century, at about the early period of the Kleophrades
Painter, are figures in profile depicted with the standing leg vertical and the
forward-set free leg bent.[26] Examples of this new type regularly depict figures
standing still. In contrast to the equally new poses of figures actively strid-
ing—for example Herakles on a cup by Onesimos in New York (fig. 67)[27]—it
might be reasonable to conclude that the new stance for figures in profile is in-
tended to represent "standing still." Yet the additional element of motion in-
herited from the kouros remains so strong that the stance was also used for the
depiction of walking figures, as for example in the schooling of Herakles on a
skyphos in Schwerin (fig. 68).[28] Equally ambivalent is the stance of figures
with the heel of the free leg raised: the spear thrower on the stand by the An-

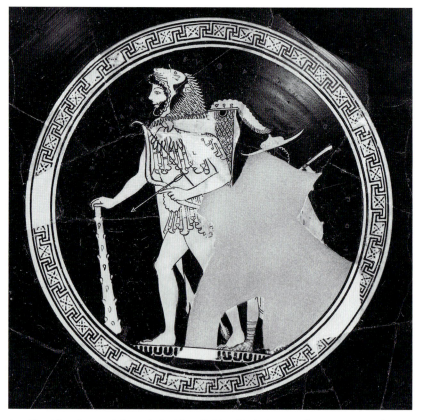

67. Herakles, Attic red-figure kylix (detail). New York, Metropolitan Museum of Art

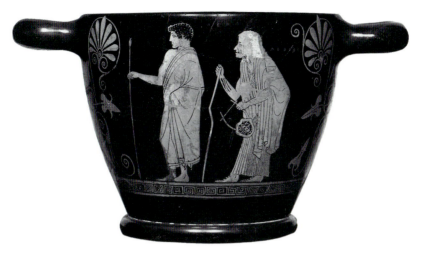

68. Schooling of Herakles, Attic red-figure skyphos. Schwerin, Staatliche Museen

tiphon Painter in Berlin is meant to be standing (fig. 69a);[29] the nude girl of the cup by Onesimos in Brussels is meant to be stepping forward (fig. 70).[30]

A more precise study of contrapposto in sculpture requires a clarification of chronology, which is still open. After working for some time on the sculpture from the period of the Persian Wars, one gets the impression that the Kritios Boy, the Blond Boy, and the Euthydikos Kore do not represent the last stylistic phase before 480 B.C., as is usually believed.[31] There is a group of sculptures that probably dates before 480 B.C. but is stylistically more advanced than those just mentioned. An example among these is the burnt Propylaia Kore, whose lower chiton is freed from the body and is fluted like a column.[32] Another is the running girl from Eleusis in which the more rigorous subordination of the details is more advanced than the Euthydikos Kore, though the latter is far higher in quality.[33] A similar rigor characterizes the head of a youth, Acropolis 644, in comparison with the head of the Kritios Boy, although a date before 480 B.C. is likely for it also.[34] Another problem arises with the armored torso on the Acropolis, which has always been dated until now in the 470s or later (fig. 71).[35] This is so different from the dynamic tension of the Tyrannicides and other comparable figures that it must have been carved in the period of the Kritios Boy. Finally, a reasoned chronology for the statues of youths in the Severe style is lacking, which would form the necessary foundation of a developmental history of contrapposto. For example, a statuette in a photograph of the German Archaeological Institute in Athens has been dated by E. Kunze to the 470s and interpreted by him as an early example of chiastic

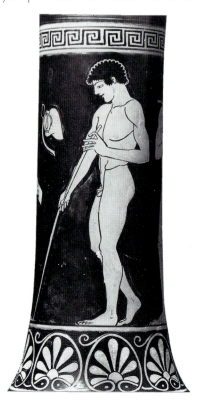
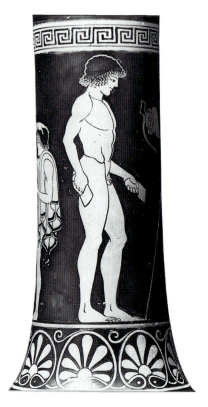

69a. Spear thrower, Attic red-figure stand. Berlin, Antikensammlung, Staatliche Museen, Preussischer Kulturbesitz

69b. Jumper, Attic red-figure stand. Berlin, Antikensammlung, Staatliche Museen, Preussischer Kulturbesitz

rhythm (fig. 72), but it really ought to be compared to the libation pourer in the Bibliothèque Nationale and the victor group in Delphi and dated accordingly near the middle of the century.[36] All of these issues cannot be treated here.[37]

In comparison to painting, sculpture, with all its possibilities to use contrapposto, at first sight remains very backward. That this impression is not completely valid, however, is shown by the plinth of a statue, Acropolis 499, which proves that a sculptor around the turn of the century could depict a plastic figure in a group context with the free leg set well to the side (fig. 73).[38] Limitation of the use of the stance must have been determined more by considerations of genres of representation than by general stylistic issues, and the available possibilities were not yet used for the single free-standing figure. To our knowledge the Kritios Boy (fig. 58, above) and the Blond Boy are the first

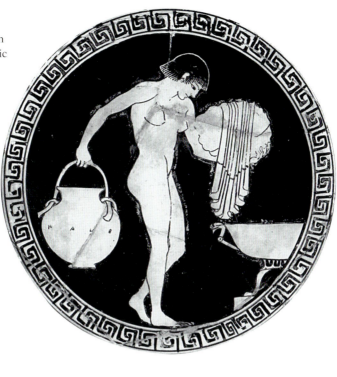

70. Nude woman
 washing, Attic
 red-figure
 kylix.
 Brussels,
 Musées
 Royaux

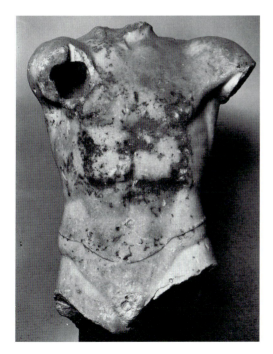

71. Armored torso, marble.
 Athens, Acropolis
 Museum

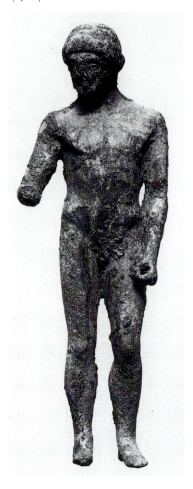

72. Standing male, bronze statuette. Present location unknown

73. Statue plinth with feet, marble. Athens, Acropolis Museum

such figures to place the free leg to the side, although this is done very cautiously in comparison with the statue plinth, Acropolis 499. Figures that maintained the legs set parallel in the manner of the older kouroi despite elements of contrapposto must have been equally numerous. This pattern of development corresponds in many respects with that discussed above of the figures in vase-painting depicted in profile and in the "walking pose." Around the turn of the century, the statue of Aristodikos already displays a loosening of the set of the legs, but both knees are equally affected and there is no differentiation of the function of the legs.[39] This is first seen in the magnificent Attic bronze athlete from the Acropolis, one of whose legs is set forward and is identified as the free leg by an indentation behind the knee (fig. 74).[40] The forward-set leg of the libation bearer of the Acropolis is clearly bent, although it is more verti-

74. Athlete, bronze statuette.
 Athens, National Museum

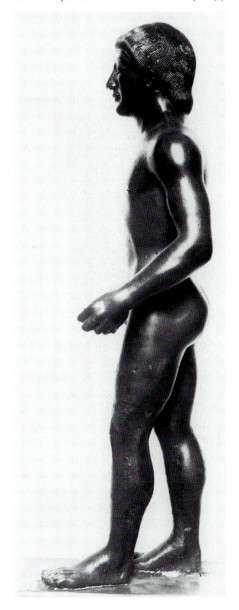

cal than the back leg, which is set at an angle.[41] It is difficult to tell which examples of the type can be dated to the period of the Kritios Boy.[42] At least we meet it again in the 470s in the powerful and active torso from Miletos[43] and in the statuette from Abbai in the Louvre (fig. 75).[44] In the latter example, the differentiation of the standing leg and free leg corresponds essentially with

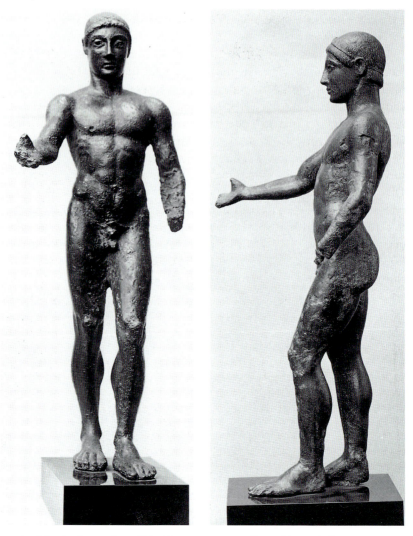

75a–b. Libation bearer from Abbai, bronze statuette. Paris, Musée du Louvre

that of the jumper on the slender stand in Berlin by the Antiphon Painter (fig. 69b, above).[45] The head is turned to the side of the standing leg even more clearly than the perhaps somewhat earlier "Hermes" in Olympia.[46] The type of the libation bearer from Abbai is clearly still in the tradition of the Archaic kouros, as the pattern of development here described shows, but on the other hand by its relationship to the youth from Adrano, the one in Mt. Holyoke (fig.

64, above), and the lost statuette in Athens, it may be considered a precursor of the "Polykleitan" type.[47]

Whereas figures with the left free leg set forward continue the parallel placement of the legs of the kouroi for the most part into the 470s,[48] figures with the right leg free, such as the Kritios Boy and the libation bearer in the Lateran,[49] carry the body at a greater angle. One might be tempted to think that a wholly new form has been created here independent of the kouros type, but a series of intervening figures argues against this. In the Archaic period the right leg is only exceptionally set forward, but it is more frequent in the early fifth century.[50] A neglected but beautiful bronze statuette of a standing youth from Olympia in the National Museum of Athens, still in the tradition of the kouros type, places the right leg forward and already displaces the weight of the body to correspond with the stance (fig. 76).[51] On the other hand, around the time of the Kritios Boy, the West Greek master of the youth from Agrigento sets the legs of the statue almost parallel to each other, though the right free leg is slightly bent.[52] The two main types of contrapposto represented by the statuette from Abbai, with the left leg free and the head turned to the right, and by

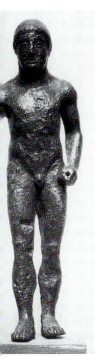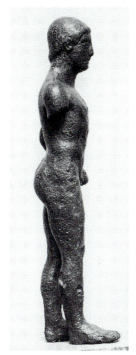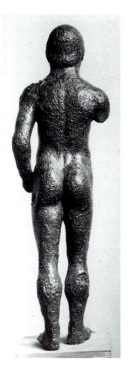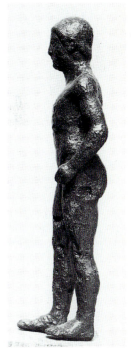

76a–d. Standing youth, bronze statuette from Olympia. Athens, National Museum

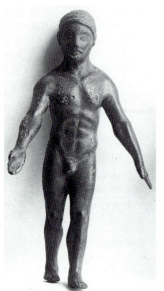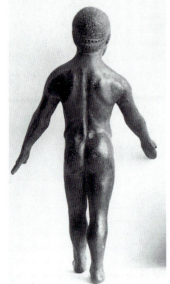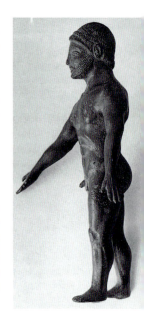

77a–c. Athlete, bronze statuette. Location unknown

the Kritios Boy, with the right leg free and the head turned to the left, clearly allow the relationship with the kouros type to be recognized nonetheless. It remains to be asked whether the stance retains its meaning and particularly its expression of potential motion. In the last phase of development, there was a heightening of the characteristics of the stance, since the bronze athlete from the Acropolis (fig. 74, above) and the Spartan statuette of Apollo both lean forward and thereby add a new dynamic element to the figures.[53]

Similar to the corresponding representations in painting, the statues of youths developed from the kouros type as a rule represent figures standing still, for example libation bearers or votaries. If the representation of libation bearers had occurred first with the new stance, one might easily take the position of the legs as a specific depiction of a natural manner of standing. In fact the motif does appear in the late Archaic period in conjunction with the "walking pose," whose component of motion was apparently not experienced as contradictory (fig. 77).[54] In the case of the libation bearer from the Acropolis, the old position of the legs for a figure of this type contributes on the contrary to a still greater dynamism.[55] It is consequently unprovable that the new stance specifically was intended to depict a figure "standing still." Moreover, the figures themselves betray an excess of movement, which is hardly justified by the subject alone. It is precisely the earliest examples of the new ponderation that

must be closest to the real meaning of the motif, and they usually convey enormous energy and thus do not support the impression of relaxed standing. This is particularly obvious in the profile view of the Kritios Boy with the strong curvature of the lower back, the swelling shoulders, and the conscious placement of the free leg (fig. 58b, above).[56] All of these characteristics recur in heightened form in the torso from Miletos and in the youth from Abbai (fig. 75). In the latter, one has a sense of "excessive" motion in relationship to the subject. Only in the course of the following development is this situation resolved by directing the motion into a vigorous externalized activity that in the end leads to Polykleitan ponderation.[57] Aside from the general effect, several examples demonstrate how strongly the activity of the new figures was experienced. The activity of these figures has a narrative consequence just as it does in the kouros or in the Polykleitan figures. This is particularly evident in the "boxer" in London (fig. 78),[58] which uses the position of the legs of the youth from Abbai (fig. 75, above) to characterize the movement of an athlete or warrior. It is equally

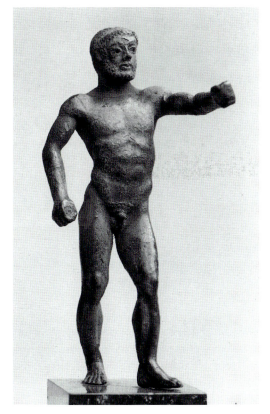

78. "Boxer," bronze statuette. London, British Museum

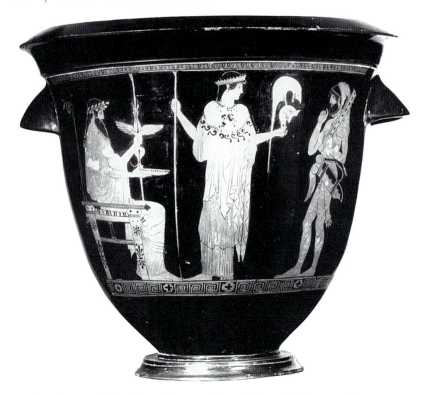

79. Introduction of Herakles to Olympos, Attic red-figure bell-krater. Palermo, Museo
Nazionale

reasonable in the cases of the "trumpeter" in Sparta and the "Hermes" in
Olympia to consider that the figures are moving on the basis of the subjects.[59]
A beautiful example of the meaning of the motif in relief is provided by the
metope from Olympia which clearly contrasts the rigid position of Herakles'
legs with the active "walking pose" of Atlas, the first weighed down and stand-
ing still, the second returning from his mission and stepping up to him.[60] Her-
akles is also shown approaching in the introduction scene of the krater by the
Altamura Painter in Palermo (fig. 79).[61]

 The manifold meanings of specific motifs of motion allowed the represen-
tation of diverse human conditions that appear to the modern viewer more for-
malistic than they did to the ancients. For example, when the Berlin Painter in
an unframed scene on a lekythos[62] depicts a single warrior in the stretched-out
pose of running and at the same time making a libation, the manner of presen-
tation clearly has the formal purpose both to arrange the motion axially and to

give it room to move. The contradiction of subject and motion is here not completely resolved, but it loses much of its harshness in the recognition of the principle of representation that essentially depends on the use of types that a priori possess a strong potentiality of motion and are independent of the context.

Let us finally return to our point of departure. The conflict Furtwängler experienced in the Polykleitan Diadoumenos led him to attribute greater importance to the Diadoumenos Farnese, because, in his opinion, it depicted the subject in a more restrained manner, that is, without the "Polykleitan" walking motif.[63] The statue, which Brunn identified with the Polykleitan Diadoumenos, was later said by Michaelis and Kekulé to be Attic. Furtwängler took up this idea and considered the statue to be the Anadoumenos of Pheidias in Olympia and earlier than the Polykleitan statue. This identification sometimes is still maintained, even though one has gradually come to experience the conception of the statue as mediocre.[64] With the exception of a head known only in photographs, no certain copy of the head of the Farnese type has yet come to light.[65] The suggestion that the type is a Roman Imperial adaptation can be deduced from Brunn's classification and is scarcely countered by a few scattered copies.[66] This suspicion is particularly strong in the case of a statue such as the Polykleitan Diadoumenos that in later antiquity stimulated endless adaptations.[67] Confirmation can be found especially in the study of the head, which agrees in all its principal aspects with that of the Polykleitan Diadoumenos, and even its particularities do not diverge from the norm as much as is commonly found in copies of the Polykleitan original.[68] It is difficult to decide whether the "Attic" appearance of the statue was intended or arose simply from the unintentional loss of mass and plasticity in the process of copying.

NOTES

1. A. Furtwängler, *Meisterwerke der griechischen Plastik* (Leipzig-Berlin 1893) 444 (English edition: *Masterpieces of Greek Sculpture: A Series of Essays on Greek Art* [New York 1895; reprint Chicago 1964]) 244. The reference to the Amazons in the cited text is to 293ff. (English edition, 134ff.)

2. Lippold, *Griechische Plastik*, 95, 136, 164, 169; E. Kunze, "Drei Bronzen der Sammlung Hélène Stathatos," 109. *BWPr* (Berlin 1953) 14ff; T. Dohrn, *Attische Plastik vom Tode des Phidias bis zum Wirken der grossen Meister des IV. Jahrhunderts v. Chr.*

(Krefeld 1957) 54f.; F. Hiller, *MarbWPr* (1965) 8f. See also also E. Buschor, *Die Plastik der Griechen*² (Munich 1958) 58.

3. R. Bianchi-Bandinelli, *Policleto* (Florence 1938) 9ff.; Lippold, *Griechische Plastik*, 168.

4. Paris, Louvre MA 831: M. Hamiaux, *Musée du Louvre, Département des antiquités grecques, étrusques et romaines: Les sculptures grecques*, I: *Des origines à la fin du IVe siècle avant J.C.* (Paris 1992) no. 132, p. 140; C. L. Lawton, *Attic Document Reliefs* (Oxford 1995) 86, no. 8, pl. 5.

Statuette of youth: *Encylopédie photographique de l'art Louvre*, III.6 (*La sculpture grecque* II) (Paris 1938) 83; Lippold, *Griechische Plastik*, 170 n. 10. Polykleitan influence on the statuette is correctly suggested. On Attic painting of the period, see E. Buschor in FR, III, 148: "The stance often exceeds in looseness and rhythm that of Polykleitos." He sees in it also formalist elements (ibid., 150). See also E. Buschor, *Griechische Vasen* (Munich 1940) 222, 226ff. (second edition 1969, pp. 234, 239).

5. Lippold, *Griechische Plastik*, pl. 70.1; B. S. Ridgway, *Fifth Century Styles in Greek Sculpture* (Princeton 1981) fig. 96; J. Boardman, *Greek Sculpture: The Classical Period* (GSCP) (London 1985) fig. 137. Back view: text to BrBr, pl. 536; S. Adam, *The Technique of Greek Sculpture* (London 1966) pl. 25c; L. E. Baumer, "Betrachtungen zur 'Demeter von Eleusis,'" *AntK* 38 (1995) pl. 6.2.

6. "Zum Kanon Polyklets," *MarbWPr* (1965) 8.

7. See also, for example, W. H. Schuchhardt, *Die Kunst der Griechen* (Berlin 1940) 254f. (on the Doryphoros), and particularly the fundamental observations of Hiller, *MarbWPr* (1965) 10. On the beginning of the phenomenon in the Geometric period, see also the profound commentary of Buschor, *Die Plastik der Griechen*² (above, n. 2) 12ff.

8. A. F. Stewart, *Greek Sculpture: An Exploration* (New Haven 1990) 160–63; S. Kraikenbom, *Bildwerke nach Polyklet: Kopienkritisch Untersuchungen* (Berlin 1990) 59–94; W. G. Moon, ed., *Polykleitos, The Doryphoros and Tradition* (Madison [WI] 1995).

9. The citations are from Kunze, 109. *BWPr* (above, n. 2) 14.

10. Bianchi-Bandinelli, *Policleto* (above, n. 3) pl. V, 31; Boardman, *GSCP* (above, n. 5) fig. 185.

11. Piraeus, Archaeological Museum 385: H. Diepolder, *Die attischen Grabreliefs des 5. und 4. Jahrhunderts v. Chr.* (Berlin 1931; reprint Darmstadt 1965) pl. 16; Lippold, *Griechische Plastik*, 195 n. 10; C. W. Clairmont, *Classical Attic Tombstones* (Kilchberg 1993) II, no. 2.156, 104–5, and illustration in vol. VI. Nymph relief, Berlin, Staatliche Museen K 83: C. Blümel, *Die klassisch griechische Skulpturen der Staatlichen Museen zu Berlin* (Berlin 1966) 60–61, no. 69, fig. 101.

12. Lippold, *Griechische Plastik*, 184 nn. 1, 2, pl. 48.4; Stewart, *Greek Sculpture* (above, n. 8) fig. 439; Meyer, "A Roman Masterpiece: The Minneapolis Doryphoros," in *Polykleitos, The Doryphoros and Tradition*, ed. W. G. Moon (Madison [WI] 1995) 89 n. 43, figs. 6.78, 6.80–81.

13. Naples, Museo Nazionale inv. 6727: H. Götze, "Die attischen Dreifigurenreliefs," *RM* 53 (1938) 191–200, pls. 32–33; L.-A. Touchette, "A New Interpretation of the Orpheus Relief," *AA* (1990) 77–90.

14. Diepolder, *Grabreliefs* (above, n. 11) pl. 54.

15. See also Buschor, *Die Plastik der Griechen*² (above, n. 2) 14.

16. "Erzählung und Figur," 73ff. (above, pp. 67ff.).

17. In *Bemerkungen*, 24, I use this expression in another fashion to characterize the pictorial closedness of Archaic sculpture.

18. K. Schefold, *Meisterwerke griechischer Kunst*² (Basel 1960) 229f., no. 273; *Master Bronzes from the Classical World*, ed. D. G. Mitten and S. F. Doeringer (Mainz 1967) no. 83; Boardman, *GSCP* (above, n. 5) fig. 13. Omphalos Apollo: ibid., fig. 66.

19. "Erzählung und Figur," n. 1 on 88f. (trans. above, pp. 81, 96 n. 49) with reference to E. Kunze, *Bericht über die Ausgrabungen in Olympia*, VII (Berlin 1961) 171. Another example of an extended stride in small sculpture is the wandering Herakles in Kassel, apparently set up as a single figure: W. Lamb, *Greek and Roman Bronzes* (London 1929; reprint Chicago 1969) pl. 26a. See also the red-figure cup: Pfuhl, *MuZ*, fig. 400; see below, n. 27, here fig. 67, above.

20. "Erzählung und Figur," 92 (trans. above, pp. 84–85).

21. "Erzählung und Figur," 91 n. 3 (above, p. 99 n. 58). The older manner of representation continues in some images such as those in N. Alfieri, P. E. Arias, *Spina: Die neuendeckte Etruskerstadt und die griechischen Vasen ihrer Gräber* (Munich 1958) pls. 25, 29, 90. See also the Argive relief cited above, n. 10. An unconvincing example is given by E. Kunze, *Bericht über die Ausgrabungen in Olympia* III (1941) (= *JdI* 56 [1941]) 136.

22. E. Pottier, *Vases antiques du Louvre*, II (Paris 1901) pl. 68, no. F67; *ABV* 67.2.

23. Paris, Louvre G1: *ARV*² 3.2, 1617; *Beazley Addenda*² 149. See also Pfuhl, *MuZ*, I, §391ff.

24. Berlin 2180: *ARV*² 13.1, 1619; *Beazley Addenda*² 152; Pfuhl, *MuZ*, figs. 396, 397.

25. Ibid., figs. 366 (amphora by Euthymides, Munich 2308: *ARV*² 26.2, 1620); 383 (amphora by Phintias, Paris, Louvre G 42: *ARV*² 23.1, 1620; *Beazley Addenda*² 154; Boardman, *ARFVAP*, fig. 41.1); Pfuhl, *MuZ*, fig. 396 (above, n. 24). In the case of the diskophoros on the amphora of Phintias (fig. 383), one may wonder if the more vertical placement of the set-back free leg does not already intimate a differentiation in the stance, but more likely a specific exercise is meant and not just standing still (see also *MuZ*, figs. 366, 375).

26. Amphora by the Kleophrades Painter, Munich 2305: *ARV*² 182.4, 1631; *Beazley Addenda*² 186; Pfuhl, *MuZ*, fig. 373; J. D. Beazley, *Der Kleophrades-Maler* (Berlin 1933) pl. 7, top.

27. New York, Metropolitan Museum of Art 12.231.2: *ARV*² 319.6; *Beazley Addenda*² 214; Pfuhl, *MuZ*, fig. 400.

28. Pistoxenos Painter: *ARV*² 862.30, 1672; *Beazley Addenda*² 298; *LIMC*, s.v. Herakles, no. 1666, pl. 557. He uses here an arrow for a staff. Since the stance indicates a restrained walking (for example on the Parthenon frieze), it is used less frequently for nude figures. A certain example is the Silene carrying a chair by the Pan Painter, New York, Metropolitan Museum 16.72: *ARV*² 551.6; *Beazley Addenda*² 257; G. M. A. Richter and L. F. Hall, *Red-Figured Athenian Vases in the Metropolitan Museum of Art* (New Haven 1936) pl. 67, no. 64; *LIMC*, s.v. Dionysos, no. 255, pl. 323. See also also the Silene on an amphora by the Berlin Painter (Berlin 2160): *ARV*² 196.1; *Beazley Addenda*² 190; FR, pl. 159.2; Boardman, *ARFVAP*, fig. 144; and the Silene of the Oionokles Painter: *ARV*² 646.3; *Beazley Addenda*² 275; Schefold, *Meisterwerke der griechischen Kunst*² (above, n. 18) 198, 203, no. 215; Boardman, *ARFVAP*, fig. 362. On Atlas on the metope from Olympia, see below, n. 60.

29. Berlin (Pergamon Museum) 2325: *ARV*² 335.1; *Beazley Addenda*² 217–18.

30. Brussels, Musées Royaux A 889: *ARV*² 329.130, 1645; *Beazley Addenda*² 217.

31. H. Payne, *Archaic Marble Sculpture from the Acropolis* (London 1936; second edition 1950) 44f., pls. 109–15, 84–87; Buschor, *Plastik der Griechen*² (above, n. 2) 60; J. Boardman, *Greek Sculpture: The Archaic Period* (*GSAP*) (London 1978) figs. 147–48, 160; Stewart, *Greek Sculpture* (above, n. 8) figs. 219–24.

32. Payne, *Archaic Marble Sculpture* (above, n. 31) pl. 89; H. Schrader, E. Langlotz, and W.-H. Schuchhardt, *Die archaischen Marmorbildwerke der Akropolis*, ed. H. Schrader (Frankfurt 1939) no. 21, pp. 62f., pls. 30–32; see also p. 79; G.M.A. Richter, *Korai: Archaic Greek Maidens* (London 1968) no. 184, figs. 587–90; Boardman, *GSAP* (above, n. 31) fig. 161.

33. F. Willemsen, *AM* 69–70 (1954–55) 36ff., *Beilage* 19; Boardman, *GSAP* (above, n. 31) fig. 202. Willemsen dates the Eleusinian figure before 480, indeed before the Euthydikos Kore (39), which I believe on stylistic grounds is untenable. This problem can also be solved by suggesting a stylistic development that goes beyond the Euthydikos Kore and occupies the years prior to 480 B.C. In addition to the Euthydikos Kore and the running girl, the winged torso in Eleusis also belongs to this phase (Willemsen, in *AM*, pl. 1.2) and the head of a youth cited in n. 34, below. A date before 480 might also be considered for other finds from the Acropolis, among which is the bronze head (*BrBr*, 461), which clearly precedes the Blond Boy. An external argument for the date of the running girl from Eleusis is provided by the discovery in Athens of a group of figures related closely to her in stance and style; these remained unfinished for no obvious reason and consequently were probably in progress when the city was abandoned (I owe knowledge of these statues to O. Alexandri and G. Despinis).

34. Schrader, *Archaische Marmorbildwerke* (above, n. 32) 246f., no. 325, pl. 152; the head has "a trace of burning above the right eye." Schuchhardt considers a date before 480 but dates the head contemporary with the Euthydikos Kore and the Kritios Boy.

35. Acropolis Museum no. 599: Schrader (above, n. 34) 202–3, no. 307, pls. 130–31; the date is given as 470/60 with a reference to the Boboli athletes; U. Knigge, *Bewegte Figuren der Grossplastik im Strengen Stil* (Munich 1965) 50f.

36. Kunze, 109. *BWPr* (above, n. 2) 16, figs. 5–6. See also *AntP*, III (Berlin 1964) pl. 20 (H. G. Niemeyer), and J. Charbonneaux, *Les bronzes grecs* (Paris 1958) pl. 22, fig. 2; C. Rolley in *Monumenta Graeca et Romana*, ed. H. F. Mussche, V: *Greek Minor Arts*, 1: *The Bronzes* (Leiden 1967) pl. 13, no. 45. The warrior in Boston mentioned by Kunze (*BWPR* n. 46) is now illustrated in the French translation of the same article in P. Amandry, *Collection Hélène Stathatos* (Strasburg 1963) III, 63, fig. 24. I cannot agree with the importance attributed by Kunze to the small, rigid figure with legs set widely apart. It is equally difficult to believe that the statuettes with roosters cited by Kunze (16) are appropriate evidence to judge the early development of contrapposto.

37. I shall also treat elsewhere the phenomenon of modeled asymmetries, which in no way establish a fixed point of view.

38. Schrader, *Archaische Marmorbildwerke* (above, n. 32) 199, no. 303, figs. 189–90; Payne, *Archaic Marble Sculpture* (above, n. 31) pl. 124.2.

39. C. Karusos, *Aristodikos: Zur Geschichte der spätarchaische attischen Plastik und der Grabstatue* (Stuttgart 1961) pl. 3b; Boardman, *GSAP* (above, n. 31) fig. 145; Stewart, *Greek Sculpture* (above, n. 8) fig. 218.

40. Athens, National Museum 6445: *AntP* III, 24f., pl. 18a (above, n. 36; H. G. Niemeyer).

41. *AntP* III, pl. 16d-f. It is difficult to judge the original condition from the photographs.

42. Possibly the trumpeter in Sparta may be with reservations ascribed to this type: E. Langlotz, *Fruehgriechische Bildhauerschulen* (Nuremberg 1927) pl. 50c. On the motif see K. A. Neugebauer, *Staatliche Museen zu Berlin, Die griechischen Bronzen der klassischen Zeit und der Hellenismus* (Berlin 1931) 21 n. 2. The "Hermes" in Olympia should be a little younger: *Deltion* 17, 2 (1961–62) 122f., pl. 141c.

43. Langlotz, *Bildhauerschulen* (above, n. 42) pl. 3; G. M. A. Richter, *Kouroi: Archaic Greek Youths*[2] (London 1960) no. 192, figs. 579–81.

44. Paris, Louvre inv. Br 4236: Langlotz, *Bildhauerschulen* (above, n. 42) pl. 21a; Charbonneaux, *Les bronzes grecs* (above, n. 36) pl. 13.2; Rolley, *Monumenta Graeca et Romana* (above, n. 36) 6, no. 54, pl. 17; E. Walter-Karydi, *Die Äginetische Bildhaverschole, Alt-Ägina* II.2 (Mainz 1987) 37, figs. 35–36. I thank P. Devambez for the photographs used here for figs. 75a–b, above.

45. Above, n. 29.

46. See reference above, n. 42.

47. See below, n. 57, and above, nn. 18 and 36.

48. Compare also the Roman copy of a youth in Boston: L. D. Caskey, *Catalogue of Greek and Roman Sculpture: Museum of Fine Arts, Boston* (Cambridge [MA] 1925) no. 14; Richter, *Kouroi*[2] (above, n. 43) no. 196, figs. 582–84.

49. W. Fuchs, *RM* 64 (1957) 222ff., pls. 46–47. On its stance see the important remarks of Fuchs, p. 224.

50. Torso of a kouros in Samos: E. Buschor, *Altsamische Standbilder*, I (Berlin 1934) 54, figs. 204–6; Richter, *Kouroi*[2] (above, n. 43) no. 176, figs. 518–20. Poseidon from Kreusis: Lippold, *Griechische Plastik*, 113, pl. 37.1; Karusos, *Aristodikos* (above, n. 39) 78. Bronze statuette in Athens, National Museum 6181 (above, figs. 76a–d). Bronze statue of Apollo in the Piraeus: Richter, *Kouroi*[2] (above, n. 43), no. 159bis, figs. 478–80; Boardman, *GSAP* (above, n. 31) fig. 150, a strongly "archaizing" work of around 480 B.C.

51. Inv. 6181: A. Furtwängler, *Olympia, Die Ergebnisse*, IV: *Die Bronzen und die übrige kleineren Funde von Olympia* (Berlin 1890) no. 52, pl. 8. For a date around 490, see particularly the side view of the Poseidon from Kreusis, above, n. 50; *ArchEph*, 1899, pl. 5.

52. E. Langlotz, "Die Ephebenstatue von Agrigent," *RM* 58 (1943) 204–12, pls. 15–18; Richter, *Kouroi*[2] (above, n. 43) no. 182, figs. 547–49; B. S. Ridgway, *The Severe Style in Greek Sculpture* (Princeton 1970) 59, 60, fig. 92.

53. Niemeyer, *AntP* III, pl. 18b. C. Karusos, "Ein lakonischer Apollon," in *Charites: Studien zur Altertumswissenschaft*, ed. K. Schauenburg (Bonn 1957) 33ff., pls. 5–6; C. Rolley, *Monumenta Graeca et Romana* (above, n. 36) 6, no. 61, pl. 20.

54. A statuette of a bearded libation bearer of around 490 B.C. of kouros type but with the head turned sharply: DAI-Athens neg. Athen Varia 623, with permission of the DAI-Athens. The "unmotivated" movement of the left arm relates to the present discussion. For the libation bearer from the Acropolis see n. 41 above. Others are as follows: from Andritsina: Langlotz, *Bildhauerschulen* (above, n. 42) pl. 35c; in New York: G. M. A. Richter, *The Metropolitan Museum of Art: Handbook of the Greek Collection* (Cambridge [MA] 1953) pl. 36d.

55. See above, n. 41.

56. Payne, *Archaic Marble Sculpture* (above, n. 31) pl. 110; Richter, *Kouroi*² (above, n. 43) no. 190, p. 149, figs. 564–69.

57. Statuettes in Adrano, Mariemont, Vienna, etc.: Langlotz, *Bildhauerschulen* (above, n. 42) pls. 89, 90, 42b-c.

58. Ibid., pl. 21b; H. B. Walters, *Catalogue of the Bronzes, Greek, Roman, and Etruscan in the Department of Greek and Roman Antiquities, British Museum* (London 1899) 20, no. 212, pl. II, top right. E. Walter-Karydi, *Alt-Ägina* II.2 (above, n. 44) 38, figs. 37–39.

59. See above, n. 42.

60. R. Lullies and M. Hirmer, *Greek Sculpture*² (New York 1960) pl. 107; Stewart, *Greek Sculpture* (above, n. 8) fig. 278. See also Atlas burdened and Herakles walking away on an Archaic shield strap: R. Lullies, *Aachener Kunstblätter* 37 (1968) 139, no. 56.

61. Mus. Naz. V 780: *ARV*² 592.32, 1660; *Paralipomena* 394; P. Jacobsthal, *Theseus auf dem Meeresgrunde: Ein Beitrag zur Geschichte der griechischen Malerei* (Leipzig 1911) pl. II.3; *LIMC, s.v.* Herakles, no. 2867.

62. Münzen und Medallien A. G. Basel, *Kunstwerke der Antike*, Auktion 34, 1967, pl. 48, no. 154.

63. *Meisterwerke* (above, n. 1) 444 (English edition, 244); Diadoumenos Farnese: Kraikenbom, *Bildwerke nach Polyklet* (above, n. 8) cat. V.6, p. 189 (with earlier bibliography), pls. 263–64.

64. Lippold, *Griechische Plastik*, 154; E. Langlotz, *Phidiasprobleme* (Frankfurt 1947) 79, with a good illustration of the head, pl. 23.

65. Ibid., 79, 110, pl. 24; H. Marwitz, *AntP* VI (Berlin 1967) pl. 15.

66. Compare copies of certain adaptations such as those of the Pheidian "Sappho" type, the leaning Aphrodite, etc.

67. N. Himmelmann, "Eine römische Bronze in Oxford," *MarbWPr* (1958) 1–8.

68. Bianchi-Bandinelli, *Policleto* (above, n. 3) pls. XI–XII; P. E. Arias, *Policleto* (Milan 1964) pls. 66ff.

THE KNIDIAN

APHRODITE

A S AN UNDERGRADUATE one used to learn that Praxiteles was the
first to depict Aphrodite completely nude. This assessment was based
on the Knidian statue of the artist (fig. 80), although the ancient
sources actually do not explicitly link the revolutionary development to the
statue.[1] The judgment might plausibly be derived from the passage in Pliny,
according to which the Koans, for whom the statue was originally intended,
preferred a clothed statue (*velata specie*) to the nude one (*severum id ac pu-
dicum arbitrantes*).[2] Modern commentators have for a long time recognized
merely aesthetic considerations in Praxiteles' alleged new depiction: the motif
of bathing was treated as a superficial justification to reveal the goddess nude,[3]
and the Knidia was considered proof of the decadence of mythology in the
Late Classical period.[4] However, since the religious bent of the fourth century
became more fully appreciated, a suggestion of Blinkenberg's has received
more attention; he proposed that Praxiteles based his depiction on an old
Cypriot-Oriental image in Knidos, which presented the goddess nude in the
manner of Ashtarte.[5] The primitive gesture with which the goddess of the an-
cient idols places her right hand on her genitals has been transformed, accord-
ing to Blinkenberg, into an artistic genre motif.[6] The suggestion contradicts,
however, Pliny's anecdote cited above, according to which the statue was first
offered to the Koans. Whether the statue created a new iconography can ac-
cordingly be answered for the moment only through examination of the monu-

"Zur knidischen Aphrodite I," *MarbWPr* (1957) 11–16, trans. William Childs.

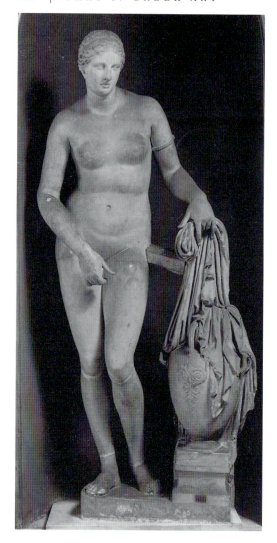

80. Knidian Aphrodite of
 Praxiteles. Rome, Vatican
 Museums

ments. Until now these have only served to confirm the prejudiced opinion
derived from the ancient sources; in narrative examples with recognizable sub-
jects in the minor arts, there appeared no clearly identifiable figure of a nude
Aphrodite and so interpretation of figures of nude women without certain at-
tributes as Aphrodite could not be definite.[7]

To test the validity of this observation, we need an approximate date for the
Knidian statue, which can be established relatively easily on the basis of the
Praxitelean oeuvre and comparison with Attic grave reliefs. The common place-
ment of the Knidia around 350 B.C. appears to depend once again on an assump-

tion, this time founded on biographical hypotheses of earlier scholars, which is scarcely defensible on stylistic grounds.[8] The Aphrodite of Arles clearly represents an earlier stage in the work of the artist; it can only have been made shortly before the Attic stele, National Museum 717, that is, around the middle of the fourth century.[9] The stronger movement and the greater openness of the Knidia as well as its extroverted pathos point to a much later date. The best comparison is with the powerful turn and heroic gaze into the distance of the youth of the Ilissos Stele.[10] The complicated curvatures and the multiplication of axes of the Knidia make it later than the simpler and less curvaceous Sauroktonos, which has been dated convincingly by Buschor in relation to the Daochos Monument.[11] The origin of the Knidia in the 330s is even detectable in the mediocre adaptations of the statue.

Even if the date of the statue could not be determined with the degree of certainty claimed here, there is a whole series of earlier and largely well-known representations of the goddess nude. Most important of these is on a delicate and ornate lekythos in St. Petersburg, which is well-illustrated here for the first time thanks to the kindness of A. Peredolski (fig. 81).[12] The old theme of the rape of Helen by Paris is free of all tragic elements in this scene, which were fundamental in representations till the end of the fifth century, and has become the unambiguous triumph of the daughter of Zeus, whose path is guided by Hermes.[13] Because of the presence of Hermes, the woman with thymiaterion and phiale can only be Aphrodite and not an unknown servant,

81a–c. Rape of Helen, Attic red-figure lekythos. St. Petersburg, Hermitage

as K. Schefold has demonstrated.[14] The correctness of his identification is assured by the very nudity of the figure, for the mantle behind the completely nude body serves not as clothing but as a foil to the nudity. The stepped base clearly indicates that the nudity here is to be understood as purely ideal. The goddess is physically present but the stepped base and the statuesque stance simultaneously place her in her own sphere while she spiritually directs the action of the scene.[15] This interpretation is confirmed by a recently published oön in New York of the time of Meidias which bears the same scene.[16] Here again Aphrodite is present but again a base indicates that she belongs in her own separate sphere; diadem and sceptre assure her identification.

The figure of the goddess on the lekythos in St. Petersburg is covered in white; one might argue that she originally wore a chiton that has disappeared due to the bleaching out of the colored layer over her. For such a suggestion there are numerous certain examples, although here it is not possible. One would expect in the case of such a carefully executed drawing some trace of the loose sleeve of the chiton on the goddess's right upper arm, or of the buttons of the chiton on shoulder and arm rendered in a thin compound of clay.[17] In a scene of the Adonia also in St. Petersburg, the details of the chiton laid over a white ground have disappeared, but the buttons have remained.[18] On our lekythos there is no trace of anything like them.

Our search for a depiction of Aphrodite completely naked more than three decades earlier than the statue of the Knidia finds further support from the figure of Helen on the same lekythos in St. Petersburg. While on a hydria by the same painter and found with the lekythos Helen is depicted naked to the waist, she was probably totally naked on the lekythos.[19] She also lacks the plastic buttons of the chiton, although she does wear jewelry.[20] There are other examples earlier than the Knidian of Helen completely nude, but it is unlikely that she could be thus depicted before Aphrodite, since she is a parallel form of the goddess. The anecdotes about the famous nude Helen of Zeuxis in Kroton already point in this direction, although the language does not allow a certain assessment.[21] Complete certainty is, however, furnished by an Apulian vase of the second quarter of the fourth century on which a heroic Paris looks on while Aphrodite decks out a nude figure of Helen.[22]

The lekythos in St. Petersburg is important not only for its date, but also for its insight into the meaning of the new depictions of Aphrodite. It is impossible to interpret the nudity of the goddess here as a genre motif, as the Knidia appears to permit. To the contrary, any realistic explanation is confounded by the timeless, statuesque pose, the divine implications of the base on which she stands, and the sacred utensils she holds up in her hands. The nudity of the goddess can be understood only in connection with these elements. Nu-

dity is the very attribute of her own divinity, which it manifests in a kind of epiphany. Once again the depictions of Helen aid our interpretation; the uncovering of the heroine on Attic vases evidently is connected to the tendency to replace the theme of the guilty-guiltless transgressor of the Trojan myth and its tragic implications with the divine epiphany of the daughter of Zeus.[23]

The nude Aphrodite on the lekythos in St. Petersburg is not unique in the first half of the fourth century. Another lekythos in the art market, painted much earlier, probably in the 390s, depicts an idol of the goddess holding a mantle behind her nude body as a foil, and holding up in each hand a phiale (fig. 82).[24] Again the new representation of the goddess is used for a picture of her, the timeless and hieratic form of which excludes absolutely any external motivation for the nudity. The supposition that a chiton was intended by the white slip over the figure is again here not probable. The sitting Aphrodite next to her idol has white face and arms, but the painted details of the chiton were laid directly on the clay-ground. One would expect the same process for the idol if clothes were intended. The plastic buttons are also missing, although the seated Aphrodite has them, and the jewelry is applied plastically.

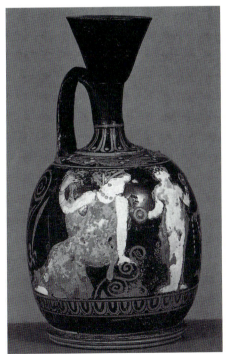
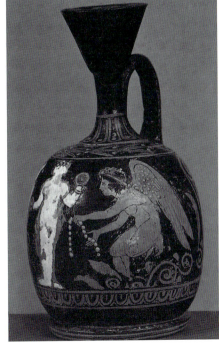

82a–b. Aphrodite, Attic red-figure lekythos. Basel, private collection

Greater certainty is furnished by a beautiful Attic plastic lekythos in Boston with the figure of an Anadyomene (fig. 83).[25] The goddess crouches on the shell, deeply introverted; she opens a large mantle over her completely nude body, while upward flying Erotes hold up the upper hem of the mantle. Although the identification of the figure of Aphrodite and the date of the vase in the first quarter of the fourth century B.C. cannot be doubted,[26] the interpretation of the figure as Anadyomene does require justification, because it has recently been questioned. The catalyst for this was the famous terracotta figurine from the sanctuary of Hera at the Foce del Sele, which also belongs in the first quarter of the century.[27] The crouching goddess is here also nude, with only her mantle falling from her head over her back. Two Erotes hang at her shoulders. This figure has been identified as Hera on the basis of the sanctuary in which it was found, and remains of the same type of figurine in the sanctuary area of Hera at Paestum appear to confirm the identification.[28] Since not every votive depicts exclusively the principal divinity of a sanctuary in which it is found, the identity of the goddess of the figurine from the Foce del Sele can

83. Aphrodite Anadyomene with Erotes, Attic plastic lekythos. Boston, Museum of Fine Arts

only be determined from the image itself and from comparisons with certain pictures of Hera.

The unusual motif of the terracotta for Hera can be explained with reference to Eileithyia, whose power is also shared by Hera and of whom a kneeling figure is possibly attested in a text.[29] This interpretation has been extended to include the Ludovisi Throne,[30] but principally it is intended to explain the crouching women of numerous terracotta groups, at the beginning of which comes the plastic lekythos in Boston, and which become particularly frequent in the Hellenistic Period.[31] The extension of the meaning is, however, refuted by two elements present in almost all of these figures. On the one hand, the common appearance of a mirror early in the series has nothing to do with Eileithyia.[32] On the other hand, the majority of the crouching women balance on their toes and do not rest their knees on the ground, which would be expected from literary testimonia and the picture tradition for representations of birth.[33] The kneeling of Eileithyia should relate to the latter, if it was indeed characteristic for her.[34] The open shell in which many of the figures crouch also does not point to the goddess of birth[35] but confirms adequately the old interpretation of Aphrodite Anadyomene. The Boston group cannot be separated from the terracottas with shell in St. Petersburg and Athens, which do not depict the goddess crouching but as a nude bust; the addition of wavy blue lines clearly indicates the sea-birth.[36] The goddess standing on a shell on the well-known pelike from Olynthos also appears on the sea.[37] It must consequently be doubtful that the motif of the terracotta figurine from the Foce del Sele can be explained on the basis of a reference to Eileithyia. It seems unlikely that the goddess's knees are intended in this case to be seen as pressed against the ground, although they are rendered in relatively shallow relief, which does not permit a certain determination on this point. The gesture of the Eros on the right, who touches the goddess's breast, is surely an Aphrodisiac motif that appears repeatedly in Aphrodite-Eros groups and in lover-pair groups but is not associated with Eileithyia.[38] Numerous terracottas from Lokri depict Erotes at the shoulder of enthroned figures of Aphrodite, and they cannot have another meaning at the Foce del Sele.[39] That Aphrodite plays a role in a sanctuary of Hera is not surprising; she may have shared the cult with the principal divinity as at Akrai in Sicily and on Samos.[40] It is also possible that an old, perhaps pre-Homeric tradition recognized the connection in a single figure, which is suggested by the mention of an Aphrodite-Hera in Sparta.[41] In any case, numerous other votives in the sanctuary at the Foce del Sele with even more clear-cut Aphrodisiac character point strongly to one of these possibilities.[42]

That Praxiteles was not the first to depict Aphrodite nude is not of great moment.[43] Far more important is the meaning of the new image imparted by

the precursors. No longer is an artificial argument needed to prove the high sanctity, that is, the ideal character, of this manner of presentation. Among others the scenes with Helen, particularly that of the lekythos in St. Petersburg (fig. 81, above), give convincing information on its meaning and eliminate all external motivation. The solemn statuesque pose or the deep introversion of the goddess separate her from her surroundings; quite obviously she is all by herself in her own sphere. The development of this self-referential sphere is intimately connected to the new formal presentation of the goddess nude; it is a kind of epiphany that allows depiction of her complete nature. The question nevertheless remains: Where is the contribution of Praxiteles to the new iconography, if he did more than simply produce in large scale a pre-existing idea?

Finally, one may ask if this phenomenon is in any way connected with the "heroic" nudity of male gods.[44] There is, indeed, a related background, but differences are also obvious. To the Greeks male and female figures were from early on subject to different rules; consequently, clothed and nude figures have a different meaning for each sex. Whereas male nudity, particularly after the beginning of the Classical period, can designate heroic idealization, for women to the end of the fifth century nudity occurs only in base everyday life and the low mythological sphere.[45] In contrast to these pictures, the occurrence of female nudity around the turn of the century marks a fundamental change bearing the meaning of the ideal for women too. In the case of figures of Selene, Pompe, Ariadne, Nike, and the Hesperidai, the trait is not to be explained by external motivation but reveals a brand-new, timeless, and otherworldly character of gods and heroines so depicted. Only if one grasps the remarkable development in its complete newness is its meaning comprehensible. The image of divinity had to be removed to a new idealizing sphere, so that what had been most profane could become most sacred.

NOTES

1. Lippold, *Griechische Plastik*, 239 and n. 3; for the ancient sources, see Overbeck, *Schriftquellen*, nos. 1227ff.

2. *NH* 36.20–22.

3. See A. Furtwängler, *Meisterwerke der griechischen Plastik* (Leipzig-Berlin 1893) 633 (English edition: *Masterpieces of Greek Sculpture: A Series of Essays on Greek Art* [New York 1895; reprint Chicago 1964] 387); C. S. Blinkenberg, *Knidia: Beiträge zur*

Kenntnis der Praxitelischen Aphrodite (Copenhagen 1933) 37. One might have observed that the bath of the goddess is also known in myth, such as *Od*. 8.363–65, and in the *Epic Cycle* (*Cypria* 6).

4. See the controversy between H. Brunn, *Geschichte der griechischen Künstler*, I¹ (Stuttgart 1857) 346ff., and K. Friederichs, *Praxiteles und die Niobegruppe* (Leipzig 1855) 24ff.

5. Blinkenberg, *Knidia* (above, n. 3) 37ff. See also G. Rodenwaldt, Θεοὶ ῥεῖα ζώοντες, *SBBerl* 1943 (Berlin 1944) no. 13, p. 14; and Lippold, *Griechische Plastik*, 239.

6. Blinkenberg, *Knidia* (above, n. 3) 44; see also O. Brendel, *Gnomon* 12 (1936) 205.

7. E. Buschor, *Von griechischer Kunst: Ausgewählte Schriften*, ed. F. Willemsen (Munich 1956) 161, fig. 47 (= "Eine griechische Bronze in Oxford," in *Festschrift für P. Hensel* [Erlangen 1923]). Elsewhere I have attempted to demonstrate that the statuette in Oxford is an eclectic work of late date: *MarbWPr* (1958) 1–8.

8. See Furtwängler, *Meisterwerke* (above, n. 3) 551 (English edition, 322); G. E. Rizzo, *Prassitele* (Milan 1932) 48. Only E. Buschor, *Maussollos und Alexander* (Munich 1950) 50, has opposed the early date in writing.

9. Rizzo, *Prassitele* (above, n. 8) 34ff. For the stele NM 717 see H. Diepolder, *Die Attischen Grabreliefs des 5. und 4. Jahrhunderts v. Chr.* (Berlin 1931 [reprint Darmstadt 1965]) 45, pl. 42.1.

10. Diepolder (above, n. 9) pl. 48; Himmelmann, *Studien zum Ilissos-Relief* (Munich 1956) pls. 18ff.

11. *Maussollos und Alexander* (above, n. 8) 50.

12. L. Stephani, *Die Vasen-Sammlung der kaiserlichen Ermitage* (St. Petersburg 1869) no. 1929; *CRPétersb* (1861) pl. 5.3–4; Schefold, *UKV*, 32f., 86f., 151 (no. 291); *LIMC* IV (Basel 1988), s.v. Helene, no. 172, pl. 322.

13. For the earlier depictions see Himmelmann, *Gnomon* 29 (1957) 220.

14. Schefold, *UKV*, 33; see also Stephani, *CRPétersb* (1861) 131ff.; L. B. Ghali-Kahil, *Les enlèvements et le retour d'Hélène* (Paris 1955) 188 (no. 159).

15. See also the observations of K. Schefold, "Statuen auf Vasenbildern," *JdI* 52 (1937) 64.

16. Ghali-Kahil, *Enlèvements* (above, n. 14) pl. 5. In my review of this book (above, n. 13) 216ff., I overlooked the fact that the interpretation of the scene on the oön and the joining of the fragments in Cincinnati (*Enlèvements*, pl. 10) were both done by D. von Bothmer. At the time of the original publication of this article, the vase was in a private collection on Long Island; it is now in the Metropolitan Museum of Art, New York, no. 1971.158.3: *LIMC* IV, s.v. Helene, no. 171, pl. 322.

17. In the case of a sleeveless chiton, there should be at least the two buttons on the shoulders. As evidence for no chiton at all, there is no visible fastening of the mantle. It should be fastened to the chiton over the shoulder. The two descriptions of the vase made in front of it, by Stephani and Schefold, claim that the figure is nude without reservation.

18. Schefold, *UKV*, no. 292, pl. 18; *LIMC*, s.v. Adonis, no. 48a, pl. 170.

19. FR, pl. 79.1; Ghali-Kahil, *Enlèvements* (above, n. 14) pl. 23.1.

20. Schefold, *UKV*, 86, thought there was a chiton, but changed his mind in a letter to the author. The patch of clay-ground color under the right upper arm apparently belongs to the mantle and not to the sleeve of a chiton.

21. Overbeck, *Schriftquellen*, nos. 1667ff. See also M. J. Milne, *AJA* 42 (1938) 342.

22. Ruvo, Museo Jatta: Ghali-Kahil, *Enlèvements* (above, n. 14) 180, no. 145, pl. 29.4.

23. For earlier examples of Helen with nude torso, see ibid., pls. 19, 21, 23.1, 28. On the divinity of Helen in the Late Classical period, ibid., 145ff.; Himmelmann, *Gnomon* 29 (1957) 220, 222.

24. *Vente Bâle* (Münzen und Medaillen-AG) XVI (30 June 1956) no. 141, pl. 35; *LIMC, s.v.* Aphrodite, no. 369, pl. 35 (Basel, private collection). The photographs by D. Widmer are owed to the kindness of Dr. Herbert A. Cahn. The vases in the hands of the idol appear to me to be phialai because of the bump in the middle, despite the curious way they are held.

25. Boston, Museum of Fine Arts 00.629: A. Fairbanks and G. Chase, *Greek Gods and Heroes as Represented in the Classical Collections of the Museum; Boston Museum of Fine Arts*[4] (Boston 1948) 41, fig. 38; *LIMC* II, *s.v.* Aphrodite, no. 1011, pl. 98. The illustration of figure 6 in the original article was kindly supplied by H. Palmer and C. Vermeule.

26. According to H. Palmer there is no trace of clothing, and a simple coloring layer on the figure is out of the question. For the date compare the profile of the mouth to that of the lekythos in St. Petersburg.

27. P. Zancani Montuoro and U. Zanotti Bianco, *Heraion alla Foce del Sele* (Rome 1951) I, pl. 6; *LIMC* II (Basel 1984), *s.v.* Aphrodite, no. 997, pl. 97 (Paestum museum); a side-view is given in *AJA* 40 (1936) 185, fig. 1. For the type see the certainly earlier Rhodian terracotta: C. S. Blinkenberg, *Lindos, Fouilles et recherches 1902–1914* (Berlin 1931) I, pl. 137, no. 2966, from the sanctuary of Athena Lindia (now in Copenhagen, NM 10752: *LIMC* II, *s.v.* Aphrodite, no. 995, pl. 97).

28. In case 35 of the museum in Paestum. On the heads of the replicas are traces of flower attachments. See also C. P. Sestieri, "Iconographie et culte d'Héra à Paestum," *Revue des Arts* (1955) 149–58.

29. References cited in Zancani Montuoro, *Heraion* (above, n. 27) I, 14 n. 3.

30. R. Carpenter, *Observations on Familiar Statuary*, MAAR 18 (1941) 51ff., 58ff.

31. Zancani Montuoro, *Heraion* (above, n. 27) I, 3 n. 4.

32. F. Winter, *Die Typen der figürlichen Terrakotten* (Berlin-Stuttgart 1903) in *Die antiken Terrakotten*, ed. R. Kekulé von Stradonitz, III.2, p. 202, no. 6, among many others; with jewelry box, ibid., p. 202, no. 5. According to the remains of the arm, a mirror is to be restored with certainty to the group in Stockholm, Nationalmusei Arsbok (Stockholm 1925) 59, fig. 30, which Zancani Montuoro, *Heraion* (above, n. 27) I, 17 n. 2, also considers to portray Eileithyia.

33. The knees are not on the ground already in the Boston plastic vase of fig. 83, above. See also Winter, *Typen* (above, n. 32) III.2, 202, nos. 2–3. Kneeling explicitly cited in birth: *Homeric Hymn* 3 (Delian Apollo) 117f.; see also *JdI* 26 (1911) 101, fig. 342 (Egyptian relief). Leto on an Attic pyxis (*ArchEph* [1902] pl. 5) and women giving birth on grave reliefs are shown sitting.

34. The kneeling Auge-Eileithyia in Tegea (above, n. 29) allows no extended conclusions. If kneeling were characteristic of Eileithyia, it is noteworthy that among the numerous terracottas of Paestum the motif is limited to examples of a single mould. E. Langlotz, *Das ludovisische Relief* (Mainz 1951) 10, is also against the identification of Eileithyia. B. Schweitzer, *Eileithyia Kourotrophos*, in *Festgabe Winckelmannsfeier* (Leipzig 1933) shows that standing draped figures with a child on the arm are images of the

goddess of birth, and these are related to the normal image of her mother Hera; he also cites other types of Eileithyia images.

35. The contrary view is expressed by Zancani Montuoro, *Heraion* (above, n. 27) I, 14 n. 3; Carpenter (above, n. 30) 59.

36. Winter, *Typen* (above, n. 32) III.2, 203, nos. 2–3; opposed: P. Knoblauch, *AA* (1938) 354.

37. D. M. Robinson, *Olynthos* V (Baltimore 1933) pl. 89.

38. For example *JHS* 12 (1891) pl. 4; G. M. A. Richter and L. F. Hall, *Red-Figured Athenian Vases in the Metropolitan Museum of Art* (New Haven 1936) no. 168, pl. 167. Eileithyia is cited as the mother of Eros in the hymn of Olen cited by Pausanias 9.27.2

39. R. A. Higgins, *Catalogue of the Terracottas in the Department of Greek and Roman Antiquities, British Museum* (London 1954) nos. 1228/1229, pl. 169. In the sanctuary of the Foce del Sele, the type of nude woman with mantle is also found standing (terracotta relief in case 5 of the museum in Paestum).

40. Inscription from Akrai: *IG* 14 (*Siceliae et Italiae*) (Berlin 1890) no. 208; see also B. Pace, *Arte e civiltà della Sicilia antica* [Milan 1946] III, 580; Samos: *AM* 68 (1953) 47, line 33.

41. Pausanias 3.13.9.

42. See also Erotes listed by Zancani Montuoro, *Heraion* (above, n. 27) I, 15, and the finds cited in ibid., n. 6.

43. A further example of Aphrodite completely nude in the first half of the fourth century is found on a mirror in Paris: W. Züchner, *Griechische Klappspiegel JdI-EH* 14 (Berlin 1942) pl. 17, on which Aphrodite leans on a rock; the usual date shortly before 350 B.C. is earlier than the Knidia, but the date must probably be raised. Terracottas from Olynthos must date at least before 348 B.C.; on these only the lower leg of Aphrodite is covered: *Olynthos* IV (Baltimore 1931) pls. 32, nos. 336, 336A. That Aphrodite herself is represented here is indicated by the solemn opening of the mantle. According to evidence from Olynthos, the well-known group of terracottas from In Tepe can no longer be dated later than the middle of the fourth century, and they are probably a good bit earlier: G. Mendel, *Catalogue des figurines grecques de terre cuite, Musées impériaux ottomans* (Constantinople 1908) pl. 4; *Olynthos* VII (Baltimore 1933) pl. 35, no. 275; G. Kleiner, *Tanagrafiguren: Untersuchungen zur hellenistischen Kunst und Geschichte JdI-EH* 15 (Berlin 1942) 12. One of them shows Aphrodite (with only the right leg covered) dreamily resting in a rocky landscape while Eros and Peitho stretch a large cloth behind her like a canopy: Mendel, *Catalogue*, pl. 4.3, no. 1869, p. 177; Winter (above, n. 32) III.2, 200, no. 3. A replica was found at Larisa on the Hermos: J. Boehlau and K. Schefold, *Larisa am Hermos, die Ergebnisse der Ausgrabungen 1902–1934* (Berlin 1950) III, 34, no. 69, pl. 8.1 (Schefold). Other images of the first half of the fourth century show the goddess uncovered down to the waist, such as a bronze relief in London: Ghali-Kahil, *Enlèvements* (above, n. 14) pl. 33.1.

44. Rodenwald, *SBBerlin* (1943) no. 13 (above, n. 5) 14f. See now Himmelmann, "Ideale Nacktheit in der griechischen Kunst," *JdI-EH* 26 (Berlin 1990).

45. See also Pfuhl, *MuZ*, figs. 394, 564, 565, 579. [fig. 394 = Euphronios, psykter, Leningrad 644 (St 1670): *ARV*[2] 16.15, 1619; *Beazley Addenda*[2] 153; Boardman, *ARFVAP*, fig. 27. Fig. 564 = The Group of Polygnotos, stamnos, Munich 2411: *ARV*[2] 1051.18, 1680; *Beazley Addenda*[2] 321; J. Charbonneaux, R. Martin, F. Villard, *Classical Greek Art*

(New York 1972) 256, fig. 291. Fig. 579 = Dinos Painter, calyx-krater, Bologna 300: *ARV*2 1152.7; *Beazley Addenda*2 336; *LIMC*, *s.v.* Aphrodite, no. 1523, pl. 699.]

PART II

APPROACH
AND MEANING

A "SARCOPHAGUS"

FROM MEGISTE

THE HERMENEUTIC DIRECTIVE to interpret from context is far
more ambiguous than it may at first seem to be. It is given with the ex-
pectation that the resulting interpretation will acquire an enhanced
conclusiveness. Thus it is based on the assumption that the context is a mean-
ingful whole. This is, however, by no means recognizable at the outset. Surely
context as a concept does refer to something concrete and definable, but it is
otherwise a fluid quantity. Its internal coherency must be proved—not by edi-
torial means, of course, but through interpretation. Consequently it is multi-
faceted and by no means always clearly definable. Every material aspect of an
object has implications that change the hermeneutical connections, that is,
"contexts" among which one has a choice. *Context* is, therefore, by and large a
hypothetical concept, or rather an unknown that is usually revealed only
through successful completion of the remainder of the calculation.

These difficulties are not just theoretical ones, as illustrated by a contextual
interpretation that misled Carl Robert, the most illustrious scholar in the
hermeneutics of ancient art. The focus was the figural decoration on the front
of a "sarcophagus" from Asia Minor, now in Athens, which Robert discussed
in his great work on the mythological sarcophagus reliefs (fig. 84).[1] The piece
comes from the island of Megiste off the Lycian coast. The interpretation can
be based on several readily identifiable figures, namely Aphrodite and Eros in
the center, as well as Bellerophon with Pegasos at the right end.[2] It seems logi-

"Der 'Sarkophag' aus Megiste," *AbhMainz* (1970) no. 1, pp. 5–17, trans. Hugo Meyer.

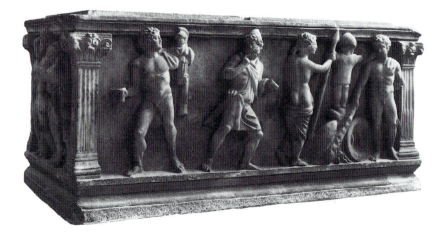

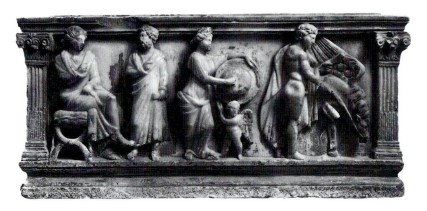

84a–b. Ossuary from Megiste. Athens National Museum

cal to follow Robert in naming the two remaining figures as additional parts of the myth of Bellerophon: Stheneboia, offended, persuades King Proïtos to send Bellerophon on a fatal errand. This reading is apparently confirmed by the scroll in the left hand of the figure called Proïtos, for it is assumed to be the letter the hero will take with him. In this interpretation the context is the visual unity of the image that appears to require the unity of content. An attempt has been made in a recent study to further corroborate Robert's interpretation by making specific reference to this context, which seems to me very hypothetical.[3] Indeed, the identification of the two figures on the left is demonstrably mistaken, and the correct one is impossible to discover on the basis of the pre-

sumed context. The identification can only be derived from a broader approach, which I wish to present here.

The sarcophagus in Athens belongs to the large group of sarcophagi from Asia Minor which, along with those from Attica and metropolitan Rome, has made the most substantial contribution to the study of this class of imperial monuments. While the material from Asia Minor can be broken up into a number of subgroups and variants,[4] these three main groups are distinct from one another in terms of architectural structure, ornamentation, and mode of narrative representation. Though their peculiarities may in part be accidental, some betray a deep-rooted connection with the older artistic traditions of the respective regions. Here I concentrate on sarcophagi with figured decoration and more specifically on the differences in their narrative techniques. A more detailed analysis could, however, not legitimately neglect other distinctive features of each group.

A comparison between Attic and Roman sarcophagus reliefs with identical topics reveals great differences in attitude, although both groups partially work with the same figure types. On the Roman Hippolytos sarcophagus in Pisa, the Euripidean plot is retold in two continuous scenes, each of which features the protagonists.[5] On the left we find Hippolytos, who is departing for the hunt, rejecting the scheme of the nurse, while on the right we witness the same Hippolytos hunting a boar with Virtue as his associate. Clearly the Roman sarcophagus is adapting principles of book illumination—that is to say, the minor arts—to a large-scale medium.[6] On the other hand, the Hippolytos sarcophagus in Agrigento, which comes from an Attic workshop, presents a style of representation that is commensurate with the vehicle's character as a monument in the literal sense of the term.[7] The types used for Hippolytos and the nurse correspond to those on the Pisa sarcophagus and show that both specimens stand in the same iconographic tradition. The Attic masters, nevertheless, monumentalize the theme by limiting themselves to one single scene and filling the space with restful, nude figures, so that the episodic narrative element yields completely to that of heroic presentation.

Another difference between the two workshop groups is evident when corresponding depictions of Amazonomachies are compared. On the Roman sarcophagus in the Vatican, the importance of the group of Achilles and Penthesilea is underscored by their larger scale and position, but also by the fact that they bear the portraits of the deceased.[8] In contrast the Attic sarcophagus in the Louvre shows a continuous, uninterrupted melee reminiscent of Classical friezes.[9] The Achilles-Penthesilea group in this iconography did not assume a prominent and symbol-laden position, although it was an integral part of the stock imagery at that workshop's disposal. Characteristically the group ap-

pears on the short side of the sarcophagus, where the craftsmanship is negligent, and the figures do not have portrait heads. The peculiarities of the style of representation attributable to metropolitan Rome—continuous narration in the manner of scroll illustrations, large scale, and added portraits—point to a particular interpretation of the myth within the framework of funerary art. Here the myth becomes the vehicle of a purposely personal symbolism, while the Attic workshops avoid fusing the sphere of myth with the human one.[10] In Greece the myth decorating the tomb monument, in terms of metaphorical implications, remains more general and thus retains more of its ancient distance and autonomy.

For the most part the differences between the Roman and the Attic traditions have already been stated in earlier commentaries.[11] But how does the material from Asia Minor relate to this picture? Although sarcophagi with figural decoration are far less numerous in relation to the total production of stone sarcophagi than in the West, they are typologically less uniform. Accordingly an easy answer is not to be expected.[12] I will use the example of the particularly characteristic columnar sarcophagus group and its relatives, for these monuments allow us to establish a third category of narrative technique. Once recognized, it constitutes a possible hermeneutical context.

A trait that these sarcophagi from Asia Minor have in common with those from Attica is that continuous narration is not applied within the confines of the individual sides of the casket,[13] nor are mythological figures fitted with portrait heads. Unlike the Roman workshops, these two artistic provinces do not blend the mythical and the human. But while the mythological images retain their autonomy to the full on Attic sarcophagi, the ones from Asia Minor adopt a more symbolic character by combining myths with human themes. A late columnar sarcophagus in Konya is decorated on three sides with the isolated deeds of Herakles; on the fourth side a seated portrait figure represents the deceased in the guise of a philosopher.[14] He is surrounded by idealized figures, types that signify modes of the intellectual life. Attic pieces do not normally have this juxtaposition of mythological and human subjects on one and the same casket.[15] The effect achieved by the form of representation peculiar to the sarcophagi from Asia Minor is twofold. On the one hand, the images remain distinct, even isolated from one another, while, on the other hand, a conceptual or "metaphorical" relationship establishes itself between them. Through the philosopher who "interprets" the scenes, the deeds of Herakles become metaphors of the struggle of existence, which by the same token characterize the philosophical endeavor. Similarly, a small frieze sarcophagus, which is closely related to the columnar sarcophagi, shows on its front the de-

ceased boy in an ideal bourgeois setting, while the other sides are decorated with cupids.[16]

Clearly the juxtaposition of heterogeneous elements is a conscious principle of narration. It is applicable even within the boundaries of a single side of a sarcophagus and thereby distinguishes itself still more sharply from the homogeneous form of representation customary in Attic sarcophagi. On the late and large sarcophagus from Sidamara in Istanbul, the philosopher and his companion as well as the mythical figures of Artemis and the Dioskouroi are united on the same side.[17] An early fragment in Beirut combines the hunting boy on horseback and the bourgeois philosopher type wearing a himation with

85a–b. Unfinished heads on a sarcophagus (details). Istanbul, Archaeological Museum

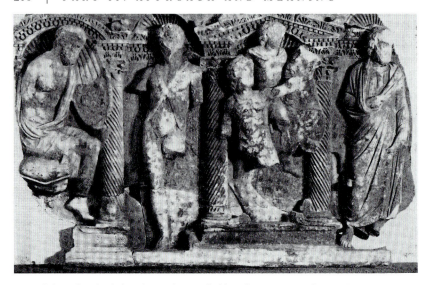

86. Philosopher (right) with Dioskouroi (left), columnar sarcophagus. Beirut

Daidalos and Ikaros, who are depicted on a larger scale (fig. 86).[18] Here is another variant from Attic practice, again enhancing the heterogeneity of the juxtaposed themes. Fragments in Smyrna show a bourgeois figure, a woman on a *scrinium*, inserted between two groups derived from the same mythological context: the nurse and the pedagogue who attempt to escape with Niobe's children.[19] Because of the separation of these elements, this interpretation has recently been disputed. It is confirmed, though, by the parallel on a small casket in Antalya, where the corresponding types are still in their original context.[20] The extent to which the isolation of elements of imagery is based on a conscious method is illustrated by the figure on the far right. It is Meleager with the boar's head, clearly another mythological figure, yet one with no narrative connection to the myth of the Niobids. The diversity of the juxtaposed themes on these monuments has not passed unnoticed and was considered due either to carelessness or to a constraint of the characteristic columned architecture, which does not allow for homogeneous representation.[21]

After this excursus, let us return to the sarcophagus in Athens, which belongs to an early stage of the development and is contemporary with the first columnar sarcophagi. As customary in Asia Minor, it is decorated with reliefs on all four sides. On one of the short sides, the drunken Herakles is supported by Pan and a Satyr, while the other one shows a centaur conquering a Lapith. One long side displays next to a pair of figures flanking a tropaion an easily identifiable episode from the myths of the Trojan Cycle: Odysseus and

Diomedes who steal the Palladion. On the other long side, Bellerophon can be recognized without a doubt. Therefore the four discrete sides do not depict a homogeneous narrative but represent four completely different myths.[22] Furthermore, it seems doubtful that the two long sides each contain a single narrative. It has been suggested that the scene at the tropaion is a companion piece to the theft of the Palladion and is a reference to the victory over Troy, but this is contradicted by the fact that the youthful hero is laying down a club;[23] he must be a member of an older generation of heroes. Finally, nobody would seriously identify the group on the left of the other long side as the royal couple from the myth of Bellerophon, if the assumption of contextual unity did not seem to demand it.[24] The man is the look-alike of the figure dressed in a himation as we know it on columnar sarcophagi. What he is holding in his left hand is not the diptych containing the sinister message of King Proïtos, but a literary scroll hinting at his spiritual inclination.[25] The seated woman is likewise clasping a scroll. She is certainly not the queen in Euripides, impassioned by unrequited love, but the philosopher's companion, lifting her right hand with two fingers extended in a measured gesture of speech: she is "lecturing."

A quick glance at a Roman sarcophagus depicting the myth of Bellerophon provides further proof that our group is not the mythical royal couple (fig. 87).[26] Following Roman custom, the relief in the Villa Pamphili subdivides the story into two episodes, namely the departure of the hero, who is accompanied by his Virtus, and, to the left, his fight with the Chimera in Lycia. The languishing figure of the queen with the cupid in front of her is as unrelated to

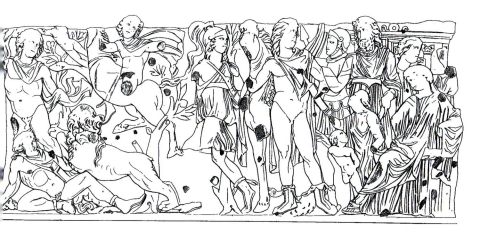

87. Myth of Bellerophon, sarcophagus, drawing. Rome, Villa Doria-Pamphili

the respective type on the Megiste sarcophagus as the high-belted king in the theatrical chiton is unrelated to the palliatus. Indeed, the relief in Athens shows nothing else but a group of middle-class figure types with philosophical connotations, which is common on columnar sarcophagi, where portrait features may be added. The combination of seated woman and standing man is paralleled, for instance, on the long side of a sarcophagus in Ankara at the ends of which are again mythological figures, the Dioskouroi (fig. 88).[27]

In spite of its different tectonic appearance and its early date of origin, the Megiste sarcophagus betrays the same principles of metaphorical narration as do the columnar sarcophagi. The manner of representation,[28] rather unusual for a frieze sarcophagus, may well have been influenced by early examples of the columnar type in the manner of the Melfi sarcophagus, which partially employs similar figures.[29] The symbolism or abstract meaning behind the combination of philosophical group and Bellerophon will have to be interpreted along the same lines as the juxtaposition of the figure in the himation and Ikaros on the fragments in Beirut (fig. 86, above).[30]

The interpretation thus suggested is contradicted by an external observation that even seems to disprove it. With a length of only 90 cm, the casket from Megiste cannot possibly have been a sarcophagus for an adult, but one for a child.[31] Seen in this light, the philosophical group becomes disturbing. For even if it should consist of ideal figures, one would be inclined to assume

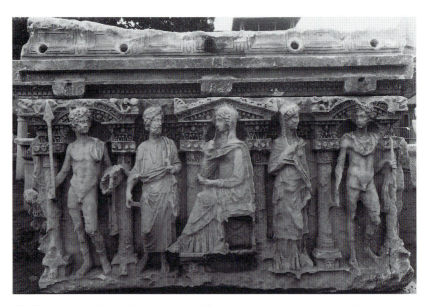

88. Dioskouroi with standing and seated figures, columnar sarcophagus. Ankara

89. Married couple,
 lid of ossuary.
 Iznik

it was personally related to the deceased. A find in the museum at Iznik sheds light on the whole group of monuments and may solve the problem. The Megiste casket belongs to the so-called Torre-Nova group, almost all of whose specimens survive by chance without the lid.[32] A solitary, recarved piece in Ancona has, however, preserved its original, roof-shaped lid,[33] which typologically matches the lids of the garland sarcophagi. In Iznik there is a lid of the kline-type, which is otherwise regularly combined with columnar sarcophagi (fig. 89).[34] Measuring only 80 to 90 cm in length, the piece cannot have belonged to a large-scale sarcophagus but obviously is an addition to the Torre-Nova group, which is also suggested by its careful, stylistically early craftsmanship. The figures on the kline are not children, but the married couple well known from columnar sarcophagi. The man clasps an open scroll with his left hand. The woman is significantly smaller than he is, but the modeling of the breast proves her to be an adult, as well.[35] The Iznik kline-lid thus suggests that the small Torre-Nova caskets were in part intended for adults.[36] In that

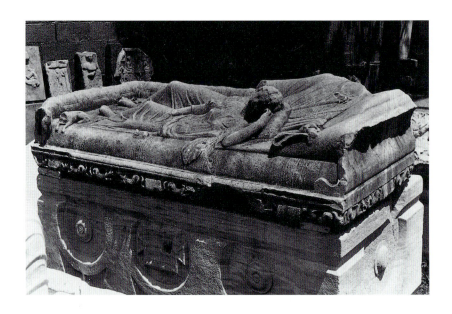

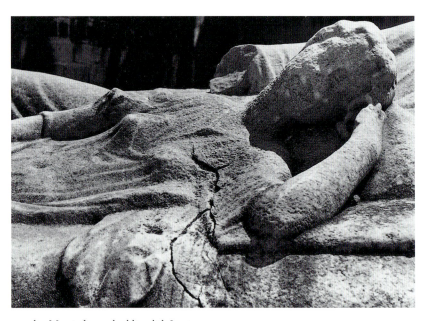

90a–b. Married couple, kline lid. Izmir

case, evidently, they cannot have served as sarcophagi, but only as ossuaries. Since the use of ossuaries in Asia Minor is also otherwise well attested at the time,[37] our interpretation has no further obstacles.

Robert's interpretation was erroneous, because he took two contexts for granted, which were in reality hypothetical. For neither was the visual unity of the image based on a narrative (rather, only an allegory), nor was the functional definition of the object as a child's sarcophagus correct. The case of the Megiste ossuary warns us not to take literally the directive to interpret from the context. It is the interpretation's task first to (re-)create the context.

NOTES

This article is the annotated version of a paper read at the Fifth International Congress on Ancient World Studies, held in Bonn in 1969. It was titled "Greek and Roman Elements in the Narrative Mode of Sarcophagi of the Imperial Age," and a certain conciseness was required by the occasion. The argument reflects the general topic assigned to the relevant section of the congress, namely, the "Interpretation of Art Historical Evidence within Its Context." The appendix of the German edition, on the typology of the sarcophagi, is not included here (see also note 4, below).

1. C. Robert, *Die antiken Sarkophag-Reliefs* II (Berlin 1890) no. 138, p. 146, pl. 50; H. Wiegartz, *Kleinasiatische Säulensarkophage* (Berlin 1965) 151, hereafter referred to in this chapter as *KS*. The short initial publication by F. von Duhn, "Sarkophag aus Lykien," *AM* 2 (1877) 132–37, pls. 10–12, contains a number of observations more pertinent than Robert's, who apparently is basing his judgment on photographs and is biased by his preconceived interpretation. His visual errors are also reflected by retouches in the much-repeated heliogravure on pl. 50 of *ASR* II; see also nn. 2 and 21.

2. The thick, staff-like object in Bellerophon's left hand has not received the finishing touch. It seems to be coming to the fore again below the hand. Duhn assumed it to be a scroll and interpreted it as a link between Bellerophon and the seated woman on the left, whom he identified as a Muse. Contrary to that, Robert took it to be a whip, which would seem somewhat foreign to the image of a rider watering his horse. This notion, likewise, is contradicted by the position of the arm and the fact that the object is held in the left hand. Robert, though, claimed that one could "very clearly" discern the whip's lash and had it entered into the heliogravure. In reality, it is the outline of the feathers on Pegasos's wing.

3. Wiegartz, *KS* (above, n. 1) 75. Among others, G. Rodenwaldt, "Ein lykisches Motiv," *JdI* 55 (1940) 46, accepted Robert's interpretation, as did S. Hiller, *Bellerophon:*

Ein griechischer Mythos in der römischen Kunst (Munich 1970) 45–46, which appeared the year after this article was originally published.

4. The unusually rich typology of the sarcophagi produced in Asia Minor, up to now, has not been systematically described. Only the sumptuous columnar sarcophagi and related material have been dealt with often; see also Wiegartz, *KS* (above, n. 1) with bibliography. Contrary to the West, modest tectonic types like the garland sarcophagi and those with a framed casket prevail, and figured friezes are exceptional. On garland sarcophagi they appear only sporadically and are functionally subordinate (for details see also the appendix to the German edition, 18–30). They are a regular feature of the columnar sarcophagi, though, where echoes of frieze-style representations are found parallel to rows of statuary owing to the calumniated architecture—of course, the former are quite restricted. Frieze sarcophagi in the proper sense are not common. They are primarily the small-scale caskets of the Torre-Nova group, which are related to the columnar sarcophagi, and the large sarcophagi with representations of Cupids or Amazonomachies. For travel notes on these and other frieze sarcophagi from Asia Minor, see the appendix to the German edition of this article, 18–30. See also also Wiegartz, *KS* (above, n. 1) 177ff. and 49ff.

5. *ASR* III, 2, no. 164, pl. 51; F. Matz, *Ein römisches Meisterwerk, JdI-EH* 19 (Berlin 1958) pl. 32; Sichtermann-Koch, *Griechische Mythen,* no. 26, pp. 33–34, pl. 55.2; Koch-Sichtermann, *Römische Sarkophage* 150, fig. 170; *LIMC, s.v.* Hippolytos I, no. 55.

6. On the problem see Himmelmann, "Erzählung und Figur," 27 (trans. above, p. 101 n. 7), with references to connections between book illumination and panel painting which have some bearing on the context. Of importance for the question of the sources of sarcophagus iconography is a silver cup in the Rheinisches Landesmuseum in Bonn, published superbly by E. Künzl, "Der augustische Silbercalathus im Rheinischen Landesmuseum Bonn," *BJb* 169 (1969) 342, 344. Künzl recognized that the main figures of the early imperial silver bowl agree typologically with those of Jason and Kreousa in the first scene of the Medea sarcophagus, the giving of presents. Yet this hardly proves that this is the original meaning of the figures. It is possible that there was another mythological or genre scene from which the figures have been adapted for the Medea cycle. Robert, *ASR* II, 197, already thought of this, but he went too far when he sought to find explicitly Roman traits in the scene. In this context it in important to note that Künzl (*BJb,* 169) points to a formerly undetected detail. In all the examples known so far that are sufficiently clear, one of the children in the sarcophagus scene is not carrying the peplos as it should according to tragedy but is raising its own little cloak so as to form a pouch filled with flowers, clearly visible, for instance, in Künzl's fig. 19.

7. *ASR* III, 2, no. 152, pl. 47; Koch-Sichtermann, *Römische Sarkophage* 394, 398, fig. 42b; *LIMC, s.v.* Hippolytos I, no. 87. See also the Hippolytos sarcophagus in Tarragona, *AA* 1954, 423, figs. 101–4.

8. *ASR* II, no. 92, pl. 39; Sichtermann-Koch, *Griechische Mythen* 23–24, no. 12, pls. 26.2, 27–28; *LIMC, s.v.* Achilleus, no. 767, pl. 167.

9. *ASR* II, no. 69, pls. 28–29; Koch-Sichtermann, *Römische Sarkophage* 391, fig. 420. The comparison is also still valid for the late Attic Amazon sarcophagi, which, as to their date, are closer to the Vatican sarcophagus. See also R. Redlich, *Die Amazonensarkophage des 2. and 3. Jahrhunderts n. Chr.* (Berlin 1942).

10. See Himmelmann's contribution on Roman and Attic cupid sarcophagi in

MarbWPr (1959) 30. An observation offered there on p. 26 nn. 14–15 presumably will continue to be useful as a rule of thumb, although, in the meantime, quite a few Attic children's sarcophagi with representations of cupids have come to light (in Athens by the Theseion, Side, Thessaloniki, Ostia, Kyrene).

11. F. Matz the elder in *AZ* (1873) 11ff.; Robert, *ASR* III, 3, 517; G. Rodenwaldt, "Sarkophagi from Xanthos," *JHS* 53 (1933) 188; Himmelmann, *MarbWPr* (1959) 30 n. 47, and *Festschrift F. Matz* (Mainz 1962) 114 n. 19. Wiegartz, *KS* (above, n. 1) 63, does not put it precisely enough: not the stringing out of images in and of itself is typical of the Roman variety, but rather the continuous change of scenes in which the same protagonists keep reappearing on one and the same side of a sarcophagus.

12. Above, n. 4.

13. The only exception seems to be the sarcophagus in Providence, which is unusual in other respects, as well; Wiegartz, *KS* (above, n. 1) 178, no. 16; see also ibid., 63. In the Attic group solely the Meleager sarcophagus in Delphi, *ASR* III, 3, no. H33, seems to deviate from the rule. Continuous narration on different sides of a casket is, by all means, current with Attic workshops (for instance, on all Hippolytos sarcophagi of the Agrigento type).

14. Y. Boysal, *TürkArkDerg* 8 (1958) II, 77ff., pls. 46–48; Wiegartz, *KS* (above, n. 1) 163 ("Konya C"); *LIMC, s.v.* Herakles, no. 1725.

15. An exceptional feature is the roughed-out *imago clipeata* for a portrait bust on one of the small sides of a sarcophagus in Kephissia: A. Giuliano, *Il commercio dei sarcofagi attici* (Studia archaeologia 4: Rome 1962) no. 75, p. 33 = *Städel-Jahrbuch*, n.s. 1 (1967) 51, fig. 10. In the courtyard of the museum in Antakya, there is an Attic sarcophagus with a victorious athlete on one of the small sides. Although this is an ideal figure, it is more in the human than in the mythical realm. The only illustration is in *GazArch* 10 (1885) pl. 29r. The sarcophagus is now standing so closely to the wall of the museum, that I was unable to examine it in detail when visiting Antakya in the spring of 1969. A special case is presented by another unpublished sarcophagus, likewise in Antakya, one of whose small sides displays the representation of a middle-class married couple. The craftsmanship here differs from that of the long sides; therefore this image must be an addition carried out locally. Responding to S. Keskil's kind invitation, I would like to deal with the piece in a later article. It is referred to in passing by A. H. Borbein, *Die Campanareliefs: Typologische und stilkritische Untersuchungen* (Heidelberg 1968) 91 n. 442.

16. F. Cumont, *Recherches sur le symbolisme funéraire des Romains* (Paris 1942) pl. 39; for the interpretation see Wiegartz, *KS* (above, n. 1) 128.

17. Wiegartz, *KS* (above, n. 1) 156f. ("Istanbul B"). As I did in *MarbWPr* (1959) 37 n. 47, Wiegartz, 157, assumes that the roughed-out heads of the philosopher and the woman were to become portraits. This assessment needs to be modified, though, if one takes into consideration the other unfinished heads on the sarcophagus. For close scrutiny of the original makes it clear that none of the uncompleted heads were intended as portraits (fig. 85) but rather adhere to the well-known ideal types. The workshop had left one or two heads unfinished on each side of the sarcophagus (that is to say, on the right small side, as well). The purpose, obviously, was to have a set of different types at one's disposal, should the customers desire to have portraits added. If that option was not used, then the heads were theoretically to be finished in the customary ideal style.

18. Beirut inv., F 5130: Wiegartz, *KS* (above, n. 1) 152f. ("Beirut A"). Our illustration is from M. Lawrence, "Additional Asiatic Sarcophagi," *MAAR* 20 (1951) 135, fig. 19.

19. Wiegartz, *KS* (above, n. 1) 160 ("Izmir C"). For the correct interpretation see F. Eichler, "Zwei kleinasiatische Säulensarkophage," *JdI* 59/60 (1944/45) 125ff. Wiegartz's objections do not hold.

20. Wiegartz, *KS* (above, n. 1) 147 ("Antalya L") pl. 28.

21. R. Delbrueck, "Der römische Sarkophag in Melfi," *JdI* 28 (1913) 298; see also Eichler (above, n. 19) 127. In principle, Wiegartz, *KS* (above, n. 1) 120, rightly objects to that, although, more often than not, I am unable to follow his detailed interpretations. Occasionally, the symbolizing or allegorizing trend of the Roman sarcophagi leads to isolation of narrative pictorial units; see, for example, the Braschi sarcophagus, H. Sichtermann, *Späte Endymion-Sarkophage* (Baden-Baden 1966) fig. 1. I cannot deal with that aspect in the present context. The juxtaposition of the deceased and the Dioskouroi on the same long side is a feature the Roman workshops take over in the process of imitating the columnar sarcophagus type from Asia Minor.

22. In this respect the other specimens in the group do not follow a specific pattern. Caskets in Rome, Beirut, and Antalya combine idealizing bourgeois figure types or Niobids on one of the long sides with cupids on the other three sides: Wiegartz, *KS* (above, n. 1) 170 ("Rome O"); 153 ("Beirut C"); 147 ("Antalya L"). On one of the long sides of the piece in Hever Castle (Wiegartz, 155), a Dionysiac scene, whose meaning is not precisely known, corresponds to the myth of Pentheus on the other, while the short sides appear to depict other, likewise unidentified themes. In addition to the Eleusinian scene on its front, the sarcophagus from Torre-Nova (Wiegartz, 168: "Rome B") shows three pictures of mourning, which form a group at least in feeling. (On the object held by the seated woman on the left small side—a ball of wool or yarn on a stick with an eye at the lower end—see also p. 20 in the appendix to the German edition of this article.) Like the Dionysiac sarcophagus in Subiaco, the frieze sarcophagi with cupids, Amazonomachy, and hunting scenes are thematically homogeneous, while the sarcophagus in Providence combines Hektor's death, cupids hunting lions, a heroic lion hunt and a "sacra conversazione" among heros.

23. Already stated correctly by Duhn, *AM* 2 (1877) 136. Although the object is not finished in terms of carving, from the way it is held it cannot possibly be a sword as Robert, *ASR* II, 148, had assumed. Duhn, whom the figure reminded of Hermes types, abstained from an identification, as did Robert. According to S. Reinach, *Répertoire de reliefs grecs et romains*, II (Paris 1912) 337, it is Herakles. Wiegartz, *KS* (above, n. 1) 76, takes the group to be a general reference to the victory over Troy.

24. Duhn, *AM* 2 (1877) 134, whose interpretation, owing to Robert's authority, was completely neglected in the literature, had considered the bearded man to be the deceased in the guise of an orator or poet joined by a seated Muse. Wiegartz, *KS* (above, n. 1) 75, is right when he objects that, in that case, the Muse ought to be standing. The stumbling block is removed, though, if the figure is understood as another idealizing embodiment of middle-class values, like the types commonly found on columnar sarcophagi (see below, p. 208).

25. Duhn, *AM* 2 (1877) 134, and Robert, *ASR* II, 146, see a diptych. But while Duhn's drawing reproduces the object with a fair degree of accuracy, nevertheless, Robert manipulates his drawing by adding the raised frame common in diptychs. Both the origi-

nal and the photograph prove indisputably, though, that the object is a scroll, pressed together by the clasping hand.

26. Robert, *ASR* III, 1, pls. 8–9, no. 34; Sichtermann-Koch, *Griechische Mythen*, no. 14, pls. 30, 32.1; see also Juvenal 10.330. On the iconography of the myth of Bellerophon, see also Helbig II⁴ no. 2007: P. Zanker (Spada relief) with further literature. With regard specifically to the sarcophagi, see B. Andreae, *Studien zur römischen Grabkunst* (Heidelberg 1963) 122 n. 122. On the Algiers Sarcophagus, the duplication of the departure scene on the lid, of course, does not mean that what is represented on the casket is the leave-taking from Iobates. Likewise, the middle scene of the casket is repeated on the lid. As to the right half of the Villa Pamphili Sarcophagus—and, by the same token, the corresponding section on that in Algiers—Robert (*ASR*, III.1, 46) proved conclusively that the figures are Proïtos and Stheneboia, as others had argued before.

27. Wiegartz, *KS* (above, n. 1) 144 ("Ankara A") with detail on pl. 22j. See also one of the long sides of the cupids sarcophagus mentioned in n. 13, above (= Wiegartz, 153 ["Beirut C"]; more in Wiegartz, 69 n. 10).

28. The well-known Hades sarcophagus in Ephesos (Wiegartz, *KS* [above, n. 1] 179, no. 36) combines civic and mythological figures in one unified scene, which becomes ambiguous, though, owing to the frontal position of the deceased.

29. Wiegartz, *KS* (above, n. 1) 164f. See also the Aphrodite with shield, ibid., pl. 22b. Thematically, the group depicting the theft of the Palladion is also in keeping, although typological relations are hardly recognizable anymore. Also, the Torre-Nova caskets with philosophical groups or a frontally posing child are clearly influenced by the columnar sarcophagi (Wiegartz, *KS*, 127f.).

30. Above, n. 18. In all likelihood the man wearing a himation there also formed a group with a seated woman (Wiegartz, *KS*, 126).

31. That has been the *communis opinio* since Robert, *ASR* II, 146. Duhn, *AM* 2 (1877) 134, had thought more reasonably of an ash urn.

32. On the Torre-Nova group, see also Wiegartz, *KS* (above, n. 1) 17, 34, 37, 43, 45.

33. Wiegartz, *KS* (above, n. 1) 144, pl. 26. The corner fragment of another roof-shaped lid very likely belongs to the Beirut Torre-Nova casket (= Wiegartz, 153 ["Beirut C"]).

34. Iznik, inv. 805. I am grateful to the museum's director, Emin Tan, for being so collegial and obliging. Unfortunately, I did not remember to take measurements and check if a connection is possible with the interesting casket fragment Iznik, inv. 36.

35. The figures on the big kline-lid from a lost columniated sarcophagus in Izmir (fig. 90) are typologically identical: Wiegartz, *KS* (above, n. 1) 161, pl. 36 ("Izmir O"). They are not, though, as Wiegartz indicates, a woman and a smaller girl, but a man (tip of beard preserved), whose back is resting flat on the couch, and a smaller woman. The latter, whose head is lying on a pillow, is likewise an adult, as can be seen from the modeling of her breast. (She has a portrait head datable to around 170.) The vegetal ornament on the mattress, the open scroll held by the man, and the hand garland of the woman also match the smaller lid in Iznik.

36. Others are attributable to children by virtue of the represented topics (cupids, Niobids, child among adults). Some of these, too, may more appropriately be referred to as ossuaries, since they are too small to accommodate the skeletons even of children.

I found infant bones, apparently calcined by fire, in an ossuary in Alanya that follows the Kilikian type discovered by Pietrogrande (see n. 37, below).

37. See, for instance, the group of Kilikian ossuaries from the Korakesion region recognized by L. A. Pietrogrande, "Nuova serie asiatica di urne e di piccoli sarcofagi," *BullCom* 63 (1935) 17ff.; see also J. Inan in *Die Agora von Side und die benachbarten Bauten, Bericht über die Ausgrabungen im Jahre 1948*, ed. A. M. Mansel, G. E. Bean, and J. Inan (Ankara 1956) 67–77. On the name ὀστοθήκη see J. Kubinska, *Les Monuments funéraires dans les inscriptions grecques de l'Asie Mineure* (Warsaw 1968) 64f. I intend to return to this type of monument in a paper dealing with an unpublished ossuary in Nicosia.

WINCKELMANN'S

HERMENEUTIC

FOLLOWING A SUGGESTION by Goethe, historians of ancient art are
wont to celebrate Winckelmann's birthday with annual lectures. Hardly
ever do these have anything to do with Winckelmann himself, though. As
a matter of fact, it is not at all easy for the specialized modern scholar to re-
trace the path back to the time and oeuvre of Winckelmann, which have be-
come the domain of Germanists and modern art historians. Furthermore,
according to a not uncommon prejudice, the art historian Winckelmann is
hopelessly outdated. That is true, of course, if one judges his work in terms of
the chronology or the range of monuments it is based on. But this judgment is
certainly inaccurate in terms of Winckelmann's art-historical method, which
was groundbreaking and continues to influence our modes of inquiry to this
day, as shown without difficulty in his most important work, the *History of An-
cient Art*. This book, published in 1764, introduced a new discipline that stud-
ied art according to both its structural and its evolutionary aspects.

I cannot pursue this issue here further, for I intend to look more closely at
another side of Winckelmann's approach to art history: his method of inter-
preting ancient mythological imagery, which in the nineteenth century was re-
ferred to as *Kunstmythologie*. As we shall see, this term accurately reflects
Winckelmann's perception of the matter.

We are dealing with one of Winckelmann's achievements that has not been
fully appreciated, because the work in which Winckelmann developed his

"Winckelmann's Hermeneutik," *AbhMainz* (1971) no. 12, 591–610, trans. Hugo Meyer.

method, the *Monumenti antichi inediti*, has always stood in the shadow of his *History of Ancient Art*.[1] Right at the beginning the author experienced a whole series of trials and tribulations in the printing of the luxurious volumes, which Winckelmann paid for himself to maintain his cherished independence. Particularly detrimental to the undertaking was the unreliability of the draftsmen and engravers, among whom Giovanni Battista Casanova, the great writer's brother, played an inglorious role. Lavishly praised by some of its contemporaries, the work also met with much criticism by others and a generation later had almost fallen into oblivion. As early as 1777, Herder, in his eulogy, avoided commenting on the *Monumenti inediti*,[2] and it is significantly omitted from the Winckelmann edition published by the Weimar *Kunstfreunde*, although Goethe in his famous essay of 1805 had rightly underscored its merits.[3] Surely budgetary constraints influenced this decision a great deal. But Fernow, the editor, explained the omission as due to a multitude of errors in the book.[4] Indeed, the Weimarians were bound to feel repelled by its confused baroque erudition. As usual, the best source on the topic is Justi's masterful biography.[5] The genesis of the *Monumenti inedititi* is depicted in lively colors and the revolutionary nature of Winckelmann's interpretations at that time become clear. In spite of his superior knowledge of the period, Justi does not question the historic conditions presupposed by Winckelmann's hermeneutic. To him, this is not a problem. In the biography Winckelmann's discovery takes on the quality of timeless intuition, a trait Justi in his narrative often attributes to his somewhat naïve hero.[6] Here we encounter a gap in the tradition which we try to remedy by scrutinizing the intellectual and methodological conditions presupposed by Winckelmann's art of interpretation.

Prior to Winckelmann, Roman antiquarians had often sought to explain monuments as representations from Roman legend and history.[7] Since most specimens had been found in Rome and its environs, this assumption seemed natural. Strangely, though, it only rarely led to conclusive readings. It was Winckelmann who claimed that the monuments displayed scenes from Greek myth to be identified in accordance with the texts of the Greek poets. I begin by setting forth a few examples of his technique.

In the frieze decorating a silver vessel that was found at Antium and belonged to the Corsini, two women stand across from each other at a table (fig. 91).[8] One of them extends her right hand over a vase. At both sides are other figures, among whom are a woman and a man who is attentively leaning forward to the left. Taking the find-spot into account, the learned Father Paciaudi proposed that the scene depicted the oracle of Fortuna at Antium. However, Winckelmann, referring to the *Eumenides* of Aeschylos, explained that the scene has to be the trial of Orestes on the Areopagus decided by Athena's

91. Trial of Orestes, silver vessel from Antium, drawing. Rome, Palazzo Corsini

ballot in favor of her protégé. To strengthen his case, Winckelmann also adduces Pliny's note on the famous silver cup by Zopyrus which was decorated with the same scene (*NH* 33.55.156). Moreover, he cites two parallels, a sarcophagus in the Giustiniani and a cameo in the Strozzi Collection. What is decisive, though, is that his suggestion results in a conclusive reading of the frieze in its entirety, while his predecessor had erred from the outset by limiting his interpretation to the protagonists. Beyond its internal evidence, Winckelmann's interpretation can also be proved by the external evidence of sarcophagi.[9] On the Giustiniani sarcophagus, the scene is located on one of the short sides. Its match on the other side is the encounter of Orestes and Iphigeneia in the land of the Taurians based on the play by Euripides. Reverting to Aeschylos, the front portrays the Erinyes at the tomb of Agamemnon, the slaying of Aigisthos and Klytaimnestra, and, finally, Orestes in Delphi striding across the sleeping Erinyes. Here, the context confirms Winckelmann's interpretation beyond all doubt.[10]

As to the famous Arrotino, or Scythian slave, in the Uffizi,[11] antiquarians had declared him to be the slave who had uncovered the conspiracy of Catiline—a romantic interpretation with no logical connection between motif and topic. Winckelmann showed that the statue depicts the Scythian who flayed

92. Rape of the Daughters of Leukippos, sarcophagus, drawing. Florence, Uffizi

Marsyas after the latter had lost the musical contest with Apollo.[12] Again, he could point to sarcophagus reliefs as proof and also to a coin, on which the same figure is combined with Marsyas hanging from a tree.[13]

On a sarcophagus now in Florence, two females are being abducted (fig. 92).[14] The traditional view was that this depicted the rape of the Sabine women. Instead, Winckelmann proved it to be the Greek myth of the rape of the daughters of Leukippos by the Dioskouroi, both of whom wear their characteristic hat, the pilos.

Likewise, a scene preserved on various sarcophagi was recognized as a depiction of the rape of the Sabines. It shows an agitated young man in a crowd of frightened maidens. Not recognizing that all these sarcophagi belong to one group, Winckelmann, tackling them individually, proposed different interpretations, including two correct ones. The first is Achilles on Skyros.[15] In this story the disguised hero is hidden among the daughters of King Lykomedes of Skyros by his mother in an attempt to prevent him from having to go to the Trojan War. Nevertheless, he is tricked into revealing himself by Odysseus. The second was the scene on the sarcophagus in Paris illustrated here (fig. 93).[16] Winckelmann believed that it depicted the argument between Achilles and Agamemnon over Briseis. He was basically pointing in the right direction. The sarcophagi themselves prove this, since they are adorned on their sides with other scenes from the life of Achilles. The badly recarved back of a related sarcophagus in the Louvre depicts Priam supplicating the undecided Achilles for the body of Hektor (fig. 94).[17] To the left is the chariot and the corpse that Achilles had dragged around the walls of Troy, and attendants in oriental dress are bringing the ransom. Given the context, Winckelmann's reading today seems obvious.[18] At the time, however, it ran counter to the received wisdom that recognized the first triumph of Romulus on the left and

93. Achilles and Agamemnon, sarcophagus, drawing. Paris, Musée du Louvre

94. Death of Hektor, and Priam supplicating Achilles for the body, sarcophagus, drawing. Paris, Musée du Louvre

the mourning of Acron on the right—the latter being a king of the Cenensian tribe, vaguely known from annalistic historiography, and hardly a figure to hold much meaning for ancient beholders.

Interrupting our line of reasoning for a moment, let us take a quick glance at other paths of transmission for the type of imagery decorating the Achilles sarcophagus. Examples can be found in sundry media, of which a prime specimen is the so-called Tensa Capitolina, a late bronze revetment with scenes from the life of Achilles in a novel-like display. Here, the ransoming of Hektor is followed by the rescue of Achilles' corpse by Odysseus and Aias.[19]

We have looked at but a few instances of Winckelmann's hermeneutic, but they suffice to give us an idea of its straightforwardness and outright baffling

obviousness. Accordingly it is probably understandable that up to now no one has inquired into the background it presupposes. Winckelmann himself does not explicitly disclose the rationale behind his method of extracting his readings from mythological poetry and prose.[20] Rather, the underlying principle is axiomatically stated. Of the two reasons indicated in passing, one is external, based on the fact that the relevant monuments described by Pausanias all depict episodes from Greek mythology. The other, more theoretical reason is more revealing and, owing to its importance, is introduced first. Here, Winckelmann refers to Simonides' famous tenet that painting is a mute kind of poetry.[21] The artist, therefore, must show his poetic nature by choosing topics from mythology. It is obvious that Winckelmann takes up the baroque concept of the learned artist and makes it the foundation for his interpretations of the ancient monuments. He thus creates a conception of the material which not only completely dominates the age of Goethe, but whose after-effects linger on until the end of the nineteenth century. This conception views the mythological monuments of antiquity as primarily works of art, that is, creations of unfettered artistic imagination.[22] Eventually, this point of view significantly alters the way in which myth as such is conceived. In the *Götterlehre*, published in 1791 by Goethe's friend, K. Ph. Moritz, it is defined as an idiom of imagination,[23] and Goethe himself, treating Winckelmann's conception of the Greek gods, confesses his "admiration for them defined as works of art."[24] The conviction that mythological monuments are works of art also expresses itself in the curious coinage of the German word *Kunstmythologie*, which remained into the early twentieth century the prevalent designation of this branch of inquiry. Apparently, the term first cropped up in lectures held in 1808 by the archaeologist and art historian K. A. Böttiger.[25]

Our observations make it sufficiently clear, I believe, that Winckelmann's hermeneutic, just as anyone else's, is founded on method, not serendipity, as the non-scholar may be inclined to assume. Winckelmann's success, though, was determined by yet another circumstance, of which he himself was not at all aware. The bulk of the monuments with which he was acquainted in Rome were late reliefs belonging to the Roman imperial period and were particularly closely related to classical literature. Furthermore, they were largely illustrative and, in some instances, can be traced back to the minor arts and perhaps even to book illuminations.[26] Exposed to monuments of the Classical era, Winckelmann's method would have failed immediately. Indeed, except for a case still to be discussed, he did err consistently whenever the monument in question was a Classical piece or a copy thereof.

His most magnificent and boldest interpretations especially testify to the limitations of his method, visible in his treatment of reliefs that retell specific

95. Medea, sarcophagus, drawing. Rome, Vatican Museums

elements of classical literature in an illustrative mode, which had been trans-
formed in the Hellenistic period from book illumination to large-scale art.[27]
One such major achievement was the explanation of the Medea sarcophagi,
which Bellori and Montfaucon had assumed to show Demeter in distress (fig.
95).[28] Referring to the Euripidean play, Winckelmann was able to identify the
representations precisely, scene by scene, figure by figure: the delivery of the
presents, Kreousa burned by the poisoned wedding robe, Medea murdering
her children, Medea saved. Or take, for instance, the amazing example of the
Vatican sarcophagus on which older interpreters had wrecked (fig. 96).[29]
Winckelmann, availing himself of the extant summary of an otherwise lost
piece by Euripides, explained it conclusively as the return of Protesilaos. Here,
the decorative and allegorizing nature of the imagery with which Winckel-
mann was dealing, and to which his baroque concept of art conformed, be-
comes particularly clear. The classical observer would have sensed an unbear-
able contrast between the monumentality of the object, i.e., the sarcophagus,
and the unmonumental, scroll-like imagery. As already stated, the imagery

96. Return of Protesilaos, sarcophagus, drawing. Rome, Vatican Museums

97. Mars and Rhea Sylvia, sarcophagus, drawing. Rome, Palazzo Mattei

originated in the minor arts such as book illumination and only subsequently infiltrated the larger-scale media.

Winckelmann's errors, like his correct readings, are a function of his approach and his presuppositions. They thus testify to the old experience that a method cannot reveal anything about the objects it is applied to beyond what is included in the presuppositions. For this reason Winckelmann was unable to recognize the only Roman sarcophagus with a Roman topic that existed at the time and which his predecessors had already identified correctly (fig. 97).[30] Here, Winckelmann saw Peleus descending to a vanquished, dormant Thetis, whereof myth and literature know nothing. This time he also violated the principles of his own method. Earlier interpreters had recognized Mars and Rhea Sylvia.[31] Their reading is confirmed by the broader context as it appears, for instance, on the Ara Casali, where the same scene is combined with other pictures illustrative of the foundation legend of Rome.[32]

It is indicative of Winckelmann's purist conception of art that he does not normally consider the function of the monuments and the corollaries to be drawn from this with respect to the meaning of the images decorating them. Usually he conceives of a representation as something absolute and independent of its medium; at best he looks for meaning in the realm of allegory.[33] An instructive example is his interpretation of a gem with cupids (fig. 98).[34] Here, one putto with a torch is supporting a second one that is emphatically turning backward while a third one is leading the way with a lantern. According to Winckelmann this is an allegory of enamored passion which, although driven

98. Gem with cupids, engraving. Present location unknown

to desperation, is being consoled by a ray of hope. The interpretation deter-
mines the rendering of the gem in the attached engraving, for the supported
putto's gaze is cast upward in despair. In reality, we are looking at Dionysiac
Erotes, i.e., drunken cupids that playfully enact the Bacchic thiasos. The
scene, expressing eschatological hopes, is frequently found in the context of
the Dionysiac mysteries on Roman sarcophagi. Its religious symbolism is evi-
dent because almost all of the sarcophagi it appears on belong to children.
Also, in some cases, the drunken cupid impersonating Dionysos is identified
with the deceased child by means of a portrait.

While allegory here allowed for a basic kind of interaction between Roman
imperial art and Winckelmann's system of thought, his method fails com-
pletely when put to the test of the truly Greek monument of the Classical pe-
riod. It is not without irony that Winckelmann, the great pioneer of Greek art,
here was unable to do justice to the Greek element. To him, every artifact was
a work of art embodying, as it were, a piece of literature. Therefore it escaped
him that the large-scale media of the Greek era, and especially monumental
relief, did not have the quality of illustrations. They are veritable monuments
in the proper sense of the term: not autonomous works of art but vehicles of
civic and religious self-presentation.

One of the significant Classical originals in Rome, the horseman relief in

the Albani Collection, of which Winckelmann himself was the curator, seems to come from an Attic state monument that was presumably dedicated to the fallen soldiers in the first years of the Peloponnesian War (fig. 99).[35] The type doubtless strikes a generically heroic note and is occasionally met with in private tombs as well, such as the grave precinct belonging to the family of Dexileos, who was killed in action in the Corinthian war of 394.[36] Tied to the presuppositions of his method, Winckelmann was bound not only to misjudge the monumental dimension of the work, but also to identify it as a scene from myth.[37] Believing the victorious figure to have a swollen ear, he takes him to be a boxer. From here it is only a step to the Dioskouros Polydeukes, and only another one to the identification of the whole scene as the slaying of Lynkeus by Polydeukes. His huge digression on the ears of athletes is one of the most exuberant outgrowths of Winckelmann's baroque book.

99. Albani rider relief, drawing. Rome, Villa Albani

100. "Leukothea" stele, drawing. Rome, Villa Albani

Likewise, already in the Villa Albani there was a grave stele of the Severe style, on which a heroized deceased woman is united with her children (fig. 100).[38] Again, this is a veritable monument from a context that implies self-presentation as well as cult. The type remained current throughout the Greek era. One may compare it to a more recent find from the island of Ikaria on which inscriptions prove the figures to be common people of the period.[39] As before, though, Winckelmann believed that the Albani relief depicts an episode from myth: Leukothea, the bereaved sister of Semele, who takes care of young Dionysos while other nymphs stand by and watch. It never occurs to him to ask what the background and religious intent could have been which led to the creation of such a monument.

Winckelmann's study also contains two examples of a type of monument that was widely distributed in Classical Greece, the so-called funeral banquet reliefs (figs. 101, 102).[40] They show a reclining hero and his companion ban-

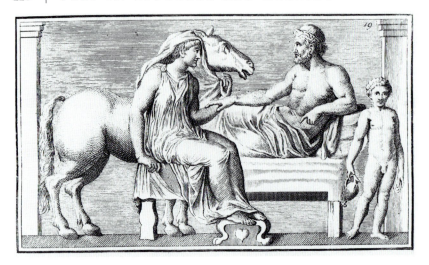

101. Funeral banquet relief, drawing. Rome, Palazzo Drago

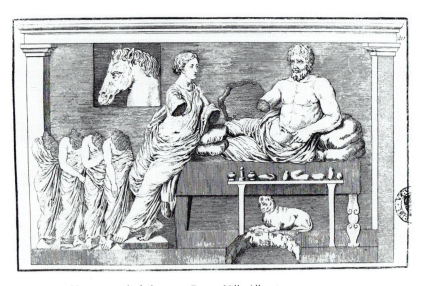

102. Funeral banquet relief, drawing. Rome, Villa Albani

queting in the blissful beyond. The horses underscore the chthonic nature of the demigod, and in one case a group of worshipers has been added. Although this time he sensed the shortcomings of his interpretation, Winckelmann, owing to his presuppositions, was unable to discover the cult meaning. Right away, he aims at an explanation in terms of *Kunstmythologie*, identifying the

animal as Arion, a talking horse known from myth; hence it was not difficult to name the couple Demeter and Poseidon, who were the parents of the horse. The nude boy is either Pelops, Poseidon's cupbearer, or the genius of the wedding bed—an entirely Roman conception. The little worshipers are identified as the Nereids entrusted with the upbringing of Arion. One can see that as soon as he leaves the area of the imperial monuments with representations of specific myths, Winckelmann, just like his predecessors, gropes around in the dark.[41] By the way, it is indicative of his powerful influence that still a hundred years later Greek votive reliefs were interpreted in "kunstmythological" terms. It was only toward the end of the nineteenth century that a viewpoint informed by the sociology of religion became predominant.[42] Thus, in the well-known votive reliefs with Hermes and the nymphs,[43] scholars recognized the Attic King Kekrops and his daughters, whom Euripides, in a wonderful chorus, has dancing a rondo on the Acropolis.[44] The realization came late that the type, which is known all over the Greek world, had to be dealt with by taking into account the locally discrete cult traditions.

A statue now in Munich of a goddess with a child on her arm was identified by Winckelmann as Leukothea with the small Dionysos (fig. 103).[45] His predecessors had recognized Rumilia, an obscure Roman goddess. Here, for once, Winckelmann argues against the plausibility of this interpretation by stating that an insignificant figure like Rumilia would hardly have possessed a temple or statue in the city of Rome. It is decisive, though, that he further insists that the statue is a Greek, not a Roman work. Hermeneutically his point of departure was the identification of the child as Dionysos, which he took to be a given based on the pitcher the woman holds in her left hand. Since it had been added by a restorer, Winckelmann acted in grave violation of the principles of method—a mistake he himself did not allow to his contemporaries. The correct interpretation was discovered one hundred years later by Heinrich Brunn, who recognized the same figure on an Attic coin commemorating a local monument also known from literature: the goddess Eirene holding the boy Ploutos and a horn of plenty.[46]

Winckelmann did not, as Justi still believed, discover a universal "Open Sesame" for the interpretation of ancient monuments. Rather, his discovery reveals a quite specific practice of art typical of a late period, which shared some presuppositions with his own conception of art. Nevertheless, it is because of Winckelmann's achievement and the discussion it engendered, that historians of ancient art—in some cases only much later—have been able to clarify further the field of hermeneutics, to categorize the body of material according to distinct features of groups, and consequently to add focus not only to the quest for identifications but also to the meaning of the works. This is an

103. Eirene and Ploutos,
drawing. Munich,
Staatliche Antiken-
sammlungen und
Glyptothek

ongoing process, and there are monuments still as open to question in these
respects as in Winckelmann's day. In fact, a number of considerations seem
problematic only to us, and were not to Winckelmann, who advocated the au-
tonomy of the work of art.

One monument that is still a riddle is included in the *Monumenti Inediti* as
no. 85 (fig. 104).[47] Winckelmann interpreted it correctly, although there are
some peculiarities. It is a relief showing a woman turning to a man with a lyre,
while a second man is approaching her from the left. Winckelmann knew it in
two versions, one bearing the forged Latin inscriptions Amphion, Antiope,
and Zethus, the other the names Hermes, Eurydike, and Orpheus in Greek
(fig. 63, above). Thus in the one instance the subject is the rescue of Antiope
by her sons, while in the other it is the dramatic separation of Orpheus and
Eurydike during their ascent from the underworld. Winckelmann, who was
unable to recognize the forgery[48]—the relief had been inserted high up in a

104. Orpheus and Eurydike, version inscribed Amphion,
Antiope, and Zethus, drawing. Paris, Musée du Louvre

wall—deemed both readings accurate, arguing somewhat confusingly that the relief had likely acquired both meanings already in antiquity and therefore required classification through inscriptions. In spite of this flaw, it is fair to assume that Winckelmann, given his method, would have been perfectly capable of finding the right solution. And here, indeed, we are dealing with a large-scale Classical relief narrating a mythical episode. As has been known for a long time, it forms a particular group with three other like-sized reliefs that also tell clearly defined stories: Medea and the daughters of Pelias, Herakles liberating Theseus from Hades, and, finally, Herakles visiting the Hesperides.[49] What to make of these monuments, modern interpreters are this time at a loss to tell. Enlightened by Winckelmann, we can certainly identify correctly the mythical events themselves, but the question of the original context of the reliefs remains completely obscure.[50] For we continue tacitly to assume without question that they were not autonomous works of art in the modern sense. The dilemma remains the same when we address the old and unanswered question of the meaning of mythological scenes on Greek temples and vases.

In this case, though, we must reckon with a considerable degree of artistic emancipation.[51]

Likewise the sarcophagus reliefs Winckelmann so happily identified are not fully explained if the only goal is to discover the myth represented. The quest for meaning leads us to understand better not only the selection and adaptation of the images but also their sources. The purpose of a Roman sarcophagus normally was to accommodate the corpses of a married couple, and this purpose also determines the iconography on the caskets. The theme of civic marriage therefore plays a prominent role accounting for most of the mythological topics, such as the story of Alkestis (*Mon.in.*, no. 86) and the marriage of Peleus (*Mon.in.*, no. 111), which Winckelmann first recognized. Moreover, the allegorical connection explains why some mythological figures may be given the portraits of the deceased, a peculiarity already noted by Winckelmann.[52] Certain alterations and additions also become understandable. Occasionally, for example, the protagonists from Greek myth appear in the Roman schema of *dextrarum iunctio*, appropriate to the bourgeois married couple, with a peculiar mixture of heterogeneous iconographic elements it entails (*Mon.in.*, no. 27). Similarly, on the Jason-Medea sarcophagus in the Cemetery of Praetextatus, the scenes covering the left section of the front are derived from earlier Greek minor arts. The *dextrarum iunctio* in the presence of Roman Concordia to the right, though, is the transposition into the ambience of myth of a schema commonly found on middle-class grave reliefs and sarcophagi.[53]

The hermeneutic of ancient art is not a matter of lucky finds unrelated to time and circumstance but follows its own methodologically determined development. It is a process still far from completion, and we are well advised to remind ourselves from time to time that it was Johann Winckelmann who first set it going. So, in this respect, too, he proves to be the true founding father, the ἥρως κτίστης, of our discipline.

NOTES

The present article was drafted in 1967 and has not been substantially altered since. However, a brief passage on a Latin manuscript of Winckelmann's *History of Ancient Art* has been omitted at Himmelmann's request as no longer pertinent to the main

theme of the paper, and several notes have been added on the occasion of the English translation.

1. The *Monumenti antichi inediti* was first published in Rome in 1767; the *History of Ancient Art* appeared in Dresden in 1764. Facsimile reprints were published of the works of Winckelmann in Baden-Baden: *Monumenti* (1967); *Geschichte der Kunst des Altertums* (1966). A second edition of the *Monumenti antichi inediti* was issued in Rome in 1821. It is from this edition that the illustrations have been drawn for this article; the pagination of the two editions is identical.

2. J. G. Herder, *Denkmal Johann Winckelmann's, Eine ungekrönte Presischrift*, ed. A. Duncker (Kassel 1782), reprinted in *Die Kasseler Lobschriften auf Winckelmann*, ed. A. Schulz (Winckelmann-Gesellschaft Stendal, Jahresgabe 1963: Berlin 1963) 31–62.

3. Goethe, *Winckelmann*, in *Goethes Werke*, ed. W. Weber and H. J. Schrimpf, XII (Hamburg 1953) 121–22 [J. W. von Goethe, *Essays on Art and Literature*, ed. J. Garney, trans. E. and E. H. von Nardroff (New York 1986: Suhrkamp edition, vol. 3) 116–17].

4. *Winckelmanns Werke*, ed. C. L. Fernow (Dresden 1808) I, 4. The text was, however, eventually included in the seventh volume of the edition (1817).

5. Carl Justi, *Winckelmann und seine Zeitgenossen*[3] (Leipzig 1923).

6. Justi[3] (above, n. 5) III, 385: "One thinks of Goethe's observation that often a scholarly success derives from an error. It depended on a familiarity with Greek myths: in one swift blow the breakthrough was accomplished: complex reasoning was seldom needed. It was still an age of the Conquistadors." Nevertheless there are elements of methodological criticism in Justi that are partly based on Heyne, Zoëga, and Welcker; see also especially ibid., 378 (typology of sarcophagi), 386 (erroneous interpretation), 391f. (myth and allegory).

7. This statement, based on Justi[3] (above, n. 5) III, 383, remains valid, although it has been shown in the meantime that correct Greek readings of Roman reliefs had already been established and systematized in the sixteenth century; see H. Wrede in H. Wrede and R. Harprath, *Der Codex Coburgensis* (exhibition Coburg 1986) 107ff. Nevertheless, local Roman interpretations were so much in vogue in Winckelmann's time that he could attack them by the score. On his merits in this respect, see Wrede, ibid., 108, and St. Lehmann in R. Harprath and H. Wrede, eds., *Antikenzeichnung and Antikenstudium in Renaissance und Frühbarock* (Mainz 1989) 224 with nn. 22–24, and 257f. with n. 223.

8. *Mon.in.*, no. 151; *LIMC*, s.v. Orestes, no. 64, pl. 55.

9. See also *Mon.in.*, no. 148ff.

10. The Giustiniani sarcophagus had been sawed apart already before Winckelmann's time, and the three discrete slabs that this produced had been put up in different locations. The front Winckelmann believed to show the death of Agamemnon; see also Robert, *ASR* II, 156.

11. J. J. Pollitt, *Art in the Hellenistic Age* (Cambridge, 1986) fig. 121, p. 119; H. Meyer, *Der weisse und der rote Marsyas* (Munich 1987) pls. 28–33, figs. 49–58.

12. *Mon.in.*, pp. 49–50.

13. *Mon.in.*, no. 42.

14. *Mon.in.*, no. 61; Florence, Uffizi: Robert, *ASR* III.2, 180; Sichtermann-Koch, *Griechische Mythen*, 39, no, 34, pl. 75.1.

15. *Mon.in.*, pp. (X)–(XI) §7, illustration at head of the "Prefazione," p. (XV); Winck-

elmann identifies the myth on two sarcophagi, one in Frascati (ill. on p. [XV]) now in Woburn Abbey: Robert, *ASR* II, no. 34, pl. 19; *LIMC, s.v.* Achilleus, no. 161. The other in the Villa Pamphili: Robert, II, no. 33, pl. 19; *LIMC,* no. 153.

16. *Mon.in.,* no. 124; Paris, Louvre: Robert, *ASR* II, 26.

17. *Mon.in.,* no. 134; Paris, Louvre: Robert, *ASR* II, 26c; see also Sichtermann-Koch, *Griechische Mythen,* 18–19.

18. Since the sarcophagus had been cut into three different slabs, Winckelmann here could not recognize the contextual relationship to the other scenes. But he does already refer to the corresponding back side of the Capitoline sarcophagus, *Mon.in.,* no. 124.

19. F. Staehlin, "Die Thensa Capitolina," *RM* 21 (1906) 332–86; *LIMC, s.v.* Achilleus, no. 13 (A. Kossatz-Deismann) with bibliography.

20. Of course, Winckelmann was not questioning the existence of scenes depicting episodes from Greek and Roman history or capturing the realism of everyday life. The third and fourth parts of his book are dedicated to those.

21. *Mon.in.,* p. (XVIII); cf. Plutarch *de glor. Ath.* 3 (*Moralia* 346f.); D. A. Cambell, *Greek Lyric,* III (Cambridge [MA] 1991) 362–63, nos. 47a-b; C. M. Bowra, *Greek Lyric Poetry from Alcman to Simonides*[2] (Oxford 1961) 363f.

22. In his Kassel eulogy C. G. Heyne was later to say, "We are directed onto the right path; we are lead to consider ancient works of art as works of art." In *Die Kasseler Lobschriften auf Winckelmann* (above, n. 2) 25.

23. K. P. Moritz, *Werke,* ed. H. Günther (Frankfurt 1981) II, 609–842.

24. Goethe, *Winckelmann* (above, n. 3) 100 [English edition, 102].

25. He used the term in the subtitle of his later book: *Amalthea oder Museum der Kunstmythologie und bildlichen Alterthumskunde* (Leipzig 1820–25).

26. Justi, too, did not have sufficient knowledge of this. Consequently he was missing a decisive prerequisite to a critical evaluation of Winckelmann's hermeneutical method. This is not the place to deal with modern discussions of the problem, but it may be useful to point out that the influence of book illumination is currently grossly overestimated. It is often more of a mediating link than a primary source; see also "Erzählung und Figur," 95 n. 2, (trans. above, p. 101 n. 67).

27. The artistic technique of continuous narration, in which the protagonists reappear wherever necessary even though there are no divisions between the narrative units, seems not to have been problematical to Winckelmann. The Classical period cherished the quite different "closed" narrative scene; see also "Erzählung und Figur," 73ff., 81ff. (trans. above, pp. 61ff., 74ff.).

28. *Mon.in.,* nos. 90–91; Rome, Vatican: Robert, *ASR* II, 194; see also Sichtermann-Koch, *Griechische Mythen,* 41–42.

29. *Mon.in.,* no. 123; Rome, Vatican: Robert, *ASR* III.3, 423; Sichtermann-Koch, *Griechische Mythen,* 65–66, no. 70, pl. 168; Koch-Sichtermann, *Römische Sarkophage,* no. 218.

30. *Mon.in.,* no. 110; Rome, Pallazo Mattei: Robert, *ASR* III.2, 190; see also Sichtermann-Koch, *Griechische Mythen,* 66–67; Koch-Sichtermann, *Römische Sarkophage,* 184–85.

31. See also the preface to *Mon.in.* in the edition of J. Eiselein, *Johann Winckelmanns sämtliche Werke* (Deutsche Classiker, Donauöschingen 1825–29) VII, 28.

32. Winckelmann could not know that the Mattei sarcophagus he discusses had a

side with an image of the Roman she-wolf (*lupa romana*). The interpretation of its figural decoration as Mars and Rhea Sylvia did not originate only after Winckelmann (Justi³ [above, n. 5] III, 383f.), for it is mentioned by the latter without a reference in the preface, p. (XX).

33. Justi³ (above, n. 5) III, 391.

34. *Mon.in.*, no. 33; A. Furtwängler, *Die antiken Gemmen* (Leipzig-Berlin 1900) pl. 42, no. 39.

35. *Mon.in.*, no. 62. Rome, Villa Albani, inv. 985: P. C. Bol, ed., *Forschungen zur Villa Albani: Katalog der antiken Bildwerke* I (Berlin 1989) 246–51, no. 80, pls. 140–46 (Bol); C. W. Clairmont, *Classical Attic Tombstones* (Kilchberg 1993) II, 89–93, no. 2.131, and illustration in vol. VI.

36. Clairmont (above, n. 35) II, 143–45, no. 2.209, and illustration in vol. VI.

37. Already his early critics blamed Winckelmann for having gone too far in his search for mythological topics and his failure to come to terms with scenes of a more general nature; see also Justi³ (above, n. 5) III, 386f. G. Zoëga replaced some of the mythological interpretations with ones inspired by everyday life: *Li bassirilievi antichi di Roma* (Rome 1808); see further below, n. 41. Another case in point is Winckelmann's discussion of the statuary type of the "drunken old woman"; see also H. Meyer, *Mannheimer Berichte* 40 (1992) 57.

38. *Mon.in.*, no. 56. Rome, Villa Albani, inv. 980: *Villa Albani* (above, n. 35) I, 251–53, no. 81 (A. Linfert), pl. 147.

39. N. M. Kontoleon, *Aspects de la Grèce préclassique* (Paris 1970) pl. 1, pp. 16ff.

40. *Mon.in.*, no. 19 (fig. 101). Rome, Palazzo Drago: R. N. Thönges-Stringaris, "Das griechische Totenmahl," *AM* 80 (1965) 75, no. 47; J.-M. Dentzer, "Reliefs grecs au banquet en Italie: Importations, copies, pastiches," in *L'Art décoratif à Rome à la fin de la République et au début du Principat* (Rome, 1981; Collection de l'Ecole française de Rome, no. 55) 5. *Mon.in.*, no. 20 (fig. 102). Rome, Villa Albani, inv. 649: *Villa Albani* (above, n. 35) IV (Berlin, 1994) 283–86, no. 478 (A. Linfert), pl. 164.

41. G. Zoëga took the funeral banquet reliefs to be Roman realistic scenes serving sepulchral purposes: *Die antiken Basreliefe von Rom*, trans. F. G. Welcker (Giessen 1811) 75ff., with annotations by the latter, who already knew finds from Greece. For the original edition, see above, n. 37.

42. Lessing, in chapter IX of his *Laokoön* (1766), is already gravitating slightly in that direction [G. E. Lessing, *Laocoön: An Essay on the Limits of Painting and Poetry*, trans. E. A. McCormick (Baltimore 1984) 55–58].

43. W. Fuchs, "Attische Nymphenreliefs," *AM* 77 (1962) 242–49.

44. Himmelmann, ΘΕΟΛΗΠΤΟΣ (Marburg 1957) 13f.

45. *Mon.in.*, no. 54; Munich, Glyptothek: A. F. Stewart, *Greek Sculpture: An Exploration* (New Haven 1990) 173–74, figs. 485–87.

46. H. Brunn, "Über die sogenannte Leukothea in der Glyptothek Sr. Majestät König Ludwigs I.," (1867) in Brunn, *Kleine Schriften*, ed. H. Bulle and H. Brunn (Leipzig-Berlin 1905) II, 328–40.

47. Paris, Louvre: H. Götze, "Die attischen Dreifigurenreliefs," *RM* 53 (1938) 192–93, pl. 32.2.

48. Doubts about the inscriptions' authenticity were first expressed by Zoëga (above, n. 41) 148.

49. Götze, *RM* 53 (1938) 189–280.

50. See, for example, the hypothesis of H. Thompson, *The Athenian Agora* XIV: *The Agora of Athens* (Princeton 1972) fig. 34, pp. 133, 135–36 (altar of the twelve gods); and L.-A. Touchette, "A New Interpretation of the Orpheus Relief," *AA* (1990) 77–90.

51. See Himmelmann, "Über Kunst in der homerischen Gesellschaft," 201f. (trans. above, pp. 42–43).

52. *Mon.in.*, no. 110, p. 150; Eiselein edition (above, n. 31) 114.

53. M. Gütschow, *Das Museum der Praetextat-Katakombe*, in *Atti della Pontificia Accademia Romana di Archeologia*, series 3, *Memorie* IV.2 (Vatican, 1938) pl. 1.

THE UTOPIAN PAST:

ARCHAEOLOGY AND

MODERN CULTURE

"Our admiration of the antique is not admiration of the old,
but of the natural."

<div align="right">RALPH WALDO EMERSON, History (1841)</div>

I. Modern Travel and Antiquity

THE MODERN INFATUATION with antiquity is evident in many
areas of life and on many different levels. It is most insistently present
where the interest in antiquity is commercial, be it tourism, advertis-
ing, or the art market. For the tourist trade the importance of antiquity (and of
history in general) sheds an interesting light on the trade's inner workings. Ex-
cavated and restored sites, especially around the Mediterranean, receive abun-
dant funding in the correct perception that for the tourist these sites, even
when remote, have an emotional value on a par with recreation and amusement.

Tourists' motives, of course, have been thoroughly studied by the travel in-

Selections from *Utopische Vergangenheit* (Berlin 1976) 27–63, 83–96, 162–75, trans.
D. Dietrich and J. Borsch.

dustry and targeted by advertisers. A brochure issued by a well-known travel agency in 1973–74 and reissued unchanged the following year, entitled "A Journey Experience," illustrates this point well (figs. 105, 106). It is aimed at the evidently large number of travelers who seek more than a beach and a meal, although as we shall see, both are amply provided. The brochure is based on careful research and demonstrates an intimate knowledge of the suggested travel routes. Some of the tours offered, for instance, *Italy #5: From Venice to the Abruzzi,* are superbly selected and make shockingly apparent that even the most undisturbed corner of the globe and distant work of art are no longer safe from German travel groups.

Distances are unlimited. Among the travel destinations are Afghanistan,

Lieber Urlaubsplaner,

sicher ist Ihnen der Urlaub die kostbarste Zeit des Jahres. Für wenige Wochen frei sein von den täglichen Pflichten. Abstand gewinnen. Das kann man durch Entspannung und Freude. In Spiel und Sport an einem schönen Strand oder in den Bergen. Das kann man auch und bisweilen nachhaltiger, indem man zu sich selber kommt. Zu sich selber kommen – das ist: sich und seine Voraussetzungen in der Welt begreifen. Nichts verhilft einem mehr dazu als reisen, um anderen Menschen, Völkern und Rassen zu begegnen. Natur und Lebensraum zu erfahren, die sie prägten. Ihre Städte und Dörfer, ihre Weltsicht und Gestaltungskraft. Ihre Kunstwerke und Heiligtümer, in denen sich ihr Wesen offenbart. Ihre Überlieferungen und Bräuche, ihre Feste und Tänze, ihre Probleme und Lösungen. Aber auch reisen, um einzigartigen Naturwundern nahezukommen. Für eine Weile im „ganz Anderen" leben. In den Tropen oder in der Tundra. Da, wo die Natur noch Herrin ihrer selbst ist. Auf abenteuerlichen Wegen lassen Sie das Geplante hinter sich. So erwächst Ihnen nicht nur Einsicht, sondern auch Freude.

Jede unserer Reisen gleicht einem überlegt ausgewählten Menü mit vielen Gängen. Bei einem Festessen werden Sie nicht von jedem gleich viel essen. So ist auch das Programm jeder unserer Reisen nicht ein Pensum, das zu absolvieren ist. Aber wir bieten Ihnen das Beste und Schönste. Und Sie greifen zu – entsprechend Ihrem Appetit. Unser Reiseleiter, mit Land und Leuten, Natur und Kultur aufs engste vertraut, ist Ihr jederzeit bereiter Helfer. Der Interpret des Schönen und Bedeutenden, das Sie erwartet. Soweit Sie es wünschen und er Ihnen nützlich ist.

Wir legen Ihnen einen Ganzjahresprospekt 1974 vor. Er umfaßt alle unsere Städte-, Studien- und Fernreisen bis 1. Oktober 1974. So können Sie schon jetzt in Ruhe Urlaubsdispositionen für 1974 treffen. Wir haben dem Routing der einzelnen Reisen eine kurze Zusammenfassung vorangestellt. Sie deutet das Charakteristische der Zielräume und Aspekte Ihres Erlebens unterwegs an. Mir scheint es übertrieben, wenn Jean Paul sagt: „Nur reisen ist Leben, wie das Leben reisen ist". Aber es ist doch sehr viel Wahres dran. So wünsche ich Ihnen viele Reise- und Entdeckerfreuden.

Herzlichst Ihr

Reinhold Tigges
und mein Team

105. Travel advertisement

Madagascar, the Galapagos Islands, and a tributary of the Amazon. Considering the enormous costs in personnel and general logistics needed for the development of these programs, we can definitely assume that the company has also carefully researched the psychological needs of its clients to address these effectively. The repetition of certain signal concepts and words within a jumble of clichés alone justifies this assumption. Let us now turn to these motifs in detail.

The brochure promises the traveler not only sights and delights, but it attempts to reach the inner self, indeed to lead one to the roots of one's own humanity. The introduction gets right to the point, accompanied by color shots of the archaic temple at Corinth, a Polynesian hula-hula girl, a sunrise in

106. Travel advertisement

Antarctica, or a view of Manhattan: "To find oneself—understanding the preconditions of one's existence in the world." That slogan touches an especially sensitive nerve in modern people, whose deeper spiritual needs are constantly repressed in everyday existence. The Greek tourist bureau exploits the same sentiment with the phrase, "Find yourself in Greece." The accompanying picture shows a young couple in summer clothing sitting on the ruins of the Parthenon, whose silhouette against the evening sky creates a rich emotive background (fig. 107). The two are obviously not romantically inclined; rather, their earnest conversation relates to their finding themselves in Greece. Since their appearance suggests that they themselves are Greek, it is difficult to understand why they would go to the Acropolis for this experience, a place filled from early morning until sunset with the rumble of tourists and the screeching whistles of the guards. But let us return to the brochure on the "Journey Experience."

The promise to help the traveler to find himself and discover his roots is realized through experiences that no longer exist in the contemporary world, but that the travel agency will provide in comfort and at a good price: the world of pristine nature, of the primitive state of humanity, of history and art. Even the envelope promises a return to the simple basic human experiences ("encounters, touching"), to the marvels of nature, vanished cultures, to living traditions, magic and spirituality, work and celebrations, dances and rites. To dismiss these activities as anachronistic, as some would, is never an issue, because they are categorized within the modern demand for information ("social revolution, computer era"). (The authors won't insist on that later on.) The participants in *Italy Tour #4: Florence, Rome, Naples* will not only satisfy their craving for a land with lemon blossoms; as Germans find their inner freedom and truly discover themselves in this land of joie de vivre, they may also encounter saints and Casanovas (of whom all Italians partake to a small extent) and find human contacts whom they may ask social questions, if they so desire.

The attempt to discover these experiences oneself is demonstrably futile; only the company offers the possibility "to experience more as a group and at a better price." Above all it provides the "mystery-mongers," the tour leaders, who, as the "interpreters of the beautiful and significant that awaits you," are able to explicate the events as they unfold, with the proviso, of course, "only as much as you desire." The intention is not to demand too much intellectual work of the traveler on his way to the wellsprings of humanity. At times the tourist will chance fortuitously on a familiar event: a baptism, a marriage, a funeral procession, a family outing, a religious festival, or a temple ceremony. Our travel is not a series of sightseeing events, but a total immersion in experience, a true expansion of one's horizon. Generally the organized tour is differ-

Zu sich
selbst finden in
Griechenland

Kommen Sie jetzt nach Athen

Wenn bei uns Winter ist, haben Sie Zeit und Muße die lebhafte Stadt ohne Rummel zu erleben. Zu günstigen Nachsaisonpreisen. Erholen Sie sich an der attischen Riviera und auf den Inseln. Machen Sie mit in der Plaka bei Wein und Sirtaki-Tanz bis zum Morgengrauen, oder gehen Sie ins Theater. Erleben Sie die Original-Aufführung einer antiken griechischen Tragödie. Jetzt ist Saison.

Kommen Sie nach Athen — wo die Vergangenheit lebendig wird.

107. Travel advertisement

ent from personal travel in that it uses time more economically. For example, the visitor to Athens has two full days ("Plenty of time!") for the city's entire area, all museums (including the "extensive guided-tour" of the National Museum) and evenings to enjoy the "life full of vitality" around Syntagma and Omonia Square. "Experience" is furthermore carefully balanced against recreation (the word *education* is of course strictly avoided). For those who prefer to shift the balance more in favor of relaxation, there is a special tour "With Baedeker and Bikini" ("7 days of adventure-travel and recreation in one"). The participants in the adventure tour will find less time to plunge into the sea but will eat plenty of meals instead. Returning from "the heroic cliffs and quiet

bays of Sicily" ("this classical landscape and mild climate moved Goethe to tears"), one will taste "pasta with sardines or squid, stuffed eggplant, stuffed turkey, couscous and langoustines." When "the sheer number of important Roman monuments dating from three millennia" may seem too overpowering, it will be consoling (and tempting as well) to know that here, "as hardly anywhere else, the spiritual and sensual are one." The list of delectables that follows (artichokes à la Romana, etc.) proves the point. The nude dancer (a little out of focus so as not to offend certain sensibilities) in the introduction on page 5, under the Alhambra and an antique head of the Medusa, develops the theme of spiritual and sensual pleasure in a different direction.

If one considers the details of each program, one finds in frivolous form the objects and ideals of experience that have defined European travel objectives for the last few centuries. The brochure addresses the audience for whom former lofty educational ideals still survive in vague fragmentary form, watered down for the middle class, and for whom the emotional realm can be successfully tapped for advertising purposes. It makes clear to the reader that adventures and experiences formerly reserved for a variety of reasons to a small segment of society can now be had economically and easily, without in any way altering the quality of that experience. Thus, an advertisement for a houseboat safari on one of the tributaries of the Amazon reads: "You have always wanted to experience the deepest jungle, the marvels, the secrets and the demonic nature of the 'green hell.' And yet you will not have to renounce the comfort of twentieth-century living. We make the impossible possible. Deep in the heart of the Brazilian subcontinent thousands of miles away from everything. A trip for hunters, fishermen, and friends of nature." Those travelers who are nevertheless concerned about their comfort are reassured that the houseboat has 220 voltage, and the price of a Coca-Cola and a Brazilian whiskey is DM 1.50. When the modern adventurer (for only DM 3,980.00) returns to Rio, he can, with the clear conscience that comes from accomplishment, visit "Rio's fascinating nightlife and countless clubs, cabarets, revues, and floor shows." In case one has more spiritual leanings after spending time in the jungle with twenty-five like-minded comrades, one may be more interested in "the pagan-Christian Macumba rituals." Most likely one will do both.

For our consideration it is important to remember that the concepts that the brochure attempts to exploit emotionally are not new, like a modern industrial product, but rather are grounded in tradition. This is the realm of the modern experience of art and nature, first developed in the middle of the eighteenth century. This era in intellectual history begins with Rousseau and Winckelmann and continues through Classicism and Romanticism into the late nineteenth century. The decline of normative aesthetics around 1900 does

not represent the end but only a momentary break, for French/German vitalism and sensualism continued the tradition under new perspectives; a constant relativization of these values right into the 1930s was reinforced by the discovery of the Archaic and Late Antique aesthetics, hitherto inaccessible. Rife with clichés that further trivialize this process, the brochure assembles it in a type of aesthetic warehouse catalogue.

The historical origins of this stereotypical view of the culture to which every generation has contributed since 1750 is evident not only in the vocabulary, but also in the fact that Greece, rather than Italy, Spain, or France, ranks first among those countries that offer an "experience." Clearly, Greece is a particularly emotion-filled destination for the clients of this agency, and the brochure does not hesitate to evoke the wellspring of those feelings. "To seek the land of the Greeks with your soul." This emotional value ascribed to Greece has been transmitted to the Germans by Winckelmann's and Goethe's adulation of Greece and even today lends that country a singular, spiritual light. But even as cliché this image is not transferable and could not, for example, be used to advertise a trip to Yugoslavia. The advertiser manages, by the way, to join seamlessly the religious idealism of a quotation from Goethe with the happy prospect of modern availability: "Our ancestors had to settle for this. But you can do better. You can fly to your dream destination and explore it on your own."

We shall see later that at the dawn of modern travel three issues came together, which we shall call the bucolic, art, and ritual; the emotive associations of these three terms are, however, largely congruent. The bucolic implies the original, simple life in nature, an idyllic, quiet, and timeless experience far away from the bustle of modern cities, permitting a spiritual contemplation of the beauty of the countryside as well as the pantheistic sentiment provided by the encounter with God in nature. The modern reception of the work of art is similarly tied to the contemplation of its spiritual meaning; it is an inner exercise reminiscent of older religious practices and surely related psychologically to them. According to this view, the work of art originates in the artist's vision that leads back to the timeless silence of the primeval world. The Romantic period, finally, opened itself up to the study of religion and its rites, wherein lay the possibility to re-experience our original proximity to God. This aspect was first applied to the Christian heritage but subsequently subsumed the pagan context as well. To the latter belongs, for example, the mystifying cult of Archaic Greek sculpture, which was thought of as pristinely primitive, an attitude typical of the 1920s and 1930s. As these preliminary investigations reveal, modern travel is marked by a strong utopian element. It is, at least in its typical, ideal form, connected to experiences that border on the spiritual or are derived from it, but in any case they extend beyond a mere need for information.

Modern travel's allure depends finally on the assumption of the existence of timeless human values that, potentially at least, are available to everyone; it has therefore a universal, humanistic character defined by the bourgeois society that produced it. Travel in earlier periods, in the sixteenth or seventeenth century for example, was markedly different in this regard.

It is against this background that we can understand the phrases used in the brochure which commercially exploit these sentiments. Here the possibility of flight from the modern world—albeit only a temporary one—is offered. Traditional ideals and desires, such as virgin nature, religious mysticism, pagan sensuality, etc., are mixed together and offered in the common jargon of modern advertising complete with practical travel tips. A few examples from the brochure to "classical" destinations like Greece or Italy show that the authors will shy away from nothing. Greece is of course the "country of light," and in the style of the 1930s, "land of bodily delights." The excitement of re-experiencing the "embodiment of the spirit and the spiritualization of the body" should not so transport you that you forget to pack warm clothing or Alka-Seltzer. "Impoverished but homey mountain villages" evoke bucolic idylls as if one could sample the simple life in the brief minutes of a bus stopover. The chance for a religious experience for the spiritually impoverished is even more blatantly advertised. Oracles and places of mystery are favorites in the brochure, and even more "the churches of the Greek-Byzantine Christians as places of worship and transfiguration." This theme finds its peak in "the possibility to participate in the timeless life in the monasteries of Mount Athos," where "the last unspoiled reservoirs of Christian mysticism" as well as "the timeless rhythm of prayer, work, and silence leave behind unforgettable impressions."

In the Abruzzi, in Italy, the twenty participants of a tour may expect to encounter "a people close to the soil with rites dating back millennia." "To experience Florence is to renew oneself in a unique synthesis of nature and art." "Did not Goethe already describe the German's eternal desire for the light and sensuality of Italy in his poem that begins: 'Kennst du das Land, wo die Zitronen blühen?' Much as Goethe found his inner freedom in this country and its people, so too will many Germans find theirs."[1]

It would hardly be worth the trouble to belabor this brochure were it only a document of the commercial exploitation of traditional sentiment. In that respect it is but another example of the sellout of bourgeois culture. It unerringly denigrates through trivialization those values it purports to esteem. Equally obvious is the make-believe quality of the picture outlined by the authors. No one with even a modicum of experience would believe that in a place chosen by the travel company for its picturesqueness, "time stands still." One knows

that this is neither the case in the Sistine Chapel, nor on Mount Athos, nor in the "idyllic mountain village" that is exposed to the consequences and ravages of modernity brought about by the state bureaucracy, the return of the worker who has long lived and labored in northern Europe, or by television. No one is so naïve to think that, without a fundamental grasp of the language and culture, a two-week organized tour through Greece is equivalent to the experience of the nineteenth-century traveler who, armed with his copy of Homer and Pausanias, crisscrossed the countryside for months by mule to discover traces of the venerated antique. The idea that everyone today can have, cheaply and comfortably, the same experience that was formerly available only with great expenditure of money and energy is so obviously false that no one could seriously believe it.

MASS TOURISM: THE CULTURAL PROBLEM

We come now to a burning cultural issue that transcends the banality of the travel brochure. We encounter it today in many areas: in this era of mass tourism, what happens to the values that originally motivated the modern ideal of traveling? Under today's conditions how can art, history, and nature unfold their intellectual, emotional, and educational potential? The culturally and politically desirable goal of making these values available to as many people as possible has largely been achieved in the industrialized nations. The feeling that one can get something previously available only to a privileged few is the principal enticement for the many who take advantage of the unlimited possibilities. The general accessibility has, of course, predictably altered the character of many monuments, and others have become even more inaccessible than before. In the Sistine Chapel, where Goethe could saunter at liberty and take a nap in the Papal chair, today hundreds of sweating people so crowd the space that one can barely find room to breathe.

The problem is, of course, many-sided, including traffic, crowds, and the accompanying pollution that endanger the very existence of the monuments. For us the main concern is that monuments become permanently altered, the evocative, revelatory experience lost forever. The gardens of the aristocracy now open to the public are stocked with wastebaskets, littered with Coca-Cola cans, covered with warning signs and children's playgrounds, and cannot create the same mood that inspired Eichendorff, the Romantic poet, and his readers at the beginning of the nineteenth century. Frederick the Great wanted to sacrifice one of his ribs if only he could once ride horseback on the Appian Way. The modern visitor would be lucky to escape with only a broken rib after an encounter on this road with its ruthless traffic and overwhelming filth.

But this is not all. Famous works of art, for example the *Mona Lisa*, are to-
day nearly inaccessible. The painting hangs in the Louvre protected by a re-
flective sheet of glass; only moments after the opening of the museum, large
clusters of noisy people have already gathered in front of it. Their aesthetic
pleasure can hardly have been greater than that of the two million Japanese
who filed past the painting when it was recently lent to Tokyo. Someone who
really wants to study the painting is better advised to begin with a reproduc-
tion. If one is lucky, one may perhaps be able to enrich an inner picture with
sporadic glimpses of the original.

What constitutes the true value and magic of the original as opposed to the
reproduction, its originality, its immediacy, and the authority of its presence—
what Walter Benjamin termed its *aura*—is not lost under these circumstances
but nevertheless changes its character.[2] While the aura of a work like the
Mona Lisa used to invite intimate contemplation, today it leads to rigid and ir-
rational idolization. The modern museum underscores the process of fetish-
ization with spotlights, optically isolating backgrounds, and restrictive rope
barriers.

For the professional who requires appropriate conditions for the reception
of the work of art to avoid arriving at historically incorrect conclusions, the sit-
uation is just about hopeless. All attempts to view the work of art undisturbed,
or even to reinterpret the disturbances as something positive, fail in the throes
of the crowds and the museum guards' insistent attempts at maintaining disci-
pline. Professional art historians and archaeologists engaged in research find
themselves in a situation comparable to that of a surgeon forced to perform an
operation in a crowded streetcar.

These problems are of course common knowledge. If one sees only the
negatives, one must conclude that general accessibility has, in fact, rendered
many monuments inaccessible or at least has fundamentally and qualitatively
trivialized them. Those who believe that monuments have more to offer than
mere information must conclude that the number of people who can feel spir-
itually enriched by the works of art has decreased rather than increased.

That is the negative side of the coin, and for its excesses there can be no ex-
cuse. Especially those who welcome mass tourism from a cultural-political
point of view surely cannot approve either the carnival atmosphere afflicting
cultural monuments today or even less the attitude fostered by the slogans of
the tourist industry ("With Baedeker and Bikini"), which encourage the multi-
tudes to spend their hard-earned money in whatever casual and raucous man-
ner they please.

Yet behind these negatives are nevertheless several problems we should
not overlook. First of all, there is the question whether the developments that

have led to the present situation are inevitable or may have had intrinsic causes. Certainly the conditions under which certain monuments exist today fall into the latter category. For example, the public garden mentioned above no longer enjoys the economic or societal conditions of its original existence. It can only survive as a preserved museum. That holds equally true for older architecture and even individual works of art that have totally lost their original function and raison d'être. This is the endless cycle of historical aging, which has led in Europe to the creation of museums since the Renaissance. As long as the object, building, or work of art still maintains its original function, its reception by a broad public remains unproblematic. Often the reception does not come qua aesthetic experience, but due to its use (as in a building) or as a religious experience of the subject matter (as in a painting). Only when the original function of the object is lost and it becomes part of a museum does its reception lose its firm footing and become problematical. Since the eighteenth century certain conventions have arisen to deal with this problem. For most monuments we take refuge in visual contemplation, that is silent, pious observation and meditation, during which aesthetic appreciation and interpretative insight meld together loosely. This process shares little with the originally intended reception, which depended primarily on function. One could say that the pious attitude demanded by a certain religious object within its original context has become disassociated from its content and turned into an aesthetic reception. One might immediately ask whether this visual contemplation is in all instances even the most appropriate—or even the only possible experience. The answer is crucial in that mass tourism has made contemplation in the traditional sense largely impossible, a development that has certainly evolved gradually since the early nineteenth century. It is equally certain that the barrier to contemplation in modern society is paralleled by an inner devaluation of this very reverence toward a work of art—glaringly apparent in the visual arts since the advent of Impressionism. At this point we momentarily leave this problem to focus in more detail on original incentives for travel. What follows is a brief overview from antiquity to the late eighteenth century, when the present-day attitude began to crystallize.

II. The History of Travel: The Classical Period

Goethe's quotation at the beginning of the first volume of his *Italian Journey* (1816) "Auch ich in Arkadien" (I too am in Arcadia) could be used as a motto for all of bourgeois travel since Winckelmann and Rousseau.[3] Its mood is partly utopian, a longing for the primeval experience of nature and art; it is

sentimental and subjective, its forms are visual contemplation, meditation, and sensation, almost a transformation in the religious sense. When Goethe relates that his "soul expands" in the presence of the beauty of nature or works or art, or that he traces his spiritual rebirth to his encounter with classical art and nature in Italy, he is actually using the language of the Christian mystics. In the twenty-first Venetian Epigram, we read: "Pilgrims we are all who seek Italy" albeit with a resigned subtext, "It is only scattered bones that we credulously and happily cherish."[4]

Modern travel, so utopian and sentimental, in search of unspoiled nature, the simple life, and the encounter with Art, has no real counterpart in antiquity. There are a few scattered traces of it in the utopian Hellenistic travel literature, and Virgil's influential pastoral poetry shows some comparable feelings. None of this, however, shaped ancient travel in any noticeable manner. In contrast, the pastoral tends more often to contain a limiting component, of which more later. Unlike the present, antique travel is suffused with a distinctly materialistic quality, even when it is unconnected to trade, and is characterized by a desire to observe. Curiosities are of central importance even if they are major natural wonders or important works of art. Although subjectivity and spiritual contemplation are surely not absent from ancient life, they mostly manifest themselves in religious or mythological form.

Travel in ancient Greece consisted of voyages of discovery, coupled with commercial ventures. In the Aristotelian text on the *Constitution of Athens* 11.1, we hear about the Attic statesman, Solon, who in 590 B.C. embarked on a voyage to Egypt: "He traveled to Egypt for commercial reasons, and to obtain an impression (*theoria*) of the country." The interests of these early travelers are manifold but utterly unsentimental: mores and customs, technology, natural wonders, constitutions, rulers, religious phenomena, etc. By the sixth century B.C., many of these trips had brought rich scientific rewards; in the first half of that century, Anaximander of Miletos had made a map of the known world, and by 500 B.C. his compatriot, Hekataios, had published an extensive account, known as the *Periegesis*, on the newly explored lands.[5] Greek travel preserved this scientific/objective character up to and beyond the Hellenistic period.

The reason for the difference in attitude between the Classical period and the more recent modern period (the older modern is still much closer to the Classical period in this respect) lies above all in two fundamental factors. An important motif of modern travel is, as we have seen, the experience of nature, especially pure, virgin landscape, but also a wilderness that stands in contrast to the civilized world. The underlying opposition of city and country that informs this type of travel is already present in the Greek period. Yet, in spite of

certain tensions that become evident, for example in comedy, these two components retain a symbiotic relationship until the Hellenistic period. Only then do the contrasts between city and country become so strong that they lead to an aesthetization of the pastoral that far transcends earlier tendencies in this direction. But even then, unlike the modern period, it is not wild, virgin nature that is sought, but the rich pastoral landscape, the shady, watered gardens, the harmonious countryside dotted with settlements. This attitude is also reflected in landscape painting since the middle of the first century B.C. and remains fundamentally the same even in the Roman Imperial period, though marked by an increasing sentimentalization of the pastoral. As has been frequently observed, the people of the Mediterranean countries remained uninterested in nature in the romantic sense until the modern period. Even today in the south, the allure of the rural manifests itself mostly in the construction of villas for relaxation in the garden, but not in the desire for hiking or the solitude of the forest.

The other difference between antiquity and modernity goes deeper still, paradoxically: the ancients did not *have* an antiquity. The great educational benefit for the modern era is that antiquity seems to be part of our culture but also alien to it, which evokes interest and distance simultaneously. The phenomenon of humanism that has shaped Western culture simply did not exist during the older Greek period; it begins to appear only in the Roman epoch, with reference to the Classical Greek period (Pliny the Younger, *Letters* 8.24). Their own history could not have had the same formative and educational value as antiquity was to have for the West, since it was simply the past, and not a conceptual alternative (in the sense of the opposition of pagan-Christian). As the Classical period lacked a true temporal alternative (or more correctly, opposite pole), it also lacked a spatial one as well. During the Imperial period, Classical culture filled almost the entire known world; only one country, Egypt, was not part of the ecumenical Graeco-Roman civilization. But even in the earlier epochs, when Greece was still limited to a small part of the Mediterranean world, things were not fundamentally different. Despite the abundance of scientific curiosity, everything that was outside was seen as alien and hostile. The barbarians were not only primitive people but comprised everyone who was not part of the Greek-speaking nation. At rare moments the barbarian world offered a kind of a cultural alternative, as Egypt with Plato or Persia with Xenophon, but it could not have true educational worth. In sum, Graeco-Roman antiquity was a culture unlike the modern world, without true alternatives. Foreign languages were studied only for commercial and not educational purposes. Only Classical Greek could become for the Romans an ancient (classical) language in a humanistic way, but obviously not in the same

sense as it did for the Christian West. There was no alternative to Graeco-Roman literature that would have demanded a thorough study of foreign languages. The same applies to the classical tradition in art, except for certain religiously motivated Egyptian influences.

Aside from the cultural background, antiquity differs from the more recent modern in its altogether dissimilar manner of experiencing art and nature. As already mentioned, nature was understood above all in terms of the pastoral: garden, villa, etc. Nature was thus not associated with distance and the desire to explore it, but with a sense of place, acquisition, and possession. The experience of landscape is transmitted through mythological forms, mythological in the religious as well as the pseudo-historical sense. The traveler in the Classical era sees a landscape populated with heroic legends evoked by the ubiquitous tombs of heroes. But even nature itself, every spring, grotto, mountain, tree, is populated with deities that objectivize what is experienced subjectively in the modern period. Similarly, the understanding of art is formed by a mythological-religious way of thinking. The most important works of art are in sacred places where they often still perform their original religious function. In the traveler's contemplation, "art," i.e., the form, serves essentially to intensify the mythological content of what is represented; this is precisely contrary to Goethe's view, since he believed (although historically wrong, but thinking in a modern fashion) that "art" could be separated from the object. Antique texts are almost always concerned with the content of the work of art. Once in a while one finds a description of someone who traveled to Knidos or Olympia solely to see Praxiteles' Aphrodite or Pheidias's Zeus.[6] This has often been interpreted as proof of an advanced, emancipated understanding of art. Yet a closer study almost always reveals that even these travelers sought a particular mythic experience in the viewing of the deity, the contemplation of particular traits that the famous artist has been able to elucidate. Even when a panel painting has been severed from its religious context, when it is displayed, for example, in a collector's private chambers, it commands first and foremost a response derived from its content and the mythology of which it is part. Philostratos, who wrote comprehensive pictorial analyses in the early third century A.D., maintained that the meaning of painting resides in *alētheia* and *sophia* (literally, "truth" and "understanding"), as long as the painting represents the tale of heroes and visible nature.[7] Painting uses for this purpose *symmetria*, through which art participates in science (*logos*).

With these introductory remarks, we may now examine a few examples of "tourists" of the antique period to complete the picture in further detail.

After the successful military campaign in the autumn of 167 B.C. against the Macedonians under Perseus, the Roman commander Aemilius Paullus de-

cided to take an excursion through Greece to see its famous sites. Livy's account (45.27ff.) relies on Polybios, who accompanied the Roman on this trip. The interests of these travelers (who also included the brother of King Eumenes of Pergamon) are identical to those that we encounter over and over again in later periods. They went to Chalkis to observe the strange natural phenomenon of the Euripos current flowing back and forth under the bridge. A visit to Aulis served to honor the memory of the fleet that gathered there to embark on the Trojan War, as well as providing a view of the temple of Artemis. Sparta, unable to offer any famous buildings, was visited for its constitution (*instituta*) and rigorous code of conduct (*disciplina*). In Athens the group visited, besides the Acropolis, the walls of the city, the harbor with its shipyards, the monuments of famous generals, and the statues of deities and people, which were remarkable for their material and artfulness (*simulacra . . . omni genere et materiae et artium insignia* [27.11]). The primary interest of these travelers was, however, religious, marked by the visits to sacred places and the presentation of offerings. The travelers made offerings in Delphi, Lebadia, Aulis, and on the Acropolis of Athens. They went out of their way to distant Oropos on the Attic-Boeotian border to honor the sacred hero Amphiaraos as well as Asklepios in Epidauros. In Olympia Paullus was especially moved by the encounter with Pheidias's *Zeus*. This episode is often cited in modern literature as an example of an antique aesthetic experience of art, because, according to other sources, Paullus is said to have stated that only Pheidias had represented Zeus as Homer described him.[8] Nevertheless, one cannot speak here of aesthetic experience in the modern, emancipated sense; the religious content surely played the major role in his response. The appearance of the deity provoked the primary response. *Iovem velut praesentem intuens motus animo est* (45.28.5). Therefore, Paullus's response is also religious: he presented offerings way beyond local customs, as if for Capitoline Jupiter.

Nevertheless, it is especially the Olympian Zeus that serves to illustrate an artistic, inner process in classical literature. According to Cicero, the creator of Zeus had a *species pulchritudinis* (*Orator* 2.9), an image of beauty in his imagination which he beheld and which guided his hand. But here, too, the emphasis lies on something objective, on the Homeric image of Zeus which had primarily a religious function for the viewer. This experience of art can assume similar form even for the visitor of a private art collection. The poet Statius, writing at the time of the Flavians, recounts in his *Silvae* 4.6 a visit to the art connoisseur, Novius Vindex, who could identify the hand of the old masters even on unsigned works of art. Among the treasures belonging to Vindex, the poet particularly delights in a small statuette of Herakles by the famous Late Classical sculptor Lysippos, which served as a table ornament.[9]

The prestige of the work is enhanced by the fact that it was once owned by Alexander the Great, Hannibal, and Sulla. Statius evokes mythological visions as he gazes on the work—visions that may have also influenced Winckelmann's famous description of the Belvedere Torso (fig. 108).[10] Despite its small scale, Statius sees the lion killer, the powerful bearer of the club, and also the blessed hero who enjoys nectar with the Olympians. The work owes its impact to a generous apparition by Herakles, in a vision to the artist; thus even the small figurine could represent and convey the awe-inspiring. The poet is deeply moved by the encounter and cannot get enough of it. Yet his exaltations do not lead to an aesthetic response, but a recognition of content and its spiritual meaning: he recognizes the figure of the god (*deus ille, deus!*) in a kind of epiphany. As artificial as this artistic encounter may seem, it was most

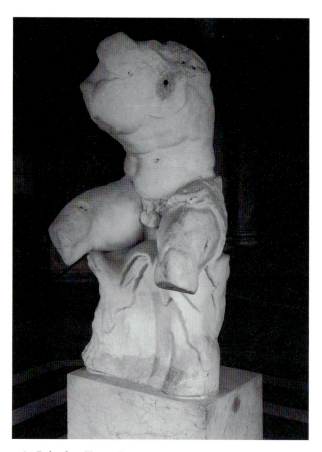

108. Belvedere Torso. Rome, Vatican Museums

likely the norm, as one sees in other writings of this time. Also typical was the comparison of the artistic image to a dream image.[11]

The reasons for travel in antiquity are outlined by a passage in the poem *Aetna* of the early Imperial period, which offers an interesting comparison between old and new, using the great natural wonder of the Sicilian volcano.[12] Sites such as temples and castles cloaked in the mythic pathos of legend are of immediate interest to the traveler. The walls of Thebes inspire thoughts of its mythical founders and the military campaigns of the Seven. In Sparta one thinks back to the time of Lykurgos. The sight of the fallen Troy and the tombs of the heroes in the Troad excite admiration and wonder. But Greek paintings and statues also captivate the viewer, who is concerned most of all with content: Anadyomene's (by Apelles) aphrodisiacal charm, Medea's tragic situation before the murder of her children (by Timomachos), Iphigeneia's sacrifice (by Timanthes), and finally the living imitation of nature, Myron's *gloria viva*. The natural wonder of Mount Aetna, to which the rest of the poem is dedicated, is observed by this otherwise unknown writer in purely scientific terms, with none of the sentimentality typically bestowed on the encounter with landscape at later times. Significantly, he does not think of climbing to the top to see the view; Emperor Hadrian did climb Mount Casius in Syria to offer the customary sacrifice to Zeus and to witness the early sunrise because of the altitude of the spot, but this was mostly out of "scientific" interest.[13]

In his famous book (2nd cent. A.D.), Pausanias sometimes writes in the first person, identifying himself in these passages as a traveler. Here we also encounter a bluntly objective description of landscape. He recounts in dry words the wonderfully scenic ascent from Delphi to the Korykian cave and from there to the peak of Parnassos (10.32.2–7):

> As one climbs from Delphi towards the summit of Parnassos one will see, about 60 stadia above Delphi, a bronze statue; from there, the ascent to the Korykian Cave is easier for a man without baggage than for mules and horses. . . . Of all the caves that I have seen, this one seemed to me the most remarkable. . . . The Korykian Cave is the largest of all; one can walk easily a great distance in it, even without torches. The ceiling arches high over the ground; there is also water there that partly bubbles forth from springs, but mostly drips from the ceiling, leaving marks everywhere on the floor of the cave. The inhabitants of Parnassos believe this to be one of the sanctuaries of the Korykian Nymphs, but especially of Pan. From the cave it is difficult even for a fit man to climb to the peaks of Parnassos. These tower above the clouds; there, the Thyiades rave, celebrating their cult in honor of Dionysos and Apollo.

This same Pausanias has left us a detailed description of the Pheidian Zeus in Olympia, extremely important because of its objectivity (5.11.1–9). What interests him personally in this famous work of art are its historical-anecdotal, mythological, and technical aspects. His only remark at all concerning questions of aesthetics is that the effect of the statue was totally different than earlier published measurements would have led him to expect. These had formed part of the Hellenistic literature on art, as is also known from another source (Strabo 8.3.30 [C 354]). Indeed, this prosaic attitude is characteristic of the epoch in general.

III. Travel from North to South in the Early Modern Period

European travel in the post-Classical era was predominantly in one direction: from north to south. At first this had nothing to do with the spiritual value of the ancient ruins in Italy, but with the cultural orientation of Europe in general. As late as 1645 the Englishman John Evelyn could state that with the exception of Italy, France, and the Netherlands, there was little to see other than peasants and an abounding barbarity. A trip to Italy in the Middle Ages was not, of course, a sightseeing tour, but rather a rigorous journey undertaken by pilgrims, visitors to the Papal Seat in Rome, or craftspeople who sought employment in the south. In the rare instance that literary documents survive, one seldom finds any mention of ancient ruins, and even those evince little interest. How much the knowledge of the Classical era had diminished in the course of the centuries can be seen in the curious book on the marvels of Rome (*Mirabilia Romae*), which recently has been dated around 1140–50.[14] The text is most likely an expression of the political ambitions of the Romans who were seeking independence from the Emperor and the Pope and felt encouraged by their independent past during the Classical era. Their motivation becomes crystal clear two hundred years later, in Cola de' Rienzi's attempt in 1354 to renew the old Roman Republic. He is said to have read the old inscriptions and explicated the ancient monuments. The political incentive to interpret archaeological relics with the aim of resurrecting former greatness is evident. The *Mirabilia Romae* demonstrates primarily, however, how an accurate knowledge of the antique had been lost. As an example, here is an excerpt from Rumpf in his historical overview of archaeology:[15]

> The two colossi on Mount Cavallo are identified as "opus Phidiae" and "opus Praxiteles." Pheidias and Praxiteles were two young philosophers who went to

Rome to explicate a dream to Emperor Tiberius. That is why they are represented in the nude, as nothing is hidden from them. The inscription on the Pantheon "M. Agrippa L. f. cos. tertium." (Agrippa consul for the third time) was misinterpreted by the writers of the *Mirabilia*. For them, Agrippa is a general who had been offered the supreme command for the campaign against Persia. He asks for three days time for reflection, has three times the same dream, and so on. The bronze Marcus Aurelius is the great peasant who, riding bareback, took the king prisoner as he was engaged in his bodily functions.

The conceptual preconditions for modern travel to the south were laid by those travelers in the fourteenth and fifteenth centuries who simultaneously discovered the antique and the beauty of landscape. This is most apparent with Petrarch, who in 1336 undertook one of the first modern mountain-climbing expeditions (Mount Ventoux near Avignon), and who also climbed with a friend to the top of the vaults of the Baths of Diocletian in Rome, to reflect on history amidst the ruins.[16] One hundred years later, there is a similar union of the experience of nature and humanist concerns in the Sienese Aeneas Silvio Piccolomini, the future Pope Pius II, about whom one can find more in the beautiful passages in Jacob Burckhardt's *The Civilization of the Renaissance in Italy*.[17] Thus, humanism makes up the conceptual background for the first travels that, in our definition, have a modern character. Not surprisingly it is above all the humanist on the north side of the Alps who is drawn to the south, and particularly Rome: Reuchlin in 1482, Peutinger in 1491, Erasmus in 1507. Artists with humanist inclinations like Dürer not only sought Italy and antiquity but wished to learn the latest advances in science (for example the new developments in perspective), which had found a place within the arts and thus made the artist equal to the scholar. While these were predominantly individual excursions, the overall number of these trips must have been considerable. Ludwig Friedländer mentions an Italian writer of the fifteenth century who characterized the English tourist in a way that would be so familiar in later literature:[18]

> In a text by Giovanni Pontano (1426–1505) the owner of an inn on the route from Naples to Rome recognizes the typical Englishmen ("Britannissimi") by their clothing. They do not understand Italian, turn up their nose ("fastum in naso gerunt"); one flatters them so that they will drink a lot and the inn owner makes them have their meals in an English way (Britannice ut discumbant).

At the time of Montaigne's stay in Rome in 1580, the Roman beggars could

identify the nationality of a passerby from his clothing and request donations in that person's language. Montaigne was annoyed to hear so much French in the streets.[19]

In the second half of the sixteenth century, a new type of travel became popular, one that prevailed well into the seventeenth and early eighteenth centuries: the educational tours of the European aristocracy, who attempted to enlarge their intellectual horizons in the Netherlands, France, and above all Italy. These trips did not primarily serve universal, aesthetic-humanist purposes, but caste interests. Travel companions whose journals were frequently published often emphasized that fact. Sigmund von Birken wrote in 1669:[20]

> Yes, because princes on this earth are what the sun is in the sky (who are, therefore, called the illustrious ones), so travel and the urge to see a great deal is inborn and comes naturally. . . . They travel not only to see many rare things, but also to learn much that is useful. As others traverse the land and sea to make profit, so much more should a prince be keen to gather the treasures of state, intellect, and morals of other republics and countries.

In 1700 Johann Balthasar Klaute accompanied the Landgrave of Hesse-Kassel to Italy, and, in his *Diarium Italicum* published in 1722, wrote "mostly of those young people of high birth (as travel to the far side of the Alps is of little value to the ordinary craftsman or farmer's son)."[21]

The interests of these princely travelers and their bourgeois contemporaries were directed for the most part toward the politically useful. Participation in foreign courts, diplomatic connections, the study of different constitutions and laws, knowledge of modern business, etc. were the primary motivations. Even when the purposes were broader and general educational goals were stressed, art and the antique played only a subordinate role. The guidelines, "in peregrinationibus observanda," were frequently found in travel books, of which L. Schudt published one example in his book *Travels in Italy in the 17th and 18th Centuries* (here given in a shortened version):[22]

What One Must Consider When Traveling

 I. The ancient and modern names of an area
 II. Sovereignty, formerly and today
 III. The name of a city and its significance when recognizable. Who founded it, enlarged it, or reconstituted it.
 IV. 1. Rivers
 2. Ocean and ports

3. Mountains
4. Forests
V. Works of Man
1. Public buildings (sacred and secular, also fortifications)
2. Private things, namely everything that is remarkable in the houses of the inhabitants, such as gardens, paintings, fountains, statues
VI. Government and everything connected to it
1. Assemblies, aristocratic families
2. Schools, education, scholars, libraries
3. Mores. Food and Dress. Trades

Thus any mention of art and antiquity in these accounts is mostly brief and neutral. Landscapes are predominantly considered from the perspective of their usefulness and through the eyes of the landholder.

Although Rome was the most important destination of the so-called gentlemen's journey, antiquities were mentioned but did not play a decisive role. Rather, Rome was the international center of the seventeenth century, a position evident in the fact that it was the home of the highest ranking diplomats of the European states. Richard Lassel, in his *The Voyage of Italy* (1670) summarizes it thus:[23]

Where can a man learn more knowledge than in Rome? Where all languages are spoken, all sciences are taught, the ablest men of Europe meet, all the best records are found, all wits appear as upon their true theater, all foreign ambassadors render themselves, all Nuntios at their return to Rome unload themselves of the observations they have made abroad; and where every stone almost is a book; every statue a master; every inscription a lesson, every antechamber an Academy?

Even though the curiosity toward the antique remained subordinate to other interests, the more serious travelers were no mere dilettantes. Their knowledge was often substantial. At the French ambassador's table in Rome, Montaigne could converse with guests who knew their Plutarch inside out.[24] A letter cited by Ludwig Friedländer written in 1578 by the Dutch antiquarian Justus Lipsius to a young compatriot about to leave for Italy gives testimony to the sentiment of these highly educated travelers toward art and antiquity:[25]

You will not be able to take a single step or glance without encountering a monument or a reminder of the antique. You will be moved when you see the Trasimenian Sea, the Battlefield of Cannae or when serenely contemplating the Al-

ban Hills, Tivoli, the famous Baiae, or the home of Pliny, the birthplace of Virgil or Propertius, the ruins of the villas of Varro and Cicero. What pleasure do such vistas offer when the spirit of these great men presents itself not only to our souls but almost in front of our eyes, and we step upon the ground on which they so often have walked? Furthermore, who would not be enlightened and enchanted to the highest degree by these ancient cities, temples, theaters, arches, tombs, and stones?

Here there is as little mention of the enjoyment of art as in other texts of the period. First and foremost are the antiquarian interests; when a viewer's spirituality is considered, it is the pathos of historical reflection, to retrace the steps of the Ancients. Senator B. H. Brockes of Hamburg (1680–1747) recalled in his autobiography that he "once experienced deep emotion when contemplating some ruins of old temples and began to consider the fatal turn of human events."[26] In a similar frame of mind, Montaigne left no stone unturned to obtain Roman citizenship, a feat that was ultimately successful. Montaigne's extensive diary of his stay in Rome in 1580–81 is especially well suited for our purposes, because he embodies the intellectual interests of the traveler of his time.[27] Montaigne already spoke Latin and Greek as a child and thus was superbly prepared for the contemplation of Roman antiquity. He spent much time visiting ruins and was soon able through diligent study to free himself of the need for a guide. He was a keen observer. He noticed, for example, that the antique building masonry in France was different from that used in contemporaneous structures in Rome. He examined the height of the rubble around the monuments and came to the disappointing conclusion that far less was known of the old Roman city than previously thought. With friends he embarked on an excursion to Ostia and to the *Isola Sacra* to study the excavations undertaken by the pope. But his enthusiasm for antiquity was only one interest among many. A visit with the pope, conversations with courtesans, an exorcism, executions, a Jewish circumcision ceremony are all treated with the same attention. Works of art are mentioned in passing, for instance, the sculpture court in the Belvedere (fig. 109), his narrative never deviating from his totally unsentimental manner of observation. Only in Tivoli does he remember several Roman sculptures that he had especially liked, among them the She-Wolf and the Thorn Puller on the Capitol, as well as the Laokoön Group and the so-called Belvedere Antinous.

Later writers like Stendhal and Chateaubriand have taken Montaigne's broad range of interests and his unsentimental attitude as an occasion to chastise him for a lack of interest in art.[28] In so doing, they did not realize that Montaigne's mode of contemplation was a result of the limitations of his time,

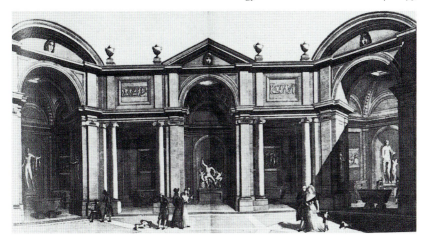

109. View of the Belvedere sculpture court, Vatican Museums, in the time of Pope Pius VI, engraving by V. Feoli

and that the contemplation of art in which they themselves engaged was developed only in the middle of the eighteenth century with the generation of Winckelmann.

IV. Aesthetic Experiences: Winckelmann's Experience of Art

In many respects Winckelmann (fig. 110) expounds the general tendencies of his time; nevertheless, the process we consider below is personally colored by him. It is no accident that the scholars of the history of European travel to Italy see him as the beginning of a new epoch.[29] It is noteworthy that, as in the Renaissance, the new experience of art and antiquity in the middle of the eighteenth century goes hand in hand with a new sentimental conception of nature. Rousseau is the acknowledged discoverer of this, yet Winckelmann played no small role, at least in the beginning. His connection with the circle around Johannes Geßner in Zurich (1709–1790) and his admiration for that author's sentimental, bucolic poetry brought him closer to this type of experience; already, his letters from his earlier trip to Rome reveal him as a captivated admirer of the Alps. In Italy, however, his attitude changed; on his second trip over the Alps, he resolutely kept the curtains of his carriage closed; this was surely not merely a reflection of his momentary mood.

When the early travelers concerned themselves with antiquity and art, their interests were historical-antiquarian. Winckelmann leveled the same ac-

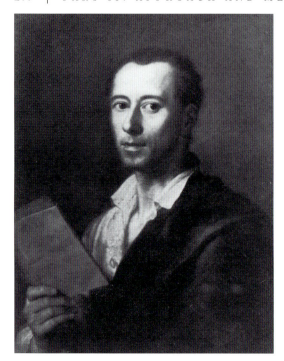

110. A. R. Mengs, *Portrait of J. J. Winckelmann*. New York, Metropolitan Museum of Art

cusation at them as he did at the scholars of his time, namely that in their erudition they failed to grasp the true nature of art. This cannot be achieved solely with a knowledge of facts but is rather an acquired skill, the ability to experience beauty. Those who allow this ability to wither remain in Winckelmann's opinion only half-human and miss their greatest chance of happiness: "This ability must be considered a rare gift of God, which allows one the enjoyment of beauty and of life itself and for whom bliss consists in a continuity of pleasant sentiments."[30]

The ideal of a gentlemen's journey is now replaced with a general human one that competes with the first. He wrote to a young aristocrat: "Enjoy your precious youth in noble pursuits far away from the foolishness of the courts so that you may fulfill yourself while you can; later, raise sons and grandchildren in your own example."[31]

Today Winckelmann is considered chiefly as the founder of art history, as the discoverer of the historical transformation in the forms of art and their grounding in a historical period. Goethe had already interpreted Winckelmann in this way and described him as the new Columbus.[32] In truth, however, the description of styles and their temporal succession was only of sec-

ondary interest to Winckelmann. Primarily he was interested in the nature of art as human ability and expression. Indeed, he considered this his own original contribution, since he had well-known precursors for the writing of the history of artists and even the characterization of artistic styles and periods, in particular the French archaeologist Caylus (1692–1765).[33] He explicitly laid out this distinction in the preface to his history of the art of antiquity: "Hardly any author will help in the understanding of the essence of art; those that deal with antiquities touch either only what can be done through scholarly approaches or, when they do talk about art, either bestow generalized praise or build opinion on alien or false foundations."[34] To attain his own goal, Winckelmann disregarded those studies and that pursuit of knowledge that would have been particularly dear to earlier scholars, namely the biographies of artists or Roman topography. These areas of scholarship were for him "book-learning" and could be accomplished without any genius whatsoever.

We will return later to Winckelmann's theories of a new, aesthetic-humanistic art history and archaeology. Here we are only concerned with the effects of his thoughts on travel in the south. In later years Winckelmann often served as a tourist guide, and in this he developed a missionary's zeal to open the eyes of his contemporaries to the "essence of art." Only half a year after his arrival in Rome, he wrote: "I think I have come to Rome to open a little the eyes of those who will visit Rome after me (I am talking only about artists), since all gentlemen arrive here as fools and leave as jackasses; this species of the human race does not deserve to be educated and edified. To a certain nation Rome is not even bearable. A Frenchman is incorrigible: antiquity and he contradict each other."[35] In his letters as well as his published texts, he engages in vehement polemics against traveling scholars and gentlemen:[36]

> Those travelers from the other side of the Alps who in my days used to come to Rome to engage in studies were either not equipped to do so or did not pursue the right goal. To the former group belonged a young Dane who arrived here from France to study legal proceedings (what do you think of that?), unabashedly declaring his inattentiveness to antiquity. To the latter group would belong a German professor who does not speak of anything except a new edition of Horace with all possible text variants. If he had the good fortune to travel to Italy, his only concern would be this, and he would believe that he was elevating the notion of the best world with his labor.

In his *Experience of Beauty in the Arts*, he complains about a "young Englishman of the highest breeding who riding in his carriage failed to show any

signs of life or even presence when I lectured to him about the beauty of Apollo and other first-rate sculptures. . . . On those people, the most exalted artistic beauties act like the *aurora borealis* that illuminate but do not warm."[37]

He directed his wrath not only against the travelers but also against their ideals. A favorite motif of the older travel literature was to linger at a place of great historical import and to surrender oneself to the pathos of historical reflection. Winckelmann, who normally accentuates sentiment, had no sympathy for this type of experience: "It is pleasing to know where in the old city of Rome the Carinae had been and to be able to more or less indicate the house in which Pompey lived; a tourist guide who can point out these places tends to do so with a certain relish. But what has one learned when there is no longer the faintest trace of an old building to be found?"[38]

The ideal with which Winckelmann replaced the old motives was very exacting, since it was no longer concerned merely with knowledge or pure assimilation. Rather, this type of artistic contemplation engaged the entire being; one must be moved, develop skills, and change. It is not a scholarly but an ethical ideal. Art cannot be perceived in the same dispassionate manner as science but demands an inner readiness: "I contemplated works of art not as someone who saw the ocean for the first time and thought it pleasant; the Athaumasia or stoicism praised by Strabo because it brings about apathy I appreciate only in morals, but not in art, because here apathy is harmful."[39]

In the experience of art, an instinct is aroused that senses and seeks the beautiful and forces the viewer to jettison his modern prejudices. When the beauty of an Old Master's work is not immediately recognized, the viewer will nonetheless believe that it is there and search for it. This idea returns in myriad variations: "One should always imagine that one will find much, so that one sets out to look for it in order to perceive something."[40] This belief can be reinforced by authoritative artistic sources from the past:[41]

> The torso of a Hercules by the Hands of Apollonius of Athens that I have described elsewhere may serve as a model here. On first encounter, this work did not move me and I could not reconcile the mediocre elaboration of its various parts with the sublimity of other statues representing Hercules, especially the Farnese Hercules. But I reminded myself of the strong admiration for this work by Michelangelo and all subsequent artists; this had to serve as an article of faith, but I could not have offered my approval without finding the reasons for it myself.

The search for beauty is not enhanced by restless passion but demands a quiet receptivity: "If you approach the works from antiquity with the hope of

finding much, you will seek long and hard. You must contemplate these works with great inner tranquility, for the abundance-within-little quality and the quiet simplicity will otherwise not edify you, much like a quick glance at the unadorned Xenophon."[42]

The contemplation of the work of art demands not only a feeling but also a thinking individual. Because mere erudition will distract the scholar from the essence of art, the viewer of a work of art should not be blinded by mere caprice, allusion, and the virtuosity of a work. He should be able to evaluate whether the artist had original ideas and whether he understood and emulated the antique or whether he was a mere copyist. Furthermore, the viewer should not only feel the beauty but must be able to enumerate the reasons why something is beautiful.

Inspired by pedagogical love for a young Baltic nobleman, Winckelmann put down his thoughts on art contemplation in a programmatic text, *On the Ability of the Perception of Beauty in Art and the Instruction Thereof*.[43] Since we have touched already on several basic ideas, I shall mention only a few particular perspectives. The ability to experience beauty is a natural ability, connected to the entire physical and moral self: "Your constitution allowed me to deduce what I desired; I found in a beautiful body a virtuous soul, endowed with the ability to perceive beauty." Like the Platonic Eros, this tendency asserts itself in a young person "in dark and confused stirrings like those fleeting itches on the skin whose spot one cannot identify when scratching." This ability is developed through education, not mere erudition. The old authors must be read so that "sentiments are stirred gently." It demands delicate and impressionable senses, and not only the sense of sight. "The Cardinal Alexander Albani is able to identify by mere touch and feel of a coin which emperor it represents." The instruction in the ability to experience the beautiful in art is directed once again toward the whole person, and therefore is only totally successful when one is at leisure. The heart and sentiment of a growing boy should be awakened with the reading of the poets, and at the same time his eyes should become accustomed to the beautiful by the contemplation of art. Reproductions and casts of coins and cameos are a good beginning. But "the true and deep knowledge of the beautiful in art" can be obtained only "from the study of the originals themselves, best of all in Rome." A trip to Italy, for those who have attained and developed the ability to perceive beauty, is a true revelation.

Winckelmann's lofty ideal of artistic contemplation is not merely vaguely sentimental, as a hasty modern reader may think, but it is also critical. The observer of art must be able to recognize modern additions to an ancient sculpture. He must be able to detect where even great artists have moved away

from beauty and he must be able, above all, to recognize the quality of a work of art. For example, Winckelmann demonstrated to Stosch, the famous connoisseur, that he had mistakenly ranked the Vatican Apollo (fig. 111) behind the Barberini Faun (fig. 112), "which is a forest creature."[44] Herr von Stosch recognized his error after the exchange of several letters on this subject, but he excused himself by explaining that "he had seen the classical works as a young man in the company of two still-living artists from the far (north) side of the Alps, and that he had based his opinion on theirs."[45] As in more recent times the cult of the "original" has shunted aside all other points of view; the Barberini Faun today is seen once again as the superior work, whereas the Apollo Belvedere is understood as the characterless Roman copy.

That Winckelmann's approach to art was so quickly and thoroughly accepted during his time was due mostly to the effect of two descriptions of works of art in the Vatican, the famous Torso (fig. 108, above) and the Apollo (fig. 111), both in the Belvedere of the Vatican.[46] The modern aesthetic contemplation of works of art is founded on these short and demanding descriptions, on which Winckelmann expended an extraordinary amount of effort. We cannot here pursue all the implications contained within these short texts, but will only consider them as guidelines on looking at art. Winckelmann requests explicitly that other such descriptions be written for the education of young artists and traveling amateurs.

The elevated claim for looking at art that addresses the entire being becomes especially clear in his description of the Apollo. In 1756 Winckelmann wrote to one of his friends: "The description of the Apollo demands the most elevated style, an elevation above all that is human. It is impossible to describe the effect made by this sculpture."[47]

The text, finally published in 1764 as a section in his history of art, was only one page long.[48] Its position within the section on the era of Nero seems oddly out of place, but was put there because the statue of Apollo came from Nero's villa in Antium, and Anton Raphael Mengs maintained that the statue had been made at the time of Nero.[49] In addition, the lofty tenor of the description is toned down by a single sentence of scientific language, which achieves a peculiar stylistic discontinuity. This discrepancy between exalted sentiment and prosaic science arose mainly by chance; however, it is an inherent problem of archaeological study itself, which is aimed simultaneously at material conditions and emotional values. We frequently encounter similar contrasts throughout Winckelmann's work, and they are still typical of archaeological studies today.

The reader is asked to find in this statue a strangely incorporeal ideal of beauty that has unmistakable Neoplatonic traits:

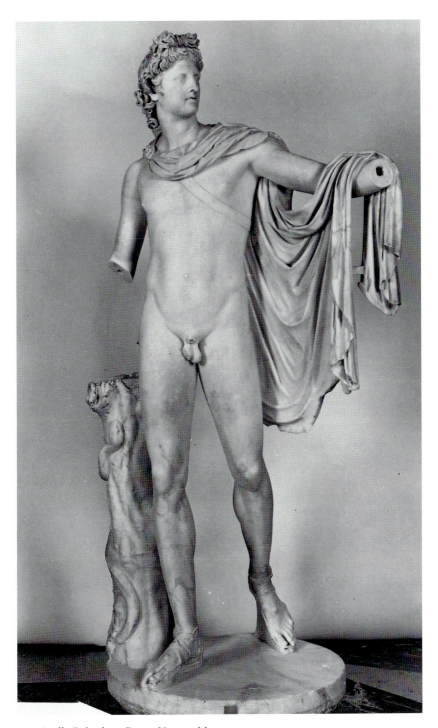

III. Apollo Belvedere. Rome, Vatican Museums

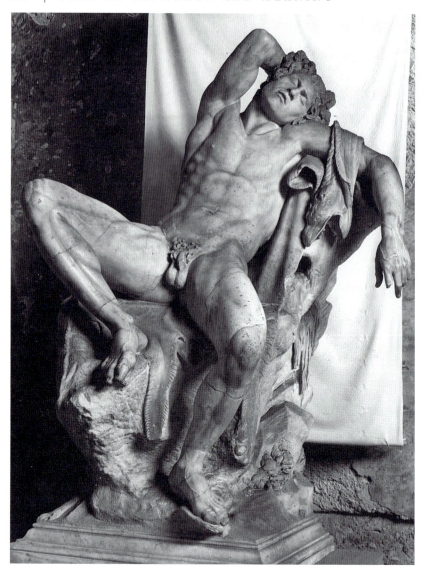

112. Barberini faun. Munich, Staatliche Antikensammlungen und Glyptothek

With your soul approach the empire of incorporeal beauties, and try to become the creator of heavenly nature so as to fill the soul with beauty that transcends nature: since here there is nothing mortal, nor anything that human needs require.

Contemplation is not passive viewing or superficial pleasure but endows the entire being with a new spirit:

> I forget everything else on viewing this marvel of art and take on an elevated stance myself so that I may observe with dignity. My chest expands and lifts up in reverence like those whom I observe swollen with the spirit of revelation, and I feel carried away to Delos and the Lycian groves, places which Apollo had honored with his presence, since my image seems to be infused with life and movement like Pygmalion's beauty. How can one paint or describe it? Art itself would have to advise me and lead my hand to elaborate in the future what I have sketched out here. I will lay down at his feet the idea that I have gained from this image like a wreath placed by those who wanted to crown the heads of the deities but could not reach them.

Art contemplation takes on distinct traits of religious contemplation and addresses less the forces of the intellect than emotional imagination. The thoughts of the person in contemplation are strangely ethereal. Aesthetics and content, as well as a little scholarship, mingle in associative sequences and elicit great reflections:

> An eternal Spring as in the blessed Elysian Fields cloaks the appealing mature maleness with the mantle of pleasing youth and plays with gentle caresses on the proud architecture of his limbs. . . . No veins nor tendons warm or move this body, but a godly spirit has filled the entire contour of this figure like a gentle current. He has pursued the Python against whom he first aimed his bow and with his forceful gait has overtaken and killed him. From the height of his sovereignty his lofty glance reaches into the endless space far beyond his victory; contempt curls his lips and the ill-humor that he inhales causes his nostrils to flare and fills him to the noble forehead. But peace, floating in holy silence on his brow, remains undisturbed, and his eyes are full of sweetness as when he is among the Muses that try to embrace him.

For the modern reader it may be difficult to imagine that these lines provoked an aesthetic revolution in Europe whose effect is still felt today. Among the many examples I could cite, I mention only a note on the Apollo published by Jacob Burckhardt, who is usually averse to exaltation:[50]

> [T]he true identifying trait of Apollo is his ideal figure, totally free of any trace of restraint or want; he holds not only the highest place next to the athletic Hermes

and the delicate Dionysos, but among all deities. A slim body with the precise amount of power that the given movement demands; an oval head that appears even more elongated with his full pile of curls over his forehead; traits of lofty beauty and clarity.

Of the surviving sculptures in Italy few, however, offer such perfection; for at most they are only Roman and often only decorative works. Yet among these there is the *Vatican Apollo* (in a special chamber in the Belvedere). Depicted as victor over the dragon Python, perhaps over the Niobids, or even as the one who banished the Erinyes—depending on one's interpretation—he turns away after his arrow has hit its mark, with pride and even a trifle indignation.

Winckelmann's contemporaries not only adopted his point of view but also deeply experienced the revolutionary aspect of the process. This was expressed most clearly in the Salon of 1765 by Diderot, whose rational mind, however, regarded the irrational component of the new experience of art with mistrust:[51]

> I love fanatics; not those, however, who spread absurd beliefs and set the dagger to your throat and exclaim: "Sign or die!" No, I love those fanatics who are obsessed with a special but harmless passion, and who don't see anything anywhere that can hold a candle to their special love; who defend their love with all their might at home and on the street, and who are ready, not with a sword, but a syllogism, and who ask all and sundry who happen to walk past either to admit the absurdity of their own taste or accept the superiority of the charms of their Dulcinea. They are entertaining, these people. They amuse me, but at times astonish me as well. When they happen to have chanced upon the truth they reveal it with an energy that breaks and overturns everything. Although they paradoxically pile image upon image and call for assistance on all the powers of persuasion, symbols, daring comparisons, expressions and turns of phrase, and address one's feelings and imagination and seek to gain control of the soul and its sensibilities from all sides, so their attempts nevertheless offer a nice spectacle. Jean Jacques Rousseau is of this type when he attacks the sciences, although he had practiced them all his life. . . . So is Winckelmann, when he compares the works of the ancient artists with those of the modern. What does he not discover in that stump of a human being that one calls the *Torso*!

Winckelmann's description of the Belvedere Torso (fig. 108, above) is not quite as exalted as that of the Apollo but is in the same quasi-religious range. The viewer undergoes something of an initiation:[52]

On first viewing it you might not discover anything but a disfigured stone; if you manage to penetrate the mysteries of art, however, you will see a wonder when you contemplate this work with a calm eye. Then *Hercules* will appear in front of you in all his labors, and the hero and the god will become visible simultaneously.

His aesthetic contemplation goes into greater detail but is interrupted at times by mythological digressions and reflections on the ideal of beauty:

> Ask anyone who knows the most beautiful of mortals whether he has seen one side that is comparable to the left side (of the statue). The movement and countermovement of its muscles are wondrously balanced as a succession of quiet motion and quick force; the body had to be trained for all that it wanted to accomplish. Just as the ocean swells in a rising movement from calm to the misty unrest of playful waves, where one wave is swallowed by the next and in turn unfurled by it, so here does one muscle flow into the next, softly undulating in a perpetual flow; a third arises between them, seemingly strengthening its movement but getting lost in it, just as our glance is being absorbed.
>
> In this moment, my mind travels to the most distant regions of the globe where Hercules himself wandered; I am transported to the ultimate limits of his travails, to the monuments and columns on which he rested his foot, led by the view of these thighs of boundless strength on a scale comparable to that of the gods, which carried the hero himself through countless countries and peoples to immortality.

This description is important because it also presents a new view of the relationship of the viewer to art and to artists. The viewer is no longer a mere layman, but by gaining insight into the nature of beauty, he becomes more like the artist; he can even instruct the contemporary artist on how to look at these works of art. It is only before the classical artist, whose eyes beheld the ideal image, that the viewer recedes:

> Oh, how I would like to see this image in the greatness and beauty in which it revealed itself to the artist, only to garner from the remnants what he thought and how I should think. My greatest happiness after his would be to offer a worthy description of this work.

In place of the scholar influenced by social position or the aristocratic amateur of the arts, Winckelmann presents a universal, humanistic ideal that per-

mits every educated person to become a potential artist. William Blake raised this ideal in 1820 to a demand: "A Poet a Painter a Musician an Architect: the Man / Or Woman, who is not one of these is not a Christian."[53]

Winckelmann transformed the contemplation of art for the modern European into the *experience* of art. He proved it to be a fundamental human capacity to appreciate spiritual and emotional values and therefore one of the most rewarding sources of happiness. The way to that happiness is aesthetic contemplation that relies on an innate ability developed through extensive training. One's external sensory capacities and inner sensibilities are offered a range of activity, not only intellectual and social skills of a special character, but the unlimited sphere of education, because it is here that humanity in its entirety is called upon.

Winckelmann's ideal remained unchallenged until late in the nineteenth century and provided the model for people of the most diverse backgrounds and attitudes. It even withstood a strict historical trial, becoming first a fashion and then being exposed to the critics of that fashion.[54] The epoch inaugurated by Winckelmann came to an end only in the 1880s, when Nietzsche observed: "Winkelmann's and Goethe's Greeks . . . —one will finally one day discover this whole farce. Historically speaking everything was completely wrong, but—modern."[55] Nietzsche's afterthought not only confirms the effect of Winckelmann's concept but also indicates why much of it has survived until today.

V. The Modern Period

We cannot deal here exhaustively with the nineteenth century (see, for example, J. Burckhardt's lecture "The Great Collections of Art," delivered in 1883).[56] Even without further exploration of this period, it is apparent that Winckelmann's ideal of aesthetic contemplation survives into our century despite some critical skepticism.[57] It is significant, however, that the debate concerning Winckelmann's ideal centers mostly around the problems it raises: it does not suggest that the ideal itself has dubious merit. Quite the contrary, the discussions focus on the idea that peripheral distractions prevent the full development of Winckelmann's ideal.

VALÉRY: THE DIVIDED MUSEUM

Paul Valéry defined the problem of the divided museum, a museum being "something of a temple, something of a Salon, of a cemetery and of a school-

room."[58] The worst result of this concept is the endless proximity of "master-works to the left and to the right, between which one has to thread one's way like a drunkard between the tables of a tavern."[59] In this manner works lose their true meaning:[60]

> The misuse of a room filled with a collection violates not only one's sense of sight, but insults one's cognitive faculties by the crowding of important works of art. The more beautiful they are, the more extraordinary the manifestation of the human struggle for greatness, the more they must stand by themselves. The creator of these unique objects wanted to keep them unique. One often hears, "This painting overpowers all the ones next to it."

The visitor has no other choice under these circumstances: either become a superficial observer or take refuge in a scholarly attitude alien to actual experience. The museum without bounds is joined by a library without limits. This development was, however, inevitable: in the absence of their original setting, images had lost their connectedness and purpose. There is also certainly a significant link between the spiritual chaos of the museum and the "tortured state of the arts of our time."[61] The prospects are frightening: "We are and live in a dizzying confusion, the suffering of which we inflict on the art of the past."[62] Valéry perceives here the end of contemplation brought about not only by the external circumstances but also by internal needs. Contemplation is measured by this ideal. Valéry does not even want to raise the question of how it could ever be replaced: "These thoughts tell me, 'Good bye, I do not want to delve further into this question.'"[63]

THE RECEPTION OF ART BY PROUST AND BENJAMIN

Marcel Proust is another modern author who is endowed with a special sensitivity toward the object. Unlike Valéry, Proust is an advocate of museums but keeps silent about the fact that they are overcrowded. He argues that the original setting dilutes the inherent spirituality of a work of art and its creative resonance into a merely decorative effect. Only in the neutral spaces of a museum, in artistic isolation, does the artistic become apparent in a concentrated manner:[64]

> In every walk of life today there is a mania to present things in their natural context; thus they lose their most important characteristic, namely their spiritual greatness that raised them above the commonplace. Today, one "presents" a picture amongst "period" furniture, bric-a-brac and drapes in a meaningless decora-

272 PART II: APPROACH AND MEANING

tive arrangement accomplished with panache by the lady of the house, who only yesterday was totally unaware of these matters but has mastered them with studies in archives and libraries. Yet the masterpiece contemplated during dinner no longer offers us the intoxicating, blissful state that one can expect only in a museum, where the absence of all decorative details symbolizes the inner space to which the artist withdrew to create the work of art.

But this ideal in which an "intoxicating blissful state" is sought is also based on aesthetic feeling and contemplation. Proust has dealt elsewhere with this topic in a much more discriminating manner. We must, however, postpone the discussion of his observations to a later section (below), in which the relation between archaeology and modern art is discussed.

The difficulty of the modern experience of art for these two French authors is mostly aesthetic, for Proust even more than for Valéry. That it also contains a sociological dimension has been developed by Proust's translator, Walter Benjamin, in his famous essay of 1936, "The Work of Art in the Age of Mechanical Reproduction."[65] Benjamin begins his reflections where Valéry left off but transforms them into a positive argument. Since 1900, when mechanical reproduction had become fully developed, the modern definition of art experienced a profound transformation. To understand this one must consider the relation between reality and mass society and set aside for the moment such transmitted concepts as genius and meditation. The most conspicuous trait of our epoch is the reproduction of works of art and film. Through reproduction, works of art are accessible everywhere, at all times, under any desired condition, and can be multiplied on command. By its nature, reproduction undermines the originality and authority of the work of art, the aura, and increases the sense of global homogeneity. Reproduction undercuts the connection of the original work to ritual, ownership, and the uniqueness of its surroundings. But these values had already been undermined during the nineteenth century, as exhibitions increasingly removed the work of art from its traditional context. Such new tendencies are most apparent in film, in which the montage of disconnected movements and constantly changing perspectives have replaced traditional theater, with its unified performance and fixed viewpoint. Unlike theater and painting, which invite empathy, film assaults the viewer with multiple impressions, and he "devours" them. This experience of art is appropriate for the masses, whereas collective reception of paintings has always been difficult. The masses, therefore, always lag behind in the reception of modern painting, whereas they prove to be distracted but critical judges of film. The downfall of the aura and with it of contemplative medita-

tion ("which became in the degeneracy of the bourgeoisie a school of asocial behavior")[66] had a precursor in modern art.

The Dadaists tried diligently to prevent their objects from becoming icons:[67]

> The Dadaists attached much less importance to the financial value of their work than to its uselessness for contemplative immersion. The studied degradation of their material was not the least of their means to achieve this uselessness. Their poems are "word salads" containing obscenities and every imaginable waste product of language. The same is true of their paintings, on which they mounted buttons and tickets. What they intended and achieved was a relentless destruction of the aura of their creations, which they branded as reproductions with the very means of production.

Distraction is no longer an irritation but something positive, an artistic principle as in film. The old truism that the masses seek diversion but that art demands concentration thus appears in a new light. Architecture has always been an example of art that was not necessarily perceived through concentration and meditation but through usage and routine. The development of all the arts will go in that direction, namely reception through diversion; film is the great training ground. Diversion will replace contemplation; critical evaluation will take the place of experiencing (which is still somewhat characterized by its connectedness to cult), just as the newspaper boys expertly discuss bicycle races. "The audience is an examiner, but a distracted one."[68]

I have discussed Benjamin at such length for two reasons: he perceived more clearly than others the destruction of contemplation in modern society, and, building on Valéry, he sought a more profound explanation of the phenomenon. We are dealing here with an issue that has been with us since the beginning of the nineteenth century.[69] The deeper causes for this are the emancipation of the masses, the release of the work of art from its cult context, the structural changes in the work of art itself insofar as it already takes into consideration its own reproducibility in its making. The loss of contemplation on the part of the viewer parallels the loss of aura of the reproduced work of art.

ORIGINAL AND REPRODUCTION

Forty years after Benjamin's treatise, the situation is not fundamentally different from the one he analyzed in 1936. Mechanical reproduction has increased not only in regard to the distribution of works of art but also in their produc-

tion. More than ever photography influences the style of painting, as in "Photorealism." The boundary between work of art and commodity (the manufactured object) has become fluid. The tradition of Dada has led to new extremes. Wealth and leisure have created ever-greater audiences. Nevertheless, Benjamin's predictions have not proved true. The masses are not content with the role Benjamin allowed for them of professional newspaper boy or of absentminded examiners, even if they are absentminded. The fact that technological reproduction robs the original of its uniqueness has not led to the loss of aura. To the contrary, aura has been deified. That the *Mona Lisa* can be reproduced with the finest nuance of color detail does not prevent millions from making the pilgrimage to the original, although one sees far less through the reflecting glass than in any cheap copy.[70]

According to Benjamin, film realized the newest tendencies most effectively, but it has certainly not become the predominant art form of our epoch. On the other hand, events that serve the auratic work of art, such as exhibitions of original works (regardless of type), draw enormous audiences. It remains unclear whether the longing for the original aims at something concrete or is simply an expression of disaffection with today's one-dimensional existence.

Benjamin glosses over or at least does not answer unequivocally the problem of how the historical work of art is properly received. Mechanical reproduction may rob the work of its aura but not of its intellectual content; in fact it is strengthened, if we adhere to Proust's argument, through the neutralization of the setting. How should the modern viewer analyze the historical work of art when he approaches it in a reproduction? This question, of special interest to us in the context of our discussion, is not addressed by Benjamin. Even the attempt to answer it oneself on the basis of the points of view given by him does not lead to a satisfying conclusion. The fact that the reproduction has already directed its interpretation in a certain way through a chosen point of view, enlargement, etc. does not alleviate the problem.

One might expect that changes in the reception of the work of art will become apparent first in modern art itself. In any case, it is here that one registers the most sensitive reactions to these issues. For example, the motif of a traditional easel painting multiplied and arranged comic-strip fashion with banal advertisements can be found more than once; it is an expression and at the same time a critique of the superficiality caused by a veritable flood of artistic and pseudo-artistic images in modern media. Equally apparent is the critique of the growing tendency to understand the work of art as a commodity produced in series.[71] The *Mona Lisa* is the favored subject for this discussion.

The adulation of the *Mona Lisa* had found its literary expression in Walter

Pater's famous description of 1873,[72] but the masterpiece was treated with biting irony only fifty years later by Marcel Duchamp. In his work of 1920, Duchamp fitted *Mona Lisa* with a moustache (in a later unaltered version of the same reproduction he added the caption: "*Mona Lisa* rasée").[73] The Dutch artist Saskia de Boer produced *Mona Lisa* portrait busts in plastic and brought them serially together.[74] The same approach was taken with another art fetish, the Berlin Nofretete. Andy Warhol gathered thirty reproductions of the *Mona Lisa* and called the result "Thirty is better than one."[75] Salvador Dalí offered his contribution to this subject with a self-portrait as *Mona Lisa*.[76]

Valéry and Benjamin could rightly point out that the destruction of the viewer's contemplation is connected to the parallel phenomenon in modern art. It was part of the Dadaists' program to irritate and undermine the modes of bourgeois artistic appreciation, which they considered ideologized and reduced to mere convention. Duchamp ironically elevated a bottle rack and a urinal into the realm of aesthetic contemplation.[77] Hans Richter, whose beginnings were connected to Dada, recalls:[78]

> Of course, the bottle-rack and the urinal are not art. . . . In opposition to Art, as represented by the *Vénus de Milo* or the *Laocoön*, Duchamp set up Reality, as represented by his ready-mades. His purpose was to administer a strong purgative to an age riddled with lies—and to the society which had brought it into being—an age of shame for which he found an artistic counterpart in the shape of a *Mona Lisa* with a moustache.

The Dadaists' derision of aesthetic contemplation finds a parallel in other areas of modern art where the possibilities for contemplation and empathy are consciously dismantled or thwarted. This is everywhere the case where objects assault the viewer as if in the cinema: the photographic enlargement, the foreshortened perspective, etc., effects much favored by the Photorealists. Works that do not permit cohesion because of montage processes or fragmentation can also be included here. The oft-used form of serial imagery similarly contains irritating elements that counteract empathy. Finally we must also remind the reader of all those works that seek to shock or consciously repel the viewer with unpleasant themes or materials.

However obvious the hostile tendencies in modern art are to contemplation, the attitude is by no means unanimous. Leading modern masters such as Mondrian, Klee, Jawlensky, Baumeister, etc., although fundamentally different in their intentions, have this in common: they even enhance the contemplative component of art in comparison to nineteenth-century painting. One has thus called works of Mondrian and Jawlensky "icons" and "objects of . . .

meditation."[79] This direction within modern art continues to develop even to-day, as is apparent, for example, in the Collection Ludwig in Cologne;[80] more than half of the works in this broad collection may be considered as "objects of meditation."

But even in those developments that seem to undermine aesthetic contem-plation completely, the relation is in fact not so clear. Marcel Duchamp's at-tempt to destroy aesthetic contemplation with his ready-mades, an intention that as such was fully realized by his contemporaries, has achieved the oppo-site effect; his works have become fetishes of modern art. An author who is well acquainted with the history of Dada writes:

> Marcel Duchamp has not transformed things and objects into images, but rather has reconstituted the original reality of objects. It is especially his inclu-sion of unimportant everyday objects into the unfamiliar sphere of art which en-dow his ready-mades with a fetish-like character.[81]

One can observe similar tendencies in literature, where phrases of ordinary speech are passed off as art to demonstrate the typical sterility of elevated po-etry. But equating a poetic stanza with an advertising slogan has not only made an absurd situation manifest; the advertising slogan itself has become a kind of linguistic fetish with its own aesthetics: e.g., "I wandered lonely as a cloud," and "Coke's the One."

These observations apply similarly to all instances where everyday objects, or reproductions of everyday objects, even mere material or material struc-tures, have been elevated to meditational status (an aesthetic possibility that has systematically been employed by the advertising industry). Thus, among commodities, Duchamp's *Bottle Rack* has become a sort of melancholy Don Quixote.[82] Dada has become so fully integrated into the history of art that a critic can confidently speak of "classical" Dadaism.[83]

The idolizing of artifacts within modern art finds a parallel in archaeology, demonstrating that contemplation has re-entered, so to speak, by the back door. Only now contemplation is no longer concerned with content but with surface, thus further tipping the balance of experience toward the aesthetic. An analogous process can be seen in the realm of drama, where the Theater of the Absurd, for example in Beckett, has a decidedly meditative character. Similar tendencies can be observed in contemporary music.

This look at modern art is of interest because the polemics against the ideal-ized eighteenth- and nineteenth-century definition of art have led to forms that call for more active viewer participation, rather than mere visual contem-plation. This too can be traced to the early Dada period but has gained general

importance only after World War II. The purpose here is to include the viewer in the work of art either spatially or through participation in an event, and hence the distance between work and viewer that still survived in rudimentary form as a remnant of devotional contemplation is eliminated. But again, the point is not mere distraction and diversion. Quite the contrary, Environments and Happenings often have a decidedly meditative character. In the Environment this is often apparent in a paucity of motifs and a highly concentrated atmosphere. Similarly, the Happening utilizes a great amount of time with minimal action and constant repetition of the same theme. Seemingly senseless gestures thus obtain an almost ritual quality. The statements by former Happening artists about their intentions are not unequivocal. While they originally had a critical or even satirical goal, everything has subsequently given way to quasi-ritual.[84] In the last few years several new approaches have become apparent, which partly recall Marcel Duchamp. In the future, these may gain greater import still, namely the transference of scientific modes of reception to the realm of aesthetics.

For the viewer, contemplation is equivalent to an idealistic definition of art that postulates that artistic creativity originates in the artist's inner imagination. Benjamin thought he could offer an alternative to this obsolete mode of contemplation: "Architecture has always represented the prototype of a work of art, the reception of which is experienced in a state of distraction by a group. The laws of its reception are most instructive."[85] This view is correct in the sense that architecture could never be received in the same distanced, optical manner as could a painting; it demands bodily and spatial experience that is gained by moving in and around it. Yet, this is primarily only a generic difference. The case is again different for music; here, the listener identifies with the vibration and thus does not have the same distance as in the experience of painting or sculpture. Furthermore, music has always been received collectively by a large audience. It is also a fact that characteristic aspects of the reception of architecture and music have been transferred to the pictorial arts, which constitutes a dismantling of the traditional, idealistic attitude. It is wrong, however, to link the reception of architecture with distraction and mere use. Surely there are unconscious effects that architecture may in the long run produce; as a conscious act, even the "walking through" (*Begehen*) of architecture demands an inner concentration of the public.[86]

Let us finally return to the question, what can be deduced from this for the appropriate contemplation of the historical work of art? One can certainly conclude that the type of aesthetic contemplation propagated by Winckelmann for Classical art is not historically binding. As such, this form of contemplation is not absolute, nor eternally valid. It is, however, still connected to

the older form of spiritual contemplation but has shifted toward a more general aesthetic plane. Historically speaking, this process parallels the one that negates the original function of works of art and turns them into collectors' items. There was from the beginning a certain noncommittal element about it, not to mention that the practice itself was problematical, a point already addressed by Herder, Goethe, and Moritz.[87]

How the experience of modern art will effect the reception of historical works is difficult to assess. The deification of artifacts, buttressed by the elevation of ordinary objects to works of art worthy of contemplation, now conversely effects a fetishization of works of art and thus has a measurable effect on museum policy. Nowadays, museum galleries are usually darkened; objects radiate under the magic beam of spotlights that create dramatic highlights and shadows. This nonsense is especially unfortunate for Graeco-Roman monuments: the art of Classical antiquity is thus transformed into a kind of cave culture. The new type of museum, which one could characterize as a type of historical wonder-grotto, in turn influences contemporary art, with its Environments in the form of cult caves, an important element in the last few years. The idea cannot be discounted that one day historical works of art may even be incorporated in Environments and ritual Happenings; this would be logical in the sense of the modern reception of works of art. The loss in contemplation would be offset by a gain in action. The typical, ritual attitude of the museum visitor may be understood as a type of Happening that should offer plenty of material to modern artists. As far as archaeology is concerned, a specifically anti-archaeological Happening has already been proposed in jest, permitting the audience the opportunity to bury objects from the Academic Art Museum in the Hofgarten in Bonn.

In archaeology one cannot avoid augmenting mere visual contemplation with concrete actions, as, for example, in questions of restoration. Furthermore, despite Valéry's negative commentary, the methodical-scientific engagement with the work of art remains a legitimate and even necessary component of artistic contemplation, if this is not to become totally irrational. A scholarly guided-tour additionally offers the opportunity to help a larger audience achieve a common state of concentration and thus a complete experience. It is undoubtedly true that in this manner the "aura" cannot be captured. Closer study reveals that almost all art-historical evaluations, even those concerning form, can be done from good reproductions. As desirable as it may be to have scholarly tours in front of originals, the commentaries they produce reveal that they often do not refer to the original and thus could be done just as well with reproductions. This is especially true today, when formal considerations have receded in favor of historical questions in contemporary scholar-

ship. There is no special need to discuss these in front of the originals, which are used merely to illustrate a point.

I would like to consider this issue once more dialectically to avoid the mistaken impression that the importance of the original is marginalized because of its relative inaccessibility. Inasmuch as the original possesses artistic authority, it personifies, so to speak, the persuasive power of the work of art. I don't want to propose, of course, that the richness and radiating depth of Rembrandt's brush or the lively grace of a Greek marble statue can be captured by a perfect color reproduction or a dull plaster cast. Far from it. Indeed, there is always the danger of falsification, as is always an issue, for example, with photography. But one can state that art-historical knowledge has not penetrated into the realm of the original as far as it has artistic authority but remains in the same relationship to the original as the material reproductions.

That branch of art history that comes closest to the original qua original, namely connoisseurship, is the least able to articulate it. Connoisseurship manifests itself only in laconic attributions or de-attributions, or in the observation that something is an original or a mere copy.

There is something else to consider in regard to the appearance of the original: After an immersion in the original works of art of a period, a school, or a master, it is possible to add conceptually the qualities of the original to the copy. Every archaeologist worth his salt is able, for example, to consider issues of workmanship, surface, patina, etc., when studying the photograph of a new discovery. Nevertheless, as far as art is concerned, the effect of the original is more inspiring than the reproduction. It is not uncommon that the encounter with the original leads to an idea that can later be tested with the reproduction, but the reproduction would not have led to the idea.

Parenthetically let me suggest a critical exercise that is not always undertaken at the proper moment: to test whether one is really dealing with an original. When surface treatment is first and foremost the factor that contributes to an ancient work's value and artistic authority, we must admit that it is usually not an original, since in works of marble we are certainly only dealing with an intermediary state; the completed object was covered with colors and wax glazes.[88] Experts know how paintings have been manipulated in this respect by modern restoration.

One can endlessly debate about original, copy, and reproduction because, contrary to common belief, they do not stand in a purely mechanical relationship, but in a dialectical one. Even the technically most perfect, detailed reproduction contains an element of interpretation, as for example a flattening of the material structure in even the most faithful color reproduction. Photography, the most common means of reproduction, is indeed replete with ar-

bitrary interpretations. Oscar Wilde commented that "cows are very fond of being photographed, and, unlike architecture, don't move."[89] It is well known that photographs of works of art and archaeological objects can be dated by their own style.

We cannot here pursue in greater detail the relationship between original and copy but must content ourselves with a final comparison. An original, as long as it has artistic authority and personality, is much like the book and its author. One can understand the book without ever having met the author. When one does meet the author personally, then one's understanding of the book gains an added dimension, without, however, altering its content.

The solution to the problem of transforming the aura into an object of concrete experience cannot be forced externally. That the present-day pursuit of this solution has primarily an illusionary and uncritical character denies neither its existence nor its value. For historical consciousness it is imperative to restore the hierarchy of works that has become lost in modern, so-called autonomous, art. Polykleitos said that work becomes most difficult when clay approaches the thickness of a nail, and further that perfection derives from many different dimensions, of which the smallest is the most important.[90]

It is said that Leonardo worked on the *Mona Lisa*, the portrait of a young Florentine woman, for three years.[91] With works of such sublime character, the original may possess an unsurpassed and irreplaceable *artistic* value. This is matched on the part of the viewer by certain trained receptorial faculties— among them, but by no means solely, connoisseurship. They are the same faculties employed in literature to clarify the historical difference between a poetic stanza and an advertising slogan ("I wandered lonely as a cloud" and "Coke's the One").

In these cases the original represents a concrete artistic value that enables the knowledgeable viewer to partake of certain spiritual experiences. But the authority of the original, the aura in the sense of Benjamin, depends by no means solely nor even mostly on these artistic and intellectual properties. Even totally nonartistic objects, like inscriptions or ordinary objects that are tied to historical memories (for example, an executioner's sword) are historical originals whose aura cannot be reproduced.

ARCHAEOLOGY AS A MOTIF IN CONTEMPORARY ART

Since the late 1960s a new and perhaps only passing connection between archaeology and the plastic arts has arisen. This connection was underscored in 1972 by the public exhibition in Paris of the model of Ostia by Anne and Patrick Poirier.[92] The prerequisites for this development are, however, funda-

mentally different from earlier contacts between the two fields. Their connection no longer depends on a shared theme, namely the antique, but rather on a common sensibility. The subject of contemporary art has become archaeology itself, rather than the artifact of archaeology. Evidence is that today's artist no longer differentiates between past cultures and the phenomena of his contemporary surroundings, of ethnology, and the relics of his own life. Thus the artist engages in a kind of archaeology of the present. In these works there is a certain sensibility toward the passage of time that borrows its forms from archaeological experience.

Like other developments in contemporary art, this one also encounters difficulties in eliciting the comprehension of the audience. It is an old prejudice that a work of art should immediately convince and that if it does not, the artist cannot claim legitimacy. Modern art in particular has been accused of being esoteric and, politically speaking, antidemocratic. But this is a fundamental misunderstanding. Every artistic production presupposes a certain level of communication that provides the basis for its understanding. One could compare the modern art of any time with a game that one plays before the rules have been established. Value is then solely determined by the inner necessity of the work that serves to convey an important facet of reality. The viewer has to participate in this game if he wants to understand the content of the work. The incomprehension with which any new art is first met is evidence of this. It happens as frequently that the rules of play of an earlier art have been forgotten; consequently, the old work of art is no longer understood and thus prone to destruction. One must allow for such as yet undefined rules of play—to remain with this metaphor—in contemporary art. They interest us in this context because they have been borrowed from the perceptions of the archaeologist.

The things that are the focus of archaeology are different from others in that they are more intensively colored by a sense of lived, historical time. Theoretically, time can only be experienced and transmitted as a succession of events, but for archaeologists it manifests itself in objects. The plastic arts must use this device when they want to represent time as lived experience and as memory, which Futurism actually attempted with success. But, whereas Futurism suggested abstract movement or process, in archaeology one touches on phenomena that have become more or less part of every archaeologist's aesthetic consciousness through his practical work. In part this is due to the objective characteristics of the archaeological find, in part to the relative conditions and circumstances of those finds. For example, the different types of patina, a kind of historical sediment on marble and bronze objects, belongs to the first group of phenomena. In modern times this has always been consid-

ered an aesthetic value. Whether this was already the case in the Roman Imperial period is disputed, but possible. It was certainly undesirable in the Greek Classical period; rather, marble statues were painted and bronze sculptures were polished to a high golden sheen. Roman connoisseurs sought another characteristic, also favored today: traces of lived experience, such as marks resulting from long use. This was particularly the case for silver utensils, which were more valuable the more worn the decoration and the figures. A pleasing patina has always been considered to have high aesthetic value; since the end of the nineteenth century, modern art included stronger traces of aging and the sense of transience. In this respect art has become ever more ruthless. Corrosion and encrustation in all its manifestations, a poisonous green patina, blistered areas melted by fire, traces of burns, shrill tints, drips and dabs of paint on the surface, etc., all become vehicles for artistic expression in contemporary works of art. Similarly, the use of the torso and of fragments in general becomes ever more radical. For Rodin the torso still had an aesthetic balance that paradoxically made it the carrier of heightened vitality, in spite of its destruction; in more recent art the torso, mutilated and decrepit, has lost all elevating potential and reflects only the process of inevitable decay. Yet the transience of life is not conjured up in the sense of the baroque; rather, in modern art, decay is neutralized into another form of becoming and change of structure. Often, neither the macabre representations nor the revolting materials escape an aesthetic cast, to be considered at first fascinating, then, in the end, even beautiful.

In these cases we deal mostly with given characteristics that, in regard to historical time and lived experience, often exhibit a dispassionate quality; they deeply impress, however, within the ensemble of an archaeological find. The excavated tomb with its jewels on a skeleton and offerings in situ, the quickly hidden hoard of coins in a burned pot, offerings stored in depots, the subterranean cult chambers with broken utensils, etc., all are capable of deepening one's sense of time as existential and fateful. Artists of the 1970s used objects in this sense. More subliminal are the small, often unnoticed events that take place before the eyes of the archaeologist and seem to repeat the aging of the objects. More crass examples of this kind are the fading colors that Fellini made a motif in his film *Roma*, and the sudden deterioration of wooden parts.

Not only objects, but the activities of the archaeologist prompt a greater awareness of memory linked to those objects; this has been given considerable symbolic value in modern art. Excavations, the observation of sedimentation and organic discolorations (as from post holes), the cleansing of encrusted objects that elucidate their long history by their stratifications, the revelation of the finest structure by the use of damp filter paper pressed against the surface

with a brush, casts of profiles, etc.—all these can be isolated from their practical applications for expressive purposes in and of themselves. Even the creation of inventories and the museum-like arrangement of insignificant objects can be elevated to symbolic gestures.[93]

The archaeologist participates in these processes in two ways: first as researcher for whom the processes are only a means to a goal, and second as museum curator who physically displays the finds. In this respect the archaeologist is particularly close to the modern artist, and it is here that the respective influences become most apparent. The wooden boards strewn with earth, sand, or ash that have been used for generations in archaeological museums to demonstrate stratification show, for example, surprising similarities to the modern sand paintings of A. Tàpies.[94] The connections are often more complex than they may appear on first glance. When the displays in the Römisch-Germanisches Museum in Cologne were prepared for public exhibition, lamps and other similar-looking items were arranged according to an aesthetic principle common in modern art, namely the serial arrangement of more or less identical objects. This type of display has long been customary in natural history museums but was disparaged as dull and uninteresting when it merely brought together objects of the same size. Seriality has always been consciously employed in archaeological and natural history museums in their developmental displays (as of utensils, for example), as well as in their publications. Science here developed the aesthetic prototype that modern art discovered as an independent concept and severed from its practical context. This process can be generalized and has had deeper effects than first thought possible. It is not important to establish the priority of one over the other. It is more important to recognize that artistic, seemingly willful forms have a parallel in another area where their form is logical and consistent with their use.

Among those concepts first developed in the context of archaeology before they were adopted in the plastic arts are, for example, the autonomy of the torso, the empathy with the shapes of utensils and material structures, the aesthetic approach to ordinary objects and unattractive materials. The gesture of the neo-Dadaists to elevate defective, ordinary objects to the level of works of art by placing them on a pedestal had been done thousands of times in archaeological museums. Dehydrated food, leached-out glasses, fissured amber, all were exhibited long before they became themes in modern art. The historical "aura-tization" of humble things long preceded its artistic one; without the scientific deification of artifacts (which was of course always latently present), the artistic deification would not have been possible, or at least not in this way.

Although the activities in both areas have led to very similar sensibilities, their paths divide at that point where questions of form are concerned. The ar-

chaeologist differentiates between real time as historical past and the present in the very act of dating his objects. His approach remains indebted to Idealism, in that he imagines or scientifically reconstructs a former whole through the fragmented find. In making stylistic connections, relying on economic and political information, etc., he subjects his monuments to a rational, historical conception of time, which is characterized by clearly defined chronological sequences, by stylistic influences, and by cause and effect. In contrast, the plastic arts of the last few decades suppress and sabotage all those characteristics that may lead us back to a former whole and its rational existence; instead, they insist on the chance encounter with the object. Thus it is perfectly correct that the first Dadaists rejected archaeology as a rational science. Tristan Tzara did this programmatically in his Dada-Manifesto of 1918 when he called not only for the abolition of logic but also stated: "Dada = abolition of archaeology."[95]

An example of this attitude may be seen in the work of Jürgen Brodwolf, an artist who works as a restorer and often includes archaeological motifs in his work. In 1974 he exhibited a set of metal shelves on which he had placed three shrunken "corpses" bound in white cloth that were reminiscent of mummies as well as of the plaster casts of the victims of the eruption of Vesuvius in Pompeii (fig. 113).[96] At the same time he exhibited drawings he had done on the plates of a popular nineteenth-century art history book, W. Lübke's *Denkmäler der Kunst* (fig. 114).[97] Following the taste of the period, the monuments reproduced in the book were reconstructed as much as possible, or at least sketched in, so that the processes of decay and corrosion were barely apparent. Brodwolf deconstructed this idealistic reconstruction by returning the overly smooth figures to a state of decay and ruin; he also furnished the burial chambers in the pyramids with brittle mummies. The reconstruction is stripped of its rationality, and the fortuitousness and ambience of the original find, with its poetic and symbolic values, is rediscovered. Brodwolf's approach to decay is not merely sentimental, as in Romantic painting; rather, the arrested contrast with the idealized model gives the impression that the irrational form has been scientifically and rationally derived from its model. Sublime moments are totally absent, and the directional markers included in the drawing underscore its prosaic, quasi-textbook character.

The best-known modern artwork of the archaeological type is the model of Ostia by the Poiriers. They presented a first variation on classical monuments in 1971 when they made casts of the herms in the garden of the French Academy in Rome, the Villa Medici.[98] They made paper casts in accordance with the process used to make squeezes of inscriptions and exhibited these white crumpled figures in wood and glass display cases, in which they looked

113. J. Brodwolf,
*Wrapped
"Mummies"*

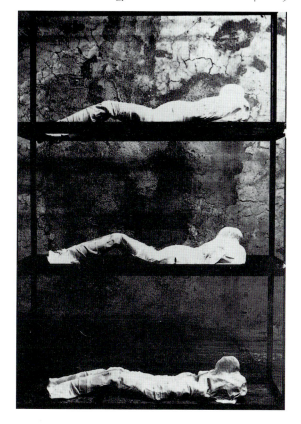

like ghostly mummies or sarcophagus lids. Accompanied by inscriptions, measurements, and numbers, they looked like scientific displays, like objects in a natural history museum. The cases were not displayed individually but formed part of a larger ensemble of photographs, drawings, and collages. The contemplation of the viewer was no longer focused on individual, isolated works of art; rather, the display demanded a quasi-scientific attitude by forcing the viewer to trace the idea in various media; all facets of the exhibition are thus relevant to the problem discussed above. Aesthetic reception is here, if only formally, equivalent to scientific reception; the aesthetic appeal of the brittle and crumbly surface that could be peeled off like a film is also important in the Ostia work. Here again we deal with an assemblage of different media, including paper casts of Roman walls in *opus reticulatum*. Peeling paper is a *Leitmotif* in modern art, known from advertising columns and their artistic counterpart, collages. Marcel Proust made sublime narrative use of a related phenomenon:[99]

114. J. Brodwolf, drawing of two figures (L, M) from the east pediment of the Parthenon

For three years my mother ignored the minute traces of lipstick one of her nieces used, an amount so small as something invisibly dissolved in a liquid, until that day when one extra particle, and a different circumstance, brought about that phenomenon we call supersaturation. At that moment, the previously ignored lipstick crystallized, and faced with this sudden orgy of color, my mother pronounced . . . this a disgrace and broke almost completely with her niece.

The model of Ostia, which bears the anonymous title *Ville Construction*, consists of 288 individual component parts of fired clay, books with texts and drawings, photos on porcelain, and casts, which together make for a model measuring 11.40 x 5.75 m (fig. 115). The model itself is based on a sketch-like plan made without scientific precision but also without purposeful distortions. It is done in a monotone, rather plain and drab, and the joints between the individual slabs have not been smoothed out. The whole is constructed without sentimental exaggeration, without falling prey to the romanticism of ruins. Significantly, vegetation has been left out. The photographs of the model, as well as the accompanying photographs of the original ruin are grey, without light, and void of painterly charm. The plans, drawings, and texts give in part

115. (Top) View of ruins, Ostia; (bottom) Anne and Patric Poirier, *Ville Construction*, clay model. Aachen, Neue Galerie

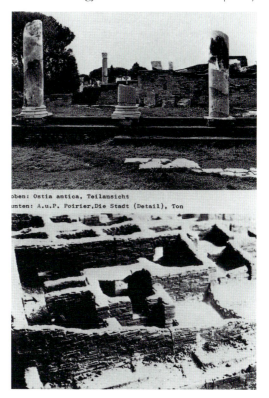

oben: Ostia antica, Teilansicht
unten: A.u.P. Poirier,Die Stadt (Detail), Ton

the impression of scientific archaeological investigation, in part one of personal perceptions recorded during the making of the work. They are subjective, floating impressions that seamlessly blend present and past: the inaudible decay of ruins, the leaden heat, the noise of aircraft from nearby Fiumicino, the modern barbed wire surrounding an area in which time seems to have been arrested. Only the work of the archaeologists disturbs the peace; they search for memories and try to glue the fragments back together:

A buried house, arrested time.
It seems as if the forces of destruction have never stopped spreading,
OSTIA slowly depopulates itself.
OSTIA is becoming a barren and deserted place.
One digs, one turns up the earth to find memories in its moist ground
penetrated by nature; stones and ruins appear in the silence;
a second silence; airplanes . . .
the noise of shovels: one tries to reassemble the pieces.
hours pass; time stops; silence.

They died of hunger, malaria, from this silence.

Time, this time has stopped.

A field of ruins has been shored up, like time, in this forbidden zone,

surrounded by barbed wire; a privileged zone, guarded by day and guarded by night;

they have destroyed the houses with great clamor, the inhabitants

have scattered,

the pink city extinguished, the city dissolving; death.

The earth heaves, time flows past.

they forget.

The ensemble of the Ostia work has an ostensible archaeological tenor that pushes the viewer to a pseudo-scientific form of reception. A simple contemplative approach to the work is thwarted, as the object, monotonous and without expression, neither evokes a sentiment nor creates the mood associated with ruins. The viewer is not guided toward an idealized reconstruction that would lead him into an objective, rationally defined historical past. Modern artists and critics often speak of memory as a search for a lost time, in the sense of Proust. But memory belongs in the realm of the personal, which is not the same as history. The Poiriers' *Ville Construction* refers to a kind of history beyond history that is not subject to a rational, constructing history but is treated like an existential, personal memory. It is a negative "coming to terms" with rational history with a sensualized mode of perception that remains decidedly on the surface. That which rational history represses, namely the existential experience of history as a diffused, uncanny memory of humankind, returns here as a nightmare.

The span of history no longer has a perspectival orientation but is experienced as a vacuous emptiness, as elapsing silence.

The Ostia work is no longer based on the concept of a single object ideally accessible through contemplation and empathy. Rather, a pseudo-scientific, abstract perception is juxtaposed with an emotive one. For this reason, as well as this work's fundamental opposition to empathy, it cannot be characterized solely as a contemporary, alienated, and dispassionate variation of the love for ruins, although, according to its motif, that would be correct.

While the idealist approach tries to free monuments as much as possible from the arbitrary element of their existence and to re-establish them as an autonomous whole, modern art insists on the existing condition, on decay, defacement, and the reflexes of a given environment. In Adalbert Stifter's *Indian Summer*, one sees already how the atmosphere of a specific environment colored the representation of a classical monument.[100] In the notes for the model of Ostia of the Poiriers, this tendency is so developed that even what is old is

barely able to lead from the present into the past; instead, it is mostly registered as present, i.e., as visible, unfolding decay. This attitude has led modern art to insist on the dominance of the condition and its haphazard environment, and to assign a decisive importance to surface. It was again Marcel Proust who, in his inimitable way, noted this particular sentiment in *Within a Budding Grove*. His observations are of particular importance since they consciously contrast a sentimental with an idealistic reception, while simultaneously acknowledging the problem of copy and original. The narrator disembarks at Balbek to look at the original portal figures of the cathedral in situ, known to him from reproductions, and cannot maintain his idealistic attitude in the face of reality. The figures are totally lost in their prosaic environment, and the narrator, who had hoped to be swept away by the original, after fruitless efforts dejectedly departs. One could say, however, that that which has a negative connotation from the point of view of idealism has become a part of reality for modern art and is thus a subject for representation:[101]

> Like the young man on the day of his exams or a duel, who will not find much importance in the questions he has been asked, or the bullet he fired, compared to the vast reserves of his untapped knowledge, and courage, that he so much would have liked to demonstrate, so was I astonished when I saw the Virgin in the portal without all the reproductions I had seen and constructed in my own mind, inaccessible to the vicissitudes that might endanger these, forever intact even if they were destroyed, ideal and with universal value, this statue, recreated in my mind a thousand times, now reduced to stone, within arm's reach where she had to compete with an election notice and the tip of my walking stick; chained to a distinct location, inseparable from the corner where the main street entered, forever subjected to the glances from the café and the bus station, her face illuminated by half the rays of the setting sun—and soon, in a few hours, by the light of the street lamp—whereas the discount bank received the other half, and together with this branch of a credit institution she shared the stale air wafting from the bakery shop; this famous Virgin was so subjected to the tyranny of uniqueness that, if I had wished to write my signature on this stone, it is she, the illustrious Virgin, whom until then I had endowed with a general existence and an intangible beauty, the Virgin of Balbek, the unique (which means, alas, the only one), who on her body soiled with the same soot as the neighbouring houses, would have, without being able to rid herself of it, showed to all admirers who came there to contemplate her the marks of my piece of chalk and the letters of my name.

The viewers of the model of Ostia were frequently reminded of an older

genre of art rediscovered a few years earlier, namely cork models of classical architecture from the last quarter of the eighteenth century. These were reproductions of well-known Roman buildings that were sought after both as souvenir and archaeological teaching tool. A group of the highest quality, signed by a certain Antonio Chichi, best reveals the characteristics of this type.[102] Unlike Piranesi's romantic exaggerations of classical architecture, these models appear sober and instructive. The Pantheon, for example, can be opened in the middle to reveal the interior (fig. 116). These cork models limited themselves to depicting the actual state of the buildings; reconstructions are rare. Sometimes the buildings are placed on a ground, but without indicating vegetation. Cork had earlier been used for the making of crèches; here it was evidently used because its brittle, porous structure could best convey a sense of the corrosion of the original surfaces. The similarity in aesthetic effect to the model of Ostia is surely no accident, coinciding with the date of rediscovery in the late 1960s. Located historically between the romantic attraction for ruins and idealistic reconstruction, the cork-builders used the archaeological find as a point of orientation. They belong in the same category as Trivial Archaeology, a pursuit popular in Goethe's time in Rome; the Privy Councillor Reiffenstein and his circle of dilettantes devoted themselves to the

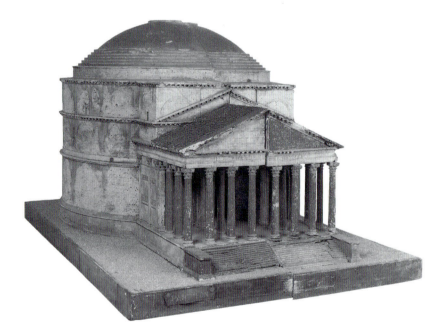

116. Cork model of the Pantheon, Rome. Darmstadt, Hessisches Landesmuseum

reproduction of antique sculptures in wax colors and pastes.[103] It is more than possible that Reiffenstein himself had influenced the construction of the cork models: he acquired a set for Germany.

A group of artists interested in archaeological motifs mounted an exhibition in 1974 in Hamburg and Munich under the title "Safeguarding the Traces: Archaeology and Memory."[104] The issues addressed by individual contributions indicate that the point of orientation is not antiquity as objects, but archaeological activity as a symbolic gesture of memory. The French artist Didier Bay, using numerous banal photographs, attempted to explore the environments of his Paris housing blocks for "simultaneously real and symbolic occurrences."[105] Christian Boltanski and Nikolaus Lang created museums of unsightly objects and refuse and added fictitious biographical references to enrich the element of memory.[106] Measurements, numbering, inventory entries all suggest scientific-archaeological work that here, as they are simulated and nonsensical, obtains a purely symbolic character. Claudio Costa used old anthropological photographs of Maori with tattoos and headgear and transferred them unaltered to the canvas and included a text: "The hidden colors of the forest in the eyes of the Maori."[107] Already mentioned above are the contributions of Brodwolf and the Poiriers.

In an exhibition in Cologne entitled *Project '74*, Claudio Costa displayed an old-fashioned vitrine filled with crude reproductions of heads, hands, and feet of prehistoric people.[108] The other motifs of the "archaeological" search for memory were to be found as well in different variations. Especially remarkable was the exhibit by the American artist Norman Daly, who invented an ancient culture called "Llhuros," complete with fictitious finds, inscriptions, etc., and all the necessary scientific literature.[109] While other "archaeologists" brought the artifact to its crudest form, in his work there was a playful note of parody. His idea finds a precursor in Honoré Daumier, who parodied the Classical myths on fictitious reliefs.

NOTES

Although Himmelmann regarded these reflections as an essay in cultural criticism rather than as a historical study, the editor felt that it also serves the latter function. Consequently references to the sources of quotations cited in the study have been

added with the extensive aid of Himmelmann; notation of English translations have been made wherever available to the editor. The citation at the head of the treatise from Emerson, "History," may be found in *The Collected Works of Ralph Waldo Emerson*, ed. A. R. Ferguson and J. F. Carr (Cambridge 1979) II: *Essays, First Series* 15.

1. *Mignon*: "Do you know the land where the lemons blossom?"

2. W. Benjamin, *Das Kunstwerk im Zeitalter seiner technischen Reproduzierbarkeit* (Frankfurt 1963) 16 (§2) (originally published as an essay in 1936).

3. J. W. von Goethe, *Italienische Reise*, in *Goethes Werke* (Hamburg 1957) XI, 7; *Italian Journey*, trans. R. R. Heitner (New York, 1989: Suhrkamp edition, vol. 6). All references to Goethe's works in German are to the Hamburg edition (1950–59); in English the references are to the Suhrkamp (New York) edition of 1983–89, unless otherwise noted.

4. J. W. von Goethe's *Roman Elegies and Venetian Epigrams, A Bilingual Text*, trans. L. R. Lind (Lawrence [KS] 1974) 92–93.

5. O. A. W. Dilke, *Greek and Roman Maps* (Ithaca [NY] 1985) 22–23, 56–57. Anaximander: W. K. C. Guthrie, *A History of Greek Philosophy* (Cambridge 1967) I, 74; Hecataios: K. von Fritz, *Die griechische Geschichtsschreibung* (Berlin 1967) I, 48–76.

6. Praxiteles' Aphrodite: Pliny *NH* 36.20; Pheidias's Zeus: Polybios 30.15.3; Livy 45.28, on which see further below.

7. *Imagines* 1.1.

8. Plutarch, *Aemilius Paullus* 28.5.

9. Herakles Epitrapezios: J. J. Pollitt, *Art in the Hellenistic Age* (Cambridge 1986) 50–51, fig. 42.

10. J. J. Winckelmann, *Beschreibung des Torso im Belvedere zu Rom*, in *WKlSchriften* 169–73; Belvedere Torso: A. F. Stewart, *Greek Sculpture: An Exploration* (New Haven 1990) 230, fig. 856.

11. Thus the statement by the painter Parrhasios: Pliny *NH* 35.71.

12. Incertis auctoris, *Aetna*, ed. F. R. D. Goodyear (Cambridge 1965) lines 568–99.

13. *Life of Hadrian* in the *Historia Augusta* 14.3.

14. *The Marvels of Rome (Mirabilia Urbis Romae)*, ed. and trans. F. M. Nichols (New York 1986).

15. A. Rumpf, *Archäologie* (Berlin 1953) I, 36–37.

16. *Familiarim rerum* IV, 1 (Mount Ventoux); VI, 2, 15ff. (Baths of Diocletian) in Francesco Petrarca, *Le familiari*, ed. V. Rossi (Florence 1933) I, 153–61; (Florence 1934) II, 58ff.; translations of the Mount Ventoux letter are widely available in English, e.g., *Petrarch: A Humanist among Princes, An Anthology of Petrarch's Letters and Selections from His Other Works*, ed. D. Thompson (New York 1971) 27–36. See also J. C. Burckhardt, *Die Kultur der Renaissance in Italien*, Part III, §2 (see below, n. 17).

17. *Die Cultur der Renaissance in Italien* (Leipzig, 1860; first English translation, London 1878) *s.v.* Pius II.

18. L. Friedländer, *Erinnerungen, Reden und Studien von Ludwig Friedländer* (Strassburg 1905) II, 449.

19. M. E. Montaigne, *Journal de voyage*², ed. L. Laudrey (Paris 1909) 206.

20. Sigmund von Birken, *Hochfürstlicher Brandenburgischer Ulysses* (Bayreuth 1669) unpaginated, text pp. 7, 8.

21. Johann Balthasar Klaute, *Diarium Italicum* (Kassel 1722) introduction, n.p.

22. L. Schudt, *Italienreisen im 17. und 18. Jahrhundert* (Vienna 1959) 139.

23. R. Lassel, *An Italian Voyage or A Complete Journey Through Italy* (London 1698; original edition, Paris 1670) II, 156.

24. Montaigne, *Journal de voyage*[2] (above, n. 19) 239–41.

25. L. Friedländer, *Erinnerungen* (above, n. 18) II, 458.

26. *Selbstbiographie des Senator Barthold Heinrich Brockes*, ed. J. M. Lappenberg, in *Zeitschrift des Vereins für Hamburgische Geschichte* 2 (1847) 167.

27. Montaigne, *Journal de Voyage*[2] (above, n. 19) 205–76.

28. Stendhal, *Promenades dans Rome*, in his *Oeuvres complètes* (Geneva-Paris 1986) VIII, 107–9; Chateaubriand, *Mémoires d'outre-tombe*[2], ed. M. Levaillant (Paris 1964) 423–24, 436 (3e partie, 2e époque, livre 8, §7, 9); *The Memoirs of François René Vicomte de Chateaubriand*, trans. A. Teixeira de Mattos (London 1902) IV, 243–44, 257.

29. Friedländer, *Erinnerungen* (above, n. 18); H. Jedin, *Die deutsche Romfahrt von Bonifatius bis Winckelmann* (Krefeld 1951); Schudt, *Italienreisen* (above, n. 22).

30. *Abhandlung von der Fähigkeit der Empfindung des Schönen in der Kunst*, in *WKlSchriften*, 220.

31. Ibid., 233.

32. Goethe, *Winckelmann*, in *Goethes Werke* (Hamburg 1953) XII, 110 (§Mengs); *Winckelmann and His Age*, in *Essays on Art and Literature*, ed. J. Gearey, trans. E. and E. H. von Nardroff (New York 1986 [Suhrkamp edition, vol. 3]) 108.

33. Anne Claude Philippe Comte de Caylus, *Vie d'artistes du XVIIIe siècle: Discours sur la peinture et la sculpture (Salons de 1751 et de 1753); Lettre à Lagrande*, ed. A. Fontaine (Paris 1910).

34. J. J. Winckelmann, *History of Ancient Art*, trans. A. Gode (New York 1968) preface §3, pp. 3–4. Note that the translations in the text here and elsewhere are those of D. Dietrich and J. Borsch, with the exception of passages originally in English.

35. J. J. Winckelmann, *Briefe*, ed. W. Rehm and H. Diepolder (Berlin 1952) I, no. 151, p. 235, to Berendis, probably 7 July 1756.

36. *Sendschreiben Von der Reise eines Gelehrten nach Italien und insbesondere nach Rom an Herrn M. Franken*, in *WKlSchriften*, 190.

37. *Empfindung des Schönen* (above, n. 30) in *WKlSchriften*, 213–14.

38. *Vorrede* to *Anmerkungen über die Geschichte der Kunst des Altertums*, in *WKlSchriften*, 251. See also *Sendschreiben Von der Reise eines Liebhabers der Künste nach Rom an Herrn Baron von Riedesel*, in *WKlSchriften*, 204.

39. Ibid., 252. This begins a tradition that includes, among others, Rilke's "Apollo's Archaic Torso," (1908) in which aesthetic experience also leads to an ethical demand: "You must change your life."

40. *History of Ancient Art* (above, n. 34) IV, Book xii.iii.13 (p. 365).

41. *Vorrede* to *Anmerkungen* (above, n. 38) in *WKlSchriften*, 253.

42. *Erinnerung über die Betrachtung der Werke der Kunst*, in *WKlSchriften*, 150–51.

43. *Empfindung des Schönen* (above, n. 30) in *WKlSchriften*, 212–33.

44. Ibid., 214; see also Winckelmann, *Briefe* (above, n. 35) I, no. 164a, pp. 257–58. Barberini Faun: Stewart, *Greek Sculpture* (above, n. 10) 207, fig. 676; Apollo Belvedere: ibid., 191, fig. 573.

45. C. Justi, *Winckelmann und seine Zeitgenossen*[3] (Leipzig 1923) II, 271.

46. For the Apollo, above, n. 44; Belvedere Torso, above, n. 10.

47. *Briefe* (above, n. 35) I, 212, no. 135 (20 March 1756), to J. W. Franke.

48. *History of Ancient Art* (above, n. 34) XII, iii §11 (pp. 312–14). The following quotations are all from this single passage on the Apollo Belvedere. The earlier, longer versions of the text may be found in *WKlSchriften*, 269–79.

49. A. R. Mengs, "Fragment d'une seconde réponse de M. Mengs à M. Fabroni," in his *Oeuvres complètes* (Paris 1786) II, p. 20.

50. J. C. Burckhardt, *Der Cicerone: Eine Anleitung zum Genuss der Kunstwerke Italiens*⁹ (Leipzig 1904) I, 93–94. The original edition is dated 1855 and an English translation was made in 1873.

51. D. Diderot, *Le Salon de 1765: Diderot, Salons*², ed. J. Seznec, II: *1765* (Oxford 1979) 206–7.

52. *Beschreibung des Torso im Belvedere zu Rom*, in *WKlSchriften*, 169–73. The text, much shortened, appears in the *History of the Ancient Art* (above, n. 34) X, iii §16–17 (pp. 264–65), while earlier drafts may be found in *WKlSchriften*, 280–85.

53. From the drawing "The Laocoön," in *The Complete Poetry and Prose of William Blake*², ed. D. V. Erdman (Berkeley 1982) 274, cited by J. Barzun, *The Use and Abuse of Art* (Princeton 1973) 35–36.

54. For example, G. Christoph Lichtenberg, *Verse unter die Kupfer des Gothaischen Kalenders vom Jahr 1772*, in *Georg Christoph Lichtenberg: Aphorismen, Schriften, Briefe*, ed. W. Promies (Munich 1974) 382–95.

55. F. Nietzsche, *Aus dem Nachlass der achtziger Jahre*, in his *Werke*, ed. K. Schlechta (Munich 1966) III, 644.

56. "Aus grossen Kunstsammlungen," in *Jakob Burckhardt, Vorträge, 1844–1887*³, ed. E. Dürr (Basel 1919) 193–201.

57. For example, E. Buschor, *Winke für Akropolis-Pilger* (Munich 1960).

58. "Le Problème des musées," in *Oeuvres*, ed. J. Hytier (Paris 1960) II, 1290–91. Originally published in *Le Gaullois*, 4 April 1923, and reprinted in various forms, especially in *Pièces sur l'art* (Paris 1934) 53ff.

59. "Le Problème des musées" (above, n. 58) in *Oeuvres*, II, 1291.

60. Ibid., II, 1291–92.

61. Ibid., II, 1293.

62. Ibid.

63. Ibid.

64. M. Proust, *Remembrance of Things Past: Within a Budding Grove*, trans. C. K. Scott Moncrieff (New York 1934) I [III], 310–11; (*A la recherche du temps perdu: A l'ombre des jeunes filles en fleurs* [Paris 1954: édition de la Pléiade] I, 644–45).

65. W. Benjamin, *Das Kunstwerk* (above, n. 2).

66. Ibid., 43 (§14).

67. Ibid.

68. Ibid., 48 (§15).

69. See, for example, Heinrich Heine's introduction to his account of the Paris Salon of 1831 in which he describes with moving words the homelessness of the autonomous work of art and the distraction of the audience: H. Heine, *Französische Maler*, in *Historisch-kritische Gesamtausgabe der Werke*, ed. M. Windfuhr, vol. 12.1 (Hamburg 1980) 11–12.

70. Over one million people saw the painting in the four weeks during which it was

exhibited in New York in 1963. A report cited by C. Tomkins, *Merchants and Master-pieces: The Story of the Metropolitan Museum of Art* (New York 1970) 341, informs us: "From February 7 until March 4, 1963 the Metropolitan Museum of Art was the Mother Church for the religion of art. . . . The picture was flanked by two guards. . . . Another museum attendant exhorted the pilgrims to keep moving. No one was allowed to pause in front of the shrine, and once past it the anointed were funneled out through a side entrance. . . . Nearly every day a few of them would go around to the front of the building and get in line again." What those in this pilgrimage may have thought cannot even be assumed: "For all the quasi-religious ardor with which they came to view the holy relic, what was the quality of their experience?" (ibid., 342).

71. See, for example, George Deem (formerly restorer at the Metropolitan Museum of Art), *Statistical Landscape* (1969), in P. Sager, *Neue Formen des Realismus* (Cologne 1973) color plate 1, p. 37.

72. W. Pater, *The Renaissance: Studies in Art and Poetry*[5] ([1873] London 1910) 123–26.

73. A. d'Harnoncourt and K. McShine, eds., *Marcel Duchamp*[2] (Munich/New York 1989) color pl. facing p. 128; no. 131, p. 289; no. 185, p. 315.

74. Sager, *Neue Formen des Realismus* (above, n. 71) fig. 26, p. 49.

75. d'Harnoncourt and McShine, *Marcel Duchamp*[2] (above, n. 73) fig. on p. 171.

76. Ibid., fig. on p. 195.

77. Ibid., no. 106, p. 275; no. 120, p. 282.

78. *Dada: Art and Anti-Art* (New York 1965) 90–91.

79. W. Haftmann, *Malerei im 20. Jahrhundert* (Munich 1954–55) I, 193f., II, 193, 287 (*Painting in the Twentieth Century* [New York 1960] I, 128; II, 193, 287).

80. *Kunst der 60er Jahre (Sammlung Ludwig): Hundert Werke im Wallraf-Richartz-Museum*, ed. G. von der Osten (Cologne 1969).

81. O. Bihalji-Merin, *Ende der Kunst im Zeitalter der Wissenschaft* (Stuttgart 1969) 29. Historically speaking, it is probably not totally correct to speak of an inversion of meaning, because this seemingly new way of seeing had been formulated already before Dada. The main witness is above all Rilke at the very beginning of the century with his cult of disregarded objects. These find their expression in texts that could have been written about objects of the 1960s or 1970s, as for example the description of a pencil in the hands of a Parisian panhandler:

> She stood all quiet and I believed that she, like me, was preoccupied with the contemplation of the displayed wares and barely paid attention to her. Finally, however, her presence disquieted me and I don't know why I suddenly glanced at her strangely folded and worn hands. Very slowly an old, thin, long pencil reached up from these hands and grew and grew; it took a long time until it was totally visible, visible in its total misery. I can't say what was so terrifying about this scene, but it seemed to me that an entire fate unfolded in front of me, a long fate, since the pencil grew no longer and, faintly shivering, jutted out of the lone-liness of these empty hands. [Letter to Lou Andreas-Salomé, 18 July 1903, in *Rainer Maria Rilke—Lou Andreas-Salomé: Briefwechsel*, ed. E. Pfeiffer (Zurich 1952) 56–57 (*Letters of Rainer Maria Rilke, 1892–1910*, ed. J. B. Greene and M. D. H. Norton [New York 1969] no. 47, p. 110); the passage appeared slightly altered

in *Die Aufzeichnungen des Malte Laurids Brigge* (Leipzig 1910) I, 55–56 (*The Notebooks of Malte Laurids Brigge*, trans. S. Mitchell [New York 1985] 40)].

Against this background Duchamp's gesture takes on a different meaning than it had for him and his audience; similarly, the question that he asked himself, namely whether it was meaningful to repeat the gesture, solved itself. The question would have to be negated without any doubt if only provocation was intended. The visual arts of today repeat Duchamp inasmuch as they, too, largely dispense with the representational, idealistic character of art, which they replace with arranging objects.

82. Above, n. 77.

83. Bihalji-Merin, *Ende der Kunst* (above, n. 81) 71.

84. See Wolf Vostell as discussed by O. Bihalji-Merin, *Ende der Kunst* (above, n. 81) 79.

85. Benjamin, *Das Kunstwerk* (above, n. 2) 46 (§15).

86. *Begehen* is an expression used in archaeology that describes a purposeful and concentrated walking over antique sites or antique architecture to feel oneself part of a mostly fragmentary structure. See, for example, E. Buschor, *Winke für Akropolis-Pilger* (Munich 1960).

87. For Goethe, Winckelmann's notion of the experience of art soon became a problem. As a young man he rushed to study the plaster cast collection at Mannheim; his hope of "reaching some kind of clarity" was dashed: "I didn't know how impossible it would be to revel simultaneously in the experience of looking and to maintain an objective account of the process. I forced myself to reflect critically, and as little as I succeeded in gaining some degree of clarity, I nevertheless sensed that each object was natural and important in and of itself." *Aus meinem Leben: Dichtung und Wahrheit*, part III, book II, in *Goethes Werke* 9 (Hamburg 1955) 501; *Poetry and Truth*, in *From My Life*, trans. R. Heitner (New York 1987; Suhrkamp edition, vol. 4) 371; see also *Italienische Reise* (above, n. 3) 547 (April 1788); *Italian Journey*, 442.

His journey to Italy deepened the problem. During a visit to the Antiquarium on his way through Munich, he already became aware that he lacked experience in these matters (*Italienische Reise*, 12 [6 September 1786]; *Italian Journey*, p. 15). His prognosis, in the first few weeks of his travels, about the fate of the plastic arts in general was remarkably gloomy. Thus, architecture was a dead language no longer capable of offering living pleasures: "Architecture rises up before me like an old ghost out of the tomb. She asks me to study her teachings like the rules of a dead language, not to practice or to enjoy but only to worship in a contemplative manner the eternally lost existence of former epochs" (*Italienische Reise*, 97–98 [12 October 1786]; *Italian Journey*, 82). Indeed, the era of Beauty is over: "On this journey I hope to calm my mood towards the plastic arts and to imprint my soul with its holy spirit, to guard it there for quiet contemplation. But then I will deal with the craftsmen and, after my return, I will study chemistry and mechanics. For the era of Beauty is past; now only need and demanding requirements occupy our days" (*Tagebuch der italienischen Reise für Frau von Stein*, in *Johann Wolfgang Goethe: Gedenkausgabe der Werke, Briefe und Gespräche: Tagebücher*, ed. E. Beutler [Zurich-Stuttgart 1964] 166 [5 October 1786]). Significantly, both these notations of the original diary were deleted in the final publication of Goethe's *Italian Journey*.

Already in 1768–70, J. G. Herder, who was myopic, offered in a laconically entitled

essay, "Plastik," a fundamental critique of the visual reception of antique sculpture: J. G. Herder, *Werke* (Munich 1953) I, 673ff. His concern was not so much with contemplation in general, but with mere viewing. Only when the viewer manages to translate his seeing into plastic feeling, to turn the eye into the hand, does the sculpture gain life (ibid., 681):

> Look at the connoisseur who in deep contemplation staggers around a statue. What doesn't he do to make his face seem as if in deep feeling, to appear as if he were feeling in the dark? He floats back and forth, seeks serenity but can't find it for, unlike painting, there is not one dominant point of view, thousands are not enough for him and, as soon as he adopts an established point of view, the three-dimensional becomes two-dimensional and the beautiful figure in the round breaks apart into a multitude of fragments. That is why he seems to float: his eye became a hand and the ray of light turned into his finger; or rather, it was his soul, having a much more subtle touch than his hand or the ray of light, it could grasp it! The deception is complete: it lives and the soul feels that it lives; and now the soul speaks, not as if it were seeing, but feeling and touching. A sculpture coolly described transmits as few ideas as painted music; it is better to let it alone and walk past it.

Karl-Philipp Moritz, Goethe's daily companion in Rome, draws attention to the fact that most tourists are not capable of living up to Winckelmann's high standards: "Surely nothing in this world demands more effort than when, out of propriety, one has to pretend to be in a state of ecstasy; [that is why one can state that] the contemplation of works of art brings about more suffering in this world than one would ever imagine" (K. Ph. Moritz, *Über die Bedeutung der Kunstwerk*, in *Schriften zur Aesthetik und Poetik*, ed. H. J. Schrimpf [Tübingen 1962] 238). Above all, he fundamentally criticizes Winckelmann's description of the Apollo, because it fragments the impression of the sculpture, whereas it was most important to perceive the work as a complete whole *all at once* (ibid., 244): "To me, Winckelmann's description of the Apollo of Belvedere is much too discontinuous and artificial."

88. [Editor's note: See, for example, *The Getty Kouros Colloquium*, ed. A. Kokkou (Athens 1993).]

89. Oscar Wilde, letter to Robert Ross, 21 April 1900: *The Letters of Oscar Wilde*, ed. R. Hart-Davis (New York 1962) 824. [The editor thanks Don Novak for locating this quotation.]

90. Plutarch, *Quaestiones convivales* 2.3.2; Galen, *De placitis Hippocratis et Platonis* 5 (ed. Müller, p. 425); both cited in J. J. Pollitt, *The Art of Greece 1400–31 b.c.* (Englewood Cliffs [NJ] 1965) 91–92, 89.

91. F. Zöllner, *Leonardo da Vinci: Mona Lisa* (Frankfurt 1994) 18; see also R. Whiting, *Leonardo: A Portrait of the Renaissance Man* (London 1992) 52.

92. The catalogue consisted of loose sheets that the visitor could take, but not a published work.

93. See, for example, the works of C. Boltanski in L. Gumpert, *Christian Boltanski* (Paris 1994) 47; and those of N. Lang in the Kestner-Gesellschaft exhibition catalogue *Nikolaus Lang* (Hannover 1975) no. 21, p. 50.

94. V. C. Dexeus, *Tàpies* (New York 1990).

95. T. Tzara, *Seven Dada Manifestos and Lampisteries*, trans. B. Wright (London 1977) 13.

96. *Spurensicherung: Archäologie und Erinnerung*, ed. G. Metken and U. M. Schneede (Hamburg 1974) 34.

97. Ibid., 29–33; W. Lübke, *Denkmäler der Kunst von den ersten künstlerischen Versuchen bis zu den Standpunkten der Gegenwart*² (Stuttgart 1858).

98. No formal catalogue was published of this exhibition; loose sheets were available for the visitor to take. The works are now (1996) on deposit in the Musée de Picardi, Amiens.

99. M. Proust, *Remembrance of Things Past* (above, n. 64) I [III], 3–4; (*A la recherche du temps perdu*, I, 433).

100. *Indian Summer* (*Nachsommer*) trans. W. Freye (New York 1985).

101. M. Proust, *Remembrance of Things Past* (above, n. 64) I [III], 332–33; (*A l'ombre des jeunes filles en fleurs*, I, 659–60. It is very informative to compare Goethe's highly idealistic attitude toward the same problem: *Reisebuch der italienischen Reise* (above, n. 3) 152–53 (25 September 1786).

102. A. Büttner, *Das antike Rom in Korkmodellen des 18. Jahrhunderts von Antonio Chichi und Kupferstichen von Giovanni Battista Piranesi, 1720–1787* (Karlsruhe 1969).

103. Goethe, *Italienische Reise* (above, n. 3) 406f. (September 1787); *Italian Journey*, 325–26.

104. *Spurensicherung* (above, n. 96).

105. Ibid., 12–18.

106. Ibid., 20–26, 42–48.

107. Ibid., 36–40.

108. *Kunst bleibt Kunst: Projekt '74* (Cologne 1974) 166–69.

109. Ibid., 170–71.

Index of Ancient Authors

Specific works are cited by book, canto, or line number (where applicable); page references within the present text appear in bold type.

Index of Works

This index contains references to selected works that are illustrated, discussed in the text, cited in the notes, or have a particular importance in Himmelmann's arguments. In the case of illustrated works, page numbers refer to the discussion in the text, not the location of the illustration. The inventory number of the work (if one exists) is followed by a brief descriptive phrase, which is followed by the page number in the text. Because the majority of the Roman sarcophagi do not have inventory numbers, the work's number as it appears in C. Robert, *Die Antiken Sarkophag-Reliefs* (*ASR*), is given in parentheses.

PARIS
Bibliothèque Nationale
190, Lakonian cup, 73
444, red-figure hydria, 136n. 55
bronze statuette, libator, 172 and n. 36
Musée du Louvre
183, bronze statuette, libator, 158 and n. 4
439, Aphrodite from Arles, 189
441, Apollo Sauroktonos, 189
A479, black-figure cup-skyphos, 91n. 3,
96n. 42, 100n. 64
A517, Geometric krater (fig. 10), 39, 76, 81,
83, 166
Br 4236, bronze statuette from Abbai (fig.
75), 175–77, 177–78, 179–80
C 105 (CA 860), Melian plaque, Odysseus
and Penelope, 86–87 and n. 69
C10634, black-figure neck-amphora,
131n. 9
CA2271, red-figure relief-oinochoe,
135n. 44
E635, Corinthian column-krater, 142
E688, Lakonian cup, 130n. 8
F66, black-figure cup, 74 and n. 23
F67, black-figure cup, 168 and n. 22
F225, black-figure neck-amphora, 153n. 32
F342, black-figure oinochoe, 95n. 30
G1, red-figure amphora (fig. 65), 130n. 7, 168
G151, red-figure cup, 133n. 25
G162, red-figure calyx-krater, 131–32n. 12
MA 831, decree relief (fig. 57), 158
MA 854, three-figure relief, Orpheus and
Eurydike (fig. 104), 230–31
MND 2792, marble torso from Miletos,
175–76, 179
(ASR II, 26), Roman sarcophagus, Achilles
and Agamemnon (fig. 93), 220 and n. 16
(ASR II, 26c), Roman sarcophagus, Priam
supplicates Achilles (fig. 94), 220
2119 (ASR II, 69), Roman sarcophagus,
Amazonomachy, 203–4

PAROS
Archaeological Museum
760, stele with seated figure, 42 and n. 58

PIRAEUS
Archaeological Museum
385, grave relief, Chairodemos and Lykeas
(fig. 60), 162–63, 164
4645, bronze statue, Apollo, 153n. 25,
185n. 50

PISA
Campo Santo
(ASR III.2, 164), Roman sarcophagus,
Hippolytos, 203

RIEHEN, GERMANY
Dr. G. Kuhn Collection
black-figure cup, 94n. 23

ROME
Catacombe di Pretestato
Roman sarcophagus, Medea, 232
Conservatori Palace
966, Tensa Capitolina, 221
Museo Nazionale Romano (Terme)
152, Ludovisi Throne, 193
Palazzo Corsini
671, silver vessel from Antium (fig. 91),
218–19
Palazzo Doria-Pamphili
(ASR II, 33), Roman sarcophagus,
Achilles, 220 and n. 15
(ASR III.1, 34), Roman sarcophagus,
Bellerophon (fig. 87), 207–8
Palazzo Drago
funeral banquet relief (fig. 101), 227–29
Palazzo Giustiniani
(ASR II, 156), Roman sarcophagus,
Orestes, 219 and n. 10
Palazzo Mattei
MD2235 (ASR III.2, 190), Roman
sarcophagus, Mars and Rhea Silvia
(fig. 97), 224
Palazzo Spada
1817, Bellerophon relief, 215n. 26
Vatican Museums
237 (ASR II, 194), Roman sarcophagus,
Medea (fig. 95), 223
353, black-figure amphora, 132n. 18
812, Knidian Aphrodite (fig. 80), 187–98
933 (ASR II, 92), Roman sarcophagus,
Achilles, 203
1015, Apollo Belvedere (fig. 111), 264–68,
297n. 87
1186, Ara Casali, 224
1192, Belvedere Torso (fig. 108), 252, 262,
264, 268–69
2465 (ASR III.3, 423), Roman sarcophagus,
Return of Protesilaos (fig. 96), 223
16563, red-figure cup, 113n. 71
(ASR II, 197), Roman sarcophagus,
Medea, 212n. 6

General Index

Ancient authors are cited only when they figure in the text discussions; for a complete listing of specific passages, see the Index of Ancient Authors. Named works of art are included here; additional listings can be found in the Index of Works. In the case of illustrated works, page numbers refer to the discussion in the text, not the location of the illustration. Greek "χ" is alphabetized as "ch."

Abbai, bronze statuette from (fig. 75), 176, 178
Achilles, 46, 51; arms of, 95n. 30; body of, 221; and Briseis, 45; death predicted, 101n. 71; depicted on Roman sarcophagi, 203, 220 (figs. 93, 94); shield of, in *Iliad*, 5, 8, 12, 35–40, 42–43
Acron (myth of), 221
Adonia, 190
Aegina, Temple of Aphaia, 98n. 51
Aemilius Paullus, 250–51
Aeneas, 34
Aeschylos, *Eumenides*, 218, 219
aesthetic(s), 261, 267, 276, 277, 278, 281, 282, 283; Archaic and Late Antique, 243; distrusted by Diderot, 268; experience, 247, 251; feeling, 272; as new function of art, 16–17; of the ordinary, 283; Plato on, 14; revolution, in Europe, 267–68; equivalent to scientific reception, 285; Winckelmann as founder of, 264–70. *See also* art; *Kunstmythologie*; Winckelmann, Johann
Aetna (anonymous poem), 253
ἀγάλμα(τα), 31, 34 and n. 35, 35, 36, 43, 46, 60, 64n. 57
Agamemnon, 33, 35, 44, 47, 51, 66n. 97, 219; depicted on Roman sarcophagus, 220 (fig. 93)
Agorakritos, 28
Aigisthos, 80 and n. 41, 219
Ajax, 87, 88, 221
Akrai (Sicily), 193
Albani Collection, 225–26 (fig. 99), 227 (fig. 100)

Alkestis, 232
Alkinoös, palace of, 32, 35, 65n. 78
allegory, 224, 225, 232
Amazonomachies, 203, 212nn. 4, 9, 214n. 22
Amphiaraos, 83–84 (fig. 19), 88–90, 134n. 35
Amphion, 230
Anadouomenos (statue by Pheidias), 181
Anadyomene, 253; *see also* Aphrodite
Anaximander of Miletos, 248
ἀνδραποδώδεις, 29, 58
Antium: as origin of Apollo Belvedere, 264; as origin of Corsini silver cup, 218
Apelles, painting of Anadyomene, 253
Aphrodite, 125; as Anadyomene, 192–93, 253; Arles type, 189; association with Hera, 193; bath of, 187 and n. 3; birth of, 119–20; dating images of, 188–89; depicted on Parthenon, 80, 103 (fig. 23); depicted on Roman sarcophagus, 201, 215n. 29; endures own power, 104; fourth-century nude figures of, 197n. 43; iconography of, 107–8, 187; identification of, 189–90; in Judgment of Paris, 107–10, 112–15; Knidian, 12, 13–14, 187–98 passim, 250; life-image of, 117–20; pours libation 125–27, 134n. 37; on shell, 192, 193 (fig. 83). *See also* gods/goddesses, Greek; nudity
Apollo, 117, 122; in apotheosis of Herakles, 146; in assembly of the gods, 135, 142; bearded vs. beardless, 19–20n. 38, 80–81 and n. 43, 130n. 7; and birth of Athena, 147; and epiphany, 110 (fig. 30); experiences own power, 104; kills Python, 124, 267, 268;